PICTURE-WRITING
OF THE AMERICAN INDIANS

by GARRICK MALLERY

FOREWORD
by J. W. Powell

IN TWO VOLUMES

VOLUME

TWO

DOVER PUBLICATIONS, INC.
NEW YORK

Published in Canada by General Publishing
Company, Ltd., 30 Lesmill Road, Don Mills,
Toronto, Ontario.
Published in the United Kingdom by Con-
stable and Company, Ltd., 10 Orange Street,
London WC 2.

This Dover edition, first published in 1972, is
an unabridged republication of the Accompany-
ing Paper, "Picture-Writing of the American
Indians," of the *Tenth Annual Report of the
Bureau of Ethnology to the Secretary of the
Smithsonian Institution, 1888–'89, by J. W.
Powell, Director*, originally published by the
Government Printing Office, Washington, D. C.,
in 1893. The first section of the original volume,
"Report of the Director," has been omitted in
the present edition, except for a few pages
referring directly to the Accompanying Paper.
The original edition (Report plus Accompany-
ing Paper) was in one volume. The present
edition (unabridged Accompanying Paper and
excerpt from Report) is in two volumes.
The following plates, which appear in black
and white in the present edition, were in color
in the original edition: XVI, XX through XXIX,
XXXIX, XLV, XLVI, XLVIII and XLIX.

International Standard Book Number: 0-486-22843-6
Library of Congress Catalog Card Number: 76-188815

Manufactured in the United States of America
Dover Publications, Inc.
180 Varick Street
New York, N. Y. 10014

CONTENTS.

ILLUSTRATIONS.

411

MALLERY,

VOL 2.

411

MAL

Please renew/return this item by the last date shown.

So that your telephone call is charged at local rate, please call the numbers as set out below:

	From Area codes 01923 or 020:	From the rest of Herts:
Renewals:	01923 471373	01438 737373
Enquiries:	01923 471333	01438 737333
Textphone:	01923 471599	01438 737599

L32 www.hertsdirect.org/librarycatalogue

CHAPTER XIV.

RELIGION.

The most surprising fact relating to the North American Indians, which until lately had not been realized, is that they habitually lived in and by religion to a degree comparable with the old Israelites under the theocracy. This was sometimes ignored, and sometimes denied in terms, by many of the early missionaries and explorers. The aboriginal religion was not their religion, and therefore was not recognized to have an existence or was pronounced to be satanic. Many pictorial representations are given in this chapter of concepts of the supernatural, as operative in this world, which is popularly styled religion when it is not condemned as superstition. The pictographic examples presented from the Siouan stock are generally explained as they appear. Those from the Ojibwa and other tribes are not so fully discussed. It is therefore proper to mention explicitly that, in the several localities where the tribes are now found which have been the least affected by civilization, they in a marked degree live a life of religious practices, and their shamans have a profound influence over their social character. A careful study of these people has already given indication of facts corresponding in interest with those which have recently surprised the world as reported by Mr. Cushing from among the Zuñi and Dr. Matthews from among the Navajo.

The most extensive and important publications on the subject have been made by Maj. J. W. Powell (a), Director of the Bureau of Ethnology. These have been made at many times and in various shapes, from the Outlines of the Philosophy of the North American Indians, read in 1876, to the present year.

A considerable amount of detail respecting religion appears in Chap. IX, Sections 4 and 5, in the present work.

The discussion of the religions and religious practices of the tribes of America is not germane to the present work, except so far as it elucidates their pictographs. In that connection it may be mentioned that the tribes of Indians in the territory of the United States, which have been converted to Christianity, seem not to have spontaneously turned their pictographic skill to the representation of objects connected with the religion to which they have been converted. This might be explained by the statement, often true, that the converts have been taught

461

to read and write the languages of their teachers in religion, and therefore ceased to be pictographers. But where they have not been so instructed, indeed have been encouraged to retain their own language and to write it in a special manner supposed to be adapted to their ancient methods, the same result is observed. The Micmacs still with delight draw on bark their stories of Glooscap and Lox, and scenes from the myths of their old faith, but unless paid as for a piece of work, do not produce Christian pictures. This assertion does not conflict with the account of the "Micmac hieroglyphs" in Chap. XIX, Sec. 2. All the existing specimens of these were made by Europeans, and the action of the first Indian converts, which was imitated by Europeans, was the simple use of their old scheme of mnemotechny to assist in memorizing the lessons required of them by missionaries. It is also to be noted that some tribes for convenience have adopted Christian emblems into their own ceremonial pictographs (see Fig. 159).

It has been found convenient to divide this chapter into the following sections: (1) Symbols of the supernatural. (2) Myths and mythic animals. (3) Shamanism. (4) Charms and amulets. (5) Religious ceremonies. (6) Mortuary practices.

SECTION 1.

SYMBOLS OF THE SUPERNATURAL.

This group shows the modes of expressing the idea of the supernatural, holy, sacred, or, more correctly, the mystic or unknown (perhaps unknowable), that being the true translation of the Dakota word wakan. The concept of "crazy," in the sense of influenced by superior powers or inspired, is in the same connection. Not only the North American Indians, but many tribes of Asia and Africa, consider a demented person to be sacred and therefore inviolable. The spiral line is but a pictorial representation of the sign for wakan, which is: With its index finger extended and pointing upward, or all the fingers extended, back of hand outward, move the right hand from just in front of the forehead spirally upward nearly to arm's length from left to right.

Fig. 640.—Crazy-Dog, a Dakota, carried the pipe around and took the war path. Cloud-Shield's Winter Count, 1838–'39.

The waved or spiral lines denote crazy or mystic, as above explained.

FIG. 640.

Fig. 641.—Crazy-Horse says his prayers and goes on the war-path. Cloud-Shield's Winter Count, 1844–'45.

The waved lines are used again for crazy. "Says his prayers," which are the words of the interpreter, would be more properly rendered by referring to the ceremonies of organizing a war party.

FIG. 641.

Fig. 642.—Crazy-Horse's band left the Spotted-Tail agency (at Camp Sheridan, Nebraska) and went north, after Crazy-Horse was killed at Fort Robinson, Nebraska. Cloud-Shield's Winter Count, 1877–'78.

Hoofprints and lodge-pole tracks run northward from the house, which represents the agency. That the horse is "crazy" is shown by the waved or spiral lines on his body, running from his nose, hoof, and forehead. The band is named from its deceased chief, and is designated by his personal device, a distinct and unusual departure among Indians tending towards the evolution of band or party emblems unconnected with the gentile system.

FIG. 642.

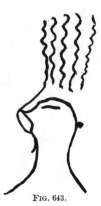

Fig. 643.—Medicine. Red-Cloud's Census. The full rendering should be medicine-man or shaman. The waving lines above the head again signify mystic or sacred, and are made in gesture in a similar manner as that before described, with some differentiation, for prayer or incantation. The shut or half-closed eye may be noted.

FIG. 643.

FIG. 644.

Fig. 644.—Medicine-man. Red-Cloud's Census. This is a rude variant of the foregoing.

FIG. 645.

Fig. 645.—Crazy-Head. Red-Cloud's Census. The wavy lines here form a circle around the head to suggest the personal name as well as the quality.

FIG. 646.

Fig. 646.—Medicine-Buffalo. Red-Cloud's Census. This is probably an albino buffalo, and may refer to the man who possessed one who is venerated therefor. See Chap. XIII.

Fig. 647.—Kangi-wakan, Sacred-Crow. The Oglala Roster. The lines above the bird's head signify sacred, mystic, sometimes termed "medicine," as above.

FIG. 647.

Fig. 648.—White-Elk. Red-Cloud's Census. This is an albino elk which partakes in sacredness with the albino buffalo. The elk was an important article of food, though not so much a reliance as the buffalo, and the practices relating to the latter would naturally, and in fact did, measurably, apply to the former.

FIG. 648.

Fig. 649.—The Dakotas had all the mini wakan (spirit water, or whisky) they could drink. American-Horse's Winter Count, 1821–'22. A barrel with a waved or spiral line running from it represents the whisky, the waved line signifying wakan, or spirit, in the double sense of the English word.

FIG. 649.

Fig. 650.—Cloud-Bear, a Dakota, killed a Dakota, who was a long distance off, by throwing a bullet from his hand and striking him in the heart. American-Horse's Winter Count, 1824–'25. The spiral line is used for wakan.

FIG. 650.

Fig. 651.—A Minneconjou clown, well known to the Indians. The Flame's Winter Count, 1787–'88. His accouterments are fantastic. The

character is explained by Battiste Good's Winter Count for the same year as follows:

"Left-the-heyoka-man-behind winter." A certain man was heyoka, that is, in a disordered frame of mind, and went about the village bedecked with feathers singing to himself, and while so joined a war party. On sighting the enemy the party fled and called to him to turn back also, but as he was heyoka he construed everything that was said to him as meaning the

FIG. 651.

very opposite, and, therefore, instead of turning back he went forward and was killed. This conception of a man under superhuman influence being obliged to believe or speak the reverse of the truth is not uncommon among the Indians. See Leland (a) Algonquin Legends.

Fig. 652, from Copway (b), gives the representation of "dream."

The recumbent human figure naturally suggests sleep, and the wavy lines to the head indicate the spiritual or mythic concept of a dream.

FIG. 652.—Dream. Ojibwa.

Fig. 653: a is an Ojibwa pictograph taken from Schoolcraft representing "medicine man," "meda." With these horns and spiral may be collated b in the same figure, which portrays the ram-headed Egyptian god Knuphis, or Chnum, the spirit, in a shrine on the boat of the sun, canopied by the serpent goddess Ranno, who is also seen facing him inside the shrine. This is reproduced from Cooper's Serpent Myths (a). The same deity is represented in Champollion (a) as reproduced in Fig. 653, c.

d is an Ojibwa pictograph found in Schoolcraft (i) and given as "power." It corresponds with the Absaroka sign for "medicine man" made by passing the extended and separated index and second finger of the right hand upward from the forehead, spirally, and is considered to indicate "superior knowledge." Among the Otos, as part of the sign with the same meaning, both hands are raised to the side of the head and the extended indices pressing the temples.

e is also an Ojibwa pictograph from Schoolcraft, same volume, Pl. 59, and is said to signify Meda's power. It corresponds with another sign made for "medicine man" by the Absaroka and Comanche, viz, the hand passed upward before the forehead, with index loosely extended. Combined with the sign for "sky" it means knowledge of superior matters, spiritual power.

In many parts of the United States and Canada rocks and large stones are found which generally were decorated with paint and were regarded as possessing supernatural power, yet, so far as ascertained, were not directly connected with any special personage of Indian

mythology. One of the earliest accounts of these painted stones was made by the Abbé de Gallinée and is published in Margry (*d*). The Abbé, with La Salle's party in 1669, found on the Detroit river, six leagues above Lake Erie, a large stone remotely resembling a human figure and painted, the face made with red paint. All the Indians of the region—Algonquian and Iroquoian—believed that the rock-image could give safety in the passage of the lake, if properly placated, and they never ventured on the passage without offering to it presents of skins, food, tobacco, or like sacrifices. La Salle's party, which had met with misfortune, seems to have been so much impressed with the evil powers of the image that they broke it into pieces.

Keating's Long (*e*) tells:

At one of the landing places of the St. Peters river, in the Sioux country, we observed a block of granite of about eighty pounds weight; it was painted red and covered with a grass fillet, in which were placed twists of tobacco offered up in sacrifice. Feathers were stuck in the ground all round the stone.

Mrs. Eastman (*a*) also describes a stone painted red, which the Dakotas called grandfather, in reverence, at or near which they placed as offerings their most valuable articles. They also killed dogs and horses before it as sacrifices.

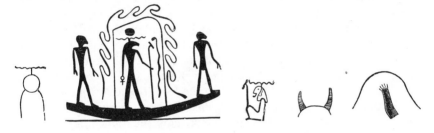

FIG. 653.—Religious symbols.

In "A study of Pueblo Architecture," by Victor Mindeleff, in the Eighth Annual Report of the Bureau of Ethnology, is an account of the cosmology of the Pueblos as symbolized in their architecture and figured devices, as follows:

In the beginning all men lived together in the lowest depths, in a region of darkness and moisture; their bodies were misshappen and horrible and they suffered great misery, moaning and bewailing continually. Through the intervention of Myuingwa (a vague conception known as the god of the interior) and of Baholikonga (a crested serpent of enormous size, the genius of water) "the old man" obtained a seed from which sprang a magic growth of cane. It penetrated through a crevice in the roof overhead and mankind climbed to a higher plane. A dim light appeared in this stage and vegetation was produced. Another magic growth of cane afforded the means of rising to a still higher plane, on which the light was brighter; vegetation was reproduced and the animal kingdom was created. The final ascent to this present or fourth plane was effected by similar magic growths and was led by mythic twins, according to some of the myths, by climbing a great pine tree, in others by climbing the cane, *Phragmites communis*, the alternate leaves of which afforded steps as of a ladder, and in still others it is said to have been a rush,

through the interior of which the people passed up to the surface. The twins sang as they pulled the people out, and when their song was ended no more were allowed to come, and hence many more were left below than were permitted to come above; but the outlet through which mankind came has never been closed, and Myuingwa sends through it the germs of all living things. It is still symbolized by the peculiar construction of the hatchway of the kiva and in the designs on the sand altars in these underground chambers, by the unconnected circle painted on pottery, and by devices on basketry and other textile fabrics.

SECTION 2.

MYTHS AND MYTHIC ANIMALS.

Among the hundreds of figures and characters seen by the present writer on the slate rocks that abound on the shores and islands of Kejimkoojik Lake, Queen's county, Nova Scotia, described in Chap. ii, Sec. 1, there appears a class of incised figures illustrating the religious myths and folk lore of the Indian tribes which inhabited the neighborhood within historic times. It is probable that in other parts of America, and, indeed, in all lands, the pictographic impulses and habits of the people have induced them to represent the scenes and characters of their myths on such rocks as were adapted to the purpose, as they are known to have done on bark, skins, and other objects. But these exhibitions of the favorite or prevalent myths in the shape of petroglyphs, though doubtless existing, have seldom been understood and deciphered by modern students. Sometimes they have not originally been sufficiently distinct or have become indefinite by age, and frequently their artists have been people of languages, religions, and customs different from the tribes now or lately found in the localities and from whom the significance of the petroglyphs has been sought in vain. The conditions of the characters at Kejimkoojik, now mentioned, are perhaps unique. They are drawn with great distinctness and sufficient skill, so that when traced on the rocks they immediately struck the present writer as illustrative of the myths and tales of the Abnaki. Many of these myths had been recently repeated to him by Mrs. W. Wallace Brown, of Calais, Maine, the highest authority in that line of study, and by other persons visited in Maine, New Brunswick, Nova Scotia, and in Cape Breton and Prince Edwards Islands, who were familiar with the Penobscot, Passamaquoddy, Amalecite, and Micmac tribes. A number of these myths and tales had before been collected in variant forms by Mr. Charles G. Leland (a). It is a more important and convincing fact that the printed impressions of the figures now presented were at once recognized by individual Indians of the several Abnaki tribes above mentioned to have the signification explained below. It is also to be noted that these Abnaki have preserved the habit of making illustrations from their stories by scratchings and scrapings on birch bark. The writer saw several such figures on bark ornaments and utensils which exhibited parts of the identical myths indicated in the petroglyphs but not the precise scenes or characters depicted on the rocks. The selection

of themes and their treatment were not conventional and showed some
originality and individuality both in design and execution. From the
appearance and surroundings of the rock drawings now specially under
discussion they were probably of considerable antiquity and suggested
that the Micmacs, who doubtless were the artists, had gained the idea of
practicing art for itself, not merely using the devices of pictography for
practical purposes, such as to record the past or to convey information.

Fig. 654 is one of the drawings mentioned, and indicates one episode
among the very numerous adventures of Glooscap, the Hero-God of the
Abnaki, several of which are connected with a powerful witch called by
Mr. Leland Pook-jin-skwess, or the Evil Pitcher, and by Mrs. W.
Wallace Brown, Pokinsquss, the Jug Woman. She is also called the
toad woman, from one of her transformations, and often appeared in a

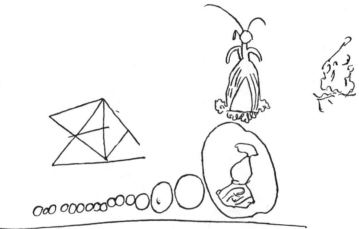

FIG. 654.—Myth of Pokinsquss.

male form to fight Glooscap after he had disdained her love proffered
as a female. Among the multitude of tales on this general theme, one
narrates how Glooscap was at one time a Pogumk, or the small animal
of the weasel family commonly called Fisher (Mustela Canadensis), also
translated as Black Cat, and was the son of the chief of a village of
Indians who were all Black Cats, his mother being a bear. Doubtless
these animal names and the attributes of the animals in the tales refer
to the origin of totemic divisions among the Abnaki. Pokinsquss was
also of the Black Cat village, and hated the chief and contrived long
how she could kill him and take his place. Now, one day when the
camp had packed up to travel, the witch asked the chief Pogumk to
go with her to gather gull's eggs; and they went far away in a canoe
to an island where the gulls were breeding and landed there, and then
she hid herself to spy, and having found out that the Pogumk was
Glooscap, ran to the canoe and paddled away singing:

Nikhed-ha Pogumk min nekuk,
Netswil sāgāmawin!

Which being translated from the Passamaquoddy language means—

I have left the Black Cat on an island,
I shall be chief of the Fishers now!

The continuation of the story is found in many variant shapes. In one of them Glooscap's friend the Fox came to his rescue, as through Glooscap's m'toulin or magic power he heard the song of appeal though miles away beyond forests and mountains. In others the Sea Serpent appears in answer to the Hero-God's call, and the latter, mounting the serpent's back, takes a load of stones as his cargo to throw at the serpent's horns when the latter did not swim fast enough. In

Fig. 655.—Myth of Atosis.

the figure the island is shown at the lower right hand as a roundish outline with Glooscap inside. The small round objects to the left are probably the gull's eggs, but may be the stimulating stones above mentioned. Pokinsquss stands rejoicing in the stern of a canoe, which points in the wavy water away from the island. The device to the left of the witch may be the dismantled camp of the Black Cats, and the one to her right is perhaps where the Fox "beyond forests and mountains" heard Glooscap's song of distress.

Fig. 655, another specimen of the same class, refers to one of the tales about At-o-sis, the Snake, who was the lover of a beautiful Abnaki woman. He appeared to her from out the surface of a lake as a young hunter with a large shining silvery plate on his heart and covered with brilliant white brooches as fish are covered with scales. He provided her with all animals for food. The bow attached to the semi-human head in the illustration may refer to this expertness in the chase. The head of the female figure is covered or masked by one of the insignia of rank and power mentioned in Chap. XIII, Sec. 2. She became the mother of the Black Snakes.

Fig. 656, from the same locality, shows simply a crane, and a woman who bears in her hand two branches; but this is a sufficient indication of the tale of the Weasel girls, who had come down from Star-land by means of a diminishing hemlock tree, and flying from Lox had come to a broad river which they could not cross. But in the edge of the water stood motionless a large crane, or the Tum-gwo-lig-unach, who was the ferryman. "Now, truly, this is esteemed to be the least beautiful of all the birds, for which cause he is greedy of good words and fondest of flattery. And of all beings there were none who had more bear's oil ready to annoint every one's hair with—that is to say, more compliments ready for everybody—than the Weasels. So, seeing the Crane, they sang:

FIG. 656.—Myth of the Weasel girls.

> Wa wela quis kip pat kasqu´,
> Wa wela quis kip pat kasqu´.
>
> The Crane has a very beautiful long neck,
> The Crane has a very beautiful long neck.

"This charmed the old ferryman very much, and when they said: 'please, grandfather, hurry along,' he came quickly. Seeing this, they began to chant in chorus sweetly as the Seven Stars themselves:

> Wa wela quig nat kasqu´,
> Wa wela quig nat kasqu´.
>
> The crane has very beautiful long legs,
> The crane has very beautiful long legs.

"Hearing this the good crane wanted more; so when they asked him to give them a lift across he answered, slowly, that to do so he must be well paid, but that good praise would answer as well. Now they who had abundance of this and to spare for everybody were these very girls. 'Have I not a beautiful form?' he inquired; and they both cried aloud: 'Oh, uncle, it is indeed beautiful!' 'And my feathers?' 'Ah, *pegeakopchu*.' 'Beautiful and straight feathers, indeed!' 'And have I not a charming long, straight, neck?' 'Truly our uncle has it straight and long.' 'And will ye not acknowledge, oh maidens, that

my legs are fine?' 'Fine! oh, uncle, they are perfection. Never in this life did we see such legs!' So, being well pleased, the crane put them across, and then the two little weasels scampered like mice into the bush."

Though but one woman figure is drawn, the two boughs borne by her suggest the two weasel girls, who had come down the hemlock tree and had also been water fairies until their garments were stolen by the marten, and thereupon they had lost their fairy powers and become women in a manner at once reminding of the Old World swan-maiden myth.

FIG. 657.—The Giant Bird Kaloo.

Fig. 657 is a sketch of the Giant Bird Kaloo, or, in the literation of Mr. Leland, Culloo. He was the most terrible of all creatures. He it was who caught up the mischievous Lox in his claws and, mounting to the top of the sky among the stars, let him drop, and he fell from dawn to sunset. Lox was often a badger in the Micmac stories, and was more Puck-like than the devilish character he showed among the Passama-quoddy, being then generally in the form of a wolverine, though some-times in that of a lynx. In the illustration Kaloo is soaring among the stars, and appears to possess an extra pair of legs armed with claws. Perhaps one of the objects beneath his beak represents Lox or some

other victim falling through the air. There is another story of Lox's two feet talking and acting independently of the rest of his body, and the two feet and legs without any body may be a symbol of the tricksy demigod.

Fig. 658 represents Kiwach, the Strong Blower, a giant who kills people with his violent breath. Tales of him seem to be more current or better preserved among the Amalecites than among the other Abnaki.

Fig. 659 is an exact copy of the design on a birch-bark jewel box made by the Passamaquoddy of Maine, amiably contributed by Mrs. W. W. Brown, together with the description of that part of the myth which is illustrated on the box. There are several variants of this myth, the nearest to the form now pre-sented being published by Mr. J. Walter Fewkes (a).

The Sable and the Black Cat wanted some maple sugar, and went to a wood where the maple trees grew. Toward night they lost their way and separated from each other to find it, agreeing to call to each other by *m'toulin* power. These animals were as frequently in human form as in that designated by their names, and could change to the forms of other animals. It is not certain, from anything in the present version of the myth, which one of the daimons was represented by the Sable, but the Black Cat afterward appears as Glooscap. Sable, in his wanderings, came to a wigwam in which was a large fire with a kettle boiling over it, tended by a great Snake. The Snake said he was glad the Sable had come, as he was very hungry and would eat him, but in gratitude for his coming would put him to as little pain as

Fig. 658.—Kiwach, the Strong Blower.

was possible. The Snake told him to go into the woods and get a straight stick, so that when he pierced him he would not tear open his entrails. Sable then went out and sang in a loud voice a *m'toulin* song for the Black Cat to hear and come to his aid. The Black Cat heard him and came to him. Then the Sable told the Black Cat how the Snake was going to kill him. The Black Cat told Sable not to be afraid, but that he would kill the big Snake. He told him that he would lie down behind the trunk of a hemlock tree which had fallen and that Sable should search out a stick that was very crooked, only pretending to obey the commands of the great Snake. After finding such a stick he should carry it to the Snake, who would complain that the stick was not straight enough, and then Sable should reply that he would

straighten it in the fire, holding it there until the steam came out of the end. Then while the Snake watched the new mode of straightening sticks Sable should strike the Snake over the eyes. The Sable sought out the most crooked stick he could find and then returned to the wigwam where the Snake was. The Snake said the stick was too crooked. The Sable replied as directed and held it in the fire. When it was burning he struck the Snake with it over the eyes, blinded him, and ran away. The Snake followed the Sable, and as he passed over the hemlock trunk the Black Cat killed him and they cut him into small pieces.

FIG. 659.—Story of Glooscap.

The two human figures on the left show the animals under the forest trees in human form bidding good-bye before they parted in search of the right trail. Their diminutive size gives the suggestion of distance from the main scene. Next comes the great Snake's wigwam, the stars outside showing that night had come, and inside the kettle hung over a fire, and on its right appear the wide-open jaws and an indication of the head of the great Snake. The very crooked stick is on the other side. Farther on the Black Cat comes responsive to the Sable's call. Next is shown the Black Cat and the Sable, who is in human form, near the hemlock tree. The fact that the tree is fallen is suggested, without any attempt at perspective, by the broken-off branches and the thick part of the trunk being upturned. The illustration ends with the Black Cat sitting upon the Snake, clawing and throwing around pieces of it.

The illustration above presented gives an excellent example of the art of the Passamaquoddy in producing pictures by the simple scraping of birch bark.

The characters in Fig. 660 are reproduced from Schoolcraft (k).

FIG. 660.—Ojibwa shamanistic symbols.

The first device, beginning at the left, is used by the Ojibwa to denote a spirit or man enlightened from on high, having the head of the sun.

The second device is drawn by the Ojibwa for a "wabeno" or shaman.

The third is the Ojibwa "symbol" for an evil or one-sided "meda" or higher-grade shaman.

The fourth is the Ojibwa general "symbol" for a meda.

Mr. William H. Holmes, of the Bureau of Ethnology, gives the following account (condensed from the American Anthropologist, July, 1890) of a West Virginia rock shelter (shown in Pl. XXXI). The copy is in two rows of figures, but in the original there is only one row, the parts marked a and a being united:

In Harrison county, West Virginia, a small stream, Two-Lick creek, heading near the Little Kanawha divide, descends into the west fork of the Monongahela about 4 miles west of Lost Creek station, on the Clarksburg and Weston railroad. Ascending the stream for a little more than 2 miles and turning to the right up a tributary called Campbells run, is a recess in the rocks, the result of local surface undermining of an outcrop of sandstone assisted by roof degradation, which therefore is a typical rock shelter. At the opening it is about 20 feet long and in the deepest part extends back 16 feet.

The rock sculptures, of which simplified outlines are given in Pl. XXXI, occupy the greater part of the back wall of the recess, covering a space of some 20 feet long by about 4 feet in height. At the left the line of figures approaches the outer face of the rock, but at the right it terminates in the depths of the chamber, beyond which the space is too low and uneven to be utilized. There are indications that engravings have existed above and below those shown, but their traces are too indistinct to be followed.

The more legible designs comprise three heads, resembling death's-heads, one human head or face, one obscure human figure, three birds resembling cranes or turkeys (one with outspread wings), three mountain lions or beasts of like character, two rattlesnakes, one turtle, one turtle-like figure with bird's head, parts of several unidentified creatures (one resembling a fish), and four conventional figures or devices resembling, one a hand, one a star, one the track of a horse, and the fourth the track of an elk, buffalo, deer, or domestic cow.

The serpents, placed above and toward the right of the picture, are much larger than life, but the other subjects are represented somewhat nearly natural size. The animal figure facing the two death's-heads is drawn with considerable vigor and very decidedly suggests the panther. A notable feature is the two back-curving spines or spine-like tufts seen upon its shoulder; it is possible that these represent some mythical character of the creature. Two of the animal figures, in accordance with a widespread Indian practice, exhibit the heart and the life line, the latter connecting the heart with the mouth; these features are, as usual, drawn in red.

The human head or face is somewhat larger than life; it is neatly hollowed out to the nearly uniform depth of one-fourth of an inch, and is slightly polished over most of the surface. Ear lobes are seen at the right and left, and an arched line, possibly intended for a plume, rises from the left side of the head. A crescent-shaped band of red extends across the face, and within this the eyes are indistinctly marked. The mouth is encircled by a dark line and shows six teeth, the spaces between being filled in with red.

Probably the most remarkable members of the series are the three death's-heads seen near the middle of the line. That they are intended to represent skulls and not the living face or head is clear, and the treatment is decidedly suggestive of that exhibited in similar work of the more cultured southern nations. The eye spaces are large and deep, the cheek bones project, the nose is depressed, and the mouth is a mere node depressed in the center.

All the figures are clearly and deeply engraved, and all save the serpents are in full intaglio, being excavated over the entire space within the outlines and to the

depth of from one-eighth to one-fourth of an inch. The serpents are outlined in deep unsteady lines, ranging from one-fourth of an inch to 1 inch in width, and in parts are as much as one-half an inch in depth. The example at the left is rather carefully executed, but the other is very rude. It is proper to notice a wing-like feature which forms a partial arch over the larger serpent. It consists of a broad line of irregular pick marks, which are rather new looking and may not have formed a part of the original design; aside from this, there are few indications of the use of hard or sharp tools, and, although picking or striking must have been resorted to in excavating the figures, the lines and surfaces were evidently finished by rubbing. The friable character of the coarse, soft sandstone makes excavation by rubbing quite easy, and at the same time renders it impossible to produce any considerable degree of polish.

The red color used upon the large face and in delineating the life line and heart of the animal figures is a red ocher or hematite, bits of which, exhibiting the effects of rubbing, were found in the floor deposits of the recess. The exact manner of its application is not known (perhaps the mere rubbing was sufficient), but the color is so fixed that it can not be removed save by the removal of the rock surface.

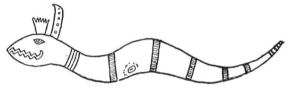

FIG. 661.—Baho-li-kong-ya. Arizona.

Regarding the origin and purpose of these sculptures, it seems, prob-able that they are connected with religious practices and myths. If the inscriptions were mnemonic records or notices it is reasonable to suppose that they would have been placed so as to meet the eye of others than those who made or were acquainted with them. But these works are hidden in a mountain cave, and even yet, when the forest is cleared and the surrounding slopes are cultivated, this secluded recess is invisible from almost every side. The spot was evidently the resort of a chosen few, such as a religious society. Such sequestered art gives evidence of a mystic purpose.

In this connection it may be noted that a rock drawing in the Canyon Segy, Arizona (Fig. 661), shows Baho li-kong-ya, a god, the genius of fructification, worshipped by living Moki priests. It is a great crested serpent with mammæ, which are the source of the blood of all the ani-mals and of all the waters of the land.

FIG. 662.—Mythic serpents, Innuits.

The serpents in the last-mentioned plate and figure may be compared with two Ojibway forms published by Schoolcraft (*l*).

The upper design of Fig. 662 undoubtedly represents a mythical ani-mal, referred to in the myths of some of the Innuits. It is reproduced

PICTOGRAPH IN ROCK SHELTER, WEST VIRGINIA.

from a drawing on walrus ivory, bearing Museum No. 40054, obtained at Port Clarence, Alaska. This form is not so close in detail to that form usually described and more fully outlined in the lower design of the same figure, which is reproduced from a specimen of reindeer horn drill-bow, from Alaska, marked No. 24557, collected by L. Turner.

Ensign Niblack, U. S. Navy (d), gives the following description of the illustration reproduced here as Fig. 663.

It represents T'kul, the wind spirit, and the cirrus clouds, explaining the Haida belief in the causes of the changes in the weather. The center figure is T'kul, the

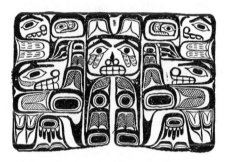

FIG. 663.—Haida Wind Spirit.

wind spirit. On the right and left are his feet, which are indicated by long streaming clouds; above are the wings, and on each side are the different winds, each designated by an eye, and represented by the patches of cirrus clouds. When T'kul determines which wind is to blow, he gives the word and the other winds retire. The change in the weather is usually followed by rain, which is indicated by the tears which stream from the eyes of T'kul.

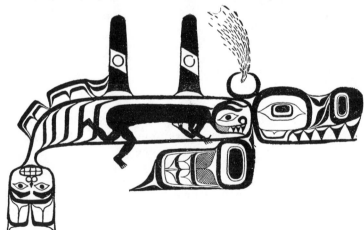

FIG. 664.—Orca. Haida.

The same author, p. 322, thus describes Fig. 664:

It represents the orca or whale-killer, which the Haida believe to be a demon called Skana. Judge Swan says that, according to their belief—

"He can change into any desired form, and many are the legends about him. One which was related to me was that ages ago the Indians were out seal-hunting. The

weather was calm and the sea smooth. One of these killers, or blackfish, a species of porpoise, kept alongside of a canoe, and the young men amused themselves by throwing stones from the canoe ballast and hitting the fin of the killer. After some pretty hard blows from these rocks the creature made for the shore, where it grounded on the beach. Soon a smoke was seen, and their curiosity prompted them to ascertain the cause, but when they reached the shore they discovered, to their surprise, that it was a large canoe, and not the Skana that was in the beach, and that a man was on shore cooking some food. He asked them why they threw stones at his canoe. 'You have broken it,' he said, 'and now go into the woods and get some cedar withes and mend it.' They did so, and when they had finished the man said, 'Turn you backs to the water and cover your heads with your skin blankets, and don't look till I call you.' They did so, and heard the canoe grate on the beach as it was hauled down into the surf. Then the man said, 'Look, now.' They looked, but when it came to the second breaker it went under and presently came up outside of the breaker a killer and not a canoe, and the man or demon was in its belly. This allegory is common among all the tribes on the Northwest Coast, and even with the interior tribes with whom the salmon takes the place of the orca, which never ascends the fresh-water rivers. The Chilcat and other tribes of Alaska carve figures of salmon, inside of which is the full length figure of a nude Indian. * * * Casual observers without inquiry will at once pronounce it to be Jonah in the fish's belly, but the allegory is of ancient origin, far antedating the advent of the white man or the teachings of the missionary.

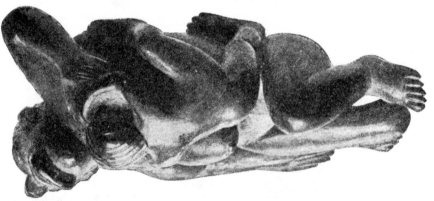

Fig. 665.—Bear-Mother. Haida.

The same author, Pl. XLIX, gives an explanation of Fig. 665, which is a copy of a Haida slate carving, representing the "Bear-Mother."
The Haida version of the myth is as follows:

A number of Indian squaws were in the woods gathering berries when one of them, the daughter of a chief, spoke in terms of ridicule of the whole bear species. The bears descended on them and killed all but the chief's daughter, whom the king of the bears took to wife. She bore him a child half human and half bear. The carving represents the agony of the mother in suckling this rough and uncouth offspring. One day a party of Indian bear hunters discovered her up a tree and were about to kill her, thinking her a bear, but she made them understand that she was human. They took her home and she afterwards became the progenitor of all Indians belonging to the bear totem. They believe that the bear are men transformed for the time being. This carving was made by Skaows-ke′ay, a Haida. Cat. No. 73117, U. S. Nat. Museum. Skidegate village, Queen Charlotte Islands, British Columbia. Collected by James G. Swan.

Dr. F. Boas (d) gives the following account of a myth of the Kwakiut Indians illustrated on a house front at Alert Bay, copied here as Fig. 666.

The house front shows how Kunkunquilikya (the thunder-bird) tried to lift the whale. The legend says that he had stolen the son of the raven, who in order to recover him, carried a whale out of a huge cedar that he covered with a coating of gum. Then he let all kinds of animals go into the whale, and they went to the land of the thunder-bird. When the bird saw the whale he sent out his youngest son to catch it. He was unable to lift it. He stuck to the gum and the animals killed him. In this way the whole family was slaughtered.

On Pl. XXXII is shown a reproduction of a native Haida drawing, representing the Wasko, a mythologic animal partaking of the charac-

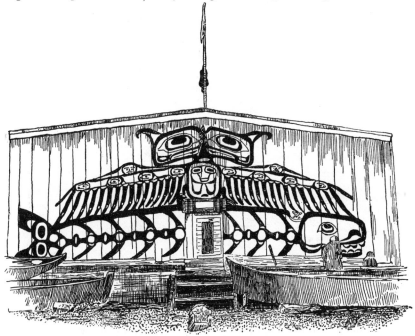

FIG. 666.—Thunder-bird grasping whale.

teristics of both the bear and the orca, or killer. It is one of the totems of the Haidas.

On the same plate is a figure representing the Hooyeh, or mythic raven. The character is also reproduced from a sketch made by a Haida Indian. Both of these figures were obtained from Haida Indians who visited Port Townsend, Washington, in the summer of 1884.

The following is extracted from Mrs. Eastman's (b) Dahcotah. The picture, reproduced here in Fig. 667, is that of Haokah, the antinatural god, one of the giants of the Dakotas, drawn by White-Deer, a Sioux warrior, living near Fort Snelling about 1840.

Explanation of the drawing.—a, the giant; b, a frog that the giant uses for an arrow point; c, a large bird that the giant keeps in his court; d, another bird; e, an orna-

ment over the door leading into the court; *f*, an ornament over a door; *g*, part of court ornamented with down; *h*, part of court ornamented with red down; *i*, a bear; *j*, a deer; *k*, an elk; *l*, a buffalo; *m, n*, incense-offering; *o*, a rattle of deer's claws, used when singing; *p*, a long flute, or whistle; *q, r, s, t*, are meteors that the giant sends out for his defense, or to protect him from invasion; *u, v, w, x*, the giant surrounded with lightnings, with which he kills all kinds of animals that molest him; *y*, red down in small bunches fastened to the railing of the court; *z*, the same. One

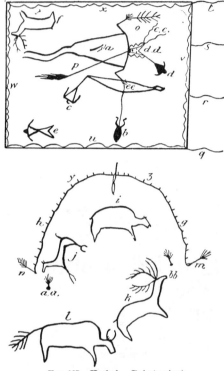

FIG. 667.—Haokah. Dakota giant.

of these bunches of red down disappears every time an animal is found dead inside the court; *aa, bb*, touchwood, and a large fungus that grows on trees. These are eaten by any animal that enters the court, and this food causes their death; *cc*, a streak of lightning going from the giant's hat; *dd*, giant's head and hat; *ee*, his bow and arrow.

Mrs. Eastman's explanation of the drawing would have been better if she had known more about the mystery lodges. It is given here in her own words.

FIG. 668.—Ojibwa Ma'nidō.

Fig. 668, from Copway (*c*), shows the representations, beginning from the left, of spirits above, spirits under water, and animals under ground, all of which are called ma'nidōs.

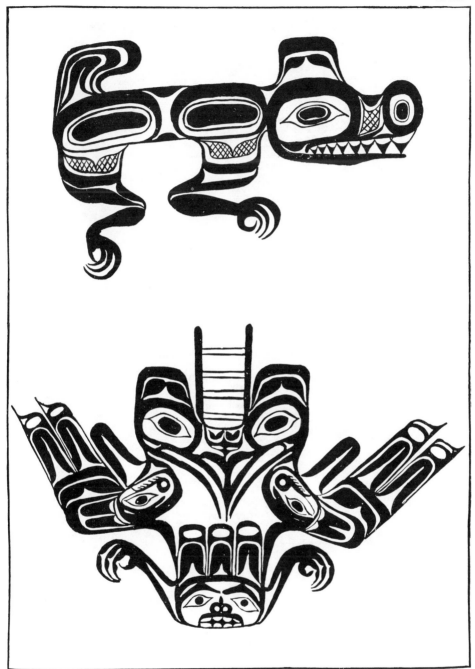

WASCO AND MYTHIC RAVEN, HAIDA.

Fig. 669 is a reproduction of a drawing made by Niópet, chief of the Menomoni Indians, and represents the white bear spirit who guards the deposits of native copper of Lake Superior. According to the myth the animal is covered with silvery hair, and the tail, which is of great length and extends completely around the body, is composed of bright, burnished copper. This spirit lives in the earth, where he guards the metal from discovery.

In a midē′ song, given by James Tanner (f), is the representation of an animal resembling the preceding, viz, the middle character of Fig. 670, to which is attached the Ojibway phrase and explanation as follows:

Che-be-gau-ze-naung gwit-to-i-ah-na maun-dah-ween ah-kee-ge neen-wa-nah gua-kwaik ke-nah gwit-to-i-ah-na.

I come to change the appearance of the ground, this ground; I make it look different each season.

FIG. 669.—Menomoni. White Bear Ma′nidō.

This is a Manito who, on account of his immensity of tail, and other peculiarities, has no prototype. He claims to be the ruler over the seasons. He is probably Gitche-a-nah mi-e-be-zhew (great underground wild-cat).

The "underground wild-cat" is again mentioned in the same work, page 377, with an illustration now presented as the left-hand character of the same Fig. 670, slightly different from the above, described as follows:

A-nah-me be-zhe ne-kau-naw.

Underground wild-cat is my friend.

At the fourth verse he exhibits his medicines, which he says are the roots of shrubs and of We-ug-gusk-oan, or herbs, and from these he derives his power, at least in part; but lest his claim, founded on a knowledge of these, should not be considered of sufficient importance, he proceeds to say, in the fifth and sixth verses, that the snakes and the underground wild-cat are among his helpers and friends. The ferocity and cunning, as well as the activity of the feline animals have not escaped the notice of the Indians, and very commonly they give the form of animals of this family to those imaginary beings whose attributes bear, in their opinion, some resemblance to the qualities of these animals. Most of them have heard of the lion, the largest of the cats known to white men, and all have heard of the devil; they consider them the same. The wild-cat here figured has horns, and his residence is under the ground; but he has a master, Gitche-a-nah-mi-e-be-zhew (the great underground wild-cat), who is, as some think, Matche-Manito himself, their evil spirit, or devil. Of this last they speak but rarely.

In another song from Tanner, p. 345, sung only by the midē', is the drawing, the right hand character of the same figure, of a similar animal with a bar across the throat, signifying, no doubt, its emerging or appearance from the surface of the ground.

Nah-ne-bah o-sa aun neen-no ne-mah-che oos-sa ya-ah-ne-no. [Twice.]
I walk about in the nighttime.

This first figure represents the wild-cat, to whom, on account of his vigilance, the medicines for the cure of diseases were committed. The meaning probably is that to those who have the shrewdness, the watchfulness, and intelligence of the wild-cat, is intrusted the knowledge of those powerful remedies, which, in the opinion of the Indians, not only control life and avail to the restoration of health but give an almost unlimited power over animals and birds.

FIG. 670.—Mythic wild-cats. Ojibway.

Schoolcraft, part II, p. 224, describes Fig. 671 as follows:

It was drawn by Little Hill, a Winnebago chief of the upper Mississippi, west. He represents it as their medicine animal. He says that this animal is seldom seen; that it is only seen by medicine men after severe fasting. He has a piece of bone which he asserts was taken from this animal. He considers it a potent medicine and uses it by filing a small piece in water. He has also a small piece of native copper which he uses in the same manner, and entertains like notions of its sovereign virtues.

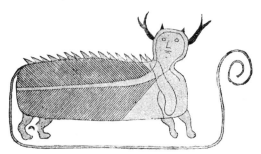

FIG. 671.—Winnebago magic animal.

The four preceding figures are to be compared with those relating to the Piasa rock. See Figs. 40 and 41, supra.

Fig. 672.—A Minneconjou Dakota, having killed a buffalo cow, found an old woman inside of her. The-Swan's Winter Count, 1850–'51.

For remarks upon this statement see Lone-Dog's Winter Count for 1850–'51, supra.

FIG. 672.—Mythic buffalo.

Graphic representations of Atotarka and of the Great Heads are shown in Mrs. Erminie A. Smith's Myths of the Iroquois, in the Second Annual Report of the Bureau of Ethnology. Several illustrations of myths and mythic animals appear in the present work in Chap. IX, Secs. 4 and 5.

THUNDER BIRDS.

Some forms of the thunder bird are here presented:

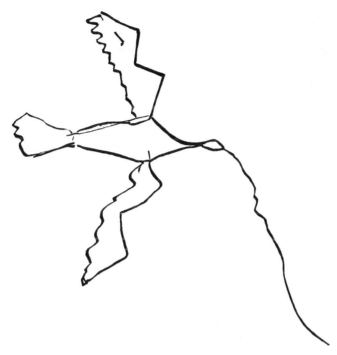

FIG. 673.—Thunder-bird, Dakota.

Figs. 673 and 674 are forms of the thunder bird found in 1883 among the Dakotas near Fort Snelling, drawn and interpreted by themselves. They are both winged, and have waving lines extending from the mouth downward, signifying lightning. It is noticeable that Fig. 673 placed vertically, then appearing roughly as an upright human figure, is almost identically the same as some of the Ojibwa meda or spirit figures represented in Schoolcraft, and also on a bark Ojibwa record in the possession of the writer.

FIG. 674.—Thunder-bird, Dakota.

Fig. 675 is another and more cursive form of the thunder bird obtained at the same place and time as those immediately preceding. It is wingless, and, with changed position or point of view, would suggest a headless human figure.

FIG. 675.—Wingless thunder-bird, Dakota.

FIG. 676.—Thunder-bird,
Dakota.

The thunder-bird, Fig. 676, is blue, with red breast and tail. It is a copy of one worked in beads found at Mendota, Minnesota.

The Sioux believe that thunder is a large bird, and represent it thus, Fig. 677, according to Mrs. Eastman (c), who adds details condensed as follows:

This figure is often seen worked with porcupine quills on their ornaments. U-mi-ne wah-chippe is a dance given by some one who fears thunder and thus endeavors to propitiate the god and save his own life.

A ring is made of about 60 feet in circumference by sticking saplings in the ground and bending their tops down, fastening them together. In the center of this ring a pole is placed, about 15 feet in height and painted red. From this swings a piece of birch bark cut so as to represent thunder. At the foot of the pole stand two boys and two girls. The boys represent war; they are painted red and hold war clubs in their hands. The girls have their faces painted with blue clay; they represent peace.

FIG. 677.—Dakota thunder-bird.

On one side of the circle a kind of booth is erected, and about 20 feet from it a wigwam. There are four entrances. When all arrangements for the dance are concluded the man who gives it emerges from his wigwam, dressed up hideously, crawling on all fours toward the booth. He must sing four tunes before reaching it.

In the meantime the medicine men, who are seated in the wigwam, beat time on the drum, and the young men and squaws keep time to the music by hopping on one foot and then on the other, moving around inside the ring as fast as they can. This is continued for about five minutes, until the music stops. After resting a few moments the second tune commences and lasts the same length of time, then the third and the fourth; the Indian meanwhile making his way toward the booth. At the end of each tune a whoop is raised by the men dancers.

After the Indian has reached his booth inside the ring he must sing four more tunes. At the end of the fourth tune the squaws all run out of the ring as fast as possible, and must leave by the same way that they entered, the other three entrances being reserved for the men, who, carrying their war implements, might be accidentally touched by one of the squaws, and the war implements of the Sioux warrior have from time immemorial been held sacred from the touch of woman. For the same reason the men form the inner ring in dancing round the pole, their war implements being placed at the foot of the pole.

When the last tune is ended the young men shoot at the image of thunder, which is hanging to the pole, and when it falls a general rush is made by the warriors to get hold of it. There is placed at the foot of the pole a bowl of water colored with blue clay. While the men are trying to seize the parts of the bark representation of their god they at the same time are eagerly endeavoring to drink the water in the bowl, every drop of which must be drank.

The warriors then seize on the two boys and girls (the representations of war and peace) and use them as roughly as possible, taking their pipes and war-clubs from

them and rolling them in the dirt until the paint is entirely rubbed off from their faces. Much as they dislike this part of the dance, they submit to it through fear, believing that after this performance the power of thunder is destroyed.

James's Long (*f*) says:

When a Kansas Indian is killed in battle the thunder is supposed to take him up they do not know where. In going to battle each man traces an imaginary figure of the thunder on the soil, and he who represents it incorrectly is killed by the thunder.

Fig. 678 is "Skam-son," the thunder-bird, a tattoo mark copied from the back of an Indian belonging to the Laskeek village of the Haida tribe, Queen Charlotte islands, by Mr. James G. Swan.

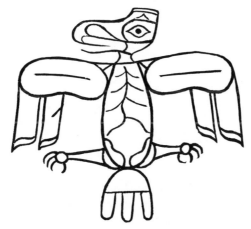

FIG. 678.—Thunder-bird. Haida.

Fig. 679 is a Twana thunder-bird, as reported by Rev. M. Eells in Bull. U. S. Geol. and Geog. Survey, III, p. 112.

There is at Eneti, on the reservation [Washington Territory], an irregular basaltic rock, about 3 feet by 3 feet and 4 inches, and a foot and a half high. On one side there has been hammered a face, said to be the representation of the face of the thunder-bird, which could also cause storms.

FIG. 679.—Thunder-bird. Twana.

The two eyes are about 6 inches in diameter and 4 inches apart and the nose about 9 inches long. It is said to have been made by some man a long time ago, who felt very badly, and went and sat on the rock and with another stone hammered out the eyes and nose. For a long time they believed that if the rock was shaken it would cause rain, probably because the thunder-bird was angry.

The three following figures, taken from Red-Cloud's Census, are connected with the thunder-bird myth:

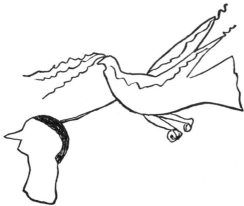

Fig. 680.—Medicine bird. Red-Cloud's Census. The word medicine is in the Indian sense, before explained, and would be more correctly expressed by the word sacred or mystic, as is also indicated by the waving lines issuing from the mouth.

Fig. 680.—Medicine bird. Dakota.

Fig. 681.—Five thunders. Red-Cloud's Census. The thunder-bird is here drawn with five lines (voices) issuing from the mouth, which may mean many voices or loud sound, but is connected with the above mentioned wavy or spiral lines, which form the conventional sign for wakan.

Fig. 681.—Five thunders. Dakota.

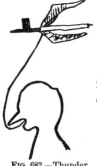

Fig. 682.—Thunder pipe. Red-Cloud's Census. This is a pipe to which are attached the wings of the thunder-bird.

Fig. 682.—Thunder pipe. Dakota.

Fig. 683, one of the drawings from the Kejimkoojik rocks of Nova Scotia, may be compared with the other designs of the thunder-bird and also with the Ojibwa type of device for woman. As regards the head, which appears to have a non-human form, it may also be compared with the many totemic designations in Chapter XIII, on Totems, Titles, and Names.

Marcano (*d*), describing Fig. 684, reports:

FIG. 683.—Micmac thunder-bird.

> At Boca del Infierno (mouth of hell), on a plain, there are found stones, separated from each other by spaces of 7 meters, on which are found inscriptions nearly a centimeter in depth. One of them represents a great bird similar to those which the Oyampis (Crevaux) are in the habit of drawing. On its left shoulder are seen three concentric circles arranged like those that form the eyes of the jaguars of Calcara. This figure is often reproduced in Venezuelan Guiana and beyond the Esequibo. The bird is united at the right by a double connecting stroke with another which is incomplete and much smaller. Furthermore, three small circles are seen below the left wing; three others, farther apart, separate its right wing from the neck of the lower bird. The triangles which form the breast and the tail of the two birds are worthy of note.

Mr. A. Ernst (*b*) describes the same figure:

> From the same place ("Boca del Infierno," a rapid of the Orinoco, 35 kilometers below the mouth of the Caura) is easily recognized a rough representation of two birds; from the feathers of the larger one water seems to be dropping; above, to the right, is seen a picture of the sun. This may be symbolic, and would then remind one of the representation of the wind and rain gods on the ruins of Central America.

FIG. 684.—Venezuelan thunder-bird.

Fig. 685 is a copy of four specimens of Indian workmanship in the collection of the Academy of Natural Sciences of Philadelphia. The objects are depicted by porcupine quills worked on pieces of birch bark, and represent various forms of the thunder-bird. The specimens are reported as having been obtained from a northwestern tribe, which may safely be designated as the Ojibwa, because the figures relate to one of the most important mythic animals of that tribe, and also because birch bark is used, a material exceedingly scarce in the country of the Sioux, among whom also the thunder-bird has a prominent religious position.

FIG. 685.—Ojibwa thunder-bird.

a. Made of neutral-tinted quills upon yellow bark, as is also *b*, which is without the projecting pieces to des-

ignate wings. In *c*, made of yellow quills on faded red bark, the head is shown with the wings and legs beneath, while in the two preceding figures the head takes the place of the bird's body. *d*. Here is still more abbreviation, the body and legs being absent, leaving only the head and wings. This is made of neutral-tint quills on straw-yellow bark.

Fig. 686 is a copy of a painting on a jar, probably of old Moki work, thus described in the manuscript catalogue of Mr. T. V. Keam:

It is the "Rain bird" (Tci-zur), the upper portion surrounded by inclosing cloud symbols, arranged so as to convey the idea of the germinative symbol implying the generative power of rain. The crosshatching, still water, in the wings denotes rain water in volume. The body or tail of the bird divided into two tapering prolongations is a very common occurrence. As a cloud emblem in the modern ware, the Tci-zur is not like the Um-tokina (Thunder-bird) in mythical creation, but is the comprehensive name used by the women for any small bird. Explained as a rain emblem by the fact that during seasons of sufficient rainfall flocks of small birds surround the villages and gardens, while during drought they take flight to the distant water courses.

FIG. 686.—Moki Rain bird.

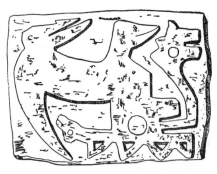

Fig. 687 is reproduced from Kingsborough (*c*). It represents Ahuitzotl, which is the name of an aquatic animal famous in Mexican mythology. The conventional sign for water is connected with this animal which Dr. Brinton (*c*) calls a hedgehog.

FIG. 687.—Ahuitzotl.

Wiener (*c*) gives a copy, here reproduced as the left-hand character in Fig. 688, of a bas-relief found at Cabana, Peru, representing a fabulous animal, a quadruped, the hair of which is floating and its tongue hanging out of the mouth and ending in serpents' heads. One-sixth actual size.

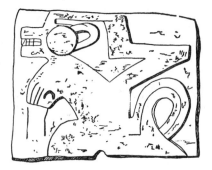

FIG. 688.—Peruvian fabulous animals.

The same author, loc. cit., gives a copy, now reproduced as the right-hand character in the same Fig. 688, of another bas-relief in granite found at Cabana, Peru, representing a fabulous animal, perhaps the alcoce, sitting like a dog. One-sixth natural size.

Mr. Thomas Worsnop (a) gives an account of Fig. 689, abbreviated as follows:

FIG. 689.—Australian mythic personages.

Sir George Grey, between 1836 and 1839, saw on a sandstone rock a most extraordinary large figure. Upon examination this proved to be

a drawing at the entrance to a cave, which he found to contain besides many remarkable paintings. On the sloping roof the principal character, i. e., the upper one of Fig. 689, was drawn. In order to produce the greater effect the rock about it was painted black and the figure itself colored with the most vivid red and white. It thus appeared to stand out from the rock, and Sir George Grey says he was surprised at the moment that he first saw this gigantic head and upper part of a body bending over and staring grimly down at him. He adds that it would be impossible to convey in words an adequate idea of this uncouth and savage figure, and therefore he only gives such a succinct account as will serve as a sort of description.

Its head was encircled by bright red rays, something like the rays one sees proceeding from the sun, when depicted on the signboard of a public house; inside of this came a broad stripe of very brilliant red, which was crossed by lines of white; but both inside and outside of this red space were narrow stripes of a still deeper red, intended probably to mark its boundaries; the face was painted vividly white and the eyes black, being, however, surrounded by red and yellow lines; the body, hands, and arms were outlined in red, the body being curiously painted with red stripes and bars.

Upon the rock which formed the left-hand wall of this cave, and which partly faced you on entering, was a very singular painting, the lower character of the same figure, vividly colored, representing four heads joined together. From the mild expression of the countenances they appeared to represent females, and to be drawn in such a manner, and in such a position, as to look up at the principal figure, before described; each had a very remarkable head-dress, colored bright blue, and one had a necklace on. Both of the lower figures had a sort of dress painted with red in the same manner as that of the principal figure, and one of them had a band round her waist. In Sir George Grey's opinion each of the four faces was marked by a totally distinct expression of countenance, and none of them had mouths.

SECTION 3.

SHAMANISM.

The term "shaman" is a corrupted form of the Sanscrit word meaning ascetic. Its original application was to the religion of certain tribes of northern Asia, but now shamanism is generally used to express several forms of religion which are founded in the supposed communion with and influence over supernatural beings by means of magic arts. The shaman or priest pretends to control by incantations and ceremonies the evil spirits to whom death, sickness, and other misfortunes are ascribed. This form or stage of religion was so prevalent among the North American Indians that the adoption of the term "shaman" here is substantially correct, and it avoids both the stupid expression

"medicine man" of current literature and the indefinite title "priest," the associations with which are not appropriate to the Indian religious practitioner. The statement that the Indians worship, or ever have worshiped, one "Great Spirit" or single overruling personal god is erroneous. That philosophical conception is beyond the stage of culture reached by them, and was not found in any tribe previous to missionary influence. Their actual philosophy can be expressed far more objectively and therefore pictorially.

The special feature of the notes now collected under the present heading relates to the claims and practices of shamans, but the immediately succeeding headings of "Charms and Amulets" and of "Religious Ceremonies" are closely connected with the same topic. It must be confessed that, as now presented, they have been arranged chiefly for mechanical convenience, to which convenience also in other parts of the present work scientific discrimination has sometimes been forced to yield without, it is hoped, much injury. Individual intercomparison, with or without cross references, is besought from any critical reader of this paper.

Feats of jugglery or pretended magic rivaling or surpassing the best of spiritualistic séances have been recounted to the present writer in many places by independent and intelligent Indian witnesses, not operators, generally of advanced age. The cumulated evidence gives an opportunity for spiritualists to argue for the genuineness of their own manifestations or manipulations as, in accordance with the degree of credence, they may be styled. Others will contend that these remarkable performances in which this hemisphere was rich before the Columbian discovery—the occidental rivaling the oriental Indians—belong to a culture stage below civilization. They will observe that the age of miracles among barbaric people has not expired, and that it still exists among outwardly civilized persons who are yet subject to superstition in its true etymologic sense of "remaining over from the past."

The most elaborate and interesting of these stories which are known relate to a time about forty years ago, shortly before the Davenport brothers and the Fox sisters had excited interest in the civilized portions of the United States; but exhibitions of a magic character are still given among the tribes, though secretly, from fear of the Indian agents and missionaries. It is an important fact that the first French missionaries in Canada and the early settlers of New England described substantially the same performances when they first met the Indians, all of whom belonged to the Algonquian or Iroquoian stocks. So remarkable and frequent were these performances of jugglery that the French, in 1613, called the whole body of Indians on the Ottawa River, whom they met at a very early period, "The Sorcerers." They were the tribes afterwards called Nipissing, and were the typical Algonquians. No suspicion of prestidigitation or other form of charlatanry appears to have been entertained by any of the earliest French and English

writers on the subject. The severe Puritan and the ardent Catholic both considered that the exhibitions were real, and the work of Satan. It is also worth mentioning that one of the derivations of the name "Micmac" is connected with the word meaning sorcerer. The early known practices of this character, which had an important effect upon the life of the people, extended from the extreme east of the continent to the Great Lakes. They have been found later far to the south, and in a higher state of evolution.

It was obvious in cross-examining the old men of the Algonquians that the performances of jugglery were exhibitions of the pretended miraculous power of an adventurer whereby he obtained a reputation above his rivals and derived subsistence and authority by the selling of charms and pretended superhuman information. The charms and fetiches which still are bought from the few shamans who yet have a credulous clientele are of three kinds—to bring death or disease on an enemy, to lure an enemy into an ambush, and to excite a return to sexual love.

Among the Ojibwa three distinct secret societies are extant, the members of which are termed, respectively and in order of their importance, the Midē', the Jĕs'sakīd, and the Wâbĕnō. The oldest and most influential society is known as the Midē'wiwin', or Grand Medicine, and the structure in which the ceremonies are conducted is called the Midē'wigân, or Grand Medicine lodge.

The following statement of the White Earth Midē' shaman presents his views upon the origin of the rite and the objects employed in connection with ceremonies, as well as in the practices connected with medical magic and sorcery:

When Minabō'sho, the first man, had been for some time upon the earth, two great spirits told him that to be of service to his successors they would give to him several gifts, which he was to employ in prolonging life and extending assistance to those who might apply for it.

The first present consisted of a sacred drum, which was to be used at the side of the sick and when invoking the presence and assistance of the spirits. The second was a sacred rattle, with which he was enabled to prolong the life of a patient. The third gift was tobacco, which was to be an emblem of peace; and as a companion he also received a dog. He was then told to build a lodge, where he was to practice the rites of which he would receive further instruction.

All the knowledge which the Midē' have, and more, Minabō'sho received from the spirits. Then he built a long lodge, as he had been directed, and now even at this day he is present at the Sacred Medicine lodge when the Grand Medicine rite is performed.

In the rite is incorporated most that is ancient amongst them, songs and traditions that have descended, not orally alone, but by pictographs, for a long line of generations. In this rite is also perpetuated the purest and most ancient idioms of their language, which differs somewhat from that of the common, every-day use.

It is desirable to explain the mode of using the Midē' and other bark records of the Ojibwa and also those of other tribes mentioned in this

paper. A comparison made by Dr. Tyler of the pictorial alphabet to teach children, "A was an archer," etc., is not strictly appropriate in this case. The devices are not only mnemonic, but are also ideographic and descriptive. They are not merely invented to express or memorize the subject, but are evolved therefrom. To persons acquainted with secret societies a good comparison for the charts or rolls is what is called the trestle board of the Masonic order, which is printed and published and publicly exposed without exhibiting any of the secrets of the order, yet through its ideography it is practically useful to the esoteric members by assisting memory in details of ceremony and it also prevents deviation from the established ritual.

Fig. 690, from Copway (d), gives the Ojibway character for Grand Medicine lodge.

FIG. 690.—Ojibwa Midē′ wigwam.

Fig. 171, supra, is a reproduction, with description, of a birch-bark record illustrating the alleged power of a Jĕssakkī′d, one who is also a Midē′ of the four degrees of the Medicine Society.

Fig. 172, supra, represents, with explanations, a Jĕssakkī′d named Niwi′kki, curing a sick woman by sucking the demon through a bone tube.

When the method of procedure of a Midē′ goes beyond the ordinary ceremonies, such as chanting prayers and drumming, the use of the rattle, and the administration of magic medicines and exorcisms, it overlaps the prescribed formulæ of the Midē′win and partakes of the rites of the Jĕssakkī′d or "Juggler."

FIG. 691.—Lodge of a Midē′.

The lodge of the Midē′ is represented as in Fig. 691, the shaman himself being indicated as sitting inside.

The Jessakkī′d represents his lodge or jugglery as shown in Fig. 692, the shaman being represented as sitting on the outside. The chief feature of the jugglery lodge is that the branch is always seen projecting from the top of one of the vertical poles, which peculiarity exists in no other religious structure represented in pictorial records.

FIG. 692.—Lodge of Jĕssakkī′d.

The following group, including Figs. 693 to 697, gives several modes of illustrating the "making buffalo medicine" by the Dakotas and other tribes of the Great Plains. The main object was to bring the buffalo to where they could be hunted successfully, and incantations, with dancing and many ceremonies, were resorted to, as upon the buffalo the tribes depended not only for food but for most of the necessaries and conveniences of their daily life. The topic is referred to elsewhere in this paper, especially in Lone-Dog's Winter Count for the year 1810–'11.

Fig. 693.—A Minneconjou chief named Lone-Horn made medicine with a white buffalo cow skin. The-Swan's Winter Count, 1858–'59.

The horned head of the animal is connected with the man figure. An albino buffalo was much more prized for ceremonial purposes than any other. Lone-Horn, chief of the Minneconjous, died in 1874, in his camp on the Big Cheyenne.

FIG. 693.—Making medicine. Dakota.

Fig. 694.—A Minneconjou Dakota named Little-Tail first made "medicine" with white buffalo cow skin. The-Swan's Winter Count, 1810–'11. Again the head of an albino buffalo.

FIG. 694.—Making medicine. Dakota.

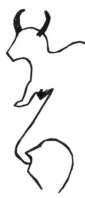

Fig. 695.—White-Cow-Man. Red-Cloud's Census. The mere possession of an albino buffalo conferred dignity and honor. To have once owned such an animal, even though it had died or been lost, gave specific rank.

FIG. 695.—Making medicine. Dakota.

Fig. 696.—Lone-Horn makes medicine. "At such times Indians sacrifice ponies and fast." The-Flame's Winter Count, 1858–'59. In this figure the buffalo head is black.

FIG. 696.—Making medicine. Dakota.

Fig. 697. Buffalo is scarce; an Indian makes medicine and brings a herd to the suffering. The-Flame's Winter Count, 1843–'44.

Here the incantation is shown by a tipi with the buffalo head drawn upon it. It is the "medicine" or sacred tipi where the rites are held.

FIG. 697.—Making medicine.

A curious variant of divination with regard to the use of songs in the removal of disease was found among the Choctaws. Each of the songs

of this class bore reference to some herb or form of treatment, each of which was represented objectively or pictorially and produced simultaneously with the chanting of the appropriate song by the shaman. The remedy or treatment to be adopted was decided upon by the degree of pleasure or relief afforded to the patient by the respective songs.

Fig. 698. Cat-Owner was killed with a spider-web thrown at him by a Dakota. Cloud-Shield's Winter Count, 1824–'25. The spider-web is shown reaching to the heart of the victim from the hand of the man who threw it and two spiral wakan lines are also shown. Blood issuing from his nose, colored red in the original, indicates that he bled to death. It is a common belief among Indians that certain "medicine men" possess the power of taking life by shooting nee-

FIG. 698.—Magic killing.

dles, straws, spider-webs, bullets, and other objects, however distant the person may be against whom they are directed.

It may be noted that the union line connecting the two figures at the base signifies that they belong to the same tribe which the hair on the figure of the left shows to be Dakota. The victim is not scalped, but has no hair or other designation, being shown only in outline.

Fig. 699. Cannaksa-Yuha, Has-a-war-club; from the Oglala Roster. This man has his father's name "war-club," and is therefore set by the ghosts in his stead as a warrior. He is supposed to be invulnerable to any mortal weapon, and the children and even women fear him as they would a ghost. He holds the war club before his face, as it partakes of the nature of insignia. In the original the whole of the man's face is painted red. This is to

FIG. 699.—Held a ghost lodge.

show that he has a wakicagapi-ecokicoupe, which means that he has put up a ghost tent, concerning which there are many and complicated ceremonies and details narrated by Rev. J. Owen Dorsey in the American Anthropologist, II, 145 et seq.

John Tanner (g) gives an account of sorcery among the Ojibwa, with illustrations copied as Fig. 700, being nearly identical with those recently obtained by Dr. Hoffman, and published in the Seventh Ann. Rep., Bureau of Ethnology, as Figs. 20 and 21.

FIG. 700.—Muzzin-ne-neen. Ojibwa.

It was thought necessary to have recourse to a medicine hunt. Nah-gitch-e-gum-me [a "medicine" maker] sent to me and O-ge-mah-we-ninne, the best two hunters of the band, each a little leather sack of medicine, consisting of certain roots pounded fine and mixed with red paint, to be applied to the little images or figures of the animals we wish to kill. Precisely the same method is practiced in this kind of hunting, at least as far as the use of medicine is concerned, as in those

instances where one Indian attempts to inflict disease or suffering on another. A drawing or a little image is made to represent the man, the woman, or the animal on which the power of the medicine is to be tried; then the part representing the heart is punctured with a sharp instrument, if the design be to cause death, and a little of the medicine is applied. The drawing or image of an animal used in this case is called muzzin-ne-neen, and the same name is applicable to the little figures of a man or women, and is sometime rudely traced on birch bark, in other instances more carefully carved of wood. These little images or drawings, for they are called by the same names, whether of carved wood or rags or only rudely sketched on birch bark, or even traced in sand, are much in use among several and probably all the Algonquin tribes. Their use is not confined to hunting, but extends to the making of love, and the gratification of hatred, revenge, and all malignant passions.

It is a prevailing belief that the necromancers, men or women of medicine, or those who are acquainted with the hidden powers of their *wusks*, can, by practicing upon the muzzin-ne-neence, exercise an unlimited control over the body and mind of the person represented. Many a simple Indian girl gives to some crafty old squaw her most valued ornaments, or whatever property she may possess, to purchase from

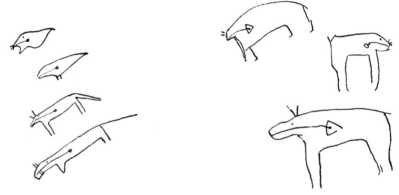

Fig. 701.—Muzzin-ne-neen. Ojibwa.

her the love of the man she is most anxious to please. The old woman, in a case of this kind, commonly makes up a little image of stained wood and rags, to which she gives the name of the person whose inclinations she is expected to control; and to the heart, the eyes, or to some other part of this she, from time to time, applies her medicines, or professes to have done so, as she may find necessary to dupe and encourage her credulous employer.

But the influence of these images and conjurations is more frequently tested in cases of an opposite character, where the inciting cause is not love, but hatred, and the object to be attained the gratification of a deadly revenge. In cases of this kind the practices are similar to those above mentioned, only different medicines are used. Sometimes the muzzin ne-neence is pricked with a pin or needle in various parts, and pain or disease is supposed to be produced in the corresponding part of the person practiced upon. Sometimes they blacken the hands and mouth of the image, and the effect expected is the change which marks the near approach of death.

The similarity, approaching identity, of these practices to those common in Europe during the middle ages and continuing in some regions until the present time will be noticed.

The same author, pp. 197, 198, gives an account of Ojibwa divination in the following address of a shaman, illustrated by Fig. 702.

For you, my friends, who have been careful to regard and obey the injunctions of

the Great Spirit, as communicated by me, to each of you he has given to live to the full age of man: this long and straight line *a* is the image of your several lives. For you, Shaw-shaw-wa ne-ba-se, who have turned aside from the right path, and despised the admonitions you have received, this short and crooked line *b* represents your life. You are to attain only to half of the full age of man. This line, turning off on the other side, is that which shows what is determined in relation to the young wife of Ba-po-wash. As he said this, he showed us the marks he had made on the ground, as below. The long, straight middle line represented, as he said, the life of the Indians, Sha-gwaw-koo-sink, Wau-zhe-gaw-maish-koon, etc. The short, crooked one below showed the irregular course and short continuance of mine; and the abruptly terminating one on the other side showed the life of the favorite wife of Ba-po-wash.

Fig. 702.—Ojibwa divination.

Fig. 703 was copied from a piece of walrus ivory in the museum of the Alaska Commercial Company, of San Francisco, California, in 1882, by Dr. Hoffman, and the interpretation is as obtained from a native Alaskan.

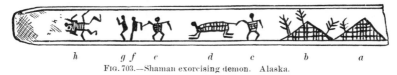

h　　　g f　c　　　　d　　　c　　　b　　　a

Fig. 703.—Shaman exorcising demon. Alaska.

a, b. The shaman's summer habitations, trees growing in the vicinity. *c.* The shaman, who is represented in the act of holding one of his "demons." These are considered as under the control of the shaman, who employs them to drive others out of the bodies of sick men. *d.* The demon or aid. *e.* The same shaman exorcising the demons causing the sickness. *f, g.* Sick men, who have been under treatment, and from whose bodies the "evil beings" or sickness has been expelled. *h.* Two "evil spirits" which have left the bodies of *f* and *g*.

Fig. 704 was copied by Dr. Hoffman from an ivory bow in the same museum. The interpretation was also obtained at the same time from the same Alaskan.

The rod of the bow upon which the characters occur is here represented in three sections, A, B, and C. A bears the beginning of the narrative, extending over only one-half of the length of the rod. The course of the inscription is then continued on the adjacent side of the rod at the middle, and reading in both directions (sections B and C),

toward the two files of approaching animals. B and C occupy the whole of one side.

The following is the explanation of the characters:

A. *a*, baidarka or skin boat resting on poles; *b*, winter habitation; *c*, tree; *d*, winter habitations; *e*, storehouse; *f*, tree. Between this and the storehouse is placed a piece of timber, from which is suspended fish for drying. *g*, storehouse. The characters from *a* to *g* represent a group of dwellings, which signifies a settlement, the home of the person to whom the history relates. *h*, the hunter sitting on the ground, asking for aid, and making the gesture for supplication. *i*, the shaman to whom application is made by the hunter desiring success in the chase. The shaman has just finished his incantations, and while still retaining his left arm in the position for that ceremony, holds the right toward the hunter, giving him the success requested. *j*, the shaman's winter lodge; *k*, trees; *l*, summer habitation of the shaman; *m*, trees near the shaman's home.

FIG. 705.—Skokomish tamahnous.

B. *n*, tree; *o*, a shaman standing upon his lodge, driving back game which had approached against his wish. To this shaman the hunter had also made application for success in the chase, but was denied, hence the act of driving back. *p*, deer leaving at the shaman's order; *q*, horns of a deer swimming a river; *r*, young deer, apparently, from the smaller size of the body and unusually long legs.

C. *s*, a tree; *t*, the lodge of the hunter (A. *h*), who, after having been granted the request for success, placed his totem upon the lodge as a mark of gratification and to insure greater luck in his undertaking; *u*, the hunter in the act of shooting; *v–w*, the game killed, consisting of five deer; *x*, the demon sent out by the shaman (A. *i*), to drive the game in the way of the hunter; *y–bb*, the demon's assistants.

The following description and illustration, Fig. 705, is kindly contributed by the Rev. M. Eells, of Skokomish, Washington:

Your figure of a shaman's lodge in Alaska [Fig. 714 in this work] reminds me of a

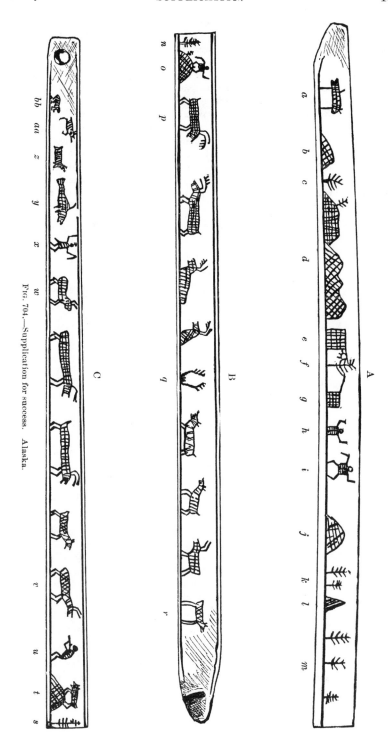

Fig. 704.—Supplication for success. Alaska.

drawing made of the same character on this reservation by one of our best educated Indian boys. His description of it is as follows: "When I was at Dr. Charley's house (the shaman or medicine man), they tamahnoused [performed incantations] over [my brother] Frank. They saw that he was under a kind of sickness. Dr. Charley took it, and just a little after that Frank shook and became stiff, and while I sat I heard my father say that his breath was gone. I went out, as I did not want to see my brother lay dead before me. When I came back he was breathing a little and his eyes were closed. Dr. Charley was taking care of his breath with his own tamahnous [guardian spirit] and waiting for more folks to come, so as to have enough folks to beat on sticks when he should tamahnous and see what was the matter with Frank. So he went on and saw that there was another kind of sickness besides the one he took first. The other one went over Frank and almost killed him. Dr. Charley took it again and went (travel) [in spirit] with another kind of tamahnous to see where Frank's spirit was. He found him at Humahuma [18 or 20 miles

Fig. 706.—Mdewakantawan fetich.

distant], where they had camped [some time previous]. So Frank got better after a hard tamahnous. From the drawing you will see how Dr. Charley fixed the kind of sickness. *b* shows the first sickness which Dr. Charley took. It has tails, which, when they come close to the sick person, makes him worse. *a* is the way it goes when it kills a person and stays in his home. *c* is the second one and is hanging over Frank, *d*. *e* is another sickness which is in Frank."

In Kingsborough (*d*) is the following: "In the year of Eleven Houses, or in 1529, Nuño de Guzman set out for Yalisco on his march to subdue that territory. They pretend that a serpent descended from the sky, exclaiming that troubles were preparing for the natives, since the Christians were directing their course hither." The illustration for this account is presented as Fig. 1224, Chap. xx, on Special Comparisons.

SECTION 4.

CHARMS AND AMULETS.

The use of material objects for the magic purposes suggested by this title is well known. Their graphic representation is not so familiar, though it is to be supposed that the objects of this character would be pictorially represented in pictographs connected with religion. The following is an instance where the use of a charm or fetich in action was certainly portrayed in a pictograph.

Fig. 706, drawn by the Dakota Indians, near Fort Snelling, Minnesota, exhibits the use as a charm or talisman of an instrument fashioned in imitation of a war club, though it is not adapted to offensive employment. The head of the talisman is a grooved stone hammer from an inch and a half to 5 inches in length. A withe is tied about the middle of the hammer, in the groove binding on a handle of from 2 to 4 feet in length. The latter is frequently wrapped with buckskin or rawhide to strengthen it, as well as for ornamental purposes. Feathers attached bear designs indicating marks of distinction, perhaps sometimes fetichistic devices not understood.

It is believed that these objects possess the charm of warding off an enemy's missiles when held upright before the body, as shown in the pictograph. The interpretation was explained by the draftsman himself.

"Medicine bags," as they are termed by frontiersmen, are worn

Fig. 707.—Medicine bag as worn.

as amulets. They are sometimes filled by the owner in obedience to the suggestions of visions, but more frequently are prepared by the shaman. They are carried suspended from the neck by means of string or buckskin cords, as shown in Fig. 707, drawn in 1889 by I-teup'-de-tĭ, No-Shin-Bone, a Crow Indian, to represent himself with his insignia, and was extracted from a record kindly communicated by Dr. R. B. Holden, physician at the Crow Agency, Montana.

Fig. 708, drawn by the same hand, shows the same medicine bag temporarily hung on a forked stick. When the bag is carried on a war party it is never allowed to touch the ground. Also among the Ojibwa some of the bags which are considered to have the greatest fetichistic power are not kept in the lodges, as too dangerous, but are suspended from trees.

FIG. 708.—Medicine bag hung up.

Capt. Bourke (d) gives the following account of the medicine hat of the Apache:

The medicine hat of the old and blind Apache medicine man, Nan-ta-do-tash, was an antique affair of buckskin, much begrimed with soot and soiled by long use. Nevertheless it gave life and strength to him who wore it, enabled the owner to peer into the future, to tell who had stolen ponies from other people, to foresee the approach of an enemy, and to aid in the cure of the sick. * * * This same old man gave me an explanation of all the symbolism depicted upon the hat, and a great deal of valuable information in regard to the profession of medicine men, their specialization, the prayers they recited, etc. The material of the hat, as already stated, was buckskin. How that was obtained I can not assert positively, but from an incident occurring under my personal observation in the Sierra Madre, in Mexico, in 1883, where our Indian scouts and the medicine men with them surrounded a nearly grown fawn and tried to capture it alive, as well as from other circumstances too long to be here inserted, I am of the opinion that the buckskin to be used for sacred purposes among the Apache must, whenever possible, be that of a strangled animal, as is the case, according to Dr. Matthews, among the Navajo.

The body of Nan-ta-do-tash's cap was unpainted, but the figures upon it were in two colors, a brownish yellow and an earthy blue, resembling a dirty Prussian blue. The ornamentation was of the downy feathers and black-tipped plumes of the eagle, pieces of abalone shell and chalchihuitl, and a snake's rattle on the apex.

Nan-ta-do-tash explained that the characters on the medicine hat meant: A, clouds; B, rainbow; C, hail; E, morning star; F, the god of wind, with his lungs; G, the black "kan;" H, the great stars or suns. "Kan" is the name given to their principal gods. The appearance of the kan himself and of the tail of the hat suggest the centipede, an important animal god of the Apache. The old man said that the figures represented the powers to which he appealed for aid in his "medicine" and the kan upon whom he called for help.

The same author says, op. cit., p. 587:

The Apache, both men and women, wear amulets, called tżidaltai, made of lightning-riven wood, generally pine or cedar or fir from the mountain tops, which are highly valued and are not to be sold. These are shaved very thin and rudely cut in the semblance of the human form. They are in fact the duplicates, on a small scale, of the rhombus. Like it they are decorated with incised lines representing the lightning. Very often these are to be found attached to the necks of children or to their cradles.

Four of the several winter counts described in the present work unite in specifying for the year 1843–'44 the recapture of a fetich called the great medicine arrow.

Fig. 709.—In a great fight with the Pawnees the Dakotas captured the great medicine arrow which had been taken from the Cheyennes, who made it, by the Pawnees. Cloud-Shield's Winter Count, 1843–'44.

The head of the arrow projects from the bag which contains it. The delicate waved or spiral lines show that it is sacred.

White-Cow-Killer calls it "The Great-medicine-arrow-comes-in winter."

FIG. 709.—Magic
arrow.

Battiste Good's record gives the following for the same year:

"Brought-home-the-magic-arrow winter. This arrow originally belonged to the Cheyennes, from whom the Pawnees stole it. The Dakotas captured it this winter from the Pawnees, and the Cheyennes then redeemed it for one hundred horses." His sign for the year is shown in Fig. 710. An attempt was made to distinguish colors by the heraldic scheme, which in this cut did not succeed. The upper part of the man's body is sable or black, the feathers on the arrow are azure or blue, and the shaft, gules or red. The remainder of the figure is of an undecided color not requiring specification.

FIG. 710.—Magic
arrow.

Fig. 711.—The great medicine arrow was taken from the Pawnees by the Oglalas and Brulés, and returned to the Cheyennes to whom it rightly belonged. American-Horse's Winter Count, 1843–'44. The arrow appears to be in a case marked over with the lines meaning sacredness.

Another account of a magic arrow and illustrations of other fetichistic objects are in Chap. IX.

FIG. 711.—Magic
arrow.

Pl. XXXIII is a copy of a cloak or mantle made from the skin of a deer, and covered with various mystic paintings. It was made and used by the Apaches as a mantle of invisibility, that is, a charmed covering for spies which would enable them to pass with impunity through the country, and even through the camp of their enemies. In this instance the fetichistic power depends upon the devices drawn. A similar but not identical pictographic fetich or charm is described and illustrated by Capt. Bourke (e) as obtained from a Chicarahua Apache which told when his ponies were lost, and which brought rain. The symbols show, inter alia, the rain cloud, and the serpent lightning, the raindrops and the cross of the winds of the four cardinal points.

Lewis and Clarke (b) say that the Chilluckittequaw, a Chinook tribe, had a "medicine" bag colored red 2 feet long, suspended in the middle of the lodge. It was held sacred, containing pounded dirt, roots, and such mysterious objects. From the chief's bag he brought out fourteen forefingers of enemies—Snakes—whom he had killed.

A remarkable drawing in an Australian cave, described by Sir George Grey, in Worsnop, op. cit., was an ellipse, 3 feet in length and 1 foot 10 inches in breadth. The outside line of the painting was of deep blue color, the body of the ellipse being of a bright yellow dotted over with red lines and spots, whilst across it ran two transverse lines of blue. The portion of the painting above described formed the ground, or main part of the picture, and upon this ground was painted a kangaroo in the act of feeding; two stone spear heads, and two black balls; one of the spear heads was flying to the kangaroo, and one away

Fig. 712.—Hunter's charm. Australia.

from it; so that the whole subject probably constituted a sort of charm by which the luck of an inquirer in killing game can be ascertained. This cave drawing is copied in Fig. 712.

George Turner (c) gives account of hieroglyphic taboos, as he calls them, which are connected with the present subject:

The sea-pike taboo. If a man wished that a sea-pike might run into the body of the person who attempted to steal, say, his bread fruits, he would plait some cocoanut leaflets in the form of a sea-pike, and suspend it from one or more of the trees which he wished to protect.

The white-shark taboo was another object of terror to a thief. This was done by plaiting a cocoanut leaf in the form of a shark, adding fins, etc., and this they suspended from the tree. It was tantamount to an expressed imprecation, that the thief might be devoured by the white shark the next time he went to fish.

The cross-stick taboo. This was a piece of any sort of stick suspended horizontally

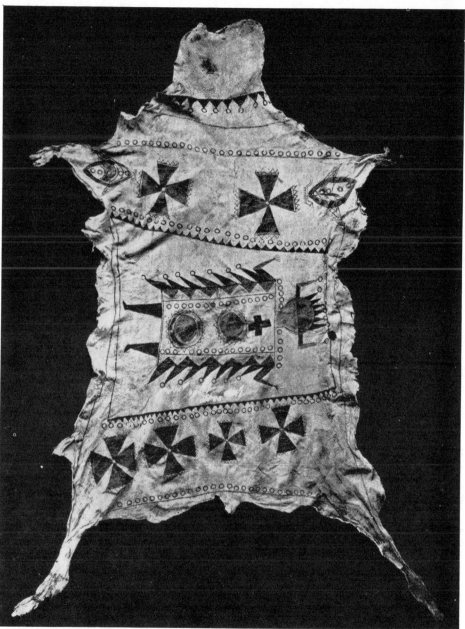

MANTLE OF INVISIBILITY.

from the tree. It expressed the wish of the owner of the tree, that any thief touching it might have a disease running right across his body, and remaining fixed there till he died.

The ulcer taboo. This was made by burying in the ground some pieces of clam shell, and erecting at the spot three or four reeds, tied together at the top in a bunch like the head of a man. This was to express the wish and prayer of the owner that any thief might be laid down with ulcerous sores all over his body.

The death taboo. This was made by pouring some oil into a small calabash, and burying it near the tree. The spot was marked by a little hillock of white sand.

The thunder taboo. If a man wished that lightning might strike any who should steal from his land, he would plait some cocoanut leaflets in the form of a small square mat, and suspend it from a tree, with the addition of some white streamers of native cloth flying. A thief believed that if he trespassed, he, or some of his children, would be struck with lightning, or perhaps his own trees struck and blasted from the same cause. They were not, however, in the habit of talking about the effects of lightning. It was the thunder they thought did the mischief; hence they called that to which I have just referred the thunder taboo.

<div align="center">SECTION 5.</div>

<div align="center">RELIGIOUS CEREMONIES.</div>

Many examples of masks, dance ornaments, and fetiches used in ceremonies are reported and illustrated in the several papers of Messrs. Cushing, Holmes, and Stevenson in the Second Annual Report of the Bureau of Ethnology. Paintings or drawings of many of them have been found on pottery, on shells, and on rocks.

An admirable article by Mr. J. Walter Fewkes (b) on Tusayan Pictographs explains many of the petroglyphs of that region as depicting objects used in dances and ceremonies.

Fig. 713 exhibits drawings of various masks used in dancing, the characters of which were obtained by Mr. G. K. Gilbert from rocks at Oakley springs and were explained to him by Tubi, the chief of the Oraibi Pueblos. They are representations of masks as used by the Moki, Zuñi, and Rio Grande Pueblos.

Dr. W. H. Corbusier, U. S. Army, writing from Camp Verde, Arizona, kindly furnished the following account of Yuman ceremonies, in which the making of sand pictures was prominent:

All the medicine men meet occasionally and with considerable ceremony "make medicine." They went through the performance early in the summer of 1874 on the reservation for the purpose of averting the diseases with which the Indians were afflicted the summer previous. In the middle of one of the villages they made a round ramada, or house of boughs, some 10 feet in diameter, and under it, on the sand, illustrated the spirit land in a picture about 7 feet across, made in colors by sprinkling powdered leaves and grass, red clay, charcoal, and ashes on the smoothed sand. In the center was a round spot of red clay about 10 inches in diameter, and around it several successive rings of green and red alternately, each ring being an inch and a half wide. Projecting from the outer ring were four somewhat triangular-shaped figures, each one of which corresponded to one of the cardinal points of the compass, giving the whole the appearance of a Maltese cross. Around this cross and between its arms were the figures of men with their feet toward the center, some made of charcoal, with ashes for eyes and hair, others of red clay and ashes, etc.

These figures were 8 or 9 inches long, and nearly all of them lacked some portion of the body, some an arm, others a leg or the head. The medicine men seated themselves around the picture on the ground in a circle, and the Indians from the different bands crowded around them, the old men squatting close by and the young men standing back of them. After they had invoked the aid of the spirits in a number of chants, one of their number, apparently the oldest, a toothless, gray-haired man, solemnly arose and, carefully stepping between the figures of the men, dropped on

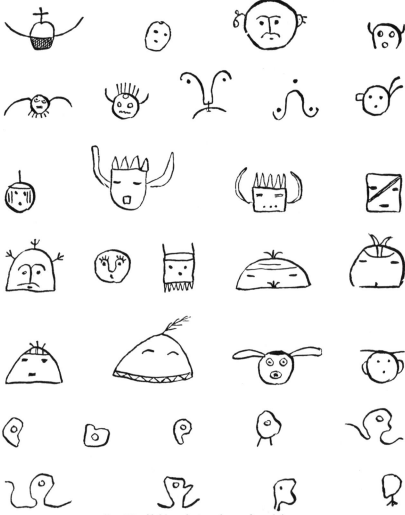

Fig. 713.—Moki masks traced on rocks. Arizona.

each one a pinch of the yellow powder which he took from a small buckskin bag which had been handed to him. He put the powder on the heads of some, on the chests of others, and on other parts of the body, one of the other men sometimes telling him where to put it. After going all around, skipping three figures, however, he put up the bag, and then went around again and took from each figure a large pinch of powder, taking up the yellow powder also, and in this way collected a heaping handful. After doing this he stepped back and another medicine man collected a

handful in the same way, others following him. Some of the laymen, in their eagerness to get some, pressed forward, but were ordered back. But after the medicine men had supplied themselves the ramada was torn down and a rush was made by men and boys; handfuls of the dirt were grabbed and rubbed on their bodies or carried away. The women and children, who were waiting for an invitation, were then called. They rushed to the spot in a crowd, and grabbing handfuls of dirt tossed it up in the air so that it would fall on them, or they rubbed their bodies with it, mothers throwing it over their children and rubbing it on their heads. This ended the performance.

According to Stephen Powers (in Contrib. to N. A. Ethnol., III, p. 140), there is at the head of Potter valley, California, "a singular knoll of red earth which the Tatu or Hūchnom believe to have furnished the material for the erection of the original coyote-man. They mix this red earth into their acorn bread, and employ it for painting their bodies on divers mystic occasions."

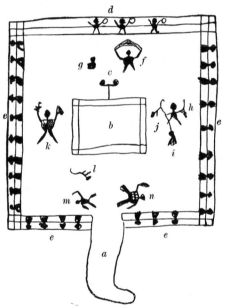

FIG. 714.—Shaman's lodge. Alaska.

Descriptions of ceremonies in medicine lodges and in the initiation of candidates to secret associations have been published with and without illustrations. The most striking of these are graphic ceremonial charts made by the Indians themselves, a number of which besides those immediately following appear in different parts of the present work.

Fig. 714 was drawn and interpreted by Naumoff, a Kadiak native, in San Francisco, California, in 1882. It represents the ground plan of a shaman's lodge, with the shaman curing a sick man.

The following is the explanation:

a, the entrance to the lodge; b, the fireplace; c, a vertical piece of wood upon which is placed a crosspiece, upon each end of which is a lamp; d, the musicians upon the raised seats drumming and pro-

ducing music to the movements of the shaman during his incantations in exorcising the "evil spirit" supposed to have possession of the patient; *e*, visitors and friends of the afflicted seated around the walls of the lodge; *f*, the shaman represented in making his incantations; *g*, the patient seated upon the floor of the lodge; *h* represents the shaman in another stage of the ceremonies, driving out of the patient the "evil being;" *i*, another figure of the patient—from his head is seen to issue a line connecting it with *j*; *j*, the "evil spirit" causing the sickness; *k*, the shaman in the act of driving the "evil being" out of the lodge—in his hands are sacred objects, his personal fetich, in which the power lies; *l*, the flying "evil one;" *m*, *n*, are assistants to the shaman stationed at the entrance to hit and hasten the departure of the evil being.

The writer in examination at three reservations in Wisconsin obtained information concerning the Midē′ ceremonies additional to the details described by Dr. Hoffman (*a*) and by others quoted in the present work. The full ceremonies of the Midē′ lodges, which the more southern Ojibwa, who speak English, translate as "grand medicine," were performed twice a year—in the fall and in the spring. Those in the spring were of a rejoicing character, to welcome the return of the good spirits; those in the fall were in lamentation for the departure of the beneficent and the arrival of the maleficent spirits. The drums were beaten four days and nights before the dance, which lasted for a whole day. After the dance twelve selected persons built a lodge, about the center of which they placed stones which had been heated, and dancing went on around it until the stones were moistened and cooled by the sweat of the performers. Singing, or more properly chanting, regulated the rhythm of the dances, although, perhaps, in the order of evolution the dance was prior to the chant. These ceremonies were performed by the body of the people, and were independent of the initiations in the secret order. With regard to the candidates who passed the initiations, it was mentioned as an undisputed fact that they always became stronger and better men, perhaps because only those succeeded who had the requisite strength of mind and body to endure the various ordeals and to pass examination in the mysteries. In pictography the spring and the fall, the drums and the steaming stones, the dancing forms and the open chanting mouth are shown.

Catlin (*a*) gives an account of Kee-an-ne-kuk, the foremost man, who, though a Kickapoo, was commonly called the Shawnee Prophet, and also the following description relating to Fig. 715, painted by that author in 1831:

Ah-tón-we-tuck, The-Cock-Turkey, is another Kickapoo of some distinction and a disciple of the [Shawnee] Prophet, in the attitude of prayer, which he is reading off from characters cut upon a stick that he holds in his hand. It was told to me in the tribe by the traders (though I am afraid to vouch for the whole truth of it) that while a Methodist preacher was soliciting him for permission to preach in his village, the Prophet refused him the privilege, but secretly took him aside and sup-

ported him until he learned from him his creed and his system of teaching it to others, when he discharged him and commenced preaching amongst his people himself, pretending to have had an interview with some superhuman mission or inspired personage, ingeniously resolving that if there was any honor or emolument or influence to be gained by the promulgation of it, he might as well have it as another person; and with this view he commenced preaching and instituted a prayer, which he ingeniously carved on a maple stick of an inch and a half in breadth, in characters somewhat resembling Chinese letters. These sticks, with the prayers on them, he has introduced into every family of the tribe and into the hands of every individual; and as he has necessarily the manufacturing of them all, he sells them at his own price and has thus added lucre to fame, and in two essential and effective ways augmented his influence in his tribe. Every man, woman, and child in the tribe, so far as I saw them, were in the habit of saying their prayer from this stick when going to bed at night and also when rising in the morning, which was invari-

Fig. 715.—Ah-tón-we-tuck.

ably done by placing the forefinger of the right hand under the upper character until they repeat a sentence or two, which it suggests to them, and then slipping it under the next and the next, and so on to the bottom of the stick, which altogether required about ten minutes, as it was sung over in a sort of a chant to the end.

Fig. 716, from the same volume, opposite page 100, is a portrait of On-sáw-kie, The-Sac, a Pottawatomie, using one of these prayer sticks, which had been procured from the Shawnee Prophet.

Figs. 715 and 716 with their descriptions exhibit an intermediate condition between the aboriginal mnemonic method and the Christian formula of prayer by the use of printed books. They should be considered in comparison with the remarks on the "Micmac Hieroglyphs," Chap. XIX, Sec. 2.

Fig. 717, incised on the Kejimkoojik rocks in Nova Scotia, suggests the midē' lodge, sometimes called the medicine lodge, of the Ojibwa,

which is described above. The ground plan indicated in this figure
seems to be divided by partitions, which, together with the human
figures and designs, probably refer to the rites of initiation and celebra-
tion performed in them. Some of the Micmacs examined had a vague
recollection of these ceremonies, which, at the time of the European dis-

FIG. 716.—On-sáw-kie.

covery of the northeastern part of North America, probably were as
widely prevalent, as they continued to be much later, among the
regions farther in the interior, also occupied by the Algonquian tribes.

FIG. 717.—Medicine lodge. Micmac.

Fig. 718, from the same locality, is a
drawing of the ground plan of another
description of ceremonial wigwam or lodge
which is remarkably similar to that now
called by the Ojibwa "the jessăkân." Its
distinguishing feature is the branch of a
tree erected on the outside, and it is the
wigwam of a juggler or wizard, and not the
lodge belonging to the regular order of the
Midē'. Such wigwams of jugglers, who
performed wonderful feats similar to those
of modern spiritualistic exhibitions, are
frequently mentioned by the early French
and English writers, who gave accounts
of the provinces of New France and New
England. The figure now presented is not suggestive without com-
parison, and would not have been selected for the foregoing descrip-

tion without the authority of living Micmac and Abnaki Indians, to whom it was significant.

Figs. 717 and 718, however, when studied, recall the use of branches and prayer plumes in the descriptions of the houses, and especially of the kivas of the Pueblos and the forms of their consecration men-

FIG. 718.—Juggler lodge. Micmac.

tioned in the study of the Pueblo Architecture, by Mr. Victor Mindeleff, in the Eighth Annual Report of the Bureau of Ethnology, as follows:

It is difficult to elicit intelligent explanation of the theory of the baho and the prayer ceremonies in either kiva or house construction. The baho is a prayer token; the petitioner is not satisfied by merely speaking or singing his prayer; he must have some tangible thing upon which to transmit it. He regards his prayer as a mysterious, impalpable portion of his own substance, and hence he seeks to embody it in some object which thus becomes consecrated. The baho, which is inserted in the roof of the kiva, is a piece of willow twig about 6 inches long, stripped of its

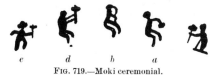

<div style="text-align:center">c d b a</div>

FIG. 719.—Moki ceremonial.

bark and painted. From it hang four small feathers suspended by short cotton strings tied at equal distances along the twig. In order to obtain recognition from the powers especially addressed, different colored feathers and distinct methods of attaching them to bits of wood and string are resorted to.

The characters in Fig. 719 are copied from a drawing on the rocks

in the Canyon Segy. They have been submitted to the most intelligent of the old Moki priests, and are said to represent the primitive sun priests. They watched for the sunrise every morning and the chief sun priest kept a reckoning of the equinoxes. The chief sun priest, *a*, made the daily sacrifices to the sun by scattering consecrated meal and singing a prayer to the sun just as it rose. His assistant,.*b*, lit a pipe of tobacco at the same time, and exhaled puffs of smoke, one toward each of the cardinal points, one to the zenith, and one to the nadir. The three other figures are flageolet priests, and the skins of different kinds of foxes were attached to their reed flageolets. *c* played to the morning star, typified by the skin of the gray fox. *d* played to the dawn, typified by the skin of the red fox. *e* played to the daylight, typified by the skin of the yellow fox.

Dr. Franz Boas (*e*) reported as follows:

The Tsimshian have four secret societies, which have evidently been borrowed from the Kwākiutl, the Olala or Wihalait, Nō'ntlem, Mē'itla, and Semhalait.

The candidate is taken to the house of his parents and a bunch of cedar bark is fastened over the door, to show that the place is tabooed, and nobody is allowed to enter. The chief sings while it is being fastened. In the afternoon the sacred house is prepared for the dance. A section in the rear of the house is divided off by means of curtains; it is to serve as a stage, on which the dancers and the novice appear. When all is ready messengers carrying large carved batons are sent around to invite the members of the society, the chief first. The women sit down in one row, nicely dressed up in button blankets and their faces painted red. The chief wears the amhalait, a carving rising from the forehead, set with sea-lion barbs and with a long drapery of ermine skins; the others, the cedar bark rings of the society. * * *

The Mēitla have a red head ring and red eagle downs, the Nōntlem a neck ring plaited of white and red cedar bark, the Olala a similar but far larger one. The members of the societies receive a head ring for each time they pass through these ceremonies. These are fastened one on top of the other.

Mr. James W. Lynd (*d*) says:

In the worship of their deities paint (with the Dakotas), forms an important feature. Scarlet or red is the religious color for sacrifices, whilst blue is used by the women in many of the ceremonies in which they participate. This, however, is not a constant distinction of sex, for the women frequently use red and scarlet. The use of paints, the Dakotas aver, was taught them by the gods. Unktehi taught the first medicine men how to paint themselves when they worshiped him and what colors to use. Takushkanshkan (the moving god), whispers to his favorites what colors are most acceptable to him. Heyoka hovers over them in dreams, and informs them how many streaks to employ upon their bodies and the tinge they must have. No ceremony of worship is complete without the wakan or sacred application of paint. The down of the female swan is colored scarlet and forms a necessary part of sacrifices.

Wiener (*d*) gives a description of Peruvian ceremonies, with an illustration reproduced here as Fig. 720.

The paintings on this vase, found by Dr. Macedo in the excavations at Pachacamac, show the principal practices of the exoteric worship of the sun. In this painting there are three entirely distinct groups. The central one is composed of the solar image surrounded by nine rays, terminating in symbols of fecundity. Two men place 1 at its right and left seem to play on pandean pipes. The group on the left is formed of four individuals, two of whom have head-dresses of royal feathers. This group is perform-

ing a dance, while the third group represents the same solar disk and the sacrifice accompanied by music performed in its honor. There are also vases of different forms containing, probably, the sacred drink, and the officiator approaching one hand to one of the great urns, while with the other he holds the vase or the bowl from which he is about to drink the *chica* consecrated to the sun. The princely personages who have the right to approach the sun wear casques with royal plumes, chemisettes extending below the middle, and ornaments at the lower part of the legs and on the feet. The musicians, four in number (two of whom play upon the pandean pipes and two upon the henna), are distinguished by bonnets without feathers and by a kind of cloak tied around the neck by a band which floats behind them. Finally, the priests, one of whom is an officiator, and the other dancers in the suite of the princely personages, wear bonnets like that of the musicians (who very probably belong to the same class). They have their faces painted.

A. W. Howitt, in MS. Notes on Australian Pictographs, contributes the following:

Among the most interesting of the pictorial markings used by the aborigines are those which are made in connection with the ceremonies of initiation. I now take as an instance the Murring tribe of the southern coast of New South Wales, whose ceremonies I have described elsewhere. The humming instrument, which is known in England as a child's toy called the bull roarer, has a sacred character with all the Australian tribes. The Murring call it Mŭdji, and the loud roaring sound made when it is swung around at the end of a cord is considered to be the voice of Dara-

FIG. 720.—Peruvian ceremony.

mŭlŭn, the great supernatural being by whom, according to their tradition, these ceremonies were first instituted.

On this instrument there are marked two notches, one at each end, representing the gap left in the upper jaw of the novice after his teeth have been knocked out during the rites; there is also figured on it the rude representations of Daramŭlŭn.

A similar rude outline of a man in the attitude of the magic dance, being also Daramŭlŭn, is cut by the old men (wizards) at the ceremonies, upon the bark of a tree at the spot where one of them knocks out the tooth of the novice. This pictograph is then carefully cut out and obliterated after the ceremonies are over.

At a subsequent stage of the proceedings a similar figure is molded on the ground in clay, and is surrounded by the native weapons which Caramŭlŭn is said to have invented. This figure, after having been exhibited to the novice, is also destroyed, and they are strictly forbidden under pain of death to make them known in any manner to "women or children;" that is to say, to the uninitiated.

The Mŭdji is not destroyed, but is carefully and secretly preserved by the principal headman who had caused the ceremonies to be held.

The ceremonies of the Wirajuri tribe in New South Wales are substantially the same as those of the Murring, although the tribes are several hundred miles apart. The details, however, differ in some respects.

For instance, at one part of the ceremonies certain carvings are made upon the tree adjoining the place of the ceremonies and upon the ground, as follows:

(1) A piece of bark is stripped off the tree from the branches spirally down the bole to the ground. This represents the path along which Daramŭlŭn is supposed to descend from the sky to the place where the initiation is held.

(2) The figure of Daramŭlŭn is cut upon the ground, resembling that which the Murring cut upon the tree at the place where in their ceremonies the tooth is knocked out. The figure represents a naked black fellow dancing, his arms being slightly extended and the legs somewhat bent outwards (sideways) at the knee, as in the well known "corroboree" attitude.

(3) The representation of his tomahawk cut on the ground, where he let it fall on reaching the earth.

(4) The footsteps of an emu of which Daramŭlŭn was in chase.

(5) The figure of the emu extended on the ground where it fell when struck down by Daramŭlŭn.

The same author (f) remarks as follows:

Speaking generally, it may be asserted with safety that initiation ceremonies of some kind or other, and all having a certain fundamental identity, are practiced by the aboriginal tribes over the whole of the Australian continent. * * *

Here, then, the novices for the first time witness the actual exhibition of those magical powers of the old men of which they have heard since their earliest years. They have been told how these men can produce from within themselves certain deadly things which they are then able to project invisibly into those whom they desire to injure or to kill; and now the boys see during the impressive magical dances these very things, as they express it, "pulled out of themselves" by the wizards.

Figs. 721, 722, and 723 are copies of the designs upon Tartar and Mongol drums, taken from G. N. Potanin (b). They are used in religious ceremonies with the belief that the sounds emanating from the surface upon which the designs are made, or, to carry the concept a little further, the sounds coming from the designs themselves, produce special influences or powers. Some of these designs are notably similar to some of those found in America and reproduced in the present paper.

The upper left-hand design (a) in Fig. 721, on the outside of the drum, represents the sun and the moon in the form of circles with a central dot. Below the crossbar were two other such figures with central dot. Besides, were represented below, on the left side, two shamans, and under them a wild goat and serpent in the form of wavy lines; on the right side three shamans and a deer.

The upper right-hand design (b) on the same figure is a group representing the bringing of a horse to sacrifice. Under a rainbow, dots represent stars, and two heavenly maidens who the shamans said were the daughters of Ulgen and who were playing. They come down to the mountains and rise up to the skies.

A bow with a knob at each end is made to represent a rainbow in the lower part of a shaman's drum.

The lower left-hand design (c) on the same figure on a drum of the telengit shaman is the external delineation of a head without eyes and nose. The lower end of the line coming from the head represents a bifurcation. Under the head is a short horizontal line like an extended arm. Above a line extending from side to side of the drum are two circles, and below six circles, all empty. According to the owner of the drum

these circles are representations of drums, and the three human figures
are masters or spirits of localities.

The lower right-hand design (*d*) in the same figure has in the upper
section five zigzag lines represented similar to those with which light-
ning is often represented. According to the shaman these are serpents.

The upper left-hand design (*a*) in Fig. 722 inside the drum has painted
two trees. On each of them sits the bird karagush, with bill turned to
the left. On the left of the trees are two circles, one dark (the moon),

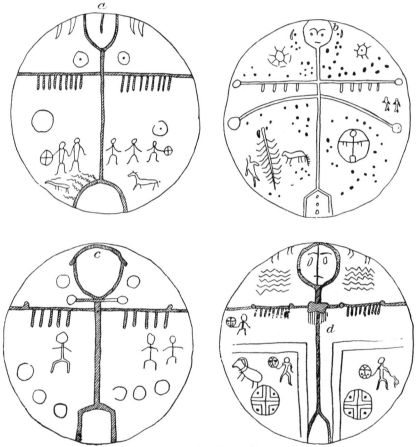

FIG. 721.—Tartar and Mongol drums.

the other light (the sun). Below a horizontal line are depicted a frog,
a lizard, and a serpent.

The upper right-hand design (*b*) in the same figure has on the upper
half two circles, the sun and moon; on the left side four horsemen;
under them a bowman, also on horseback. The center is occupied by
a picture of a net and a seive for winnowing the nuts and seeds of the
cedar tree. On the right side are two trees, baigazuin (literally the
rich birch), over which two birds, the karagush, are floating. Under a

division on the right and on the left side are oval objects with latticed-figured or scaly skin. These are two whales. In the middle, between them, are a frog and a deer, and below a serpent. Above, toward the hoop of the drum, is fastened an owl's feather.

The lower left hand design (*c*) in the same figure has represented in the upper half seven figures reminding one of horses. These are the horses, bura, going to heaven, i. e., their sacrifice. Above them are two circles emitting light, the sun and the moon; on the right of the

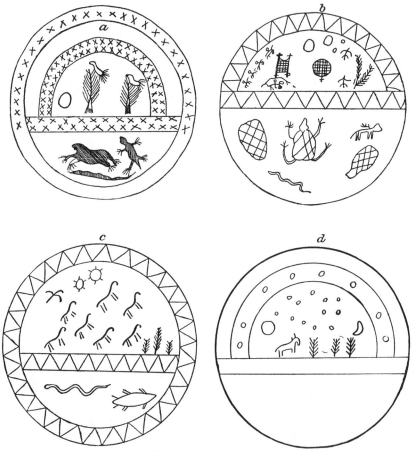

Fig. 722.—Tartar and Mongol drums.

horses are three trees; under a horizontal line on the left is a serpent; on the right a fish, the kerbuleik, the whale according to Verbıtski, literally the bay-fish.

The lower right-hand design (*d*) in the same figure has a drawing on the outside, a circle divided by horizontal bars into halves. The field of the upper half is divided into three strata, the first stratum of which is heaven, the second the rainbow, and in the lower stratum the stars. On the left side the sun, and the crescent moon on the right side; the goat, trees, and an undefined figure, which is not given in the drawing,

underneath. The kam, a kind of shaman, called it the bura. Some
said that it meant a cloud; others that it meant heavenly horses.

The left-hand design (*a*) in Fig. 723 shows four vertical and four
horizontal lines. The latter represent the rainbow; the vertical lines
borsui. Circles with dots in the center are represented in three sec-
tions, and in the fourth one circle.

The right-hand design in the same figure: On the upper sections are
represented a number of human figures. These, according to the sha-
man's own explanation, are heavenly maidens (in the original Turkish,
tengriduing kuiz). Below, under a rainbow, which is represented by
three arched lines, are portrayed two serpents, each having a cross
inside. These are kurmos nuing tyungurey, i.e., the drums are kurmos's.
Kurmos is the Alti word for spirits, which the shamans summon.

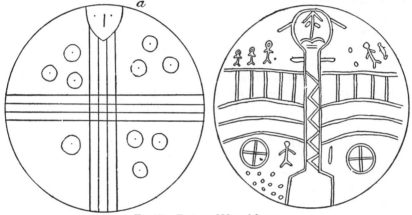

Fig. 723.—Tartar and Mongol drums.

Bastian (*a*) makes remarks as follows concerning the magic drum of
the Shamans in the Altai, which should be considered in this connec-
tion:

The Shamans admit three worlds (among the Yakuts), the world of the heavens
(hallan jurda), the middle one of the earth (outo-doidu) and the lower world or hell
(jedän tügara), the former the realm of light, the latter the realm of darkness, while
the earth has for a time been given over by the Creator (Jüt-tas-olbohtah Jürdän-
Ai-Tojan) to the will of the devil or tempter, and the souls of men at their death,
according to the measure of their merit, are sent into one or the other realm. When,
however, the earth world has come to an end, the souls of the two realms will wage
a war against each other, and victory must remain on the side of the good souls.

SECTION 6.

MORTUARY PRACTICES.

Champlain (*f*) in his voyage of 1603, says of the Northeastern Algon-
quins that their graves were covered with large pieces of wood, and
one post was erected upon them, the upper part of which was painted
red.

The same author, in 1613, writing of the Algonquins of the Ottawa

river, at the Isle des Alumettes, gives more details of the pictures on their grave posts:

On it the likeness of the man or woman who is buried there is roughly engraved. If a man, they put on a buckler, a spear, war club, and bows and arrows. If he is a chief he will have a plume on his head and some other designs or ornaments. If a boy, they give him one bow and a single arrow. If a woman or girl, they put on a kettle, an earthen pot, a wooden spoon, and a paddle. The wooden tomb is 6 or 7 feet long and 4 wide, painted yellow and red.

Some northern tribes—probably Cree—according to the Jesuit Relations (a), gave a notice of death to absent relations or dear friends of the deceased by hanging the object signifying his name on the path by which the traveler must return, e. g., if the name of the deceased was Piré (Partridge) the skin of a partridge was suspended. The main object of the notice was that the traveler, thereby knowing of the death, should not on his return to the lodge or village ask after or mention the deceased. Perhaps this explains the custom of placing pictographs of personal names and totemic marks on some prominent point or on trails without any apparent incident.

The same Relation describes a custom of the same Indians of shaping out of wood a portraiture of the more distinguished dead and inserting it over their graves, afterwards painting and greasing it as if it were the live man.

In Keating's Long (g) it is told that the Sac Indians are particular in their demonstrations of grief for departed friends. These consist in darkening their faces with charcoal, fasting, abstaining from the use of vermillion and other ornaments in dress, etc. They also make incisions in their arms, legs, and other parts of the body; these are not made for the purposes of mortification, or to create a pain which shall by dividing their attention efface the recollection of their loss, but entirely from a belief that their grief is internal and that the only way of dispelling it is to give it a vent through which to escape.

This is an explanation of the practice which has been verified in the field work of the Bureau of Ethnology and corresponds with the concept of finding relief from disease and pain by similar incisions, to let out the supposed invading entity that causes distress.

The same authority, p. 332, gives the following account of Dakota burial scaffolds:

On these scaffolds, which are from 8 to 10 feet high, corpses were deposited in a box made from part of a broken canoe. Some hair was suspended which we at first mistook for a scalp; but our guide informed us that these were locks of hair torn from their heads by the relations to testify their grief. In the center, between the four posts which supported the scaffold, a stake was planted in the ground; it was about 6 feet high, and bore an imitation of human figures; five of which had a design of a petticoat, indicating them to be females; the rest, amounting to seven, were naked, and were intended for male figures. Of the latter, four were headless, showing that they had been slain; the three other male figures were unmutilated but held a staff in their hands which, as our guide informed us, designated that they were slaves. The post, which is an usual accompaniment to the scaffold that supports a

warrior's remains, does not represent the achievements of the deceased, but those of the warriors that assembled near his remains, danced the dance of the post, and related their martial exploits.

Maximilian, Prince of Wied (d), tells that as a sign of mourning the Sioux daub themselves with white clay.

According to Powers, (d) "A Yokaia widow's style of mourning is peculiar. In addition to the usual evidence of grief she mingles the ashes of the dead husband with pitch, making a white tar or ungent with which she smears a band about two inches wide all around the edge of her hair (which is previously cut off close to the head), so that at a little distance she appears to be wearing a white chaplet.

Mr. Dorsey reports that mud is used by a mourner in the sacred-bag war party among the Osages. Several modes of showing mourning by styles of paint and markings are presented in this paper under the headings of Color and of Tattooing. Other practices connected with the present topic, and which may explain some pictographs, are described in the work of Dr. H. C. Yarrow, acting assistant surgeon, U. S. Army, on The Mortuary Customs of the North American Indians, in the First Annual Report of the Bureau of Ethnology.

Fig. 724 is copied from a piece of ivory in the museum of the Alaska Commercial Company, San Francisco, California, and was interpreted by an Alaskan native in San Francisco in 1882.

First is a votive offering or "shaman stick," erected to the memory of one departed. The "bird" carvings are considered typical of "good spirits," and the above was erected by the remorse-stricken individual, who had killed the person shown.

FIG. 724.—Votive offering. Alaska.

The headless body represents the man who was killed. In this respect the Ojibwa manner of drawing a person "killed" is similar.

The right hand Indian represents the homicide who erected the "grave-post" or "sacred stick." The arm is thrown earthward, resembling the Blackfeet and Dakota gesture for "kill."

That portion of the Kauvuya tribe of Indians in Southern California known as the Playsanos, or *lowlanders*, formerly inscribed characters upon the gravestones of their dead, relating to the pursuits or good qualities of the deceased. Dr. W. J. Hoffman obtained several pieces or slabs of finely-grained sandstone near Los Angeles, California, during the summer of 1884, which had been used for this purpose. Upon these were the drawings, in incised lines, of the fin back whale, with figures of men pursuing them with harpoons. Around the drawings were close parallel lines with cross lines similar to those made on ivory by the southern Innuit of Alaska.

Figs. 725 to 727 were procured from a native Alaskan by Dr. Hoffman in 1882, and explained to him to be drawings made upon grave posts.

Fig. 725 commemorates a hunter, as land animals are shown to be his chief pursuit. The following is the explanation of the characters:

a. The baidarka, or boat, holding two persons; the occupants are shown, as are also the paddles, which project below the horizontal body of the vessel.

b. A rack for drying skins and fish. A pole is added above it, from which are seen floating streamers of calico or cloth.

c. A fox.

d. A land otter.

e. The hunter's summer habitation. These are temporary dwellings and usually constructed at a distance from home. This also indicates the profession of a skin-hunter, as the permanent lodges, indicated as winter houses, i. e., with round or dome-like roof, are located near the sea-shore, and summer houses are only needed when at some distance from home, where a considerable length of time is spent in hunting.

Fig. 725.—Grave post. Alaska.

The following is the explanation of Fig. 726. It is another design for a grave post, but is erected in memory of a fisherman:

a. The double-seated baidarka, or skin canoe.

b. The bow used in shooting seal and other marine animals.

c. A seal.

d. A whale.

The summer lodge is absent in this, as the fisherman did not leave the seashore in the pursuit of game on land.

Fig. 727 is a drawing of a village and neighboring burial-ground, prepared by an Alaskan native in imitation of originals seen by him among the natives of the mainland of Alaska, especially the Aigalúqamut. Carvings are generally on walrus ivory; sometimes on wooden slats. In the figure, *g* is a representation of a grave post in position, bearing an inscription similar in general character to those in the last two preceding figures.

Fig. 726.— Grave post. Alaska.

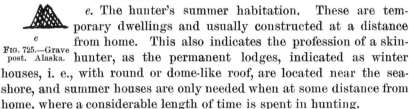

FIG. 727.—Village and burial grounds. Alaska.

The details are explained as follows:

a, *b*, *c*, *d*. Various styles of habitations, denoting a settlement.

e. An elevated structure used for the storage of food.

f. A box with wrappings, containing the corpse of a child. **The**

small lines, with ball attached, are ornamental appendages consisting of strips of cloth or skin, with charms, or, sometimes, tassels.

g. Grave post, bearing rude illustrations of the weapons or implements used by the deceased during his life.

h. A grave scaffold, containing adult. Besides the ornamental appendages, as in *f* preceding, there is a "Shaman stick" erected over the box containing the corpse as a mark of good wishes of a sorrowing survivor. See object *a*, in Fig. 724.

Schoolcraft (*m*) gives a good account, with illustration, of the burial posts used by the Sioux and Chippewas. It has been quoted so frequently that it is not reproduced here. The most notable feature connected with the posts is that the totems depicted on them are reversed, to signify the death of the persons buried.

Fig. 728 represents the grave post of a Menomoni Indian of the bear totem. The stick is a piece of pine board 2½ inches wide at the top, gradually narrowing down to a point; three-fourths of an inch thick, and about 2 feet long. On one side are two sets of characters, the oldest being incised with a sharp-pointed nail, while over these are a later set of drawings made with red ocher, represented in the illustration by shading. The figure of the bear, drawn with head to the ground, denotes the totem of which the deceased was a member, the remaining incised figures relating to some exploits the signification of which was not known. The red marks were put upon the stick at the time of the holding of a memorial service, when the father of the deceased furnished a feast to the medicine priests just previous to his being received into the society of

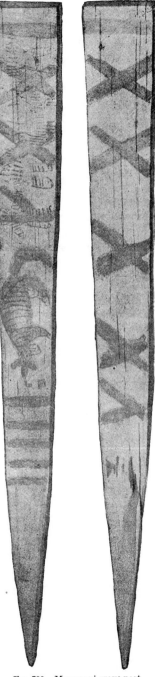

FIG. 728.—Menomoni grave post.

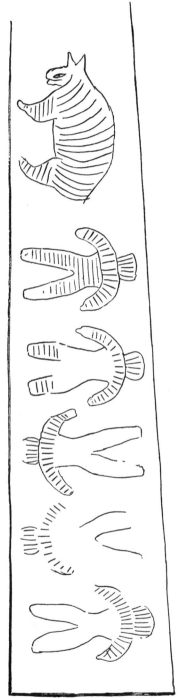

FIG. 729.—Incised lines on Menomoni grave post.

shamans to fill the vacancy caused by the death. The number of red crosses denote the number of speeches made at the grave upon that occasion, while the band at the top refers to the person acting as master of cere monies, who had been requested to make all the arrangements for the medicine ceremonies and initiation. So said some Menomoni in the neigh- borhood, but later the Indian who actually painted the red crosses came to Washington and explained that they signified the number of war parties in which the deceased had taken part.

Fig. 729 shows the incised lines on the front of the post before color was applied. The manner of placing the grave posts at the head of the grave box is shown in Fig. 730, the left- hand grave being that of Oshkosh, the late head chief of the Menomoni in Wisconsin, after whom the city of Oshkosh was named.

Before the grave is a small board, upon which tobacco is placed to gratify the taste of the dead, and during the season of sugar making pieces of that delicacy are pushed through the small openings in the head board, that the spirit of the de- ceased may be gratified and give suc- cess to the donors at future seasons.

The right-hand grave box is that of another member of the family of Oshkosh, at which the board, with tobacco, is also placed, as well as the grave post. This, however, does not bear any indications of charac- ters, which probably had been washed off by the rain.

Pieces of bark, stones, and sticks are also placed upon the grave boxes, but the signification of this practice could not be ascertained.

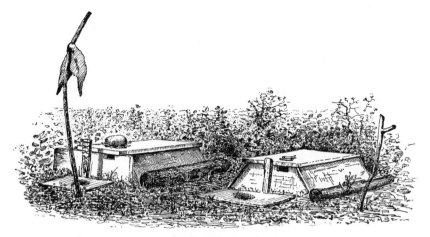

FIG. 730.—Grave boxes and posts.

The next two figures come from the Dakotas.

Fig. 731.—Held a commemoration of the dead. Cloud-Shield's Winter Count, 1826–'27. The ceremonial pipe-stem and the skull indicate the mortuary practice, which is further explained by the next figure.

FIG. 731.—Commemoration of dead. Dakota.

Fig. 732.—A white man made medicine over the skull of Crazy-Horse's brother. Cloud-Shield's Winter Count, 1852–'53. He holds a pipe-stem in his hand. This figure refers to the custom of gathering periodically the bones of the dead that have been placed on scaffolds and burying them. It appears that a white man made himself conspicuous by conducting the ceremonies on the occasion noted.

FIG. 732.—Ossuary ceremonial. Dakota.

Lewis and Clarke (c) mention the Chilluckittequaws, a division of the Chinooks of the Columbia river, as having for burial purposes vaults made of pine or cedar boards, closely connected, about 8 feet square and 6 in height. The walls as well as the door were decorated with strange figures cut and painted on them; besides these there were several wooden images of men, some of them so old and decayed

as to have almost lost their shape, which were all placed against the sides of the vaults. These images do not appear to be at all the objects of adoration, but were probably intended as resemblances of those whose decease they indicate.

Whymper (a) reports that the Kalosh Indians of Alaska construct grave boxes or tombs which contain only the ashes of the dead. These people invariably burn the deceased. On one of the boxes he saw a number of faces painted, long tresses of human hair depending therefrom. Each head represented a victim of the deceased man's ferocity. Thus the pictures are not likenesses or totemic marks of the cremated Kalosh, but of enemies whom he had killed, being in the nature of trophies or proofs of valor. Fig. 733 is a reproduction of the illustration.

Dall (c) says of the Yukon Indians:

Some wore hoops of birch wood around the neck and wrists, with various patterns and figures cut on them. These were said to be emblems of mourning for the dead.

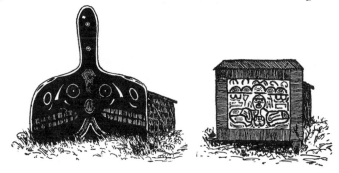

FIG. 733.—Kalosh graves.

Dr. Franz Boas (f) gives the following account of the funeral customs practiced by the Snanaimuq, a Salish tribe:

The face of the deceased is painted with red and black paint. * * * A chief's body is put in a carved box and the front posts supporting his coffin are carved. His mask is placed between these posts. The graves of great warriors are marked by a statue representing a warrior with a war club. * * * After the death of husband or wife, the survivor must paint his legs and his blanket red. * * * At the end of the mourning period the red blanket is given to an old man, who deposits it in the woods.

Didron (a) speaks of emblems on tombstones:

Even today, at Constantinople, in the cemetery of the Armenians, every tombstone is marked with the insignia of the profession followed by the defunct which the stone covers. For an Armenian tailor there is a pair of shears, thread, and needles; for a mason, hammer and trowel; for a shoemaker, a last, leather, and a leather cutter; for a grocer, a pair of scales; for a banker, pieces of money. It is the same with others. Among us [Frenchmen], in the middle ages, a compass, a rule, and square are engraved on the tomb of Hugues Libergier. In the cemetery of L'Est, at Paris, a palette indicates the grave of a painter, a chisel and hammer mark that of a sculptor. Animals are represented as talking and acting, masks grimace and smile, to announce in the same inclosure the tombs of La Fontaine and

of Molière. Among the Romans it was the same: a fisher had a boat on his tomb; a shepard, a sheep; a digger, a pickaxe; a navigator, an anchor or a trident; a vinedresser, a cask; an architect, a capital or the instruments of his art.

Howitt (g) says of the Dieri, a tribe of Central Australia:

A messenger who is sent to convey the intelligence of a death is smeared all over with white clay. On his approach to the camp the women all commence screaming and crying most passionately. After a time the particulars of the death are made known to the camp. The near relations and friends then only weep. Old men even cry bitterly, and their friends comfort them as if they were children. On the following day the near relations dress in mourning by smearing themselves over with white clay. Widows and widowers are prohibited by custom from uttering a word until the clay has worn off, however long it may remain on them. They do not, however, rub it off, as doing so would be considered a bad omen. It must absolutely wear off of itself. During this period they communicate by means of gesture language.

FIG. 734.—New Zealand grave effigy.

Dr. Ferdinand von Hochstetter (a) says:

The carved Maori figures which are met with on the road are the memorials of chiefs who, while journeying to the restorative baths of Rotorua, succumbed to their ills on the road. Some of the figures are decked out with pieces of clothing or kerchiefs; and the most remarkable feature in them is the close imitation of the tattooing of the deceased, by which the Maoris are able to recognize for whom the monument has been erected. Certain lines are peculiar to the tribe, others to the family, and again others to the individual. A close imitation of the tattooing of the face, therefore, is to the Maori the same as to us a photographic likeness; it does not require any description of name.

A representation of one of these carved posts is given in Fig. 734.

Another carved post of like character is repre-
sented in Fig. 735, concerning which the same
author says, p. 338: "Beside my tent, at Tahuahu,
on the right bank of the Mangapu, there stood an
odd, half-decomposed figure carved of wood; it was
designated to me by the natives as a Tiki, marking
the tomb of a chief."

FIG. 735.—New Zealand
grave-post.

Ball, on Nicobarese Ideographs, in Jour. Anthrop. Inst. of Gr. Br.
& I. (d), says, describing Fig. 736, which appears to be connected with
mortuary observances:

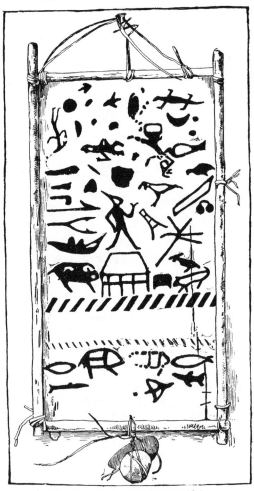

FIG. 736.—Nicobarese mortuary tablet.

The example of Nicobarese picture writing in Fig. 736 was obtained in the year 1873 on the island of Kondul, where I found it hanging in the house of a man who was said to have died a short time previously. * * *

The material of which it is made is either the glume of a bamboo or the spathe of a palm which has been flattened out and framed with split bamboos.

It is about 3 feet long by 18 inches broad. The objects are painted with vermilion, their outlines being surrounded with punctures, which allow the light to pass through. * * *

As in all such Nicobarese paintings, figures of the sun, moon, and stars occupy prominent positions. Now, the sun and moon are stated, by those who have known the Nicobarese best, to be especial objects of adoration, and therefore these paintings may have some religious significance.

At first it occurred to me that this was merely an inventory of the property of the deceased, but as some of the objects are certainly not such as we should expect to find in an enumeration of property, e. g., the lizard, while the figures of men appear to portray particular emotions, it seems probable that the objects represented have a more or less conventional meaning, and that we have here a document of as bona fide and translatable a character as an Egyptian hieroglyphic inscription.

My own efforts to discover an interpretation from the natives on the spot were not crowned with success. * * *

Mr. De Röepstorff, extra assistant superintendent of the Andamans and Nicobars, to whom I applied for such information as he might be able to collect upon the subject, assured me by letter, in 1873, that the screens had a religious significance and were used to exorcise spirits, but he did not seem to regard them as capable of being interpreted. * * *

The following is a list of the objects depicted, besides animals; many of the common utensils in use in a Nicobarese household are included:

(1) The sun and stars; (2) the moon and stars; (3) swallows or (?) flying fish; (4) impression of the forepart of a human foot; (5) a lizard (Hydrosaurus?); (6) four men in various attitudes; (7) two dás for cutting jungle; (8) two earthen cooking vessels; (9) two birds; (10) an ax; (11) two spears; (12) a ladder (?); (13) dish for food; (14) cocoanut water-vessels; (15) palm tree; (16) a canoe; (17) three pigs; (18) shed; (19) domestic fowl; (20) seaman's chest; (21) dog; (22) fish of different kinds; (23) turtle.

CHAPTER XV.

CUSTOMS.

The notes given under this heading are divided into (1) cult societies; (2) daily life and habits; (3) games.

SECTION 1.

CULT SOCIETIES.

Voluntary associations, to be distinguished from those of an exclusively religious character, have flourished among most Indian tribes and are still found among those least affected by contact with civilization. Maj. Powell, the Director of the Bureau of Ethnology, has named them cult societies. Their members are designated by special paintings and marks entirely distinct from those relating to their clans or gentes and their personal names. Travelers have frequently been confused by the diversity of such designations.

The translated names of some of these societies found among the Sioux are "Brave Night Hearts," "Owl Feathers," and "Wolves and Foxes." They control tribes in internal affairs and strongly influence their policy in external relations, and may be regarded as the substitute both for regular soldiery and for police. It is necessary that a young man proposing to be a warrior should be initiated into some one of these societies. But in distinguishing them from the purely shamanistic orders it must not be understood that their ceremonies and ties are independent of the cult of religion, or that they disregard it, for this among Indians would be impossible.

The following account of these societies among the Blackfeet or Satsika and their pictorial or objective devices is condensed from Maximilian of Wied's Travels (e):

The bands, unions, or associations are found among the Blackfeet as well as all the other American tribes. They have a certain name, fixed rules and laws, as well as their peculiar songs and dances, and serve in part to preserve order in the camp, on the march, in the hunting parties, etc. Seven such bands or unions among the Blackfeet were mentioned to me. They are the following: (1) The band of the mosquitos. This union has no police business to do, but consists of young people, many of whom are only 8 or 10 years of age. There are also some young men among them and sometimes even a couple of old men, in order to see to the observance of the laws and regulations. This union performs wild, youthful pranks; they run about the camp whenever they please; pinch, nip, and scratch men, women, and children in order to give annoyance like the mosquitos. The young people begin

528

with this union and then gradually rise higher through the others. As the badge of their band they wear an eagle's claw fastened around the wrist with a leather strap. They have also a particular mode of painting themselves, like every other band, and their peculiar songs and dance. (2) The dogs. Its badge is not known to me; it consists of young married men, and the number is not limited. (3) The prairie dogs. This is a police union, which receives married men; its badge is a long hooked stick wound round with otter skin, with knots of white skin at intervals, and a couple of eagle's feathers hanging from each of them. (4) Those who carry the raven. Its badge is a long staff covered with red cloth, to which black ravens' feathers in a long thick row are fastened from one end to the other. They contribute to the preservation of order and the police. (5) The buffalo, with thin horns. When they dance they wear horns on their caps. If disorders take place they must help the soldiers, who mark out the camp and then take the first place. (6) The soldiers. They are the most distinguished warriors, who exercise the police, especially in the camp and on the march; in public deliberations they have the casting vote whether, for instance, they shall hunt, change their abode, make war or conclude peace, etc. They carry as their badge a wooden club the breadth of a hand, with hoofs of the buffalo cow hanging to the handle. They are sometimes 40 or 50 men in number. (7) The buffalo bulls. They form the first, that is, the most distinguished, of all the unions, and are the highest in rank. They carry in their hand a medicine badge, hung with buffalo hoofs, which they rattle when they dance to their peculiar song. They are too old to attend to the police, having passed through all the unions, and are considered as having retired from office. In their medicine dance they wear on their head a cap made of the long forelock and mane of the buffalo bull, which hangs down to a considerable length.

Fig. 737.—"The policeman" was killed by the enemy. Cloud-Shield's Winter Count, 1780–'81.

The man here figured was probably one of the active members of the associations whose functions are above described to keep order and carry out the commands of the chiefs.

Fig. 737.—The policeman.

These voluntary associations are not of necessity ancient or permanent. An instance is given in Fig. 738 which is instructive in the interpretation of pictographs. It is a copy of drawings on a pipe stem which had been made and used by Ottawa Indians. On each side are four spaces, upon each of which are various incised characters, three spaces on one side being reserved for the delineation of human figures, each having diverging lines from the head upward, denoting their social status as chiefs or warriors and medicine men.

Upon the space nearest the mouth is the drawing of a fire, the flames passing upward from the horizontal surface beneath them. The cross bands are raised portions of the wood (ash) of which the pipestem is made; these show peculiarly shaped openings which pass entirely through the stem, though not interfering with the tube necessary for the passage of the smoke. This indicates considerable mechanical skill.

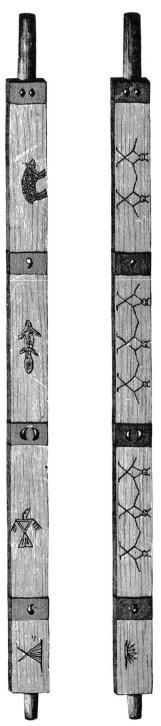

FIG. 738.—Ottawa pipe stem.

Upon each side of the stem are spaces corresponding in length and position to those upon the opposite side. In the lower space of the stem is a drawing of a bear, indicating that the two persons in the corresponding space on the opposite side belong to the bear gens. The next upper figure is that of a beaver, showing the three human figures to belong to the beaver gens, while the next to this, the eagle, means that the opposite persons are members of the eagle gens. The upper figure is that of a lodge which contains a council fire, shown on the opposite side.

The signification of the whole is that two members of the bear gens, three members of the beaver gens, and three members of the eagle gens have united and constitute a society living in one lodge, around one fire, and smoke through the same pipe.

Reference may also be made to remarks by Prof. Dall (d) upon the use of masks by associations or special classes.

SECTION 2.

DAILY LIFE AND HABITS.

Fig. 739, printed from the Kejimkoojik rocks, in Nova Scotia, represents two Indians in a canoe following a fish to shoot it. This is not a pure example of the class of totemic designs. Both Indians in the canoe have paddles in which the device resembles the Micmac tribal device, but in that the hunters pursue a deer and not a fish and the canoe is "humpback." The Passamaquoddy tribal pictographic sign in which a fish is followed, requires both Indians to have paddles, and, it may be understood that the two Indians in the canoe are Passamaquoddy, but in the figure one of them has laid aside his paddle and is shooting at the fish with a gun, which departs from the totemic device, and also shows that the drawing was made since the Indians of the region had ob-

tained firearms from Europeans, but these were obtained three centuries ago, quite long enough for hunting scenes on some of the petroglyphs to exhibit the use of a gun instead of a bow.

This kind of fish hunting by gunshot is one of daily occurrence in the region during the proper season.

FIG. 739.—Shooting fish. Micmac.

Fig. 740, from the same locality, is more ideographic. The line of the gun barrel is exaggerated and prolonged so as nearly to touch the fish, and signifies that the shot was a sure hit. The hunters are very roughly delineated. Possibly this hunting was at night with fire on a brazier and screens, a common practice which seems to be indicated.

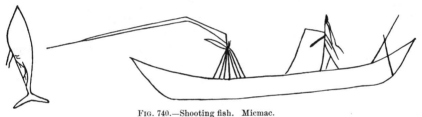

FIG. 740.—Shooting fish. Micmac.

Fig. 741, also from Kejimkoojik, is more ancient, but less distinct. The fish is larger, and the weapon may be a lance, not a gun.

FIG. 741.—Lancing fish. Micmac.

Fig. 742, copied from a walrus ivory drill-bow, from Cape Darley, Alaska (Nat. Mus. No. 44211), illustrates the mode of whale-hunting by the Innuit. The crosses over the whale and beneath the harpoon line

FIG. 742.—Whale hunting. Innuit.

represent aquatic birds; the three oval objects attached to the line are floaters to support the line and to indicate its course after the downward plunge of the harpooned cetacean.

A similar hunting scene by canoe, in which, however, the game was deer, is given in Fig. 743. The drawing is on birch bark, and was made by an old Indian named Ojibwa, now living at White Earth, Minnesota, an intimate friend and associate of the late chief Hole-in-the-Day. Ojibwa is supposed to be actor as well as depictor. He shows his lodges in *a*, where he resided many years ago; *b* is a lake; *c, c, c, c* represent four deer, one of which is shown only by the horns protruding above a clump of brush near the lake; *e* represents Ojibwa in

FIG. 743.—Hunting in canoe. Ojibwa.

his canoe, *d*, floating on the river, *h, h; g* is a pine torch, giving light and smoke, erected on the bow of the canoe, the light being thrown forward from a curve slice of birch bark at *f*, its bright inner surface acting as a reflector. The whole means that during one hunt, by night, the narrator shot four deer at the places indicated.

The accompanying Fig. 744 is reproduced from a drawing also incised on birch bark by Ojibwa, and relates to a hunting expedition made by his father and two companions, all of whom are represented by three human forms near the left-hand upper line. The circle at the left is

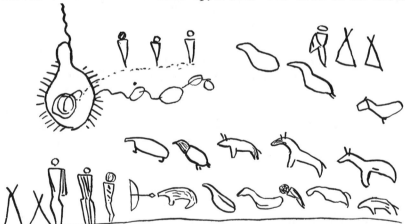

FIG. 744.—Record of hunting. Ojibwa.

Red Cedar lake, Minnesota; a river is shown flowing northward, and another toward the east, having several indications of lakes which this river passes through or drains. The circle within the lake denotes an island upon which the party camped, as is shown by the trail leading from the human forms to the island. Around the lake are a number of short lines which signify trees, indicating a wooded shore. The first animal form to the right of the human figures is a porcupine; the next a bittern. The two shelters in the right-hand upper corner indicate

another camp made by the hunters, to which one of them dragged a deer, as shown by the man in that act, just to the left of the shelter.

FIG. 745.—Fruit gatherers. Hidatsa.

Another camp of the same party of three is shown in the lower left-hand corner; the bow and arrow directed to the right indicates that there they shot a raccoon, a fisher, a duck (a man lying down decoyed this bird by calling), a mink, and an otter. The line above the lower row consists of the following animals, reading from the left to right, viz, bear, owl, wolf, elk, and deer.

FIG. 746.—Hunting antelope. Hidatsa.

Fig. 745 is a copy of a sketch made by Lean-Wolf, second chief of the Hidatsa, and shows the manner in which the women carry baskets used

in gathering wild plums, bull-berries, and other small fruits. The baskets are usually made of thin splints of wood, and very similar in manner of construction to the well known bushel-basket of our eastern farmers.

FIG. 747.—Hunting buffalo. Hidatsa.

Fig. 746 was also made by Lean-Wolf, and illustrates the old manner of hunting antelope and deer. The hunter would disguise himself by covering his head with the head and skin of an antelope, and so be enabled to approach the game near enough to use his bow and arrow.

In a similar manner the Hidatsa would mask themselves with a wolf skin to enable them to approach buffalo. This is illustrated in Fig. 747, which is a reproduction of a drawing made by the above-mentioned chief.

The next group of figures illustrates the custom of gaining and afterwards counting coups or hits, the French expression, sometimes spelled by travelers "coo," being generally adopted. This is an honor gained by hitting an enemy, whether dead or alive, with an ornamented lance, or sometimes a stick, carried for the purpose as part of a warrior's equipment. These sticks or wands are about 12 feet long, often of willow, stripped of leaves and bark, and each having some distinguishing objects, such as feathers, bells, brightly-colored cloth, or else painted in a special manner. Further remarks on this custom appear in Chapter XIII, Section 4.

a, in Fig. 748, Kills-the-Enemy, from Red-Cloud's

FIG. 748.—Counting coups. Dakota.

Census, exhibits the coup stick in contact with the dead enemy's head. *b* is taken from Bloody-Knife's robe and shows an Indian about to strike his prostrate enemy.

Fig. 749.—Killed-First. Red Cloud's Census. This is the case where a warrior struck the enemy with his coup stick first in order, which is the most honorable achievement, greater than the actual killing. The word translated kill or killed does not always imply immediate death, but the infliction of a fatal wound.

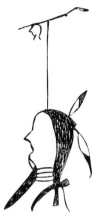

The apparent reason why the striking of the body of a dead or disabled enemy, whether or not killed or disabled by the striker, is more honorable than the actual infliction of the wound, is because the attempt to strike is vigorously resisted by the enemy, the survivors of which assemble to prevent the successful achievement; mere killing might be at a distance in comparative safety.

FIG. 749.—Counting coups. Dakota.

Fig. 750.—Enemies-hit-him. Red-Cloud's Census. In this case the Dakota has been hit by the enemy's lance or coup stick.

FIG. 750.—Counting coups. Dakota.

This group refers to the custom, east of the Rocky mountains, of exhibiting scalps.

Fig. 751.—A war party of Oglalas killed one Pawnee; his scalp is on the pole. American-Horses' Winter Count, 1855–'56. This and the next figure show the custom of a successful war party on returning to the home village to display the scalps taken. This display is the occasion of special ceremonies. The marks on the foot signify that on their way home the men of the war party froze their feet.

FIG. 751.—Scalp displayed. Dakota.

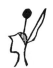

FIG. 752.—Scalp displayed.
Dakota.

Fig. 752.—Owns-the-Pole, the leader of an Oglala war party, brought home many Cheyenne scalps. American-Horse's Winter Count, 1798–'99. The cross stands for Cheyenne, as explained above.

Fig. 753.—Black-Rock, a Dakota, was killed by the Crows. American-Horse's Winter Count, 1806–'07. A rock or, more correctly translated, a large stone is represented above his head. He was killed with an arrow and was scalped. The figure is introduced here to show the designation of a scalped head, which is colored red—that is, bloody—when coloration is possible. It frequently appears in the Winter Counts of the Dakotas.

FIG. 753.—Scalped head.
Dakota.

Fig. 754 was drawn by a Dakota Indian at Mendota, Minnesota, and represents a man holding a scalp in one hand, while in the other is the gun, the weapon used in killing the enemy. The short vertical lines below the periphery of the scalp indicate hair. The line crossing the leg of the Indian is only a suggestion of the ground upon which he is supposed to stand.

FIG. 754.—Scalp taken.

The following group pictographically expresses the hunting of antelopes.

FIG. 755.—Antelope hunting. Dakota.

Fig. 755.—They drove many antelope into a corral and then killed them. Cloud-Shield's Winter Count, 1828–'29. This and the following two figures show the old mode of procuring antelope and other animals by driving them into an inclosure.

FIG. 756.—Antelope hunting. Dakota.

Fig. 756.—They provided themselves with a large supply of antelope meat by driving antelope into a corral, in which they were easily killed. American-Horse's Winter Count, 1828–'29.

Fig. 757.—They capture a great many ante-
lope by driving them into a pen. Cloud-
Shield's Winter Count, 1860–'61.

FIG. 757.—Antelope hunting. Da-
kota.

Fig. 758.—A woman who had been given to a white
man by the Dakotas was killed because she ran away
from him. Cloud-Shield's Winter Count, 1799–1800.
The gift of the woman was in fact a sale, and, in ad-
dition to the crime of marital infidelity, the tribe was
implicated in a breach of contract. The union line
below the figures, mentioned before, means husband
and wife. This picture illustrates, as far as may be
done pictorially, a Dakotan custom as regards mar-

FIG. 758.—Wife's pun-
ishment.

riage and the penalty connected with it.
 The following figures relate to several different forms:

Fig. 759.—They brought in a fine horse
with feathers tied to his tail. Cloud-Shield's
Winter Count, 1810–'11. White-Cow-Killer
calls it "Came-with-medicine-on-horse's-tail
winter." This illustrates the ornamentation
of specially valuable or favorite horses, which,
however, is not mere ornamentation, but
often connected with sentiments or symbols
of a religious character, and as often with
the totemic, which from another point of view
may also be regarded as religious.

FIG. 759.—Decorated horse.

Fig. 760.—A young man who was afflicted with smallpox and was
in his tipi by himself sang his death song and shot himself.
American-Horse's Winter Count, 1784–'85. Suicide is more
common among Indians than is generally suspected, and
even boys sometimes take their own lives. A Dakota boy
at one of the agencies shot himself rather than face his
companions after his mother had whipped him; and a Pai-
ute boy at Camp McDermit, Nevada, tried to poison himself with the
wild parsnip because he was not well and strong like other boys. The
Paiutes usually eat the wild parsnip when bent on suicide.

FIG. 760.—Sui-
cide. Dakota.

Fig. 761.—A Ree Indian hunting eagles from a hole in
the ground was killed by the Two-Kettle Dakotas. The
Swan's Winter Count, 1806–'07. The drawing represents
an Indian in the act of catching an eagle by the legs in
the manner that the Arikaras were accustomed to catch
eagles in their earth-traps. They rarely or never shot war
eagles. The Dakotas probably shot the Arikara in his
trap just as he put his hand up to grasp the bird.

FIG. 761.—Eagle
hunting. Arikara.

In this connection Fig. 762 is properly inserted. It is a sketch made by an Ojibwa hunter to illustrate the manner of catching eagles, the

feathers of which are highly prized by nearly all Indians for personal decoration and for war bonnets.

The upper character represents an eagle; the curved line at the right denotes the covering of branches and leaves of a temporary structure placed over a hole in the ground in which the

FIG. 762.—Eagle hunting. Ojibwa.

Indian is secreted. He is depicted beneath the covering, while a line, extending toward the eagle, terminates in a small oblong object, which is intended to represent the bait placed upon the covering to attract the eagle. The bait may consist of a young deer, a hare, or some other live animal of sufficient size to attract the eagle. When the latter swoops down and seizes the prey he is caught by the leg and held until assistants arrive, after which he is carried back to camp and plucked and is then liberated.

Fig. 763.—A Ree woman is killed by a Dakota while gathering pomme-blanche. The-Flame's Winter Count, 1797–'98. Pomme-blanche, or navet de prairie, is a white root, somewhat similar in appearance to a white turnip, botanically Psoralea esculenta (Nuttal) sometimes P. argophylla. It is a favorite food of the Indians, eaten boiled down to a sort of mush or hominy.

FIG. 763.—Gathering pomme-blanche.

A forked stick is used in gathering these roots.

Fig. 764.—Lodge-Roll. Red-Cloud's Census, No. 101. This figure

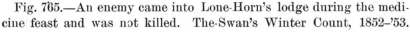

shows the mode of rolling up the skins forming the tipi for transportation. It is attached to four lodge poles, the ends of which trail on the ground and con-

FIG. 764.—Moving tipi.

stitute the "travail" which was dragged by dogs. Horses are now used for this purpose, and canvas takes the place of skins.

Fig. 765.—An enemy came into Lone-Horn's lodge during the medicine feast and was not killed. The-Swan's Winter Count, 1852–'53.

The pipe is not in the man's hand, and the head only is drawn with the pipe between it and the tipi.

An interesting custom of the Indians connected with the rite of sanctuary is that called by English writers "running the gauntlet." When captives had

FIG. 765.—Claiming sanctuary.

successfully run through a line of tormentors to a post near the council-house they were for the time free from further molestation. In the northeastern tribes this was in the nature of an ordeal to test whether or not the captive was vigorous and brave enough to be adopted into the tribe, but among other tribes it appears in a different shape. Any enemy, whether a captive or not, could secure immunity from present danger if he could reach a central post, or if there were no post, the lodge or tipi of the chief. A similar

custom existed among the Arikaras, who kept a special pipe in a "bird-box." If a criminal or enemy succeeded in smoking the pipe contained in the box he could not be hurt. This corresponds with the safety found in laying hold of the horns of the Israelite altar.

The position of the pipe is significant. Its mouthpiece points to the entrance of the tipi. The visitor does not bring or offer peace, but hopes that the tribe visited may grant it to him.

The four figures next following refer to ceremonies by which a war party was organized among some of the tribes of the Plains. A brief account of the ceremonies specially relating to the pipe is as follows:

When a warrior desires to make up a war party he visits his friends and offers them a filled pipe as an invitation to follow him, and those who are willing to go accept the invitation by lighting and smoking it. Among the Dakotas this was succeeded by a muster feast and war dance. Any man whose courage has been proved may become the leader of a war party. The word leader has been generally translated "partisan," an expression originally adopted by the French voyageurs. Among the Arapahos the would-be leader does not invite anyone to accompany him, but publicly announces his intention of going to war. He fixes the day for his departure, and states where he will camp the first night, naming some place not far off. The morning on which he starts, and before leaving the village, he invokes the aid of his guardian totem. He rides off alone, carrying his bare pipe in his hand with the bowl carefully tied to the stem to prevent it from slipping off. If the bowl should at any time accidentally fall to the ground he considers it an evil omen and immediately returns to the village, and nothing could induce him to proceed, as he thinks that only misfortune would attend him if he did. Sometimes he ties eagle or hawk plumes to the stem of his pipe, and after quitting the village, repairs to the top of some hill and makes an offering of them to the sun, taking them from his pipe and tying them to a pole which he erects in a pile of stones. Those who intend to follow him usually join him at the first camp, equipped for the expedition; but often there are some who do not join him until he has gone further on. He eats nothing before leaving the village, nor as long as the sun is up; but breaks his fast at his first camp after the sun sets. The next morning he begins another fast, to be continued until sunset. He counts his party, saddles his horse, names some place 6 or 7 miles ahead, where he says he will halt for awhile, and again rides off alone with his pipe in his hand. After awhile the party follow him in single file. When they have reached his halting place he tells them to dismount and let their horses graze. They all then seat themselves on the ground on the left of the leader, forming a semicircle facing the sun. The leader fills his pipe, all bow their heads, and, pointing the stem of the pipe upward; he prays toward the sun, asking that they may find an abundance of game, that dead shots may be made, so that their ammunition will not be wasted, but reserved for their enemies; that they may easily find· their enemies and kill them; that

they may be preserved from wounds and death. He makes his petition four times, then lights his pipe, and after sending a few whiffs of smoke skyward as incense to the sun, hands the pipe to his neighbor who smokes and passes it on to the next. It is passed from one to another toward the left, until all have smoked, the leader refilling it as often as necessary. They then proceed to their next camp, where probably others join them. The same programme is carried out for three or four days before the party is prepared for action.

Fig. 766.—Big Crow and Conquering-Bear had a great feast and gave many presents. American-Horse's Winter Count, 1846–'47. The two chieftains are easily recognized by the name characteristic over their heads. They have between them the war eagle pipe—specifically, but erroneously, called calumet by some writers.

FIG. 766.—Raising war party. Dakota.

Fig. 767.—Feather-in-the-Ear made a feast to which he invited all the young Dakota braves, wanting them to go with him. The Swan's Winter Count, 1842–'43. A memorandum is added that he failed to persuade them.

FIG. 767.—Raising war party. Dakota.

Fig. 768.—The Cheyennes carry the pipe around to invite all the tribes to unite with them in a war against the Pawnees. American-Horse's Winter Count, 1852–'53.

FIG. 768.—Raising war party. Dakota.

Fig. 769.—Danced calumet dance before going to war. The-Swan's Winter Count, 1804–'05. The specially ornamented pipe becomes the conventional symbol for the ceremonial organization of a war party.

FIG. 769.—Raising war party. Dakota.

Fig. 770 represents an Alaskan in the water killing a walrus. The illustration was obtained from a slab of walrus ivory in the museum of the Alaska Commercial Company of San Francisco.

FIG. 770.—Walrus hunting. Alaska.

The carving, Fig. 771, made of a piece of walrus tusk, was copied from the original in the same museum during the summer of 1882. Interpretations were verified by Naumoff, a Kadiak half-breed.

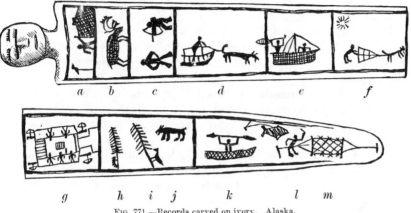

FIG. 771.—Records carved on ivory. Alaska.

a is a native whose left hand is resting against the house, while the right hangs toward the ground. The character to his right represents a "Shaman stick" surmounted by the emblem of a bird, a "good spirit," in memory of some departed friend. It was suggested that the grave stick had been erected to the memory of his wife.

b represents a reindeer, but the special import in this drawing is unknown.

c signifies that one man, the designer, shot and killed another with an arrow.

d denotes that the narrator has made trading expeditions with a dog sledge.

e is a sailboat, although the elevated paddle signifies that that was the manner in which the voyage was best made.

f, a dog sled, with the animal hitched up for a journey. The radiating lines in the upper left hand corner, over the head of the man, are the rays of the sun.

g, a sacred lodge. The four figures at the outer corners of the square represent the young men placed on guard, armed with bows and arrows, to keep away those not members of the band, who are depicted as holding a dance. The small square in the center of the lodge represents the fireplace. The angular lines extending from the right side of the lodge to the vertical partition line show in outline the subterranean entrance to the lodge.

h, a pine tree upon which a porcupine is crawling upward.

i, a pine tree, from which a bird (woodpecker) is extracting larvæ for food.

j, a bear.

k, the designer in his boat holding aloft his double-bladed paddle to drive fish into a net.

l, an assistant fisherman driving fish into the net.

m, the net.

The figure over the man (*l*) represents a whale, with harpoon and line attached, caught by the narrator.

Many customs, such, for instance, as the peculiar arrangement of hair in any tribe, are embodied in their pictorial designation by other tribes and often by themselves. Numerous examples are presented in this paper.

In Lord Kingsborough, Vol. VI, p. 45 et seq., is the text relating to the collection of Mendoza, in Vol. I, Pls. LVIII, to LXII, inclusive, here presented as Pls. XXXIV to XXXVIII. The textual language is preserved with some condensation.

Pl. XXXIV exhibits the customs of the Mexicans at the birth of a male or female infant; the right and ceremony of naming the children and of afterwards dedicating and offering them at their temples or to the military profession.

As soon as the mother was delivered of the infant they put it into a cradle and when it was 4 days old the midwife took the infant in her arms, naked, and carried it into the court of the mother's house, in which court was strewed reeds, or rushes, which they call tule, upon which was placed a small vessel of water in which the midwife bathed the infant; and after she had bathed it 3 boys being seated near the said rushes, eating roasted maize mixed with boiled beans, which kind of food they named yxcue, which provision or paste they set before the said boys in order that they might eat it. After the bathing, or washing, the midwife desired the boys to pronounce the name aloud, bestowing a new name on the infant which had been thus bathed; and the name that they gave it was that which the midwife wished. They first carried out the infant to bathe it. If it was a boy they carried him, holding his symbol in his hand, which symbol was the instrument which the father of the infant employed either in the military profession or in his trade, whether it was that of a goldsmith, jeweller, or any other; and the said ceremony having been gone through, the midwife delivered the infant to his mother. But if the infant was a girl the symbol with which they carried her to be bathed was a spinning wheel and distaff, with a small basket and a handful of brooms which were the things which would afford her occupation when she arrived at a proper age.

They offered the umbilical cord of the male infant together with the shield and arrows, the symbols with which they carried him to be bathed, in that spot and place where war was likely to happen with their enemies, where they buried them in the earth; and they did the same with that of the female infant, which they in the same way buried beneath the metate or stone on which they ground meal.

After these ceremonies, when twenty days had expired, the parents of the infant went with it to the temple, or mesquita, which they called calmecac, and in the presence of their alfaquis presented the infant with its offering of mantles and maxtles, together with some provision; and after the infant had been brought up by its parents, as soon as it arrived at the proper age, they delivered him to the

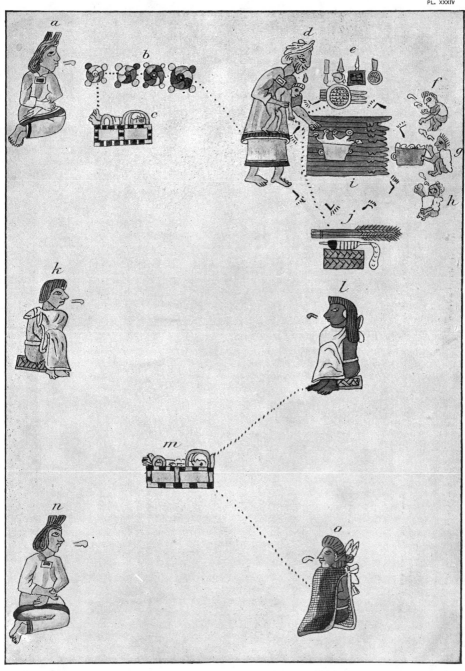

MEXICAN TREATMENT OF NEW-BORN CHILDREN.

EDUCATION OF MEXICAN CHILDREN, THREE TO SIX YEARS.

EDUCATION OF MEXICAN CHILDREN, SEVEN TO TEN YEARS.

EDUCATION OF MEXICAN CHILDREN, ELEVEN TO FOURTEEN YEARS.

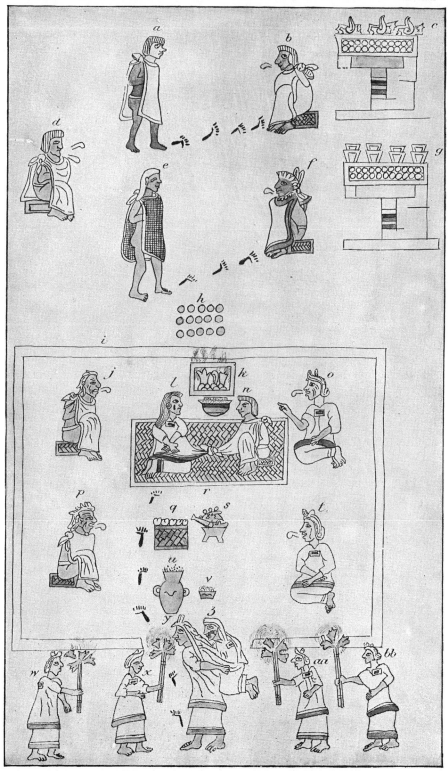

ADOPTION OF PROFESSION AND MARRIAGE, MEXICAN.

superior of the said mezquita, that he might be there instructed in order that he might afterwards become an alfaqui; but if the parents resolved that when the infant attained a fit age he should go and serve in the military profession, they immediately offered him to the master, making a promise of him, which master of the young men and boys was named Teachcauh or Telpuchtlato; which offering they accompanied with a present of provisions and other things for its celebration; and when the infant attained a fit age they delivered him up to the said master.

In the plate *a* is a woman lately delivered; the four roses, *b*, signify four days, at the completion of which period the midwife carried forth the new born infant to be bathed; *c*, is the cradle with the infant; *d*, the midwife; *e*, the symbols; *f, g, h*, the three boys who named the new-born infant; *i*, the rushes, with the small vessel of water; *j*, the brooms, distaff, spinning wheel, and basket; *k*, the father of the infant; *l*, the superior alfaqui; *m*, the infant in the cradle, whose parents are offering it at the mezquita; *n*, the mother of the girl; *o*, the master of the boys and young men.

Kingsborough's Pl. LIX—here Pl. XXXV, treats of the time and manner in which the Mexicans instructed their children how they ought to live.

The first section shows how parents corrected their children of 3 years old by giving them good advice, and the quantity of food which they allowed them at each meal was half a roll.

The three circles, *a*, indicate 3 years of age; *b*, denotes the father of the boy; *c*, the boy; *d*, the half of a roll; *e*, the mother of the girl; *f*, the half of a roll; *g*, the girl of 3 years of age.

The second section represents the parents employed in the same way, in instructing their children when they attained 4 years of age, when they began to exercise them by bidding them to do a few slight things. The quantity of food which they gave them at each meal was a roll.

The father of the boy is shown at *h;* the boy, 4 years of age, at *i; j*, a roll; *k*, the mother of the girl; *l*, a roll; *m*, the girl of 4 years.

The third section shows how the parents employed and exercised their sons of 5 years of age in tasks of bodily strength; for example, in carrying loads of wood of slight weight, and in sending them with light bundles to the tianquez or market place; and the girls of this age received lessons how they ought to hold the distaff and the spinning wheel. Their allowance of food was a roll.

In this section, *n* shows the father of the boy; *o*, two boys of 5 years of age; *p*, a roll; *q*, a roll; *r*, the mother of the girl; *s*, a roll; *t*, the girl of 5 years of age.

The fourth section shows how parents exercised and employed their sons of 6 years in personal services, that they might be of some assistance to their parents; as also in the tianquez, or market places, in picking up from the ground the grains of maize which lay scattered about, and the beans and other trifling things which those who resorted to the market had dropped. The girls were set to spin, and employed in other useful tasks that they might hereafter, through the said tasks and

works, sedulously shun idleness in order to avoid the bad habits which idleness is accustomed to cause. The allowance of food which was given to the boys at each meal was a roll and a half.

The father of the two boys appears at u; two boys of 6 years old at v; w, a roll and a half; x, the mother of the girl; y, a roll and a half; z, the girl of 6 years old.

Pl. LX, here Pl. XXXVI, treats of the time and manner in which the native Mexicans instructed and corrected their sons, that they might learn to avoid all kinds of sloth and to keep themselves constantly exercised in profitable things. It is divided into four sections.

The first section shows how fathers employed their sons of 7 years old in giving them nets to fish with; and mothers occupied their daughters in spinning and in giving them good advice. The allowance of food which they gave to their sons at each meal was a roll and a half.

The seven points, a, signify seven years; b, is the father of the boys; c, a roll and a half; d, the boy of 7 years old whose father is instructing him how to fish with the net which he holds in his hands; e, the mother of the girls; f, a roll and a half; g, the girl of 7 years whom her mother is teaching how to spin.

The second section declares how fathers chastised their sons of 8 years of age, threatening them with thorns of the aloe, that in case of negligence and disobedience to their parents they should be punished with the said thorns. The boys accordingly weep for fear. The quantity of food which they allowed them consisted of a roll and a half.

The eight points, h, signify eight years; i, the father of the boys; j, a roll and a half; k, the boy of 8 years, whose father threatens him in case of ill behavior to inflict public punishment upon him with thorns; l, thorns of the aloe; m, the mother of the girls; n, a roll and a half; o, the girl of 8 years of age, whose mother threatens her with thorns of the aloe in case of ill behavior; p, thorns of the aloe.

The third section declares how fathers punished with the thorn of the aloe their sons of 9 years of age, when they were incorrigible and rebellious toward their parents, by running the said thorns into their shoulders and bodies. They also corrected their daughters by pricking their hands with thorns. The allowance of food which they gave them was a roll and a half.

The nine points, q, signify nine years; r, a roll and a half; s, the father of the boys; t, a boy of 9 years old being found to be incorrigible, his father runs thorns of the aloe into his body; u, the mother of the girls; v, a roll and a half; w, the girl of 9 years old and her mother, who corrects her for her negligence by pricking her hands with thorns.

The fourth section shows how fathers chastised their sons of 10 years of age, when they were refractory, by inflicting blows upon them with a stick and threatening them with other punishments. The

quantity and allowance of food which they gave them was a roll and a half.

The ten points, *x*, signify ten years; *y*, a roll and a half; *z*, the father of the boys; *aa*, the boy of 10 years old, whose father is correcting him with a stick; *bb*, the mother of the girl; *cc*, a roll and a half; *dd*, the girl of 10 years old, whose mother is correcting her with a stick.

Pl. LXI, here Pl. XXXVII, is in three sections.

The first section explains that when a boy of 11 years of age disregarded verbal reproof, his parents obliged him to inhale smoke of axi through the nostrils, which was a cruel and severe punishment, that he might be sorry for such conduct and not turn out worthless and abandoned, but on the contrary employ his time in profitable things. They gave boys of such an age bread, which consisted of rolls, only by allowance, that they might learn not to be gormandizers or gluttons. Girls received similar discipline.

The eleven points, *a*, signify eleven years; *b*, a roll and a half; *c*, the father of the boys; *d*, the boy of 11 years of age, whose father is punishing him by obliging him to inhale through the nostrils the smoke of dried axi; *e*, the smoke or vapor of axi; *f*, the mother of the girls; *g*, the girl of 11 years, whose mother is punishing her by making her breathe smoke of axi; *h*, a roll and a half; *i*, the smoke of axi.

The second section represents that when boys or girls of 12 years of age would not submit to the reproof or advice of their parents, the father took the boy and tied his hands and feet and laid him naked on the ground in some damp and wet place, in which situation he kept him for a whole day, in order that by this punishment he might amend and fear his displeasure. And the mother obliged the girl of the said age to work by night before break of day, employing her in sweeping the house and the street and continually occupying her in personal tasks. They gave them food likewise by allowance.

The points, *j*, indicate twelve years; *k*, a roll and a half; *l*, the father of the boys; *m*, the boy of 12 years of age, stretched upon the wet ground, with his hands and feet tied, for a whole day; the painting at *n* signifies the night; *o*, the mother of the girls; *p*, a roll and a half; *q*, the girl of 12 years of age, who is employed by night in sweeping.

The third section of this plate represents that boys and girls of 13 years of age were occupied by their parents, the boys in fetching wood from the mountains and in bringing reed grass and other litter in canoes for the use of the house; and the girls in grinding meal and making bread, and preparing other articles of food for their parents. They gave the boys for their allowance of food two rolls each at each meal.

The father of the boys is represented at *r*; the points, *s*, indicate thirteen years; *t*, two rolls; *u*, the boy of 13 years old, who brings a load of reed grass; *v*, the boy in a canoe, with bundles of canes; *w*, the

mother of the girls; *x*, the girl of 13 years of age, who makes cakes and prepares articles of food; *y*, two cakes; *z*, a bowl; *aa*, the comali; *bb*, a pot for boiling provisions in and two cakes.

The fourth section of this plate represents how their parents employed and occupied a boy or girl of 14 years of age, the boy in going in a canoe to fish in the lakes, and the girl in the task of weaving a piece of cloth. Their allowance of food was two rolls.

The fourteen points, *cc*, represent fourteen years; *dd*, two rolls; *ee*, the father of the boys; *ff*, the boy of 14 years of age, who goes out fishing with his canoe; *gg*, the mother of the girls; *hh*, two rolls; *ii*, the girl of 14 years, who is occupied in weaving; *jj*, the web and occupation of weaving.

The figures of Pl. LXII, here Pl. XXXVIII, are in two sections.

Those contained in the first section signify that the father, who had sons nearly grown up, carried them to the two houses represented in the plate; either to the house of the master, who taught and instructed the young men, or to the mezquita, accordingly as the lad was himself inclined, and committed him to the care of the superior Alfaqui or to the master of the boys, to be educated, which lads it was fit should have attained the age of 15.

In this section *a* is a youth of 15 years of age, whose father delivers him up to the superior Alfaqui, that he might receive him as an Alfaqui; *b* is the Tlamazqui, who is the superior Alfaqui; *c*, the mezquita, named Calmecac; *d*, the father of these two youths; *e*, a young man of 15, whose father delivers him up to the master that he might teach and instruct him; *f*, the teachcauh or master; *g*, the seminary where they educated and taught the young men, which was called cuincacali; *h*, fifteen years.

The second section of the plate signifies the laws and usages which they followed and observed in marriages. The ceremony consisted in the female negotiator, who arranged the nuptials, carrying on her back on the first night of the wedding the betrothed woman, accompanied by four women with blazing torches of resinous fir, who attended to light her on the way; and having arrived at the house of the man to whom she was engaged, the parents of the betrothed man went out to receive her in the court of the house and conducted her to an apartment where the man expected her; and seating the betrothed couple on a mat on which were placed seats, near a hearth of fire, they took them and tied them to each other by their clothes and offered incense of copal to their gods. Two old men and two women afterward delivered a separate discourse to the newly married couple and set food before them, which they presently ate; and after their repast was over, the two old men and women gave good advice to the married pair, telling them how they ought to conduct themselves and to live, and by what means they might pass their lives in tranquillity.

The square inclosure, *i*, is the apartment; *j*, the old man; *k*, the

hearth of fire; *l*, the wife; *m*, copal (the latter is not shown in the draw-
ing, but the copal is between the marrying couple); *n*, the husband; *o*,
the old woman; *p*, the old man; *q*, food; *r*, a mat; *s*, food; *t*, an old wo-
man; *u*, a pitcher of pulque; *v*, a cup; *w*, *x*, the women lighting the
bride on her way with torches, when on the first night of the wedding
they accompany her to the house of the bridegroom; *y*, the female nego-
tiator; *z*, the bride; *a a*, *b b*, women lighting the bride and bridegroom
on the first night of their wedding.

<div align="center">

SECTION 3.

GAMES.

</div>

Many accounts of the games of the Indians have been published, but
they are not often connected with pictography. Those now presented
refer to the picturing connected with only three games.

Fig. 772.—A dead man was used in the
ring-and-pole game. American - Horse's
Winter Count, 1779–'80.

The figure represents the stick and ring
used in the game of haka, with a human
head in front to suggest that the corpse

FIG. 772.—Haka game. Dakota.

took the place of the usual stick. This and the next figure illustrate
the game.

Fig. 773.—It was an intensely cold winter and a
Dakota froze to death. American-Horse's Winter
Count, 1777–'78.

The sign for snow or winter, i. e., a cloud with snow
falling from it, is above the man's head. A haka-stick,
which is used in playing that game, is represented in
front of him.

Battiste Good's record further explains the illustra-
tion by the account that the Dakota was killed in a
fight with the Pawnees, and his companions left his
body where they supposed it would not be found, but
the Pawnees found it, and, as it was frozen stiff, they
dragged it into their camp and played haka with it.

FIG. 773.—Haka game.
Dakota.

The characters *a* and *b*, Fig. 774, represent one point of view of two
of a set of Haida gambling sticks, real size. They are made of juniper
or some other similar wood, and neatly carved with diverse figures.
The game is played by any number of persons, and it would seem with
any number of marked sticks. A dealer sits on the ground with a pile
of shredded cedar bark in front of him, and with much ceremony draws
out the sticks one by one without looking at them and passes them to
the players, in turn, who sit in front of him.

Each device counts a certain number, in a manner similar to the
devices on ordinary playing cards, and the winning is by the high and

low or the definite and specific values of the sticks decided upon in variations of the games. These sticks are cylindrical, and to illustrate the characters on them, *c* is presented, which shows the whole round of the character *b*. This exhibits the typical Haida style. An excellent collection of these pictured sticks is in the U. S. National Museum, No. 73552.

Dr. Fewkes (*c*) reports as follows:

Among the very interesting games played by the Hopi Indians is one of ethnological interest, which is allied to a game described by the early Spanish historians of the Mexicans. This game, to-to-lós-pi, resembles somewhat the game of checkers

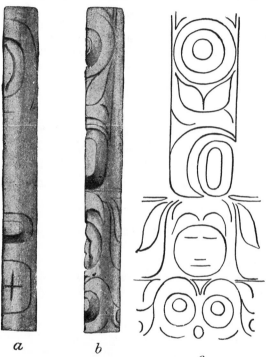

a *b*

c

Fig. 774.—Haida gambling stick.

and can be played by two persons or by two parties. In playing the game a rectangular figure, divided into a large number of squares, is drawn upon the rock, either by scratching or by using a different colored stone as a crayon. (Figures of this game formerly existed on the rocks near the village of Wál-pi.) A diagonal line, tûh-ki-o-ta, is drawn across the rectangle from northwest to southeast, and the players station themselves at each end of this line.

When two parties play, a single person acts as player and the other members of the party act as advisers. The first play is won by tossing up a leaf or corn husk with one side blackened. The pieces which are used are bean or corn kernels, stones, and wood, or small fragments of any substance of marked color. The players were stationed at each end of the diagonal line, tûh-ki-o-ta. They move their pieces upon this line, but never across it. The moves which are made are intricate and the player may move one or more pieces successively. Certain positions entitle him to this privilege. He may capture or, as he terms it, kill one or more of his opponent's

pieces at one play. In this respect the game is not unlike checkers, and to capture the pieces of the opponent seems to be the main object of the game. The checkers, however, must be concentrated and always moved towards the southeast corner.

This game is now rarely played on the East Mesa, but is still used at O-rai-be. It is said to have been played in ancient times by the sun and moon or by other mythical personages.

Turning now to old Mexico, we find that the Spanish chronicles give an account of a Mexican game called patolli, which was played with colored stones. The squares were made of a cross-shaped figure, and the stones were moved according to the throws of beans which were marked upon one side.

A discussion of the "ghost gamble," with many illustrations, some of which show marks which, in a broad sense, may be classed as pic-

Fig. 775.—Pebbles from Mas d'Azil.

tographic, is published in the paper "Study of the mortuary customs of the North American Indians," by Dr. H. C. Yarrow (a), U. S. Army.

Colored pebbles found in the grotto of Mas d'Azil, in the department of the Ariège, France, have lately awakened some discussion. These pebbles were selected as being narrow and flat, and, with rare exceptions, are no more than 9 centimeters in length. They were colored with red oxide of iron. Many of the designs could have been made by the end of a finger anointed with the coloring matter, but others would have required a small pencil. The coloring matter was thick and probably fixed by grease or glue, which time has destroyed. The color now disappears on the least rubbing. Its preservation until now has been owing to the fact that the pebbles were left undisturbed in the cindery layer where they were deposited. Only one of the faces of the pebbles bears a design, and generally their border is ornamented by a narrow band of red, resembling a frame to the design, the color being applied

in the same manner as to the latter. Fig. 775 gives examples though without color of these pebbles. They are selected from a plate in L'Anthropologie (d) illustrating the text by Émile Cartailhac, who declines to offer any hypothesis concerning the use of these objects. But to an observer familiar with the gambling games of the North American Indians in which marked plum stones, and similar objects are employed, these stained flat pebbles at once suggest their use to decide the values in a game by the several designs and by the pebbles falling on the figured or on the unmarked side.

CHAPTER XVI.

HISTORY.

It is seldom possible to distinguish by pictographs, or indeed to decide from oral accounts obtained from Indians, whether those purporting to be historical have a genuine basis or are merely traditions connected with myths. This chapter may therefore be correlated with Chapter IX, section 5, which has special relation to traditions as mnemonically pictured. The notes now following are considered to refer to actual events or to explain the devices used in the record of such events.

The account by Dr. Brinton (c) of the Walum-Olum or bark record of the Lenni-Lenapé, as also some of Schoolcraft's pictographic illustrations, may with some propriety be regarded as historic, but are so well known that their specific citation is needless.

The American Indians have not produced detailed historic pictures, such as appear on the Column of Trajan and the Bayeux tapestry, with such excellence in art as to be self-interpreting. Neither do they equal in this respect the Egyptian and Assyrian sculptures, which portray the ordering of battle, the engineering work of sieges, the plan of camps, and the tactical moves of chieftains. Those sculptures also depict the whole civil and domestic lives of the peoples of the several nations. In some of these particulars the Mexicans approached these graphic details, as is shown below, but, as a rule, in the three divisions of America, history was noted and preserved by ideographic methods supplementing the incompleteness of artistic skill.

With regard to the advance gained by the Mexicans reference is made, with regret that copious quotation is impossible, to the essay of Henry Phillips, jr. (a), and to the monumental work of Eugéne Boban, before cited. It will be noticed by students that ideography and its attendant conventionalism continually appear in the pictographic histories mentioned. The original authors had not advanced very far in art, but they had not lost the thought-language, which preceded art.

The subject is here divided into: (1) Record of expedition; (2) Record of battle; (3) Record of migration; (4) Record of sociologic events.

551

SECTION 1.

RECORD OF EXPEDITION.

The following account from Lafitau (*a*) explains the device for pris-
oner, under the heading of marked sticks, in Chapter IX, section 2,
supra:

> The most grievous time for them is at night; for every evening they are extended
> on their backs almost naked, with no other bed than the earth, in which four stakes
> are driven for each prisoner; to these their arms and legs are attached, spread apart
> in the form of a St. Andrew's cross. To a fifth stake a halter is tied, which holds
> the prisoner by the neck and is wound around it three or four times. Finally, he is
> bound around the middle of the body by another halter or girdle, the two ends of
> which are taken by the person in charge of the captive and placed under his head
> while he sleeps, so that he will be awakened if the prisoner makes any movement
> to escape.

With the same object of explaining pictographic devices, the follow-
ing is extracted from James's Long (*h*):

> Returning war parties of the Omaha peel off a portion of the bark from a tree, and
> on the trunk thus denuded and rendered conspicuous, they delineate hieroglyphics
> with vermilion or charcoal, indicative of the success or misfortune of the party, in
> their proceedings against the enemy. These hieroglyphics are rudely drawn, but
> are sufficiently significant to convey the requisite intelligence .o another division of
> the party, that may succeed them. On this rude chart the combatants are generally
> represented by small straight lines, each surmounted by a head-like termination,
> and are readily distinguishable from each other; the arms and legs are also repre-
> sented when necessary to record the performance of some particular act or to exhibit
> a wound. Wounds are indicated by the representation of the dropping of blood
> from the part; an arrow wound, by adding a line for the arrow, from which the
> Indian is able to estimate with some accuracy its direction, and the depth to which
> it entered. The killed are represented by prostrate lines; equestrians are also par-
> ticularized, and if wounded or killed they are seen to spout blood or to be in the act
> of falling from their horses. Prisoners are denoted by their being led, and the num-
> ber of captured horses is made known by the number of lunules representing their
> track. The number of guns taken may be ascertained by bent lines, on the angle of
> which is something like the prominences of the lock. Women are portrayed with
> short petticoats and prominent breasts, and unmarried females by the short queues
> at the ears.

In Margry (*e*) there is an account of La Salle's finding in 1683 on the
bark of a tree a record of the party of Tonty's pilot. The picture was
that of a man with the costumes and general appearance of the pilot who
had deserted, another man tied as a captive, and four scalps. This cor-
responded with the facts afterwards learned. The pilot had been left
free, another man kept alive, and four killed, thus accounting for the
lost party of six. The record had been made by the captors.

The figures in the following group, taken from several of the Winter
Counts of the Dakotas, picture a number of important expeditions, all
of which are independently known. Some of them are narrated in the
official documents of the United States.

Fig. 776. The Oglalas, Brulés, Minneconjous, San Arcs, and Chey-
ennes united in an expedition against the Crows. They
surprised and captured a village of thirty lodges, killed all
the men and took the women and children prisoners. Ameri-
can-Horse's Winter Count, 1801–'02.

FIG. 776.

The three tipis stand for thirty; the spots in the original are red for
blood.

Fig. 777. The Oglalas and Minneconjous took the war-path
against the Crows and stole three hundred horses. The
Crows followed them and killed eight of the party. Ameri-
can-Horse's Winter Count, 1863–'64. Eight scalped heads
are portrayed.

FIG. 777.

Fig. 778. The Dakotas assaulted and took a Crow village
of a hundred lodges. They killed many and took many
prisoners. American-Horse's Winter Count, 1820–'21.

FIG. 778.

Fig. 779. The Oglalas helped Gen. Mackenzie to whip the Cheyennes.
American-Horse's Winter Count, 1876–'77. The
head of the Indian on which is the ornamented
war bonnet represents the man who was the
first to enter the Cheyenne village, which is
figured by the tipis in a circle. The hatted, i. e.,
white man holding up three fingers is Gen.
Mackenzie, who, as was explained by the inter-
preter, is placed upon the head of the Dakota to

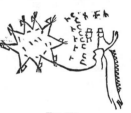

FIG. 779.

indicate that the Dakotas backed or assisted him, but it may mean that
he commanded or was at the head of the party. The other white man
is Gen. Crook, or Three Stars, as indicated by the three stars above
him, and as he is called in another record. This designation might be
suggested from the uniform, but it is not accurate. Gen. Crook's rank
as major-general of volunteers, or as brevet major-general in the Army,
did not entitle him to more than two stars on his shoulder straps. It is
possible that one of the stars in this figure belongs to Gen. Mackenzie.

Fig. 780. The Dakotas joined the whites in an expe-
dition up the Missouri river against the Rees. Cloud-
Shield's Winter Count, 1823–'24.

White-Cow-Killer calls it "Old-corn-plenty-winter."
The union line between the Indian and the white
soldier shows that on this occasion they were allies.

FIG. 780.

Fig. 781. United States troops fought Ree Indians. The-Swan's Winter Count, 1823–'24.

FIG. 781.

This and the preceding figure are signs of a specially interesting expedition, a condensed account of which follows taken from the annual report of J. C. Calhoun, Secretary of War, November 29, 1823:

Gen. William H. Ashley, a licensed trader, was treacherously attacked by the Arickaras at their village on the west bank of the Missouri river, about midway between the present Fort Sully and Fort Rice. Twenty-three of the trading party were killed and wounded, and the remainder retreated in boats and sent appeals for succor to the commanding officer at Fort Atkinson, the present site of Council Bluffs. This officer was Col. H. Leavenworth, Sixth United States Infantry, who marched June 22, with 220 men of that regiment, 80 men of trading companies, and two 6-pound cannon, a 5½-inch brass howitzer, and some small swivels, nearly 700 miles through a country filled with hostile or unreliable Indians, to the Ree villages, which he reached on the 9th of August. The Dakotas were at war with the Arickara or Rees, and 700 to 800 of their warriors had joined the United States forces on the way; of these Dakotas 500 are mentioned as Yanktons, but the tribes of the remainder are not designated. The Rees were in two villages, the lower one containing seventy-one dirt lodges and the upper seventy, both being inclosed with palisades and a a ditch and the greater part of the lodges having a ditch around the bottom on the inside. The enemy, having knowledge of the expedition, had fortified and made every preparation for resistance. Their force consisted of over 700 warriors, most of whom were armed with rifles procured from British traders. On the 9th of August the Dakotas commenced the attack and were driven back until the regular troops advanced, but nothing decisive resulted until the artillery was employed on the 10th, when a large number of the Rees, including their chief, Gray Eyes, were killed, and early in the afternoon the survivors begged for peace. They were much terrified and humbled by the effect of the cannon, which, though small, answered the purpose. During the main engagement the Dakotas occupied themselves in gathering and carrying off all the corn to be found.

See also the record of Lean-Wolf's expedition in Fig. 452.

<center>SECTION 2.</center>

<center>RECORD OF BATTLE.</center>

Lafitau (b) gives the following account, translated with condensation, of the records of expedition, battle, etc., made by the Iroquois and northeastern Algonquins:

The designs which the Indians have tattooed on their faces and bodies are employed as hieroglyphics, writing, and records. When an Indian returns from war and wishes to make his victory known to the neighboring nations through whose country he passes, when he has chosen a hunting ground and wishes it to be known that he has selected it for himself and that it would be an affront to him for others to establish themselves there, he supplies the lack of an alphabet by those characteristic symbols which distinguish him personally; he paints on a piece of bark, which is raised on a pole by a place of passage [trail], or he cuts away some pieces from a tree trunk with his hatchet, and, after having made a smooth surface, traces his portrait and adds other characters, which give all the information that he desires to convey.

When I say that he draws his portrait, it will be understood that he is not skillful enough to delineate all the features of his face in such a manner that it would be recognized. They have, indeed, no other way of painting than that monogrammatic or linear painting, which consists of little more than the mere outlines of the shadow of the body rather than of the body itself—a picture so imperfect that it was often necessary to add below the name of the object which was intended to be represented in order to make it known.

The Indian then, to represent his portrait, draws a simple outline in the form of a head, adding scarcely any marks to indicate the eyes, nose, ears, or other features of the face. In place of these he draws the designs which are tattooed upon his own face, as well as those upon his breast, and which are peculiar to him and render him recognizable not only to those who have seen him, but even to all who, knowing him only by reputation, are acquainted with his hieroglyphic symbol, as formerly in Europe an individul was distinguished by his device and as we to-day know a family by its armorial bearings. About his head he paints the object which expresses his name; the Indian, for example, called the Sun paints a sun; at the right he traces the animals which are the symbols of the nation and family to which he belongs. That of the nation is above the one representing the family, and the beak or muzzle of the former is so placed that it corresponds to the place of his right ear, as if this symbolic figure of his nation represented its spirit, which inspires him. If this Indian is returning from war, he represents beneath his portrait the number of warriors composing the party which he leads, and beneath the warriors the number of prisoners made and those whom he has killed by his own hand. At the left side are indicated his expeditions and the prisoners or scalps taken by those of his party. The warriors are represented with their weapons or simply by lines; the prisoners by the stick decorated with feathers and by the chichikoue or tortoise-shell rattle, which are the marks of their slavery; the scalps or the dead by the figures of men, women, or children without heads. The number of expeditions is designated by mats. He distinguishes those which he has accompanied from those which he has commanded by adding strings [of wampum] to the latter. If the Indian goes as an ambassador of peace all the symbols are of a pacific nature. He is represented below his portrait with the calumet in his hand; at the left is seen an enlarged figure of the calumet, the symbolic figure of the nation with which he goes to treat, and the number of those who accompany him on the embassy.

The same author, on page 194 of the same volume, explains how the mat or mattress came to mean war:

The Iroquois and the Hurons call war n'ondoutagette and gaskenrhagette. The final verb gagetton, which is found in the composition of these two words, and which signifies to bear or to carry, shows, verily, that heretofore something was borne to it [i. e., to war], which was a symbol of it [i. e., of war] to such a degree that it [war] had assumed its [the symbol's] designation. The term ondouta signifies the down [the wool-like substance] which is taken from the ear [cat-tails] of marsh reeds, and it also denotes the entire plant, which they use in making the mattresses [nattes] upon which they lie; so that it appears that they applied this term to war because every warrior in this kind of expeditions carried with him his own mattress; in fact, the mattress is still to-day the symbol employed in their hieroglyphic picture-writing to denote the number of their campaigns.

Mr. J. N. B. Hewitt, in Science, April 1, 1892, has gone deeper into the etymology of the words quoted, but coincides generally with Father Lafitau in the explanation that they were denotive of the custom of the Iroquoian warrior to carry his mattress when on the warpath.

Figs. 782 and 783 are reproductions of Lafitau's (c) illustrations, which were explained as follows by him:

Fig. 782 shows that the Indian called Two-Feathers, *a b*, of the Crane nation *c*, and the Buffalo family *d*, accompanied by fifteen warriors *h*, has made one prisoner *f*, and taken three scalps *g*, on his sixth expedition *k*, and on the fourth, when he commanded it, *i*.

Fig. 783 relates that the Indian named Two-Arrows *a*, of the nation of the Deer *c*, and the Wolf family *d*, has gone as an ambassador bearing the calumet of peace to the Bear nation *e*, accompanied by thirty persons *h*. In both figures the Indian is not only represented by his "hieroglyph," but he is also pictured at full length in the first with his arms, and in the second holding the calumet and the rattle.

A historical record relating to a fight between the Ojibwa and the Dakota ninety-one years ago is given in Fig. 784. The following narrative was given by the draftsman of the record, an Ojibwa:

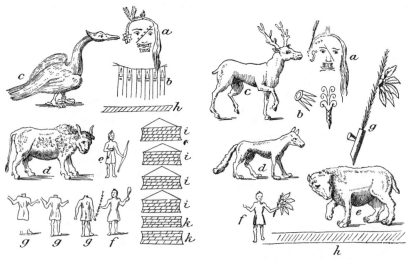

FIG. 782.—Record of battle. FIG. 783.—Record of battle.

Ninety-one winters ago (A. D. 1797) twenty-five Ojibwa were encamped on a small lake, *o*, called Zi'zabe'gamik, just west of Mille Lacs, Minnesota. The chief's lodge, *a*, was erected a short distance from the lake, *m*, where the Indians had been hunting, and as he felt unsafe on account of the hostile Sioux he directed some of his warriors to reconnoiter south of the lower lake, where they soon discovered a body of three hundred of their enemies. The chief of the reconnoitering party, *b*, sent back word for the women and children to be removed to a place of safety, but three of the old women refused to go. Their lodges are represented in *c*, *d*, and *e*. Five Ojibwa escaped through the brush, in a northwest direction (indicated in *f*).

The Sioux surrounded the lake and the fight took place on the ice. Twenty of the Ojibwa were killed, the last to die being the chief of the party, who, from appearances, was beaten to death with a tomahawk; *g* represents three bearskins; *h*, *i*, and *j*, respectively, deer, grouse, and turtle, the kinds of game hunted there during the several seasons.

The canoe *k* indicates the manner of hunting along the shore and the stream connecting the lakes, *l*, *m*, and *o*.

The Ojibwa frequently spent part of a season at the middle lake, *m*, and at another time had been engaged in a skirmish with the Sioux farther north, on the small lake indicated at *o*. The Ojibwa had been scattered about, but when the attack was made by the Sioux the former

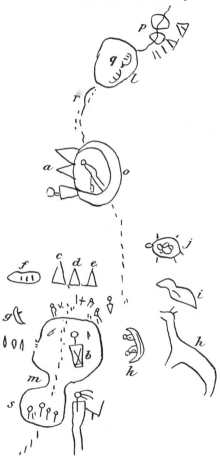

FIG. 784.—Battle of 1797. Ojibwa.

rapidly came to the rescue both by boat, *p*, and on foot, *q*, so that the enemy was gradually driven off.

In the first mentioned battle 70 Sioux were killed, their bodies being subsequently buried in the lake by cutting holes through the ice. The openings are shown at *r*, the lines representing bodies ready to be cast down into the water.

Baron Lahontan (*b*) says:

When a Party of (Algonkin) Savages have routed their enemies in any Place whatsoever, the Conquerors take care to pull the Bark off the Trees for the height of five or six Foot in all Places where they stop in returning to their own Country; and in honour of their Victory paint certain images with Coal pounded and beat up with

Fat and Oyl. These Pictures continue upon the peel'd Tree for ten or twelve Years, as if they were Grav'd, without being defac'd by the Rain.

The same author, on page 86, *et seq.*, of the same volume, gives an illustration, with descriptive explanation, of a pictographic record supposed to be made by the Canadian Algonquins. The explanation is useful as indicating the principles of pictography adopted by the North American Indians for a record of that character, but it is not deemed proper to reproduce the illustration here. It has often been copied, but it is misleading in its artistic details. It is obviously drawn by a European artist as his own interpretation of a verbal description of the record.

The more valuable parts of the explanation are condensed as follows, the quaint literation of the early translation being retained:

The Arms of France, with an Ax above. Now the Ax is a Symbol of War among the Savages as the Calumet is the Bond of Peace: So that this imports that the French have taken up the Ax, or have made a Warlike Expedition with as many tens of Men as there are Marks or Points Round the Figure. These marks are eighteen in number and so they signifie an Hundred and eighty Warriors.

A Mountain that represents the City of Monreal and the Fowl upon the Wing at the top signifies Departure. The Moon upon the Back of the Stag signifies the first Quarter of the July Moon which is call'd the Stag-Moon.

A Canow, importing that they have travel'd by Water as many Days as you see Huts in the Figure, i, e., 21 Days [the huts undoubtedly mean stopping places for night shelters].

A foot, importing that after their Voyage by Water they march'd on Foot as many Days as there are Huts design'd; that is, seven Days Journeys for Warriors, each Days Journey being as much as five common French Leagues, or five of those which are reckon'd to be twenty in a Degree.

A Hand and three Huts, which signifie that they are got within three Days Journey of the Iroquese Tsonnontouans [Senecas], whose Arms are a Hut with two trees leaning downwards, as you see them drawn. The Sun imports that they were just to the Eastward of the Village.

Twelve marks, signifying so many times ten Men like those last mentioned. The Hut with two Trees being the Arms of the Tsonnontouans, shows that they were of that Nation; and the Man in a lying posture speaks that they were surpris'd.

In this row there appears a Club and eleven Heads, importing that they had kill'd eleven Tsonnontouans, and the five men standing upright upon the five Marks signifie that they took as many times ten prisoners of War.

Nine Heads in an Arch [i. e., Bow] the meaning of which is, that nine of the Aggressors or of the Victorious side were kill'd; and the twelve Marks underneath signifie that as many were Wounded.

Arrows flying in the air, some to one side and some to the other, importing a vigorous Defence on both sides.

The arrows all point one way, which speaks the worsted Party either flying or fighting upon a Retreat in disorder.

The meaning of the whole is: A hundred and eighty French soldiers set out from Montreal in the first quarter of the month of July and sailed twenty-one days; after which they marched 35 leagues over land and surprised 120 Senecas on the east side of their village, 11 of whom were killed and 50 taken prisoners; the French sustaining the loss of 9 killed and 12 wounded, after a very obstinate engagement.

Fig. 785 is a reproduction of a drawing by a Winnebago Indian of

the battle of Hard river, fought against a large force of Sioux by
Gen. Sully's command, with which was a company of Winnebagos.

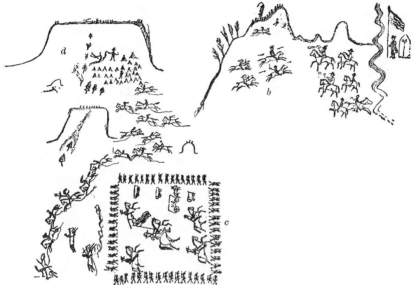

FIG. 785.—Battle of Hard river, Winnebago.

a. Gen. Sully's camp, on the left bank of Hard river, from which camp the company
of Winnebagos were sent across the river.

b. The Winnebagos skirmishing with a party of hostile Sioux. Two Winnebagos,
having gone ahead of the main party, came first upon about thirty Sioux, who imme-
diately gave chase. The two Winnebagos are represented endeavoring to escape
arrows from pursuing Sioux flying about them, and the blood from the horse of one
of them flowing over the ground. The rest of the Winnebagos are coming to rescue
their companions.

c. Gen. Sully's entire force, after crossing Hard river, were assailed by a number of
Sioux. Gen. Sully's forces formed in hollow square to repulse the Sioux, who with
loud yells went galloping about them, trying to stampede horses or throw his men
into confusion.

d. The camp of the Sioux, the women and children escaping over the hills. One
squaw was left in the camp and with her papoose is seen. One of the Sioux pre-
viously wounded was found dead and was scalped, a representation of which opera-
tion the artist has given.

FIG. 786.—Battle between Ojibwa and Sioux.

Fig. 786 is a copy of a birch-bark record made and also explained by
the leader of the expedition referred to.

In 1858 a war party of Mille Lacs Ojibwa Indians, *a*, under the leadership of Shahâsh'king, *b*, went to attack Shákopi's camp, *c*, of Sioux at St. Peter's river, *d*. Shákopi is represented at *e*. The Ojibwa lost one man, *f*, at the St. Peter's river, while the Ojibwa killed five Sioux, but succeeded in securing only one arm of an Indian, *g*.

FIG. 787.—Megaque's last battle.

The line *h* is the trail followed between Mille Lacs, *a*, and Shákopi's camp, *c*. The spots at *c* designate the location of lodges, while the vertical line with short ones extending from it, *i*, signifies the prairie with trees growing near camp.

Fig. 787 is the pictorial story of Megaque's last battle, drawn on birch bark by the Passamaquoddy chief, Sapiel Selmo, with his interpreted description.

In the old times there was a certain Indian chief and hunter. He was so cruel and brave in time of war and his success in conquering his enemies and taking so many scalps was so great that he was called Megaque, or the Scalping Man. In hunting seasons he always went to his hunting grounds with his warriors to defend and guard their hunting grounds from the trespassing of other hunters. He was well known by other Indians for his bravery and his cruelty to his prisoners. He conquered so many other warriors and tortured them that he was hated, and they tried to capture him alive. Some of the warriors from other tribes gathered an army and marched to his hunting grounds when they knew that he could not escape from their hands. When they come near where he is they send messengers to him and notify him of the approaching army; he is out hunting when they reach his camp, but they make marks on a piece of birch bark, a figure of an Indian warrior with tomahawk in one hand and spear in the other, similar to that seen in *g*, which is put up in a village of wigwams, *i*. When Megaque returned from his hunt and found someone had visited him during his absence, he also found the pieces of bark which read to mean a band of warriors. He has no time. He was so brave and proud he did not try to escape. In a day or two the band of warriors had reached him. After fighting, when he killed many as usual, he was finally captured and taken to the enemy's country to be tortured. He can stand all the usual tortures bravely and sing his usual war songs while he is tormented. Finally he was killed.

The following is the explanation of the details: *a*, Megaque; *b*, his braves; *c*, the course by which the enemy comes; *d, e, f*, Megaque's rivers and lakes; *g*, the enemy; *h*, their warriors; *i*, their village; *j*, river boundary line.

The figures now following are those notices of battle pictured in the several Winter Counts which have been selected as being of more than ordinary interest either from the importance and notoriety of the events or from their mode of delineation:

Fig. 788.—The Oglalas killed three lodges of Omahas. Cloud-Shield's Winter Count, 1785–'86. The Omaha is prostrate and scalped.

FIG. 788.

Fig. 789.—The Omahas made an assault on a Dakota village. Cloud-Shield's Winter Count, 1802–'03. Bullets are flying back and forth. The single rider represents the whole of the troop. He is partially covered by the shield and the horse's neck, behind which he hangs in a manner common among the Indian horsemen. The ornamented shield with its device of a

FIG. 789.

displayed eagle, and the lance with eagle feather for a pennon, recalls
the equipments of chivalry.

FIG. 790.

Fig. 790.—The Dakotas and Pawnees
fought on the ice on the North Platte
river. American-Horse's Winter Count,
1836–'37. The Dakotas were on the
north side (the right-hand side in the
figure), the Pawnees on the south side
(the left in the figure). Horsemen and
footmen on the left are opposed to
footmen on the right. Both sides have
guns and bows, as shown by the bullet-
marks and the arrows. Blood-stains are on the ice.

FIG. 791.

Fig. 791.—The Dakotas fought the
Pawnees across the ice on the North
Platte. Cloud-Shield's Winter Count,
1836–'37. The man on the left is a
Pawnee. This is a variant of the pre-
ceding figure, far less graphically ex-
pressed.

FIG. 792.

Fig. 792.—The Dakotas fought with
the Cheyennes. Cloud-Shield's Winter
Count, 1834–'35. The stripes on the
arm are for Cheyenne, as before ex-
plained.

FIG. 793.

Fig. 793.—White-Bull and thirty
other Oglalas were killed by the Crows
and Shoshoni. American-Horse's Win-
ter Count, 1845–'46.

FIG. 794.

Fig. 794.—Mato-wayuhi, Conquering-
Bear, was killed by white soldiers, and
thirty white soldiers were killed by
the Dakotas, 9 miles below Fort Lara-
mie. American-Horse's Winter Count,
1854–'55. The thirty black dots in three
lines stand for the soldiers, and a red
stain at the end of the line, starting
from the pictured discharge of a gun, means killed. The head covered

with a fatigue cap further shows the soldiers were white. Indian soldiers are usually represented in a circle or semicircle. The gesture-sign for white soldier means "all in line," and is made by placing the nearly closed hands, with palms forward and thumbs near together, in front of the body and then separating them laterally about 2 feet.

Fig. 795.—The Dakotas killed one hundred white men at Fort Phil. Kearny. American-Horse's Winter Count, 1866–'67. The hats and the cap-covered head represent the whites; the red spots, the killed; the circle of characters around them, rifle or arrow shots; the black strokes, Dakota footmen; and the hoof-prints, Dakota horsemen. The Phil. Kearny massacre oc-

FIG. 795.

curred December 21, 1866, and eighty-two whites were killed, including officers, citizens, and enlisted men. Capt. W. J. Fetterman was in command of the party.

THE BATTLE OF THE LITTLE BIGHORN.

Dr. Charles E. McChesney, acting assistant surgeon, U. S. Army, has communicated a most valuable and unique account, both in carefully noted gesture-signs and in pictographs, of the battle, now much discussed, which was fought in Montana on June 25, 1876, and is popularly but foolishly styled "Custer's massacre." If the intended surprise, with the object of killing as many Indians as possible, had been successful instead of being a disastrous defeat, any surviving Indians might with some propriety have spoken of "Custer's massacre." The account now presented in one of its forms, was given by Red-Horse, a Sioux chief and a prominent actor in the battle. The form which gives the relation in gesture-signs and shows the syntax of the sign-language perhaps better than any published narrative, will be inserted in a work now in preparation by the present writer to be issued by the Bureau of Ethnology. The narrative, closely translated into simple English, is given below. Accompanying the record of signs are forty-one sheets of manila paper, besides one map of the battle ground, all drawn by Red-Horse, which average 24 by 26 inches, most of them being colored. These may either be considered as illustrations of the signs or the signs may be considered as descriptive of the pictographs. It is impossible to reproduce now this mass of drawing on any scale which would not be too minute for appreciation. It has been decided to present, with necessary reduction from the above-mentioned dimensions, the map and nine of the typical sheets in Pls. XXXIX to XLVIII. Indeed, without considering the space required, there would be small advantage in reproducing all of the sheets, as they are made objectionable by monotonous repetitions.

Here follows the story of Red-Horse. Pl. XXXIX is the map of the

Little-Bighorn battlefield and adjacent territory, embracing part of Montana and the Dakotas, drawn at Cheyenne River agency, South Dakota, in 1881. The map as now presented is reduced to one-sixteenth from the original, which is drawn in colors on a sheet of manila paper. The letters were not on the original and are inserted only for reference from the descriptive text, as follows:

a, Wind River mountains, called by the Sioux "the Enemies' mountains."

b, Bighorn mountains.

c, Missouri river.

d, Yellowstone river.

e, Bighorn river.

f, Little Bighorn river, called by the Sioux Greasy Grass creek and Grass Greasy creek.

g, Indian camp.

h, battlefield.

i, Dry creek.

j, Rosebud river.

k, Tongue river.

l, Powder river.

m, Little Missouri river.

n, Cheyenne river, called by the Sioux Good river. The North and South Forks are drawn but not lettered.

o, Bear butte.

p, Black hills.

q, Cheyenne agency.

r, Moreau or Owl creek.

s, Thin butte.

t, Rainy butte.

u, White butte.

v, Grand or Ree river.

w, Ree village.

x, White Earth river.

y, Fort Buford.

Five springs ago I, with many Sioux Indians, took down and packed up our tipis and moved from Cheyenne river to the Rosebud river, where we camped a few days; then took down and packed up our lodges and moved to the Little Bighorn river and pitched our lodges with the large camp of Sioux.

The Sioux were camped on the Little Bighorn river as follows: The lodges of the Uncpapas were pitched highest up the river under a bluff. The Santee lodges were pitched next. The Oglala's lodges were pitched next. The Brulé lodges were pitched next. The Minneconjou lodges were pitched next. The Sans Arcs' lodges were pitched next. The Blackfeet lodges were pitched next. The Cheyenne lodges were pitched next. A few Arikara Indians were among the Sioux (being without lodges of their own). Two-Kettles, among the other Sioux (without lodges). [Pl. XL shows the Indian camp.]

I was a Sioux chief in the council lodge. My lodge was pitched in the center of the camp. The day of the attack I and four women were a short distance from the camp digging wild turnips. Suddenly one of the women attracted my attention to a cloud of dust rising a short distance from camp. I soon saw that the soldiers were charging the camp. [Pl. XLI shows the soldiers charging the Indian camp.] To the camp I and the women ran. When I arrived a person told me to hurry to the council lodge. The soldiers charged so quickly we could not talk (council). We came out of the council lodge and talked in all directions. The Sioux mount horses, take guns, and go fight the soldiers. Women and children mount horses and go, meaning to get out of the way.

Among the soldiers was an officer who rode a horse with four white feet. [From Dr. McChesney's memoranda this officer was Capt. French, Seventh Cavalry.] The Sioux have for a long time fought many brave men of different people, but the Sioux say this officer was the bravest man they had ever fought. I don't know whether this was Gen. Custer or not. Many of the Sioux men that I hear talking tell me it was. I saw this officer in the fight many times, but did not see his body. It has

Plate XXXIX.

MAP OF LITTLE BIG HORN BATTLE FIELD.

BATTLE OF LITTLE BIGHORN. INDIAN CAMP.

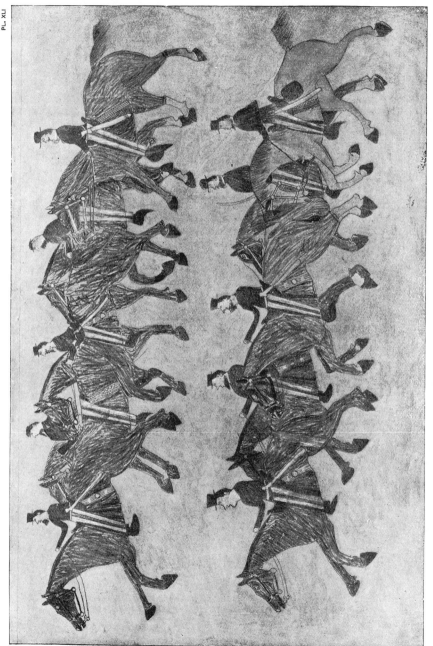

BATTLE OF LITTLE BIGHORN. SOLDIERS CHARGING INDIAN CAMP.

BATTLE OF LITTLE BIGHORN. SIOUX CHARGING SOLDIERS.

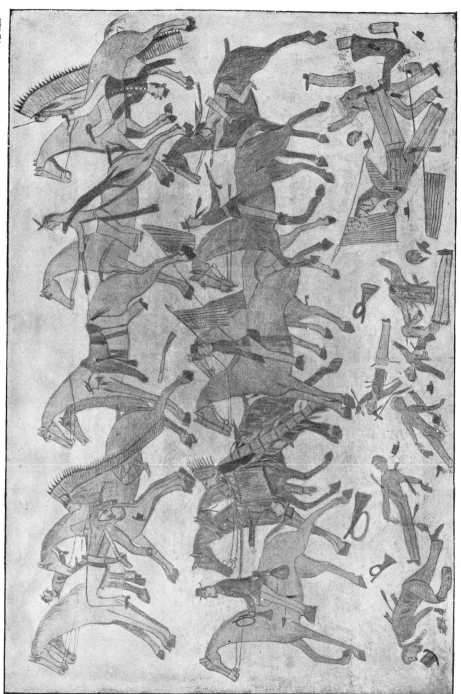

BATTLE OF LITTLE BIGHORN. SIOUX FIGHTING CUSTER'S BATTALION.

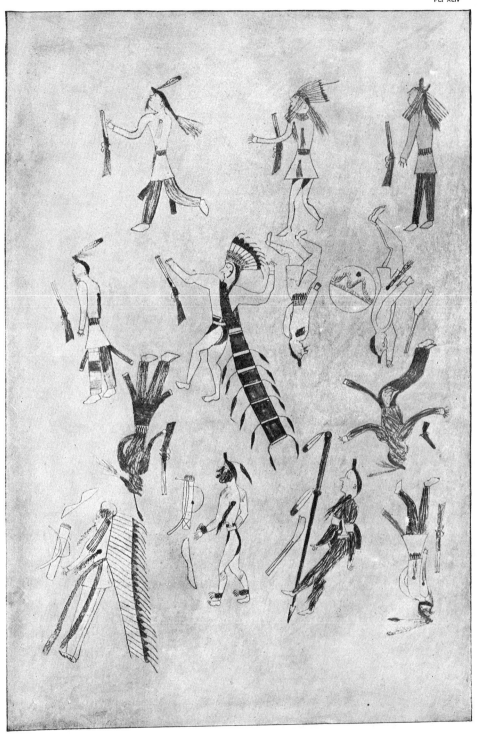

BATTLE OF LITTLE BIGHORN. THE DEAD SIOUX.

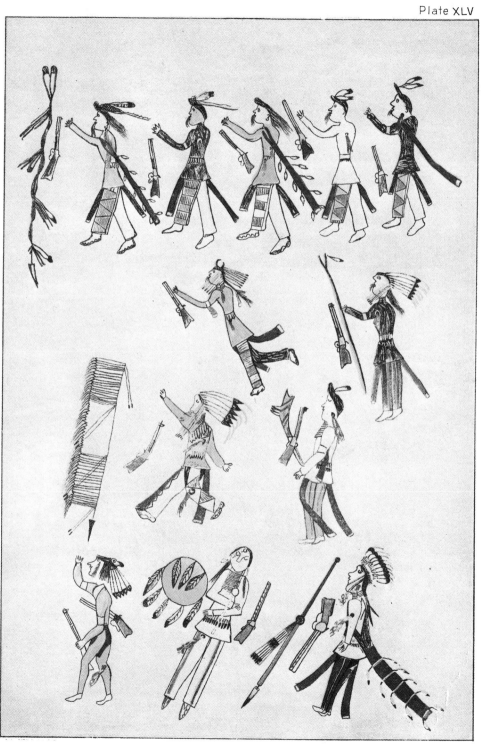

Plate XLV

BATTLE OF LITTLE BIG HORN. The Dead Sioux.

Plate XLVI.

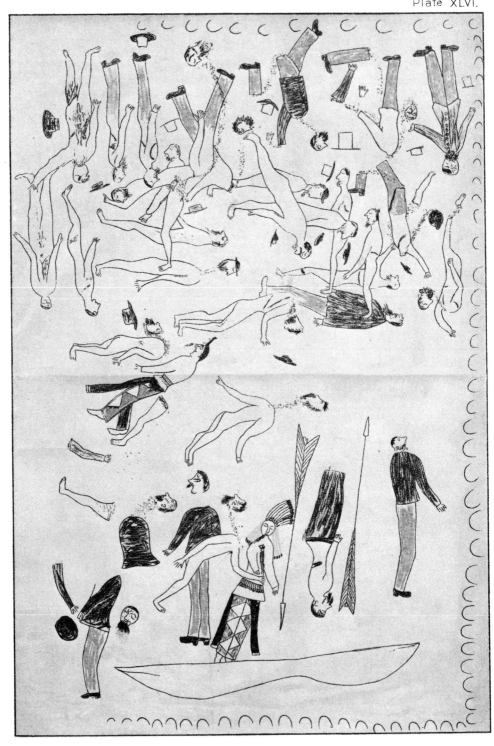

BATTLE OF LITTLE BIG HORN. Custer's Dead Cavalry.

BATTLE OF LITTLE BIGHORN. INDIANS LEAVING BATTLE GROUND.

Plate XLVIII.

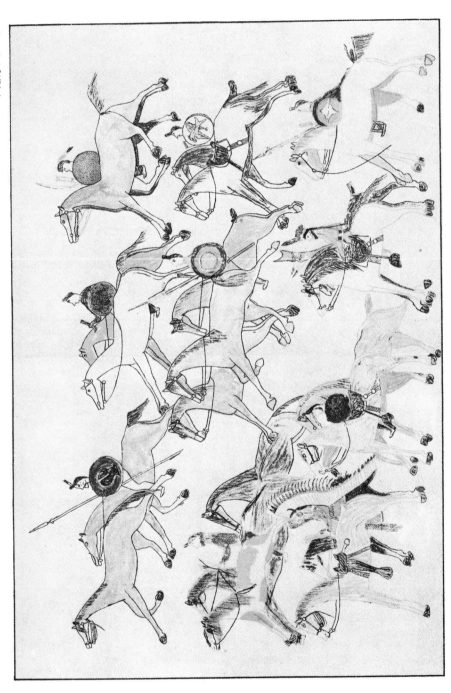

BATTLE OF LITTLE BIG HORN. Indians Leaving Battle Ground.

been told me that he was killed by a Santee Indian, who took his horse. This officer wore a large-brimmed hat and a deerskin coat. This officer saved the lives of many soldiers by turning his horse and covering the retreat. Sioux say this officer was the bravest man they ever fought. I saw two officers looking alike, both having long yellowish hair.

Before the attack the Sioux were camped on the Rosebud river. Sioux moved down a river running into the Little Bighorn river, crossed the Little Bighorn river, and camped on its west bank.

This day [day of attack] a Sioux man started to go to Red Cloud agency, but when he had gone a short distance from camp he saw a cloud of dust rising and turned back and said he thought a herd of buffalo was coming near the village.

The day was hot. In a short time the soldiers charged the camp. [This was Maj. Reno's battalion of the Seventh Cavalry.] The soldiers came on the trail made by the Sioux camp in moving, and crossed the Little Bighorn river above where the Sioux crossed, and attacked the lodges of the Uncpapas, farthest up the river. The women and children ran down the Little Bighorn river a short distance into a ravine. The soldiers set fire to the lodges. All the Sioux now charged the soldiers [Pl. XLII] and drove them in confusion across the Little Bighorn river, which was very rapid, and several soldiers were drowned in it. On a hill the soldiers stopped and the Sioux surrounded them. A Sioux man came and said that a different party of soldiers had all the women and children prisoners. Like a whirlwind the word went around, and the Sioux all heard it and left the soldiers on the hill and went quickly to save the women and children.

From the hill that the soldiers were on to the place where the different soldiers [by this term Red-Horse always means the battalion immediately commanded by General Custer, his mode of distinction being that they were a different body from that first encountered] were seen was level ground with the exception of a creek. Sioux thought the soldiers on the hill [i. e., Reno's battalion] would charge them in rear, but when they did not the Sioux thought the soldiers on the hill were out of cartridges. As soon as we had killed all the different soldiers [Pl. XLIII shows the fighting with Custer's battalion] the Sioux all went back to kill the soldiers on the hill. All the Sioux watched around the hill on which were the soldiers until a Sioux man came and said many walking soldiers were coming near. The coming of the walking soldiers was the saving of the soldiers on the hill. Sioux can not fight the walking soldiers [infantry], being afraid of them, so the Sioux hurriedly left.

The soldiers charged the Sioux camp about noon. The soldiers were divided, one party charging right into the camp. After driving these soldiers across the river, the Sioux charged the different soldiers [i. e., Custer's] below, and drove them in confusion; these soldiers became foolish, many throwing away their guns and raising their hands, saying, "Sioux, pity us; take us prisoners." The Sioux did not take a single soldier prisoner, but killed all of them; none were left alive for even a few minutes. These different soldiers discharged their guns but little. I took a gun and two belts off two dead soldiers; out of one belt two cartridges were gone, out of the other five.

The Sioux took the guns and cartridges off the dead soldiers and went to the hill on which the soldiers were, surrounded and fought them with the guns and cartridges of the dead soldiers. Had the soldiers not divided I think they would have killed many Sioux. The different soldiers [i. e., Custer's battalion] that the Sioux killed made five brave stands. Once the Sioux charged right in the midst of the different soldiers and scattered them all, fighting among the soldiers hand to hand.

One band of soldiers was in rear of the Sioux. When this band of soldiers charged, the Sioux fell back, and the Sioux and the soldiers stood facing each other. Then all the Sioux became brave and charged the soldiers. The Sioux went but a short distance before they separated and surrounded the soldiers. I could see the officers riding in front of the soldiers and hear them shouting. Now the Sioux had many

killed. [Pls. xliv and xlv show the dead Sioux.] The soldiers killed 136 and wounded 160 Sioux. The Sioux killed all these different soldiers in the ravine. [Pl. xlvi shows the dead cavalry of Custer's battalion.]

The soldiers charged the Sioux camp farthest up the river. A short time after the different soldiers charged the village below. While the different soldiers and Sioux were fighting together the Sioux chief said, "Sioux men, go watch the soldiers on the hill and prevent their joining the different soldiers." The Sioux men took the clothing off the dead and dressed themselves in it. Among the soldiers were white men who were not soldiers. The Sioux dressed in the soldiers' and white men's clothing fought the soldiers on the hill.

The banks of the Little Bighorn river were high, and the Sioux killed many of the soldiers while crossing. The soldiers on the hill dug up the ground [i. e., made earthworks], and the soldiers and Sioux fought at long range, sometimes the Sioux charging close up. The fight continued at long range until a Sioux man saw the walking soldiers coming. When the walking soldiers came near the Sioux became afraid and ran away. [Pls. xlvii and xlviii show the Indians leaving the battle ground.]

<center>SECTION 3.</center>

<center>RECORD OF MIGRATION.</center>

Fig. 796 is a pictorial account of the migrations of the Ojibwa, being a reduced copy of a drawing made by Sika'ssigĕ'. The account, especially in its commencement, follows the rule of all ancient history in being mixed with religion and myth. The otter was the messenger of Mi'nabō'zho and led the Âni'shinabē'g, who were the old or original people, the ancestors of the Ojibwa, and also of some other tribes which they knew, from an island, which was the imagined center of the world as bounded by the visible horizon, to the last seats of the tribe before interference by Europeans. The details of the figure were thus explained by the draftsman:

a. The circle signifies the earth's surface, bounded by the horizon, as before described, and the dot in the center is the imagined island or original home of the human race. *b.* A line separating the history of the Midē'wiwin, that is, the strictly religious tradition from that of the actual migration as follows: When the Otter had offered four prayers, which fact is referred to by the spot *c*, he disappeared beneath the surface of the water and went toward the west, in which direction the Âni'shinabég followed him, and located at Ottawa island, *d.* Here they

FIG. 796.—Record of Ojibwa migration.

erected the Midē'wigân and lived for many years. Then the Otter again disappeared beneath the water, and it a short time reappeared at A'wiat'ang (*e*), when the Midē'-wiwin was again erected and the sacred rites conducted in accordance with the teach-

ings of Mi'nabō'zho. Afterwards an interrupted migration was continued, the several resting places being given below in their proper order, and at each of them the rites of the Midē'wiwin were conducted in all their purity. The next place to locate at was Mi'shenama'kinagung—Mackinaw (f); then Ne'mikung (g); Kiwe'winang' (h); Bâ'wating—Sault Ste. Marie (i); Tshiwi'towi' (j); Nega'wadjĕ'ŭ—Sand mountain (k), northern shore of Lake Superior; Mi'nisa'wik [Mi'nisa'bikkăng]—Island of Rocks (l); Kawa'sitshiŭwongk'—Foaming rapids (m); Mush'kisi'wi [Mash'kisi'bi]— Bad river (n); Sha'gawâ'mikongk—"Long sand bar beneath the surface" (o); Wikwe'dânwong'gan—Sandy bay (p); Neâ'shiwikongk'—Cliff point (q); Neta-wa-ya-sink—Little point of sand bar (r); Ân'nibis—Little elm tree (s); Wikup'bin-minsh—Little island basswood (t); Makubin'-minsh—Bear island (u); Shage'skike'-dawan'ga (v); Ne'wigwas'sikongk—The place where bark is peeled (w); Ta'pakwe'-ikak [Sa'apakwe'shkwa'okongk]—The place where lodge-bark is obtained (x); Ne'uwesak'kudĕze'bi [Ne'wisak'udĕsi'bi]—Point dead wood timber river (y); Anibi'kanzi'bĭ [modern name Ashkiba'gisi'bĭ] rendered by different authorities both as Fish Spawn river, and "Green Leaf river" (z).

This locality is described as being at Sandy lake, Minnesota, where the Otter appeared for the last time, and where the Midē'wigân was finally established. The Ojibwa say that they have dispersed in bands from La Pointe, as well as from Sandy lake, over various portions of Minnesota and into Wisconsin, which final separation into distinct bodies has been the chief cause of the gradual changes found to exist in the ceremonies of the Midē'wiwin.

Reference may be made to a highly interesting record of migration in Kingsborough, Codex Boturini, being a facsimile of an original Mexican hieroglyphic painting from the collection of Boturini, in twenty-three plates.

SECTION 4.

RECORD OF NOTABLE EVENTS.

In this group are presented some figures from the Dakota Winter Counts, which record events of tribal or intertribal importance not included under other heads.

Fig 797.—The-people-were-burnt winter. Battiste Good's Winter Count 1762–'63. He explains the origin of the title "Brulé" Dakota as follows:

Some of the Dakotas were living east of their present country, when a prairie fire destroyed their entire village. Many of their children and a man and his wife, who were on foot some distance away from the village, were burned to death. Many of their horses were also burned to death. All the people that could get to a long lake which was near by saved themselves by jumping into it. Many of

FIG.797.—Origin of Brulé Dakota.

these were badly burned about the thighs and legs, and this circumstance gave rise to the name, si-can-gu, translated properly in to English as Burnt Thigh and by the French abbreviated as Brulé, by which latter name they have since been generally known.

FIG. 798.—Kiyuk-
sas.

Fig. 798.—The Oglalas engaged in a drunken brawl, which resulted in a division of the tribe, the Kiyuksas (Cut-Offs) separating from the others. American-Horse's Winter Count, 1841–'42.

FIG. 799.—First
coming of traders.

Fig. 799.—Nine white men came to trade with the Dakotas. American-Horse's Winter Count, 1800–'01.

The hatted head stands for a white man and also indicates that the eight dots over it are for white men. According to this count the first whites came in 1794–'95, and the party now depicted succeeded them and were the first traders.

FIG. 800.—First
coming of traders.

Fig. 800.—The Good-White-Man came. Cloud-Shield's Winter Count, 1800–'01.

He was the first white man to trade and live with that division of the Dakotas of which Cloud-Shield's chart gives the early records.

FIG. 801.—First
coming of traders.

Fig. 801.—A trader brought the Dakotas their first guns. Cloud-Shield's Winter Count, 1801–'02.

FIG. 802.—First
coming of traders.

Fig. 802.—The Dakotas saw wagons for the first time. Red-Lake, a white trader, brought his goods in them. American-Horse's Winter Count, 1830–'31.

The earliest traders came by the river, in boats.

FIG. 803.—Boy scalped.

Fig. 803.—Some Crows came to the Dakota camp and scalped a boy. Cloud-Shield's Winter Count, 1862–'63.

This is represented also in the next figure.

Fig. 804.—The Crows scalped an Oglala boy alive. Ameri-can-Horse's Winter Count, 1862–'63.

This unusually cruel outrage renewed the violence of war-fare between Dakota and Absaroka.

FIG. 804.—Boy scalped alive.

Fig. 805.—All of Standing Bull's horses were killed. Cloud-Shield's Winter Count, 1832–'33.

Hoof-prints, blood-stains, and arrows are shown under the horse. It may be remarked with regard to the name-device for Stand-ing-Bull, that the quadruped can stand on two legs, but cannot run or even walk with that limitation, so that the exhibition of two legs only may properly signify standing, though for convenience the fore legs are de-picted.

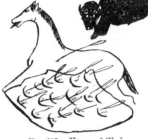

FIG. 805.—Horses killed.

Fig. 806.—They received their first annuities at the mouth of Horse creek. American-Horse's Winter Count, 1851–'52.

A one-point blanket is depicted and denotes dry goods. It is surrounded by a circle of marks which represent the people.

FIG. 806.—Annuities received.

Fig. 807.—Many goods were issued to the Dakotas at Fort Laramie. Cloud-Shield's Winter Count, 1851–'52.

The goods were the first they received from the United States Government. The blanket which is represented stands for the whole issue.

White-Cow-Killer calls it "Large-issue-of-goods-on-the-Platte-river-winter."

This is a more conventionalized form of the preceding figure.

FIG. 807.—Annuities received.

Fig. 808.—The Dakotas received annuities at Raw-Hide Butte. American-Horse's Winter Count, 1856–'57.

The house and the blanket represent the agency and the goods.

FIG. 808.—Annuities received.

Fig. 809.—The Dakotas bought Mexican blankets of John Richard, who bought many wagon-loads of the Mexicans. Cloud-Shield's Winter Count, 1858–'59.

FIG. 809.—Mexican blankets bought.

Fig. 810.—They captured a train of wagons near Tongue river. The men who were with it got away. American-Horse's Winter Count, 1867–'68.

The blanket protruding from the front of the wagon represents the goods found in the wagons.

FIG. 810.—Wagon captured.

Fig. 811.—The Oglalas killed the Indian agent's (Seville's) clerk inside the stockade of the Red Cloud agency at Fort Robinson, Nebraska. American-Horse's Winter Count, 1873–'74.

FIG. 811.–Clerk killed.

Fig. 812.—The Oglalas at the Red Cloud agency, near Fort Robinson, Nebraska, cut to pieces the flagstaff which had been cut and hauled by order of their agent, but which they would not allow him to erect, as they did not wish to have a flag flying over their agency. American-Horse's Winter Count, 1874–'75.

This was in 1874. The flag which the agent intended to hoist was lately at the Pine ridge agency, Dakota.

FIG. 812.—Flag staff cut down.

Fig. 813.—Horses taken by United States government. The-Flame's Winter Count, 1876–'77.

This figure refers to the action of the military authorities of the United States toward the Indian tribes which had been connected with or suspected of favoring the outbreak which resulted in the defeat of the force under Gen. Custer. A body of troops swept the reservations on the Missouri river and took away all the ponies of the tribes, thereby depriving them of their means

FIG. 813.—Horses taken.

of transportation for hostile purposes. The hatted man with a star above his head is the brigadier-general in command of the United States forces. The hoof prints without marks of horseshoes indicate the Indian ponies as usual. The black blurs among them probably refer to the considerable number of the ponies that fell and died before they reached Bismark and other points of sale to which they were driven. It was promised that the amount realized from the sale of the drove should be returned to the owners, but the latter received little.

CHAPTER XVII.

BIOGRAPHY.

Pictographs under this head may be grouped as: 1st. Continuous record of events in life. 2d. Particular exploits or events. Pictographs of both of these descriptions are very common. An excellent collection is published in the George Catlin Indian Gallery in the U. S. National Museum, with memoir and statistics by Thomas Donaldson, a part of the Smithsonian Report for 1885, Pls. 100 to 110.

SECTION 1.

CONTINUOUS RECORD OF EVENTS IN LIFE.

An authentic and distinct example of a continuous record is the following "autobiography," which was prepared at Grand River, Dakota, in 1873, in a series of eleven drawings, by Running-Antelope, chief of the Uncpapa Dakotas. Seven of these, regarded as of most interest,

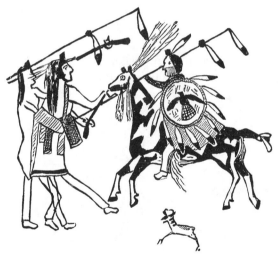

Fig. 814.—Killed two Arikara.

are now presented. The sketches were painted in water colors and were made for Dr. W. J. Hoffman, to whom the following interpretations were given by the artist.

The record comprises the most important events in the life of Running-Antelope as a warrior. Although frequently more than one person is represented as slain, it is not to be inferred that all included in the same figure were killed at one time unless it is so specified, but that thus they were severally the victims of one expedition, of which the warrior was a member or leader. The bird (*Falco cooperi?*) upon the

shield always borne by him, refers to the clan or band totem, while the antelope always drawn beneath the horses, in the act of running, identifies his personal name.

Fig. 814.—Killed two Arikara Indians in one day. The lance held in the hand, thrusting at the foremost of the enemy, signifies that Running-

FIG. 815.—Shot and scalped an Arikara.

Antelope killed him with that weapon; the left-hand figure was shot, as is shown by the discharging gun, and afterwards struck with the lance. This occurred in 1853.

Fig. 815.—Shot and scalped an Arikara Indian in 1853. It appears that the Arikara attempted to inform Running-Antelope of his being

FIG. 816.—Killed ten men and three women.

unarmed, as the right hand is thrown outward with distended fingers, in imitation of making the gesture for *negation, having nothing.*

Fig. 816.—Killed ten men and three squaws in 1856. The grouping of persons strongly resembles the ancient Egyptian method of drawing.

Fig. 817.—Killed two Arikara chiefs in 1856. Their rank is shown by the appendages to the sleeve and coat, which are made of white weasel skins. The arrow in the left thigh of the victor shows that he was

FIG. 817.—Killed two chiefs.

wounded. The scars remained distinct upon the thigh of Running-Antelope, showing that the arrow had passed through it.

Fig. 818.—Killed one Arikara in 1857. Striking the enemy with a bow is considered the greatest insult that can be offered. See for a

FIG. 818.—Killed one Arikara.

similar concept among the eastern Algonquians (Leland, *b*). The act entitles the warrior to count one *coup* when relating his exploits in the council chamber.

Fig. 819.—Killed two Arikara hunters in 1859. Both were shot, as is indicated by the figure of a gun in contact with each Indian. The cluster of lines drawn across the body of each victim represents the

FIG. 819.—Killed two Arikara hunters.

discharge of the gun, and shows where the ball took effect. The upper one of the two figures was in the act of shooting an arrow when he was killed.

FIG. 820.—Killed five Arikara.

Fig. 820.—Killed five Arikara in one day in 1863. The dotted line indicates the trail which Running-Antelope followed, and when the Indians discovered that they were pursued, they took shelter in an iso-

lated copse of shrubbery, where they were killed at leisure. The five guns within the inclosure represent the five persons armed.

The Arikara are nearly always delineated in these pictures wearing the topknot of hair, a fashion specially prevalent among the Absaroka, though as the latter were the most inveterate enemies of the Sioux, and as the word Palláni for Arikara is applied to all enemies, the Crow custom may have been depicted as a generic mark.

Wiener (e) gives the following account of the tablet found at Mansiche, reproduced as Fig. 821, one-fifth actual size:

It gives all the descriptive elements of the life of the deceased; in fact his biography. He was a chieftain of royal blood (vide the red planache with five double plumes). He commanded an entire tribe. He had a military command (v. the mace which he holds in his right hand). He had taken part in three battles (v. the three arms which three times proved his strength). He was a judge in his district (v. the sign of the speaking-trumpet in the center). He had under him four judges (v. the four signs of the speaking-trumpet in the corners). He had during his administration irrigated the country (v. the designs which surround the painting); and he had constructed great buildings (v. the checkers surrounding the meanders). He had busied himself besides all that in the raising of cattle (v. the indications of llamas). He had lived 42 years (v. the blocks, which indicate years, just as the rings indicate the age

FIG. 821.—Peruvian biography.

of trees). He had had five children, three sons and two daughters (indicated by the little drops of sperm). Such is the life of this person, written by ideography on a tablet, which at first would be taken as a fantasy of an infant painter.

SECTION 2.

PARTICULAR EXPLOITS OR EVENTS.

In the Doc. Hist. N. Y. (b) is an illustration, presented here as Fig. 822, of an Iroquois "returning from hunting, who has slept two nights

FIG. 822.—Hunting record. Iroquois.

on the hunting ground and killed three does; for when they are bucks they add their antlers."

From the same volume, page 9, the following extract is made, describing Fig. 823:

b. This is the way they mark when they have been to war, and when there is a bar extending from one mark to the other it signifies that, after having been in battle, he did not come back to his village, and that he returned with other parties whom he met or formed.

c. This arrow, which is broken, denotes that they were wounded in this expedition.

d. Thus they denote that the belts which they gave to raise a war party and to avenge the death of some one, belonging to them or to some of the same tribe.

e. He has gone back to fight without having entered his village.

f. A man whom he killed on the field of battle, who had a bow and arrow.

g. These are two men, whom he took prisoners, one of whom had a hatchet and the other a gun in his hand.

gg. This is a woman who is designated only by a species of waistcloth.

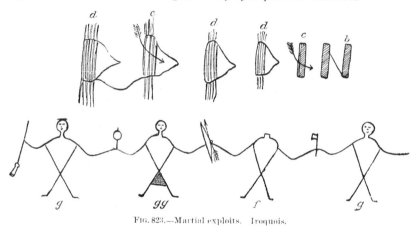

FIG. 823.—Martial exploits. Iroquois.

Fig. 824 is taken from the Winter Count of Battiste Good for the year 1853–'54.

He calls the year Cross-Bear-died-on-the-hunt winter.

The character on the extreme left hand is a "travail," and means

FIG. 824.—Cross-Bear's death.

they moved; the buffalo, to hunt buffalo; the bear with mouth open and paw advanced, cross-bear. The involute character frequently repeated in Battiste's record signifies pain in the stomach and intestines, resulting in death. In this group of characters there is not only the brief story, an obituary notice, but an ideographic mark for a particular kind of death, a noticeable name-totem, and a presentation of the Siouan mode of transportation.

The word "travail" may require explanation. It refers to the peculiar sledge which is used by many tribes of Indians for the purpose of transportation. It is used on the surface of the ground when not covered with snow even more than when snow prevails. In print the word is more generally found in the plural, where it is spelled "tra-

vaux" and sometimes "travois." The etymology of this word has been
the subject of much discussion. It is probably one of the words which
descended in corrupted form from the language of the Canadian voy-
ageurs, and was originally the French word "traineau," with its mean-
ing of sledge. The corrupt form "travail" was retained by English
speakers from its connection with the sound of the word "travel."

Fig. 825 is taken from a roll of birch bark, known to be more than sev-
enty years old, obtained in 1882 from the Ojibwa Indians at Red Lake,
Minnesota. The interpretation was given by an Indian from that
reservation, although he did not know the author nor the history of
the record. With one exception, all of the characters were understood
and interpreted to Dr. Hoffman, in 1883, by Ottawa Indians at Harbor
Springs, Michigan.

FIG. 825.—A dangerous trading trip.

a represents the Indian who visited a country supposed to have been
near one of the great lakes. He has a scalp in his hand which he ob-
tained from the head of an enemy, after having killed him. The line
from the head to the small circle denotes the name of the person, and
the line from the mouth to the same circle signifies (in the Dakota
method), "That is it," having reference to proper names.

b, the enemy killed. He was a man who held a position of some con-
sequence in his tribe, as is indicated by the horns, marks used by the
Ojibwas among themselves for shaman, wabeno, etc. It has been sug-
gested that the object held in the hand of this figure is a rattle, though
the Indians, to whom the record was submitted for examination, are in
doubt, the character being indistinct.

c, three disks connected by short lines signify, in the present instance,

three nights, i. e., three black suns. Three days from home was the distance the Indian *a* traveled to reach the country for which he started.

d represents a shell, and denotes the primary object of the journey. Shells were needed for making ornaments and to trade, and traffic between members of the different and even distant tribes was common, although attended with danger.

e, two parallel lines are here inserted to mark the end of the present record and the beginning of another.

The following narrative of personal exploit was given to Dr. W. J. Hoffman by "Pete," a Shoshoni chief, during a visit of the latter to Washington, in 1880. The sketch, Fig. 826, was drawn by the narrator, who also gave the following explanation of the characters:

FIG. 826.—Shoshoni raid for horses.

a, Pete, a Shoshoni chief; *b*, a Nez Percés Indian, one of the party from whom the horses were stampeded, and who wounded Pete in the side with an arrow; *c*, hoof-marks, showing course of stampede; *d*, lance, which was captured from the Nez Percés; *e, e, e*, saddles captured; *f*, bridle captured; *g*, lariat captured; *h*, saddle-blanket captured; *i*, body-blanket captured; *j*, pair of leggings captured; *k*, three single legs of leggings captured.

The figures in the following group represent some of the particular exploits and events in life which have been considered by the recorders of the Winter Counts of the Dakotas to be specially worthy of note:

FIG. 827.—Life risked for water.

Fig. 827.—While surrounded by the enemy (Mandans) a Blackfeet Dakota indian goes at the risk of his life for water for the party. The-Flame's Winter Count, 1795–'96. The interpreter stated that this was near the present Cheyenne agency, Dakota. In the original character there is a bloody wound at the shoulder.

showing that the heroic indian was wounded. He is shown bearing a water vessel.

Fig. 828.—Runs-by-the-Enemy. Red-Cloud's

Census. This figure suggests a feat of special courage and fleetness in making a circuit of a hostile force.

Fig. 829.—Runs-Around. Red-Cloud's Census. This figure seems to indicate a warrior surrounded and

FIG. 828.—Runs by the enemy. shot at by a number of enemies, who yet escapes by his swiftness.

FIG. 829.—Runs around.

Fig. 830. — Goes-through-the-Camp. Red-

Cloud's Census. This figure notes the successful passage of a spy through the enemy's camp.

Fig. 831. — Cut-Through.

FIG. 830.—Goes through the camp. Red-Cloud's Census. Here a

FIG. 831.—Cut through.

footman cuts his way through a line of hostile horsemen.

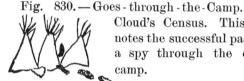

Fig. 832.—Paints-His-Face-Red, a Dakota, was killed in his tipi by the Pawnees. Cloud-Shield's Winter Count, 1837–'38. The right to paint the face red was sometimes gained by providing the ceremonial requirements for a commemoration of the dead, which were very expensive. There are two facts depicted by the figure. The man

FIG. 832.—Killed in tipi. and his tipi are surrounded by a ring of enemies,

who are shooting him, and, touched by the upper part of the ring, is the bottom of another and more minute tipi, marked with the sign of a fatal shot.

Fig. 833.—Paints-His-Cheeks-Red and his fam-

ily, who were camping by themselves, were killed by Pawnees. American-Horse's Winter Count, 1837–'38. This character tells the same story as the one preceding, but is more conventional.

FIG. 833.—Killed in tipi. Fig. 834.—Spotted-Horse carried the pipe around and took

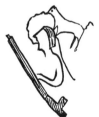

FIG. 834.—Took the warpath.

the warpath against the Pawnees to avenge the death of his uncle, Paints-His-Cheeks-Red. American-Horse's Winter Count, 1838–'39. This figure is the sequel to those immediately preceding.

Fig. 835.—White-Bull and many others were killed in a fight with the Shoshoni. Cloud-Shield's Winter Count, 1845–'46.

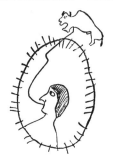

This warrior seems to have lost more than the normal quantity of scalp.

Fig. 836.—Brave - Bear was killed in a quarrel over a calf. Cloud-Shield's Winter Count, 1854–'55. He was killed by ene-mies; hence his scalp is gone.

Fig. 837.—The - Brave - Man was killed in a great fight. Cloud-Shield's Winter Count, 1817–'18. The fight is shown by the arrows flying to and from him. He is also scalped.

FIG. 835.—White-Bull killed.

FIG. 836.—Brave-Bear killed.

Fig. 838.—A soldier ran a bayonet into Crazy-Horse and killed him. American-Horse's Winter Count, 1877–'78. This was done in the guard house at Fort Robinson, Nebraska, September 5, 1877. The horse in this instance does not dis-tinctly exhibit the wavy lines shown in several other repre-sentations of the chief which appear among the illustrations of this paper. This omission is doubtless due to careless-ness of the Indian artist.

FIG. 837.—Brave-Man killed.

FIG. 838.—Crazy-Horse killed.

Fig. 839.—Striped-Face stabbed and killed his daughter's husband for whip-ping his wife. American-Horse's Winter Count, 1829–'30.

Fig. 840. — Spotted - F a c e stabs his daughter's husband for whipping his wife. Cloud-Shield's Winter Count, 1829–'30. This is another form of the preceding figure.

FIG. 839.—Killed for whip-ping wife.

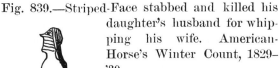

FIG. 840.—Killed for whip-ping wife.

Fig. 841.—Kaglala-kutepi, Shot-Close. The Oglala Roster. This may refer to an incident in the warrior's life in which he had a narrow escape, or may, on the other hand, refer to his stealing upon and shooting from near by at an enemy. The design, as often occurs, allows of dou-ble interpretation. The close shooting is not accurate markmanship, but with proximity as suggested by the arrow touching the head while still near the bow. This figure may receive some interpretation from the one following.

Fig. 842.—The-Swan's Winter Count, 1835–'36. A Minneconjou chief named Lame-Deer shot an Assiniboin three times with the same arrow. He kept so close to his enemy that he never let the arrow slip away from the bow but pulled it out and shot it in again.

FIG. 842.

Fig. 843 consists of two stories pictured by Lean-Wolf, a Hidatsa chief, showing the attack made by Sioux Indians in search of horses and the result of the raid. In the upper figure, at the left end, is shown the Sioux camp from which the trail of the horse thieves extends to near the camp of the Hidatsa, at Fort Berthold, North Dakota. This

FIG. 841.

FIG. 843.—Lean-Wolf's exploits.

village is indicated by the circular dirt lodges within a square inclosure. The Sioux captured some Indian horses and rode away, as indicated by the prints of horse hoofs. A series of short lines from the

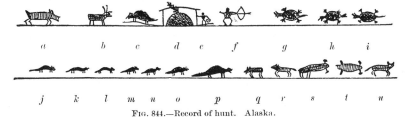

a　　　　b　　c　　　d　　e　　　f　　　　g　　　　h　　　　i

j　　k　　l　　m　　n　　o　　　p　　　q　　r　　s　　t　　　u

FIG. 844.—Record of hunt. Alaska.

Hidatsa village indicates that Lean-Wolf and his companions followed on foot, subsequently overtaking the Sioux, killing one and taking his

scalp. The scalp is shown above the figure of the human head, while the weapon with which he struck the Sioux is also shown. This is the war club. The lower division of the figure is similar to the upper. In the pursuit of the Sioux, who had come to Fort Berthold on another occasion to steal horses, Lean-Wolf assisted in capturing and killing three of the marauders. In the left-hand group of the three human heads he is shown to have killed an enemy; in the second he was the third to strike a Sioux after he was shot, but took his scalp, and in the third, or right hand, he was the fourth to strike the fallen enemy.

A record on ivory shown as Fig. 844 was obtained by Dr. Hoffman in San Francisco, California, in 1882, and was interpreted to him by an Alaskan native. The story represents the success of a hunt; the animals desired are shown, as well as those which were secured.

The following is the explanation of the characters:

a, b, deer; *c,* porcupine; *d,* winter, or permanent, habitation. The cross-piece resting upon two vertical poles constitutes the rack, used for drying fish; *e,* one of the natives occupying the same lodge with the recorder; *f,* the hunter whose exploits are narrated; *g, h, i,* beavers; *j, k, l, m, n,* martens; *o,* a weasel, according to the interpretation, although there are no specific characters to identify it as different from the preceding; *p,* land otter; *q,* a bear; *r,* a fox; *s,* a walrus; *t,* a seal; *u,* a wolf.

By comparing the illustration with the text it will be observed that all the animals secured are turned toward the house of the speaker, while the heads of those animals desired, but not obtained, are turned away from it.

The following is the text in the Kiatexamut dialect of the Innuit language as dictated by the Alaskan, with his own literal translation into English:

Huí-nu-ná-ga huí-pu-qtú-a pi-cú-qu-lú-a mus'-qu-lí-qnut. Pa-mú-qtu-līt'
I, (from) my place. I went hunting (for) skins. martens
(settlement.) (animals)

ta-qí-měn, a-mí-da-duk' a-xla-luk', á-qui-á-muk pi-qú-a a-xla-luk'; ku-qú-
five, weasel one, land otter caught one;

lu-hú-nu-mŭk' a-xla-luk', tun'-du-muk tú-gu-qlí-u-gú me-lú-ga-nuk',
wolf one, deer (I) killed two,

pé-luk pi-naí-u-ṅuk, nú-nuk pit'-qu-ní, ma-klak-muk' pit'-qu-ní, a-cí-a-
beaver three, porcupine (I) caught none, seal (I) caught none,

na-muk pit'-qu-ni, ua-qí-la-muk pit'-qu-ní, ta-gú-xa-muk pit'-qu-ní.
walrus (I) caught none, fox (I) caught none, bear (I) caught none.

CHAPTER XVIII.

IDEOGRAPHY.

The imagination is stimulated and developed by the sense of sight more than by any other sense, perhaps more than by all of the other senses combined. The American Indians, and probably all savages, are remarkable for acute and critical vision, and also for their retentive memory of what they have once seen. When significance is once attached to an object seen, it will always be recalled, though often with false deductions. Therefore, like deaf-mutes, who depend mainly on sight, the American Indians have developed great facility in communicating by signs, and also in expressing their ideas in pictures which are ideographic though seldom artistic. This tendency has likewise affected their spoken languages. Their terms express with wonderful particularity the characters and relations of visible objects, and their speeches, which are in a high degree metaphoric, become so by the figurative presentation in words of such objects accompanied generally by imitative signs for them, and often by their bodily exhibition.

The statement once made that the aboriginal languages of North America are not capable of expressing abstract ideas is incorrect, but the tendency to use tangible and visible forms for such ideas is apparent. This practice was most marked in reference to religious subjects, which were often presented under the veil of symbols, as has been the common expedient of most peoples who have emerged from the very lowest known stages of human culture, but have not attained the highest.

Many instances appear in this work in which pictures expressive of an idea present more than mere portraitures of objects, which latter method has been styled imitative or iconographic writing.

It is, however, impossible to classify with scientific precision the pictured ideograms collected, for the reason that many of them occupy intermediate points in any scheme that would be succinct enough to be practically useful. In the arrangement of the present chapter the division is made into: 1st. Abstract ideas expressed pictorially. 2d. Signs, symbols, and emblems. 3d. Significance of colors. 4th. Gesture and posture signs depicted. When any of the graphic representations of ideas have become successful, i. e., commonly adopted, it soon becomes

more or less conventionalized. Chapter XIX is devoted specially to that branch of the general subject.

<center>SECTION 1.</center>

<center>ABSTRACT IDEAS EXPRESSED PICTORIALLY.</center>

The first stage of picture-writing, as considered in the present chapter, was the representation of a material object in such style or connection as determined it not to be a mere portraiture of that object, but figurative of some other object or person. This stage is abundantly exhibited among the American Indians. Indeed, their personal and tribal names thus objectively represented constitute the largest part of their picture-writing so far thoroughly understood.

The second step was when a special quality or characteristic of an object, generally an animal, became employed to express a general quality, i. e., an abstract idea. It can be readily seen how, among the Egyptians, a hawk with bright eye and lofty flight might be selected to express divinity and royalty, and that the crocodile should denote darkness, while a slightly further advance in metaphors made the ostrich feather, from the equality of its filaments, typical of truth. All peoples whose rulers used special objective designations of their rank, made those objects the signs for power, whether they were crowns or umbrellas, eagle feathers, or colored buttons. A horse meant swiftness, a serpent life—or immortality when drawn as a circle—a dog was watchfulness, and a rabbit was fecundity. It is evident from examples given in the present paper that the American tribes at the time of the Columbian discovery had entered upon this second step of picture-writing, though with marked inequality between tribes and regions in advance therein. None of them appear to have reached such proficiency in the expression of connected ideas by picture, as is shown in the sign-language existing among some of them, which may be accounted for by its more frequent use required by the constant meeting of many persons speaking different languages. There is no more necessary connection between abstract ideas and sounds, the mere signs of thought that strike the ear, than there is between the same ideas and signs addressed only to the eye. The success and scope of either mode of expression depends mainly upon the amount of its exercise, in which oral language undoubtedly has surpassed both sign-language and picture-writing.

The examples now following in this chapter are by no means all the graphic representations of abstract ideas collected. Indeed many others are contained in the work under other headings, but the following are selected for grouping here with an attempt at order. In the popular definition, or want of definition, some of them would be classed as symbols.

AFTER.

Fig. 845.—Charge after; Red-Cloud's Census.

Here is suggested the order in a charge upon an enemy, apparently a Crow. The concept is not the general charge of a number of warriors upon the Crows, but the succession between themselves of the men who made that charge. The person whose name is represented probably followed in but did not lead some celebrated charge.

Fig. 846.—John Richard shot and killed an Oglala named Yellow-Bear, and the Oglalas killed Richard before he could get out of the lodge; American-Horse's Winter Count, 1871–'72. This occurred in the spring of 1872. As the white man was killed after the Indian, he is placed behind him in the figure. The bear's head is shown.

FIG. 845.—
Charge after.

FIG. 846.—
Killed after.

AGE—OLD AND YOUNG.

OLD.

FIG. 847.—Old-Horse.

Fig. 847.—Old-Horse; Red-Cloud's Census. Here the old age is shown by the wrinkles and projecting lips.

Fig. 848.—Old-Mexican; Red-Cloud's Census. The man in European dress is bent and supported by a staff, thus depicting the gesture-sign mentioned in connection with Fig. 994. The Dakota had probably received his name from killing an aged Mexican.

FIG. 848.—Old-Mexican.

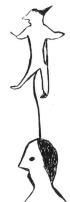

FIG. 849.—Young-
Rabbit.

FIG. 850.—Bad-Boy.

FIG. 851.—Bad-Horn.

YOUNG.

Fig. 849.—Young-Rabbit, a Crow, was killed in battle by Red-Cloud. Cloud-Shield's Winter Count, 1861–'62. Here the youth of the Rabbit is expressed by diminutive size and short legs.

Fig. 850.—Bad-Boy. Red-Cloud's Census. The boyhood is expressed by the short hair and short scalp lock.

BAD.

Fig. 851.—Bad-Horn. Red-Cloud's Census. The bad quality of the horn is expressed by its decayed and broken condition and its distorted curve.

Fig. 852.—Bad-Face, a Dakota, was shot in the face. Cloud-Shield's Winter Count, 1794–'95. The bad face may have been broken out with blotches of disease before the shot, or the scars may have been the result of the shot, which gave occasion for a new name, as is common. The idea of "bad" is often expressed by an abnormality,

FIG. 852.—Bad-Face. especially one which disfigures.

Fig. 853, taken from Copway (d), represents "bad." The concept appears to be the preponderance of "below" to "above."

BEFORE.

FIG. 853.—Bad. Ojibwa.

Fig. 854.—Got there first. Red-Cloud's Census. The figure portrays a successful escape of an unmounted

FIG. 854.—Got there first.

Indian from a chase by enemies on horseback. The chased man gets home to his tipi before being overtaken by his pursuers, whose horses' tracks are shown.

BIG.

Fig. 855.—Big-Turnip. Red-Cloud's Census. The plant is also known as the navet de prairie. The large size of the specimen, as compared with the human head, is apparent.

Fig. 856.—A Minneconjou Dakota, named Big-Crow, was killed by the Crow Indians. Swan's Winter Count, 1859–'60. He had received his name from killing a Crow Indian of unusual size. The bird is portrayed much larger than similar objects in the Winter Count, from which it is taken.

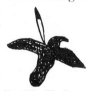

Fig. 857.—Grasp. Red-Cloud's Census. Here the indication of size and strength of the hand is suggested by one

FIG. 855.—Big-Turnip.

FIG. 856.—Big-Crow.

hand growing out from another, a species of duplication. To have drawn two distinct hands would only have been normal and not suggestive of unusual power of grip.

FIG. 857.—Grasp.

FIG. 858.-Big-Hand.

FIG. 859.—Big-Thunder.

Fig. 858.—Big-Hand. From Red-Cloud's Census. Here the fingers are widely separated and displayed.

Fig. 859.—Big-Thunder. From Red Cloud's Census. Here the size or power is suggested by implication. The double or two-voiced thunder is big thunder.

Fig. 860.—Big-Voice. From Red-Cloud's Census. In this figure there are still more voices than in the preceding.

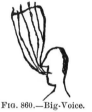

FIG. 860.—Big-Voice.

CENTER.

Fig. 861.—Upi-Yaslate. Center-Feather. The Oglala Roster. This is the indication of a particular feather, i. e., the middle tail feather of a bird, probably of an eagle, the tail feathers of which bird are represented in many pictographs in this paper. There was some reason for the selection of the center feather for the name, and to indicate the center three feathers were depicted with a line touching the middle one.

FIG. 861.—Center-Feather.

FIG. 862.—Deaf-Woman.

DEAF.

Fig. 862.—Wi-nugin-kpa, Deaf-Woman. The Oglala Roster. The ears are covered by a line, i. e., are closed, and the ear most in view is connected with the crown of the head, to show that the name is expressed.

DIRECTION.

This title has been selected as being the most comprehensive one for the five following figures. The first shows a moccasin with a serpentine track, at the farthest end of which is an angular design, indicating leadership as well as the direction taken. This suggests the leader of a war party conducting his band over an uncertain trail. The second is explanatory of the first. That the chief goes in front is indicated in a manner the reverse of that which would appear in the designs common in our military text-books. He is supposed to be in the opening in the angle of the advance and not at its apex. The third figure show a steadfast leadership in the determined straight direction of attack against the enemy. This is still more ideographically represented by the single strong straight line showing that he "Don't turn" in the fourth figure of this group.

FIG. 864.—Goes-in-Front.

FIG. 863.–Direction.

Fig. 863.—Warrior. Red - Cloud's Census. The name does not give any idea of the design.

Fig. 864.—Goes - in - Front. Red-Cloud's Census.

Fig. 865. — Don't - turn. Red-Cloud's Census. This means that the warrior don't—that is, won't—turn from his direct course.

Fig. 866. — Don't - turn. Red Cloud's Census. This figure is a variant of the last, and a body of mounted men following the leader, all on horseback as shown by the lunules.

FIG. 865.—Don't-turn.

FIG. 866.—Don't-turn.

Fig. 867.—Tunweya-gli, Returning - Scout. The Oglala Roster. The returning is ingeniously represented by the line curving backward and returning to the point of starting. The two balls above the head are simply two fixed points, which establish the course of the line.

DISEASE.

Fig. 868.—Many had the whooping cough. American-Horse's Winter Count, 1813–'14. The cough is represented by the lines issuing from the man's mouth, but the characteristics of the disease are better expressed in the three charts of the Lone-Dog system, Figs. 196, 197, and 198.

FIG. 867.—Returning Scout.

FIG. 868.—Whooping cough.

Fig. 869.—All the Dakotas had measles, very fatal. Swan's Winter

FIG. 870.—Measles or smallpox.

FIG. 869.—Measles.

Count, 1818–'19. Battiste Good says: "Smallpox-used-them-up-again winter." They, i. e., the Dakotas, at this time lived on the Little White river, about 20 miles above the Rosebud agency. The character in Battiste Good's chart is presented here in Fig. 870 as a variant.

Fig. 871.—Dakota war party ate a buffalo and all died. Swan's Winter Count, 1826–'27. Battiste Good

FIG. 871.—Ate buffalo and died.

calls the same year, "Ate-a-whistle-and-died winter," Fig. 872, and explains that six Dakotas on the warpath had nearly perished with hunger, when they found and ate

FIG. 872.—Died of "whistle."

the rotting carcass of an old buffalo, on which the wolves had been feeding. They were seized soon after with pains in the stomach, their bellies swelled, and gas poured from the mouth and the anus, and they "died of a whistle," or from eating a whistle. The sound of gas escaping from the mouth is illustrated in the figure. The character on the abdomen and on its right may be considered to be the ideograph for pain in that part of the body.

Fig. 873.—Many people died of smallpox. Cloud-Shield's Winter Count, 1782–'83. The charts all record two successive winters of

FIG. 873.—Smallpox.

smallpox, but American-Horse makes the first year of the epidemic one year later than that of Battiste Good, and Cloud-Shield makes it two years later.

FIG. 874.—Smallpox.

Fig. 874.—Many died of smallpox. American-Horse's Winter Count, 1780–'81. Here the smallpox marks are on the face and neck of a Dakota, as indicated by the arrangement of the hair.

Kingsborough (e) explains Fig. 875 by these words in the text: "In the year of Seven Rabbits, or in 1538, many of the people died of the smallpox." This may be compared with the two preceding figures.

Fig. 876.—Many died of the cramps. American-Horse's Winter Count, 1849–'50. The cramps were those of Asiatic cholera, which was epidemic in the United States at that time, and was carried to the plains by the California and Oregon emigrants. The position of the man is very suggestive of cholera.

FIG. 875.—Smallpox. Mexican.

Fig. 877.—Many women died in childbirth. Cloud-Shield's Winter Count, 1798–'99.

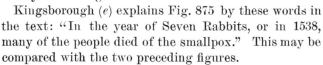
FIG. 876.—Died of cramps.

Fig. 878.—Many women died in childbirth. American-Horse's Winter Count, 1792–'93.

Fig. 879, from Copway (*e*), represents sickness. It evidently refers to the loss of flesh consequent thereon. The sick man is a European.

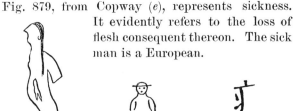

FIG. 877.—Died in childbirth.

FIG. 878.—Died in childbirth.

FIG. 879.—Sickness. Objiwa.

FIG. 880.—Sickness. Chinese.

Edkins (*a*) gives Fig. 880 as "sickness," and calls it a picture of a sick man leaning against a support. All words connected with diseases are arranged under this head.

FAST.

The following figures clearly indicate rapidity of motion:

FIG. 881.—Fast-Horse.

FIG. 882.—Fast-Elk.

Fig. 881.—Fast-Horse. Red-Cloud's Census.
Fig. 882.—Fast-Elk. Red-Cloud's Census.

FEAR.

The following ideograms for the concept of fear show respectively an elk, a bear, and a bull surrounded by a circle of hunters. It would seem that the latter were supposed to be afraid to attack the animals when at bay in hand-to-hand fight, but stood off in a circle until they had killed the enraged beast, or at least wounded it sufficiently to allow of approach without danger.

Fig. 883.—Afraid-of-Elk. Red-Cloud's Census.
Fig. 884.—Afraid-of-Bull. Red-Cloud's Census.

FIG. 883.—Afraid-of-Elk. FIG. 884.—Afraid-of-Bull. FIG. 885.—Afraid-of-Bear.

Fig. 885.—Afraid-of-Bear. Red-Cloud's Census.

Fig. 886.—Matokinajin, The-Bear-Stops. The Oglala Roster. The bear is surrounded by a circle of hunters, so is forced to stop. This figure is in no essential respect different from the one preceding, yet the name is suggestive of the converse of the fact expressed. In this case the bear is forced to stop, and doubtless fear is exhibited by that animal and not his hunters. Each of the ideas is appropriately expressed, the point of consideration being changed.

Fig. 887 is taken from Copway, loc. cit. It probably represents "fear," the concept being the imagined sinking or depression of the

FIG. 887.

FIG. 886.—The-Bear-stops.

heart and vital organs, as is correspondingly expressed in several languages.

FRESHET.

This small group shows the Dakotan modes of portraying the freshets of the rivers on the banks of which they lived, which were often disastrous. Each of the three figures pictures differently the same event.

Fig. 888.—"Many-Yanktonais-drowned winter." The river bottom on a bend of the Missouri river, where they were encamped, was suddenly submerged, when the ice broke and many women and children were drowned. Battiste Good's Winter Count 1825–'26.

FIG. 888.—River freshet.

Fig. 889.—Many of the Dakotas were drowned in a flood caused by a rise in the Missouri river, in a bend of which they were encamped. Cloud-Shield's Winter Count, 1825–'26. The curved line is the bend in the river; the waved line is the water, above which the tops of the tipis are shown.

FIG. 889.—River freshet.

Fig. 890.—Some of the Dakotas were living on the bottom lands of the Missouri river, below the Whetstone, when the river, which was filled with broken ice, rose and flooded their village. Many were drowned or else killed by the floating ice. Many of those that escaped climbed on cakes of ice or into trees. American-Horse's Winter Count, 1825–'26.

FIG. 890.—River freshet.

GOOD.

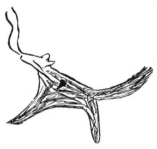

Fig. 891.—Good-Weasel. Red-Cloud's Census. The character is represented with two waving lines passing upward from the the mouth in imitation of the gesture sign, good talk, as made by passing two extended and separated fingers (or all fingers separated) upward and forward from the mouth. This gesture is made when referring either to a shaman or to a Christian clergyman. It is connected with the idea of "mystic" frequently mentioned in this work.

FIG. 891.—Good weasel.

HIGH.

Various modes of delineating this idea are represented as follows:

Fig. 892.—Top-man. Red-Cloud's Census. This character for Top-man, or more properly "man above," is drawn a short distance above a curved line, which represents the character for sky inverted. The gesture for sky is sometimes made by passing the hand from east to west, describing an arc. Other pictographs for sky are shown in Fig. 1117.

Fig. 893. — High - Cloud. Red-Cloud's Census. The light and horizontal char-

FIG. 892—Top-man.

FIG. 893.—High-Cloud.

acter of the cloud suggests that it is one of those classed by meteor-

ologists as belonging to the higher regions of the atmosphere. This

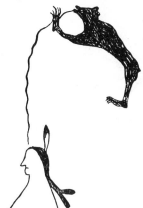

differs from all the varieties of clouds depicted in the Da-kotan system.

Fig. 894.— High-Bear. Red-Cloud's Census. The length of the line and the animal's stretch of attitude suggest the altitude.

Fig. 895.— High-Eagle. Red-Cloud's Census. Here there is an additional sug-

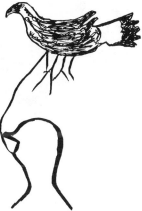

FIG. 894.—High-Bear.

FIG. 895.—High-Eagle.

gestion of elevation from the upward angle or pointer delineated below the eagle's body and in front of its legs.

Fig. 896.—Wolf-stands-on-a-hill. Red-Cloud's Census. This and the following representation of the same name show variation in execution. The first, which is faint, as if distant vertically, is connected with a straight line. The second shows the hill, appearing from vertical distance too small to be the support of the wolf, which requires an imaginary support for its hind legs.

Fig. 897.—Wolf-stands-on-hill. Red-Cloud's Census.

FIG. 897.—Wolf on height.

FIG. 896.—Wolf on height.

LEAN.

In the five figures next following the leanness of the several animals is objectively portrayed. In Fig. 903 the idea is conveyed of "nothing inside."

Fig. 898.—Lean-Skunk. Red-Cloud's Census.

Fig. 899.—Lean-Dog. Red-Cloud's Census.

Fig. 900.—Lean-Bear. Red-Cloud's Census. This bear being ex-cessively hungry is

FIG. 898.—Lean-Skunk.

FIG. 899.—Lean-Dog.

rendered ferocious by devouring unaplatable provender.

Fig. 901.—Lean-Elk. Red-Cloud's Census.

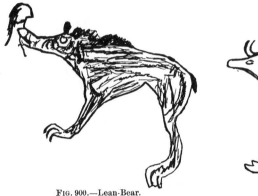

FIG. 900.—Lean-Bear.

FIG. 901.—Lean-Elk.

Fig. 902.—Lean-Bull. Red-Cloud's Census.

The original of Fig. 903 was made by Lean-Wolf, second chief of the

Hidatsa, in 1881, and represents the method which he had employed to designate himself for many years past. During his boyhood he had another name. This is a current, or perhaps it may be called cursive, form of the name, which is given more elaborately in Fig. 548.

FIG. 902.—Lean-Bull.

FIG.903.—Lean-Wolf.

LITTLE.

Fig. 904.—Little-Ring. Red-Cloud's Census. This and the six following figures express smallness by their minute size relative to the other characterizing figures among nearly three hundred in the census.

Fig. 905.—Little-Ring. Red-Cloud's Census.

FIG. 905.—Little-Ring.

FIG. 904.—Little-Ring.

Fig. 906.—Little-Crow. Red-Cloud's Census.
Fig. 907.—Little-Cloud. Red-Cloud's Census.
Fig. 908.—Little-Dog. Red-Cloud's Census.

FIG. 906.—Little-Crow.

FIG. 907.—Little-Cloud.

FIG. 908.—Little-Dog.

Fig. 909.—Little-Wolf. Red-Cloud's Census.
Fig. 910.—Little-Bear. Red-Cloud's Census.

FIG. 910.—Little-Bear.

Fig. 911.—Little-Elk. Red-Cloud's
Census. Here there is an ideogram ex-
plained by the sign-language for small,
little, as follows:

Hold imaginary object between left
thumb and index; point (carrying right
index close to tips) to the last. In the

FIG. 909.—Little-Wolf. original appears a small round spot

FIG. 911.—Little-Elk.

over the back of the deer representing the imaginary point made in the
gesture.

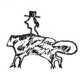

Fig. 912.—Little-Beaver and three
other white men came to trade. Ameri-
can-Horse's Winter Count, 1797-'98. In
this figure the man is small and the
beaver abnormally large.

FIG. 912.—Little-
Beaver. Fig. 913.—Little-Beaver's trading

FIG. 913.—Little-
Beaver.

house was burned down. American-Horse's Winter Count, 1808-'09.
The beaver is not comparatively so large as in the preceding figure,

but still much too large for a proper
proportion with the human head. It is
indicated that the man is small.

Fig. 914.—Little-Beaver's house was
burned. Cloud-Shield's Winter Count,
1809-'10. White-Cow-Killer says, "Lit-
tle-Beaver's (the white man) house-
FIG. 914.—Little- burned-down winter." This is a third
Beaver. method of representing the same name.

Fig. 915.—Little-Moon. Red-Cloud's
Census. This figure shows a phase of
the moon when the bright part of its
disk is small.

LONE.

FIG. 916.—Lone-
woman. Fig. 916.—Winyan-isnala, Lone-Wo-

FIG. 915.—Little-
Moon,

man. The Oglala Roster. It is possible that the single straight line
above the woman's head shows unity, loneliness, or independence, as it
may be interpreted.

Fig. 917.—Lone-Bear was killed in battle. Cloud-Shield's Winter Count, 1866–'67. This figure is perhaps to be explained by the one preceding. The bear is drawn sitting upright and solitary, not standing as it would be with the device turned, feet to ground, as might be suspected to be the intended attitude instead of that here shown.

MANY, MUCH.

In the two following figures the idea of "many" is conveyed by repetition.

In the third, Fig. 920, the representation is that of a heap, for much.

Fig. 918.—Many-Shells. Red Cloud's Census.

FIG. 917.—Lone-Bear.

FIG. 918 —Many-Shells.

Fig. 919.—General Maynadier made peace with the Oglalas and Brulés. American-Horse's Winter Count, 1865–'66. The general's name (the sound of which resembles the words "many deer") is indicated by the two deer heads connected with his mouth by lines. The pictographers represented his name in the same manner as they do their own. It is not an example of rebus, but of misunderstanding the significance of the word as spoken and heard by such Indians as had some

FIG. 919.—Many deer.

knowledge of English. The official interpreters would be likely to commit the error as they seldom understand more than the colloquial English phrases.

Fig. 920 is taken from the winter count of Battiste Good for the year 1841–'42. He calls the year "Pointer-made-a-commemoration-of-the-dead winter." Also "Deep-snow winter."

The extended index denotes the man's name, "Pointer," the circular line and spots, deep snow.

The spots denoting snow occur also in other portions of this count, and the circle, denoting much, is in Fig. 260 connected with a forked stick and incloses a buffalo head to signify "much meat." That the circle is intended to signify much is made

FIG. 920.—Much snow. probable, by the fact that a gesture for "much" is made by passing the hands upward from both sides and together before the body, describing the upper half of a circle, i. e., showing a heap.

FIG. 921.—Great, much.

Fig. 921, from Copway, gives the character meaning "great," really "much." See the above mentioned gesture.

OBSCURE.

Fig. 922.—Ring-Cloud. Red-Cloud's Census. The semicircle for

cloud is the reverse in execution to that shown in Fig. 893. The ring is partially surrounded by the cloud.

FIG. 923.—Cloud-Ring.

FIG. 922.—Ring-Cloud.

Fig. 923.—Cloud-Ring. Red-Cloud's Census. Here the outline of the ring is intentionally contorted and blurred, thus becoming obscure.

Fig. 924.—Fog. Red-Cloud's Census. The obscurity here can only

be appreciated by comparison with the other figures of the chart. The outline is drawn broad and with a blurred and in part double line, and there is no distinguishing mark of identity, as if to suggest that the man was so much obscured in the fog as not to be recognizable.

FIG. 924.—Fog.

OPPOSITION.

The following two figures, 925 and 926, are introduced to show the opposition in attitude, which would not be understood without knowledge of the fact that these are perhaps the only instances in a collection of nearly three hundred in which the characterizing faces are turned to the right, all others being turned to the left. This shows the opposite of normality, i. e., opposition, as suggested in each case, with a different shade of meaning.

Fig. 925.—Kills-Back. Red-Cloud's Census. Here the backward concept is presented by the unusual attitude. The coup stick or lance is supposed to be wielded in the reverse manner.

Fig. 926.—Keeps-the-Battle. Red - Cloud's Census. The concept is that of stubborn retreat while fighting against the advancing foe.

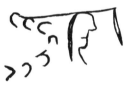

FIG. 925.—Kills-Back.

FIG. 926.—Keeps-the-Battle.

Fig. 927.—Keeps-the-Battle. Red-Cloud's Census. This is the same name as the preceding, but the opposition suggested is that which is usual in pictographs of a battle, with the important addition of the opposed arrow points being attached together by striking the same object,

FIG. 927.—Keeps-the-Battle.

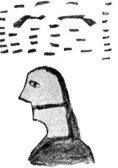

and possibly being connected by an imaginary knot. This keeps or continues the struggle.

Fig. 928.—Okicize-tawa, His-Fight. The Og-

FIG. 928.—His-Fight.

lala Roster. The opposed guns and tracks indicate the fight in which this warrior was conspicuous and probably victorious. This figure is introduced here as typical of simple opposition in battle.

Fig. 929.—Battiste Good's Winter Count, 1836–'37. An encounter is represented between two tribes, separated by the banks of a river, from which arrows are fired across the water at

FIG. 929.—River fight.

the opposing party. The vertical lines represent the banks, while the opposing arrows denote a fight or an encounter.

POSSESSION.

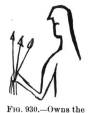

FIG. 930.—Owns the arrows.

Fig. 930.—Owns-the-Arrows. Red-Cloud's Census. This is a common mode of expressing possession by exhibition in hand.

Fig. 931.—Pesto-yuha, Has-something-sharp (weapon). Oglala Roster. The weapon or sharp utensil is held in front to denote its possession.

FIG. 931.—Has some-thing sharp·

PRISONER.

This group shows the several modes of expressing the idea of a prisoner.

Fig. 932.—The Ponkas attacked two lodges of Oglalas, killed some of the people, and made the rest prisoners. The Oglalas went to the Ponka village a short time afterward and took their people from the Ponkas. American-Horse's Winter Count, 1802–'03.

In the figure an Oglala has a prisoner by the arm leading him away. The arrow indicates that they were ready to fight. The hand grasping the fore arm is the ideogram of prisoner.

FIG. 932.—Prisoner. Dakota.

Fig. 933.—Takes-Enemy. Red-Cloud's

FIG. 933.—Takes enemy.

Census. This man is represented as not killed nor even wounded. He is touched by the coup stick or feathered lance, when he can not escape, and becomes a prisoner.

Lafitau (d) gives the following account descriptive of Fig. 934, which reminds of the classic Roman parade of prisoners in triumph:

Those who have charge of the prisoners prepare them for this ceremony, which is a sort of triumph, having for them something of glory and of sorrow at the same time; for, whether it is desired to do them honor or to enhance the triumph of the conquerors, they paint their faces black and red as on a solemn feast day. Their

heads are decorated with a crown embellished with feathers; in the left hand is placed a white stick covered with swan skin, which is a sort of commander's baton or scepter, as if they represented the chief of the nation [sic] or the nation itself which had been vanquished; in the right hand is placed the rattle, and around the neck of the most prominent of the slaves the wampum necklace which the war chief has given or received when he raised the party and on which the other warriors have sealed their engagement. But if on one hand the prisoners are honored, on the other, to make them feel their miserable situation, they are deprived of everything else; so that they are left entirely naked and made to walk with the arms tied behind the back above the elbow.

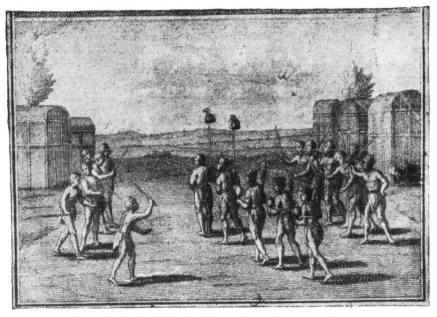

FIG. 934.—Iroquois triumph.

Fig. 935 is taken from Mrs. Eastman (d), and shows a Dakota method of recording the taking of prisoners. a and c are the prisoners, a being a female as denoted by the presence of mammæ, and c a male; b is the person making the capture. It is to be noted that the prisoners are without hands, to signify their helplessness.

FIG. 935.—Prisoners. Dakota.

In Doc. Hist. New York (c) is the following description of Fig. 936:

On their return, the Iroquois, if they have prisoners or scalps, paint the animal of the tribe to which they belong rampant (debout), with a staff on the shoulder along which are strung the scalps they may have and in the same number. After the animal are the prisoners they have made, with a chichicois (or gourd filled with beans which rattle) in the right hand. If they be women, they represent them with a cadenette or queue and a waistcloth.

a. This is a person returning from war who has taken a prisoner, killed a man and woman, whose scalps hang from the end of a stick that he carries. *b*. The prisoner. *c*. Chichicois (or a gourd), which he holds in the hand. *d*. These are

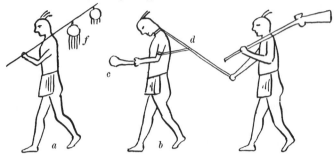

FIG. 936.—Prisoners. Iroquois.

cords attached to his neck, arms, and girdle. *e*. This is the scalp of a man; what is joined on one side is the scalp-lock. *f*. This is the scalp of a woman; they paint it with the hair thin.

FIG. 937.—Prisoners. Mexico.

The expression prisoner and slave are often convertible. The following from Kingsborough (*f*), explaining this illustration reproduced as Fig. 937, refers in terms to slavery. "The figures are those of the wife and son of a cacique who rebelled against Montezuma, and who, having been conquered, was strangled. The 'collars' upon their necks show that they have been reduced to slavery."

SHORT.

Fig. 938.—Short-Bull. Red-Cloud's Census, No. 16. The buffalo is markedly short even to distortion.

FIG. 938.—Short-Bull.

SIGHT.

Fig. 939.—Sees-the-Enemy. Red-Cloud's Census. In this collection the eye is not indicated except where that organ is directly connected with

the significance of the name. Here its mere presence suggests that vision is the subject matter. But, in addition, the object above the head is probably a hand mirror, which by its reflection is supposed to "see" the objects reflected. The plains Indians make use of such mirrors not only in their face painting but in flash signaling.

FIG. 939.—Sees-the-Enemy.

FIG. 940—Crier.

Fig. 940.—In a fight with the Mandans, Crier was shot in the head with a gun. Cloud-Shield's Winter Count, 1827–'28. This figure is

FIG. 941.—Comes-in-
Sight.

introduced to present another rare instance in which the eye is delineated. Here the act is that of weeping.

Fig. 941.—Comes - in - Sight. Red-Cloud's Census, No. 235. Distant objects, probably buffalo or other animals of the chase, are observed coming into the line of vision.

Fig. 942.—Bear - comes - out. Red-Cloud's Census. Here the bear is supposed to come into sight through a hole in the tipi.

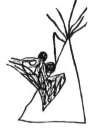

FIG. 942.—Bear-comes-out.

Fig. 943.—Bear-comes - out. Red - Cloud's Census.

This figure is explained by the one preceding. Only half of the bear—the fore part—is to be seen as if emerging through some orifice. Heads and other parts of animals are frequently portrayed as signifying the whole, by synechdoche, but in this case the presentation of the head and forequarters has special significance.

Fig. 944.—Taken from Copway, p. 136, is the character which is employed to represent "see."

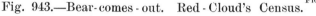

FIG. 944.

FIG. 943.—Bear-comes-out.

SLOW.

Fig. 945.—Slow - Bear. Red - Cloud's Census. In this figure the bear seems to be in backing or retrograde motion, which is slower than any normal advance, and is therefore ideographically suggestive of slowness.

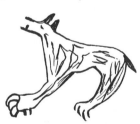

FIG. 945.—Slow-Bear.

TALL.

Fig. 946.—Tall-Man. Red-Cloud's Census. This and the five following animal figures show length and individual height objectively.

FIG. 946 —Tall-Man.

Fig. 947.—Wasicun-wankatuya, Tall - White - Man. The Oglala Roster. The hat shows the man of European origin, but his figure is large in the face and short in the legs; so not tall in a usual sense. He was probably killed by the Oglala.

Fig. 948.—Tall - White-Man. Red-Cloud's Census. This expresses the height much more graphically than the one preceding.

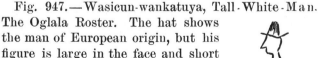

FIG. 948.—Tall-White-Man.

FIG. 947.—Tall-White-
Man.

Fig. 949.—Long - Panther. Red - Cloud's Census.

Fig. 950.—Tall-Panther. Red-Cloud's Census.

FIG. 949.—Long-Panther.

FIG. 950.—Tall-Panther.

Fig. 951.—Tall-Bull was killed by white soldiers and Pawnees on the south side of the South Platte river. American-Horse's Winter Count, 1869-'70. The combined arrangement of the human head and the buffalo so as to produce the effect of abnormal height in the latter is ingenious. The plan of this chart did not allow of long lines above the head, so the effect is attained by comparison of the standing buffalo with the height of the man.

Fig. 952.—Tall - Pine. Red - Cloud's Census. In this as in the two next figures the length of the trunk of the tree is apparent.

FIG. 951.—Tall-Bull.

FIG. 952.—Tall-Pine.

Fig. 953.—Long-Pine was killed in a fight with the Crows. American-Horse's Winter Count, 1879-'80. The absence of his scalp denotes that he was killed by an enemy. The fatal wound was made with the bow and arrow.

Fig. 954.—Long-Pine, a Dakota, was killed by Dakotas, perhaps accidentally or perhaps in a personal quarrel. Cloud-Shield's Winter Count, 1846-'47. He was not killed by a tribal enemy, as he has not lost his scalp.

FIG. 953 —Long-Pine.

FIG. 954.—Long-Pine.

TRADE.

Fig. 955.—They were compelled to sell many mules and horses to enable them to procure food, as they were in a starving condition. They willingly gave a mule for a sack of flour. American-Horse's Winter Count, 1868–'69. The mule's halter is connected with two sacks of flour.

Fig. 956 is taken from Prince Maximilian, of Wied's (*h*) Travels. The cross signifies, I will barter or trade. Three animals are drawn on the right hand of the cross; one is a buffalo (probably albino); the two others, a weasel (*Mustela Canadensis*) and an otter. The pictographer offers in exchange for the skins of these animals the articles which he has drawn on the left side of the cross. He has

FIG. 955.—Trade.

there, in the first place, depicted a beaver very plainly, behind which there is a gun; to the left of the beaver are thirty strokes, each ten separated by a longer line; this means: I will give thirty beaver

FIG. 956.—Trade.

skins and a gun for the skins of the three animals on the right hand of the cross.

The ideographic character of the design consists in the use of the cross—being a drawing of the gesture-sign for "trade"—the arms being interchanged in position. Of the two things each one is put in the place before occupied by the other thing, the idea of exchange.

UNION.

The Dakotas often express this concept by uniting two or more figures by a distinct inclusive line below the figures. This sometimes means family relationship and sometimes common membership in the same tribe.

Fig. 957.—Antoine Janis's two boys were killed by John Richard. Cloud-Shield's Winter Count, 1872–'73. The line of union shows them to be intimately connected; in fact, they were brothers.

Fig. 958.—The Oglalas got drunk at Chug creek and engaged in a quarrel among themselves, in which Red-Cloud's brother was killed and Red-Cloud killed three men. Cloud-Shield's Winter

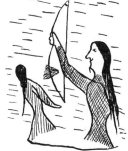

FIG. 957.—Brothers.

FIG. 958.—Same tribe.

Count, 1841–'42. The union line shows that the quarrel was in the tribe.

Fig. 959.—Torn-Belly and his wife were killed by some of their own people in a quarrel. Cloud Shield's Winter Count, 1855–'56. Here the man and wife are united by the inclusive line.

Fig. 960.—Eight Minneconjou Dakotas were killed by Crow Indians at the mouth of Powder river. The-Swan's Winter Count, 1805–'06. This

FIG. 960.—Same tribe.

device is very frequently used to denote the death of the Dakotas. The black strokes indicate the death of persons of the number delineated and the union line shows that they were of

FIG. 959.—Man and wife.

the same tribe.

Fig. 961.—Blackfeet Dakotas kill three Rees. The-Flame's Winter Count for 1798–'99. Here the uniting line of death refers to others than Dakotas, which does not often appear, but the principle is maintained that the dead are of the same tribe.

FIG. 961.—Same tribe.

WHIRLWIND.

Fig. 962.—Mato-wamniyomni, Bear-Whirlwind. The Oglala Roster. This figure shows over the bear's head a variant of the character given in Red Cloud's Census, Fig. 963. The figure appears, according to the explanation given by several Oglala Dakota Indians, to signify the course of a whirlwind with the trans-

FIG. 962.—Bear-Whirlwind.

verse lines in imitation of the circular movement of the air, conveying dirt and leaves, observed during such aerial disturbances.

.Fig. 963. — Represents White-Whirlwind, above referred to, from Red-Cloud's Census: In this the designating character is more distinct.

Fig. 964.—Leafing. Red-Cloud's Census. This seems to be of the same description. It is said to be

FIG. 963.—White-Whirlwind.

FIG. 964.—Leafing.

drawn in imitation of a number of fallen leaves packed against one another and whirled along the ground. It also has reference to the season when leaves fall —autumn.

Mr. Keam's MS. describing Fig. 965, says:

It is a decoration of great frequency and consisting of the single and double spirals. The single spiral is the symbol of Ho-bo-bo, the twister, who manifests his power by the whirlwind. It is also of frequent occur-

FIG. 965.—Whirlwind.

rence as a rock etching in the vicinity of ruins, where also the symbol of the Ho-

be-bo is seen. But the figure does not appear upon any of the pottery. The myth explains that a stranger came among the people, when a great whirlwind blew all the vegetation from the surface of the earth and all the water from its courses. With a flint he caught these symbols upon a rock, the etching of which is now in Keam's Cañon, Arizona Territory. It is 17 inches long and 8 inches across. He told them that he was the keeper of breath. The whirlwind and the air which men breathe comes from this keeper's mouth.

Fig. 966 is a copy of part of the decoration on a pot taken from a mound in Missouri, published in Second Annual Report of the Bureau Ethnology, Pl. LIII, fig. 11. On the authority of Rev. S. D. Hinman, it is the conventional device among the Dakotas to represent a whirlwind.

FIG. 966.—Whirlwind.

WINTER—COLD—SNOW.

Fig. 967.—Glue, an Oglala, froze to death on his way to a Brulé village. American-Horse's Winter Count, 1791–'92. A glue-stick is rep-

resented back of his head. Glue, made from the hoofs of buffalo, is used to fasten arrow-heads to the shaft and is carried about on sticks. The cloud from which hail or snow is falling represents winter.

FIG. 967.—Froze to death.

Fig. 968.—A Dakota, named Glue, froze to death. Cloud-Shield's Winter Count, 1820–'21. This figure is introduced to corroborate of the preceding one as regards the name Glue. It gives another representation of the glue stick.

FIG. 968.—Froze to death.

Fig. 969.—A Dakota named Stabber froze to death. American-

Horse's Winter Count, 1782–'83. The sign for winter is the same as before, but doubled, as if of twofold power or excessively severe.

Fig. 970.—The winter was so cold that many crows froze to death. Cloud-Shield's Winter Count, 1788–'89. White-Cow-Killer says "Many-black-crows-died winter."

FIG. 969.—Crows froze.

The crow falling stiff and motionless is a good symbol for the effect of excessive cold.

FIG. 970.—Froze to death.

Fig. 971.—The snow was very deep. American-Horse's Winter Count, 1827–'28. The piled-up snow around the bottoms of the tipis is graphic; no other material than snow could make that kind of surrounding heap.

Fig. 972.—From Copway, page 135, is the representation of "cold," "snow."

FIG. 971.

FIG. 972.—Cold, snow.

The Shoshoni and Banak sign for cold, winter, is: Clinch both hands and cross the forearms before the breast with a trembling motion. It

<div align="center">

Fig. 973. Fig. 974.

</div>

is represented in Fig. 973. Cf. Battiste Good's Winter count for 1747–'48 and 1783–'84.

In Kingsborough (*g*) is the painting reproduced in Fig. 974 with this description: "In the year of seven Canes and 1447 according to our calculation, it snowed so heavily that lives were lost."

In the same work and volumes, p. 146 and Pl. 26, is the original of Fig. 975, with the explanation that: "In this year of seven Flints, or 1512, there were heavy falls of snow."

Wiener, op. cit., p. 762, gives the following description (condensed) of Fig. 976, a remarkable example of ideography:

<div align="center">Fig. 975.</div>

This is on a cloth on which the eight fortresses of Paramonga were presented. Between these bridges are drawn; these forts are of three stages and on each stage is a representation of a man or of two men. The men who are down on the plain had clothing of another color and even another colored face from those who appear on the different stages. Those who are on the plain at the foot of the fortress have no arms, but they have highly developed ears. The same is true of those who appear on the first stage. Those of the following stage are provided with arms, and the ears are of normal size. On the highest platform appear individuals with arms and they have ears like those on the second stage. In the middle a figure is provided with one arm and only one developed ear, which are on opposite sides. The men without arms are also without weapons. Those of the second stage carry at the height of the belt a kind of hatchet and those of the upper platform have each a club.

Considering the character of the locality where this cloth was found, the number of forts there, the marshy land which prevented dry-shod communication between them, it can not be doubted that the subject matter was the representation of that region, but this representation is not a drawing on a plan, but is a description which does not only treat of the nature of the place and of the work that man raised there, but it also indicates the rôle that the inhabitants played there.

The function of the men with exaggerated ears and no arms was that of scouts. The armed men with normal ears were guards or warriors

bearing different weapons, ax and club, and differently uniformed. The highest figure with one large ear was the chief of the garrison.

It will be noticed that the scouts have enormous feet which do not rest on the ground. This in connection with their exaggerated ears implies that their duty is to listen and when they hear the enemy not to engage him, as they have no arms or weapons, but to fly to the head-quarters and make the report. The duty of the warriors is not to listen, so their ears are not abnormal, but to fight, and therefore they have arms, one of which is exposed and the other holds a weapon. Their feet are attached to their several stations. The chief must both listen and direct, wherefore he is drawn with one exaggerated ear and one

FIG. 976.—Peruvian garrison.

arm. His feet do not touch the platform, which signifies that he has no special station, but must move wherever he is most needed.

SECTION 2.

SIGNS, SYMBOLS, AND EMBLEMS.

The terms sign, symbol, and emblem are often used interchangeably and therefore incorrectly. Many persons ascribe an occult and mystic signification to symbols, probably from their general religious and esoteric employment. All characters in Indian picture-writing have

been loosely styled symbols, and, as there is no logical distinction between the characters impressed with enduring form and when merely outlined in the ambient air, all Indian gestures, motions, and attitudes, intended to be significant, might with equal appropriateness be called symbolic. But an Indian sign-talker or a deaf-mute represents a person by mimicry, and an object by the outline of some striking part of its form, or by the pantomime of some peculiarity in its actions or relations. Their attempt is to bring to mind the person or thing through its characteristics, not to distinguish the characteristics themselves, which is a second step. In the same manner a simple pictorial sign attempts to express an object, idea, or fact without any approach to symbolism. Symbols are less obvious and more artificial than mere signs, are not only abstract, but metaphysical, and often need explanation from history, religion, and customs. They do not depict, but suggest subjects; do not speak directly through the eye to the intelligence, but presuppose in the mind knowledge of an event or fact which the sign recalls. The symbols of the ark, dove, olive branch, and rainbow would be wholly meaningless to people unfamiliar with the Mosaic or some similar cosmology, as would the cross and the crescent be to those ignorant of history.

The loose classification by which symbols would include every gesture or pictorial sign that naturally or conventionally recalls a corresponding idea, only recognizes the fact that every action and object can, under some circumstances, become a symbol. And indeed lovers of the symbolic live in, on, and by the symbols which they manufacture.

A curious instance of the successful manufacture of a symbol by the ingenuity of one man is in the one now commonly pictured of a fish to represent Christ. The fish for obvious reasons has been connected with Eurasian mythology, and therefore was a heathen symbol many centuries before the Christian era; indeed, probably before the creed of the Israelites had become formulated. It was used metaphorically or emblematically by the early Christians without the apparent propriety of the lamb-bearing shepherd, the dove, and other emblems or symbols found in the catacombs, and Didron (b) says that only in the middle of the fourth century Optatus, bishop of Milesia, in Africa, declared the significance of the letters of the Greek word for fish, ΙΧΘΥΣ, to be the initials of 'Ιησοῦς Χριστὸς Θεοῦ 'Υιος Σωτηρ, which acrostic was received with acclamation, and new characteristics were from time to time invented, adding force to the thenceforth commonly displayed symbol. It may be noted that when symbols, which were generally religious, received acceptance, they were soon used objectively as amulets or talismans.

This chapter is not intended to be a treatise on symbolism, but it is proper to mention the distinction in the writer's mind between a pictorial sign, an emblem, and a symbol; though it is not easy to preserve accurate discrimination in classification of ideographic characters. To partly express the distinction, nearly all of the characters in the Win-

ter Counts in this work are regarded as pictorial signs, and the class represented by tribal and clan designations, insignia, etc., is considered to belong to the category of emblems. There is no doubt, however, that true symbols exist among the Indians, as they must exist to some extent among all peoples not devoid of poetic imagination. Some of them are shown in this work. The pipe is generally a symbol of peace, although in certain positions and connections it signifies preparation for war, and, again, subsequent victory. The hatchet is a common symbol for war, and joined hands or approaching palms denote peace. The tortoise has been clearly used as a symbol for land, and many other examples can be admitted. Apart from the exaggerations of Schoolcraft, true symbolism is found among the Ojibwa, of which illustrations are presented. The accounts of the Zuñi, Moki, and Navajo, before mentioned, show the constant employment of symbolic devices by those tribes which are notably devoted to mystic ceremonies. Nevertheless the writer's personal experience is that when he has at first supposed a character to be a genuine symbol, better means of understanding has often proved it to be not even an ideograph, but a mere objective representation. In this connection the remarks on the circle, in Lone-Dog's Winter Count for 1811–'12, and those on the cross infra, may be in point.

The connection, to the unlettered Indian, between printed words, pictures, and signs, was well illustrated through the spontaneous copial, by a Cheyenne, of the ornate labels on packages of sugar and coffee, which he had seen at a reservation, and the lines of which he rather skillfully and very ingeniously repeated on a piece of paper when sending to a post-trader to purchase more of the articles. The printed label was to him the pictorial sign for those articles.

The following remarks are quoted from D'Alviella (a):

There is a symbolism so natural, that, like certain implements peculiar to the stone age, it does not belong to any particular race, but constitutes a characteristic trait of mankind at a certain phase of its development. Of this class are representations of the sun by a disk or radiating face, of the moon by a crescent, of the air by birds, of water by fishes or a broken line, of thunder by an arrow or a club, etc. We ought, perhaps, to add a few more complicated analogies, as those which lead to symbolizing the different phases of human life by the growth of a tree, the generative forces of nature by phallic emblems, the divine triads by an equilateral triangle, or in general by any triple combination the members of which are equal, and the four principal directions of space by a cross. How many theories have been built upon the presence of the cross as an object of veneration among nearly all the peoples of the Old and New Worlds? Roman Catholic writers have justly protested, in recent years, against attributing a pagan origin to the cross of the Christians, because there were cruciform signs in the symbolism of religions anterior to Christianity. It is also right, by the same reason, to refuse to accept the attempts to seek for infiltrations of Christianity in foreign religions because they also possess the sign of redemption. * * * Nearly all peoples have represented the fire from the sky by an arm and, sometimes also, by a bird of strong and rapid flight. It was symbolized among the Chaldeans by a trident. Cylinders going back to the most ancient ages of Chaldean art exhibit a water jet gushing from a trident which

is held by the god of the sky or of the storm. The Assyrian artist who first, on the bas-reliefs of Nimroud or Malthai, doubled the trident or transformed it into a tri-fid fascicle, docile to the refinements and elegancies of classic art, by that means secured for the ancient Mesopotamian symbol the advantage over all the other representations of thunder with which it could compete. The Greeks, like the other Indo-European nations, seem to have represented the storm-fire under the features of a bird of prey. When they received the Asiatic figure of the thunderbolt, they put it in the eagle's claws and made of it the scepter of Zeus, explaining the combi-nation, after their habit, by the story of the eagles bringing thunder to Zeus when he was preparing for the war against the Titans. Latin Italy transmitted the thunderbolt to Gaul, where, in the last centuries of paganism, it alternated on the Gallo-Roman monuments with the two-headed hammer.

The emblem writers, so designated, have furnished an immense body of literature, and apparently have considered such pictures as those of the Winter Counts in the present work and also all symbols to be in-cluded in their proper scope. The best summary on the subject is by Henry Greene (a), from which the following condensed extract is taken:

Of the changes through which a word may pass the word emblem presents one of the most remarkable instances. Its present signification, type, or allusive repre-sentation is of comparatively modern use, while its original meaning is obsolete. Among the Greeks an emblem meant something thrown in or inserted after the fashion of what we now call marquetry and mosaic work, or in the form of a de-tached ornament to be affixed to a pillar, a tablet, or a vase, and put off or on as there might be occasion.

Quintilian (lib. 2, cap. 4), in enumerating the arts of oratory used by the plead-ers of his day, describes some of them as in the habit of preparing and committing to memory certain highly finished clauses, to be inserted (as occasion might arise) like emblems in the body of their orations. Such was the meaning of the term in the classical ages of Greece and Rome; nor was its signification altered until some time after the revival of literature in the fifteenth century.

Thus, in their origin, emblems were the figures or ornaments fashioned by the tools of the artists, in metal or wood, independent of the vase, or the column, or the furniture they were intended to adorn; they might be affixed or detached at the promptings of the owner's fancy. Then they were formed, as in mosaic, by placing side by side little blocks of colored stone, or tiles, or small sections of variegated wood. Raised or carved figures, however produced, came next to be considered as emblems; and afterwards any kind of figured ornament or device, whether carved or engraved or simply traced, on the walls and floors of houses or on vessels of wood, clay, stone, or metal.

By a very easy and natural step figures and ornaments of many kinds, when placed on smooth surfaces, were named emblems; and as these figures and orna-ments were very often symbolical, i. e., signs or tokens of a thought, a sentiment, a saying, or an event, the term emblem was applied to any painting, drawing, or print that was representative of an action, of a quality of the mind, or of any pecu-liarity or attribute of character. Emblems in fact were and are a species of hiero-glyphics, in which the figures or pictures, besides denoting the natural objects to which they bear resemblances, were employed to express properties of the mind, virtues and abstract ideas, and all the operations of the soul.

The following remarks of the same author (b) are presented in this con-nection, though they pass beyond the scope of either symbols or emblems into other divisions of pictography, as classified in the present work:

Coins and medals furnish most valuable examples of emblematical figures; indeed some of the emblem writers, as Sambucus, in 1564, were among the earliest to pub-

lish impressions or engravings of ancient Roman money, on which are frequently given very interesting representations of customs and symbolical acts. On Grecian coins we find, to use heraldic language, that the owl is the crest of Athens, a wolf's head that of Argos, and a tortoise the badge of the Peloponnesus. The whole history of Louis XIV and that of his great adversary, William III, is represented in volumes containing the medals that were struck to commemorate the leading events of their reigns, and, though outrageously untrue to nature and reality by the adoption of Roman costumes and classic symbols, they serve as records of remarkable occurrences.

Heraldry throughout employs the language of emblems; it is the picture-history of families, of tribes, and of nations, of princes and emperors. Many a legend and many a strange fancy may be mixed up with it, and demand almost the credulity of simplest childhood in order to obtain our credence; yet in the literature of chivalry and honors there are enshrined abundant records of the glory that belonged to mighty names.

The custom of taking a device or badge, if not a motto, is traced to the earliest times of history. It is a point not to be doubted that the ancients used to bear crests and ornaments in the helmets and on the shields; for we see this clearly in Virgil, when he made the catalogue of the nations which came in favor of Turnus against the Trojans, in the eighth book of the Æneid; Amphiaraus then (as Pindar says), at the war of Thebes, bore a dragon on his shield. Similarly Statius writes of Capaneus and of Polinices that the one bore the Hydra and the other the Sphynx.

Emblems do not necessarily require any analogy between the objects representing and the objects or qualities represented, but may arise from pure accident. They may bear any meaning that men may choose to attach to them, so their value still more than that of symbols depends upon extrinsic facts and not intrinsic features. After a scurrilous jest the beggar's wallet became the emblem of the confederated nobles, the Gueux of the Netherlands; and a sling, in the early minority of Louis XIV, was adopted from the refrain of a song by the Frondeur opponents of Mazarin.

The several tribal designations for Sioux, Arapaho, Cheyenne, etc., are their emblems, precisely as the star-spangled flag is that of the United States, but there is no intrinsic symbolism in them. So the designs for individuals, when not merely translations of their names, are emblematic of their family totems or personal distinctions, and are no more symbols than are the distinctive shoulder-straps of an army officer.

The point urged is that while many signs can be used as emblems and both can be converted by convention into symbols or be explained as such by perverted ingenuity, it is futile to seek for that form of psychological exuberance in the stage of development attained by the greater part of the American tribes. All predetermination to interpret their pictographs on the principles of symbolism as understood or pretended to be understood by its admirers, and as are sometimes properly applied not only to Egyptian hieroglyphics, but to Mexican, Maya, and some other southern pictographs, results in mooning mysticism.

The following examples are presented as being either symbols or emblems, according to the definition of those terms, and therefore

appropriate to this section. More will be found in Chapter xx, on Special Comparisons, and indeed may appear under different headings; e. g., Battiste Good symbolizes hunting by a buffalo head and arrow, Fig. 321, and war by a special head-dress, Fig. 395.

Sir A. Mackenzie (c) narrates that in 1793 he found among the Athabascans an emblem of a country abounding in animals. This was a small round piece of green wood chewed at one end in the form of a brush, which the Indians use to pick the marrow out of bones.

Mr. Frank H. Cushing, in notes not yet reduced to final shape for publication, gives two excellent examples of symbols among the Zuñi:

(1) The circle or halo around the sun is supposed to be and is called by the Zuñi the House of the Sun-God. This is explained by analogy. A man seeks shelter on the approach of a rainstorm. As the sun circle almost invariably appears only with the coming of a storm, the Sun, like his child, the man, seeks shelter in his house, which the circle has thus come to be.

The influence of this simple inference myth on the folklore of the Zuñi shows itself in the perpetuation, until within recent generations, of the round sun towers and circular estufas so intimately associated with sun worship, yet which were at first but survivals of the round medicine lodge.

(2) The rainbow is a deified animal having the attributes of a human being, yet also the body and some of the functions of a measuring worm. Obviously, the striped back and arched attitude of the measuring worm, its sudden appearance and disappearance among the leaves of the plants which it inhabits, are the analogies on which this personification is based. As the measuring worm consumes the herbage of the plants and causes them to dry up, so the rainbow, which appears only after rains, is supposed to cause a cessation of rains, consequently to be the originator of droughts, under the influence of which latter plants parch and wither away as they do under the ravages of the measuring worms. Here it will be seen that the visible phenomenon called the rainbow gets by analogy the personality of the measuring worm, while from the measuring worm in turn the rainbow gets its functions as a god. Of this the cessation of rain on the appearance of the rainbow is adduced as proof.

The following is reported by Dr. W. H. Dall (e), and explains how the otter protruding his tongue is the emblem of Shaman:

The carvings on the rattles of the Tlinkit are matters belonging particularly to the shaman or medicine man, and characteristic of his profession. Among these very generally, if not invariably, the rattle is composed of the figure of a bird, from which, near the head of the bird or carved upon the back of the bird's head, is represented a human face with the tongue protruding.

This tongue is bent downward and usually meets the mouth of a frog or an otter, the tongue of either appearing continuous with that of the human face. In case it is a frog it usually appears impaled upon the tongue of a kingfisher, whose head and variegated plumage are represented near the handle in a conventional way. It is asserted that this represents the medicine man absorbing from the frog, which has been brought to him by the kingfisher, either poison or the power of producing evil effects on other people.

In case it is an otter the tongue of the otter touches the tongue of the medicine man, as represented on the carving. * * *

This carving is represented, not only on rattles, but on totem posts, fronts of houses, and other objects associated with the medicine man, the myth being that when the young aspirant for the position of medicine man goes out into the woods after fasting for a considerable period, in order that his to be familiar spirit may

seek him, and that he may become possessed of the power to communicate with supernatural beings; if successful he meets with a river otter, which is a supernatural animal. The otter approaches him and he seizes it, kills it with the blow of a club, and takes out the tongue, after which he is able to understand the language of all inanimate objects, of birds, animals, and other living creatures. * * *

This ceremony or occurrence happens to every real medicine man. Consequently the otter presenting his tongue is the most universal type of the profession as such, and is sure to be found somewhere in the paraphernalia of every individual of that profession.

With this account from the Pacific coast a similar determination of emblems by the Indians in the northeastern parts of the United States may be compared. The objects seen by them in their fasting visions not only were decisive of their names but were held to show the course of their lives. If a youth saw an eagle or bear he was destined to be a warrior; if a deer he would be a man of peace; and a turkey buzzard or serpent was the sign that he would be a medicine man. The figures of those animals therefore were respectively the emblems of the qualities and dispositions implied. See Fig. 159, supra, for a drawing of the Sci-Manzi or "Mescal Woman" of the Kaiowa as it appears on a sacred gourd rattle used in the mescal ceremony of that tribe, with description.

In Kingsborough (h) is the record that "in the year of Ten Houses, or 1489, a very large comet, which they name Xihuitli, appeared."

The comet is represented in the plate by the symbol of a caterpillar, in allusion, perhaps, to its supposed influence in causing blights. This may be compared with the measuring worm, symbol of the rainbow, supra. The character is reproduced in Fig. 977.

FIG. 977.—Comet. Mexican.

In the same work and Codex, Pls. 10, 12, and 33, are three characters, somewhat differing, representing earthquakes, which, according to the text in Vol. VI, p. 137, et seq., occurred in Mexico in the years A. D. 1461, 1467, and 1542. The concept appears to be that of the disruption and change of the position of the several strata of soil, which are indicated by the diverse coloration. These characters are reproduced in the present work in Pl. XLIX as the three on the right hand in the lower line.

Fig. 978 is from the same work (i), Codex Mendoza, and is the symbol for robbery, in allusion to the punishment of the convicted robber.

In the same work (k), Codex Vaticanus, is the following description, in quaint language, of the plate now reproduced in Pl. XLIX:

FIG. 978.—Robbery. Mexican.

These are the twenty letters or figures which they employed in all their calculations, which they supposed ruled over men, as the figure shows, and they cured in a corresponding manner those who became ill or suffered pains in any part of the body. The sign of the wind was assigned to the

liver; the rose to the breast; the earthquake to the tongue; the eagle to the right arm; the vulture to the right ear; the rabbit to the left ear; the flint to the teeth;

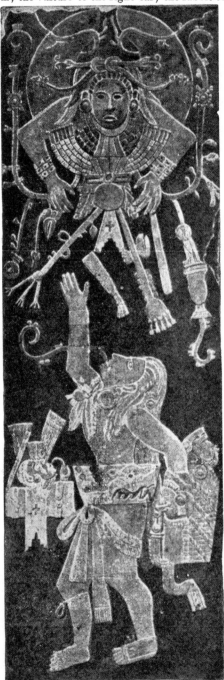

the air to the breath; the monkey to the left arm; the cane to the heart; the herb, to the bowels; the lizard to the womb of women; the tiger to the left foot; the serpent to the male organ of generation, as that from which their diseases proceeded in their commencement; for in this manner they considered the serpent, wherever it occurred, as the most ominous of all their signs. Even still physicians continue to use this figure when they perform cures, and, according to the sign and hour in which the patient became ill, they examined whether the disease corresponded with the ruling sign; from which it is plain that this nation is not as brutal as some persons pretend, since they observed so much method and order in their affairs and employed the same means as our astrologers and physicians use, as this figure still obtains amongst them and may be found in their repertoires.

a, deer or stag; *b*, wind; *c*, rose; *d*, earthquake; *e*, eagle; *f*, eagle of a different species; *g*, water; *h*, house; *i*, skull or death; *j*, rain; *k*, dog; *l*, rabbit; *m*, flint; *n*, air; *o*, monkey; *p*, cane; *q*, grass or herb; *r*, lizard; *s*, tiger; *t*, serpent.

Dr. S. Habel (*d*) gives the description concerning Fig. 979, which is presented here on account of the several symbols and gestures exhibited:

This is a block of dark gray porphyry (vulcanite) 12 feet long 3 feet broad and 2 feet thick, the upper left corner of which is slightly broken off. The sculpture occupies 9 feet of its upper part. The upper portion represents the head and breast of a female, surrounded by a circle, from which the arms project. Besides the ste-

FIG. 979.—Guatemalan symbols.

reotyped frill surrounding the forehead, the only ornament of the head consists of two

Plate XLIX

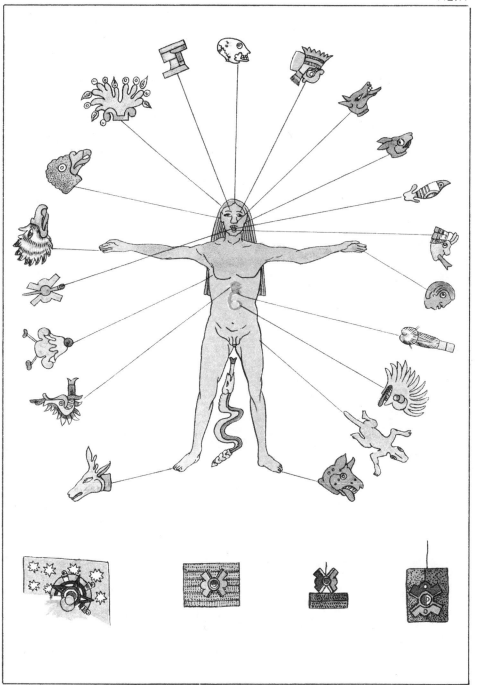

MEXICAN SYMBOLS.

entwined rattlesnakes. The hair is of medium length and descends in tresses to the shoulders and breast. The ear is ornamented with circular disks inclosing smaller ones. Around the neck is a broad necklace of irregularly-shaped stones of extra-ordinary size. Below the necklace the breast is covered with a kind of scarf or tex-tile fabric, the upper ends of which are fastened by buttons. To the center of this scarf seems to be attached a globe, the upper part of which is adorned by a knotted band from which four others ascend. From the lower part of the globe descends another band, with incisions characteristic of Mexican sculpture, while its sides are adorned by wreaths like wings. The wrists of both hands are covered with strings of large stones perforated in the center. From the semicircular bands emanate two of the twining staves; to the staves are attached knots, leaves, flowers, and various other emblems of a mythical character. The most conspicuous of these is the repre-sentation of a human face in a circle resembling the ordinary pictures of the full moon. The two central staves, originating from the neck, pass downward, and are differently ornamented. The fact that the head and part of the breast are surrounded by a circle, and that the image of the moon forms one of its ornaments, induces us to believe that this is the figure of the moon goddess. In the lower part of the sculpture appears, again, an individual imploring the deity with face upturned and elevated hand. The supplication is indicated by a curved staff knotted on the sides. Excepting a circular disk attached to the hair, the head is without ornament; the long hair hangs down to the breast and back, ending in a complicated ornament extending below the knees. In the lobe of the ear is a small ring from which a larger one depends. The breast is adorned with a globe similar to that on the breast of the goddess, only it is smaller. Around the wrist of the right hand is a plain cuff, while the left hand is covered by a skull; a stiff girdle, with a boar's head orna-menting its back part, surrounds the waist. This girdle differs from the previous ones by being ornamented with circular depressions. From the front of the girdle descend two twisted cords surrounding the thigh, and a band tied in bow and ends. Below the right knee is a kind of garter with a pear-shaped pendant. The left foot, with the exception of the toes, is inclosed in a sort of shoe.

In front of the adorer is a small altar, the cover of which has incisions similar to those in the pendant of the globe on the breast of the deity. On the altar is a human head, from the mouth of which issues a curved staff, while other staves in the shape of arrows appear on the side of the head.

Fig. 980 is reproduced by permission from Lieut. H. R. Lemly (*a*), U. S. Army, who calls it a "stone calendar." It is the work of the Chibcha Indians of the United States of Colombia, and its several parts, some of which are to be compared with similar designs in other regions, are explained as follows:

a, Ata, a small frog in the act of leaping. This animal was the base of the system, and in this attitude denoted the abundance of water. *b*, Bosa, a rectangular figure with various divisions, imitating cultivated fields. *c*, Mica, a bicephalous figure, with the eyes distended, as if to examine minutely. It signified the selection and planting of seed. *d*, Muihica, similar to the preceding, but with the eyes almost closed. It rep-resented the dark and tempestuous epoch in which, favored by the rain, the seed began to sprout. *e*, Hisca, resembling *c* and *d* of the stone, but larger, with no divi-sion between the heads. It was the symbol of the conjunction of the sun and moon, which the Chibchas considered the nuptials or actual union of these celestial spouses— one of the cardinal dogmas of their creed. *f*, Ta, almost identical with *b*. It repre-sented the harvest month. *g*, Cuhupcua, an earless human head upon one of the lateral faces of the stone. It was the symbol of the useless or so-called deaf month of the Chibchan year. *h*, Suhuza, perhaps a tadpole, and probably referred to the generation of these animals. *i*, Aca, a figure of a frog, larger than *a*, but in a simi-lar posture. It announced the approach of the rainy season. *j*, Ulchihica, two united rhomboids—a fruit or seed, and perhaps an ear. It referred to their invitations

and feasts. *k*, Guesa, a human figure in an humble attitude, the hands folded, and a halo about the head. It is supposed to represent the unfortunate youth selected as the victim of the sacrifice made every twenty Chibchan years to the god of the harvest.

The characters *b* and *f* below, markedly resemble one given by Pipart (*a*), with the same signification. It referred to the preparation of the ground for sowing.

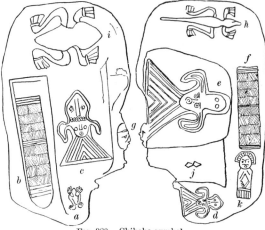

FIG. 980.—Chibcha symbols.

Wiener (*f*) gives the following summary of prominent Peruvian symbols:

In the conventional system of the Peruvians a bird indicates velocity, a lion strength, the lion and the bird united in one figure strength and velocity together, and, deductively, power. The meander indicates fertility and the pyramid with degrees or steps indicates defense. A bird combined with the meander indicates rapid production. A rectangular oblong figure (the mouth) indicates speech and discourse. A circle with a depression almost in the form of a heart means a female child, a circle with a small blade or stalk a male child. The circle with two stalks is the symbol of a man— the worker. The circle with four stalks means a married couple, marriage, etc.

Fig. 981 is presented to show another collection of engraved symbols, some of which with different execution resemble some found in North America. It is a bronze tablet found in Syria in the collection of M. Péretié, and is described by Maj. Claude R. Conder, R. F. (*a*):

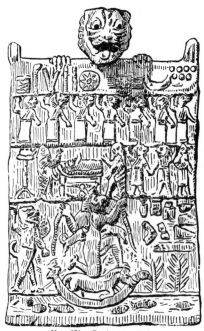

FIG. 981.—Syrian symbols.

It measures 4½ inches in height by 3¼ in width. The design is supposed to represent the fate of the soul according to Assyrian or Phenician belief. The tablet is divided into four compartments horizontally, the lowest being the largest and highest the most narrow. In the top compartment various astronomical symbols occur, many of which, as M. Canneau points out, occur on other Assyrian monuments. On the extreme right are the seven stars, next to these the crescent, next the winged solar disk, then an eight-rayed star in a circle. The remaining symbols are less easily explained, but the last is called by M. Canneau a "cidaris" or Persian tiara, while another appears to approach most nearly to the Trisul, or symbol of "fire," the emblem of the Indian Siva.

Below these symbols stand seven deities facing to the right, with long robes, and the heads of various animals. The first to the left resembles a lion, the second a wolf or hound, the fourth a ram, the sixth a bird, the seventh a serpent, while the third and fifth are less easily recognized. In the third compartment a body lies on a bier, with a deity at the head, and another at the feet. These deities have the right hand held up, and the left down (a common feature of Indian symbolism also observable in the attitude of the Mâlawîyeh dervishes), and the figure to the left appears to hold a branch or three ears of corn. Both are robed in the peculiar fish-headed costume, with a scaly body and fish tail, which is supposed to be symbolical of the mythical Oannes, who according to Berosus, issued from the Persian gulf and taught laws and arts to the early dwellers on the Euphrates. Behind the left-hand fish-god is a tripod stand, on which is an indefinite object; to the right of the other fish-god are two lion-headed human figures with eagles' claws, apparently contending with one another, the right arms being raised, the left holding hand by hand. To the right of these is another figure of Assyrian type, with a domed headdress and beard.

In the lowest compartment the infernal river fringed with rushes, and full of fish, is represented. A fearful lion-headed goddess with eagles' claws kneels on one knee on a horse (the emblem of death) which is carried in a kneeling attitude on a boat with bird-headed prow. The goddess crushes a serpent in either hand, and two lion cubs are represented sucking her breasts. To the left is a demon bearing a close resemblance to the one which supports the tablet itself, and which appears to urge on the boat from the bank; to the right are various objects, mostly of an indefinite character, among which M. Ganneau recognizes a vase, and a bottle, a horse's leg with hoof, etc.; possibly offerings to appease the infernal deities. The lion-headed goddess might well be taken for the terrible infernal deity Kali or Durga, the worship of whose consort, Yama, was the original source of that of the later Serapis, whose dog was the ancestor of Cerberus. There is also a general resemblance between this design and the well-known Egyptian picture representing the wicked soul conveyed to hell in the form of a pig.

The Oannes figures take the place of the two goddesses who in Egyptian designs stand at either end of the mummy and who form the prototype of the two angels for whom the pious Moslem provides seats at the head and foot of his tombstone. Perhaps the miserable horse who stumbles under the weight of the gigantic lion goddess may represent the unhappy soul itself, while the three ears of corn remind us of the grains of corn which have been found in skulls dug up in Syria by Capt. Burton. Corn is intimately connected with Dagon, the Syrian fish-god.

As a tentative suggestion I may, perhaps, be allowed to propose that the seven deities in the second compartment are the planets, and that the symbols above belong to them as follows, commencing on the right:

Planet.	Assyrian name.	Head of deity.	Symbol
1. Saturn	Chiun	Serpent	Seven stars.
2. Moon	Nannar	Bird	Crescent.
3. Sun	Shamash	Boar (?)	Winged disc.
4. Mars	Marduk	Ram	Rayed disc.
5. Mercury	Nebo	(?)	Two columns.
6. Venus	Ishtar	Wolf (?)	Trisul.
7. Jupiter	Ishu	Lion	Cidaris (?).

The serpent is often the emblem of Saturn, who, as the eldest of the seven ("the great serpent father of the gods"), naturally comes first and therefore on the right, and has seven stars for his symbol.

The moon, according to Lenormant, was always an older divinity than the sun.

The boar is often an emblem of the sun in its strength.

The disc (litu) was the weapon employed by Marduk, the warrior god, as mentioned by Lenormant.

The two pillars of Hermes are the proper emblem of the ancient Set or Thoth, the planet Mercury.

The trisul belongs properly to the Asherah, god or goddess of fertility—the planet Venus.

The Cidaris occurs in the Bavian sculptures in connection with a similar emblem. In the Chaldean system, Jupiter and Venus occur together as the youngest of the planets.

It should also be noted that the position of the arms and the long robe covering the feet resemble the attitudes and dress of the Mâlawîyeh dervishes in their sacred dance, symbolic of the seven planets revolving (according to the Ptolemaic system) round the earth.

Didron (c) thus remarks upon the emblems in the Roman catacombs:

The large fish marks the fisher who catches it or the manufacturer who extracts the oil from it. The trident indicates the sailor, as the pick the digger. The trade of digger in the catacombs was quite elevated; the primitive monuments thus represent these men who are of the lower class among us, and who in the beginning of the Christian era, when they dug the graves of saints and martyrs, were interred side by side with the rich and even beside saints, and were represented holding a pickaxe in one hand and a lamp in the other; the lamp lighted them in their subterranean labors. The hatchet indicates a carpenter, and the capital a sculptor or an architect. As to the dove, it probably designates the duties of the mother of a family who nourishes the domestic birdlings as would appear to be indicated by a mortuary design in Bosis. It is possible, moreover, that it originated from a symbolic idea, but this idea would be borrowed from profane rather than religious sentiments, and I would more willingly see in it the memorial of the good qualities of the dead, man or woman, the fidelity of the wife, or of the dove, which returning to the ark after the deluge announced that the waters had retired and the land had again appeared; from this we can not conclude that the fish filled a rôle analogous to it, nor above all that it is the symbol of Christ; the dove is in the Old Testament, the fish neither in the old nor in the new.

Edkins (b) says respecting the Chinese:

It is easy to trace the process of symbol-making in the words used for the crenelated top of city walls, which are ya and c'hi, both meaning "teeth" and both being pictures of the object, and further, when the former is found also to be used for "tree buds" and "to bud." Such instances of word creation show how considerable has been the prevalence of analogy and the association of ideas. The picture writing of the Chinese is to a large extent a continuation of the process of forming analogies to which the human mind had already become accustomed in the earlier stages of the history of language.

D'Alviella (b) furnishes this poetical and truthful suggestion:

It is not surprising that the Hindoos and Egyptians should both have adopted as the symbol of the sun the lotus flower, which opens its petals to the dawn and infolds them on the approach of night, and which seems to be born of itself on the surface of the still waters.

SECTION 3.

SIGNIFICANCE OF COLORS.

The use of color to be considered in studies of pictography is probably to be traced to the practice of painting on the surface of the human body. This use is very ancient. The Ethiopians in the army of Xerxes

applied vermillion and white plaster to their skins, and the German tribes when first known in history inscribed their breasts with the figures of divers animals. The North British clans were so much addicted to paint (or perhaps tattoo) that the epithet Picti was applied to them by the Romans. In this respect comparisons may be made with the Wichita, who were called by the French Pawnees Piqués, commonly rendered in English Pawnee Picts, and Marco de Niça, in Hakluyt, (e) says that Indians in the region of Arizona and New Mexico were called Pintados "because they painted their faces, breasts, and arms." The general belief with regard to the employment of paint in the above and similar cases is that the colors had a tribal significance by which men became their own flags; the present form of flag not having great antiquity, as Clovis was the first among western monarchs to adopt it. Then the theory became current that colored devices, such as appeared on ensigns and on clothing, e. g., tartans, were imitated from the painted marks on the skin of the tribesmen. In this connection remarks made supra about tattoo designs are applicable. There is but little evidence in favor of the theory, save that fashions in colored decorations probably in time became tribal practices and so might have been evolved into emblems. But it is proper to regard such colorations as primarily ornamental, and to remember that even in England as late as the eighth century some bands of men were so proud of their decorated bodies that they refused to conceal them by clothes.

This topic may be divided into: 1. Decorative use of color. 2. Idiocrasy of colors. 3. Color in ceremonies. 4. Color relative to death and mourning. 5. Colors for war and peace. 6. Colors designating social status.

DECORATIVE USE OF COLOR.

The following notes give instances of the use of painting which appear to be purely decorative:

Fernando Alarchon, in Hakluyt, (f) says of the Indians of the Bay of California: "These Indians came decked after sundry fashions, some came with a painting that couered their face all ouer, some had their faces halfe couered, but all besmouched with cole and euery one as it liked him best."

John Hawkins, in Hakluyt, (g) speaking of the Florida Indians, tells of "Colours both red, blacke, yellow, and russet, very perfect, wherewith they so paint their bodies and Deere skinnes which they weare about them, that with water it neither faded away nor altereth in color."

Maximilian of Wied (f), reports:

Even in the midst of winter the Mandans wear nothing on the upper part of the body, under their buffalo robe. They paint their bodies of a reddish brown colour, on some occasions with white clay, and frequently draw red or black figures on their arms. The face is, for the most part, painted all over with vermillion or yellow, in which latter case the circumference of the eyes and the chin are red. There are,

however, no set rules for painting, and it depends on the taste of the Indian dandy; yet, still, a general similarity is observed. The bands, in their dances and also after battles, and when they have performed some exploit, follow the established rule. In ordinary festivals and dances, and whenever they wish to look particularly fine, the young Mandans paint themselves in every variety of way, and each endeavors to find out some new mode. Should he find another dandy painted just like himself, he immediately retires and makes a change in the pattern, which may happen three or four times during the festival. If they have performed an exploit, the entire face is painted jet black.

A colored plate in the report of the Pacific Railroad Expedition (*f*) shows the designs adopted by the Mojave Indians for painting the body. These designs consist of transverse lines extending around the body, arms, and legs, or horizontal lines or different parts may partake of different designs. Clay is now generally used.

Everard F. im Thurn (*h*) describes the painting of the Indians of Guiana as follows:

The paint is applied either in large masses or in patterns. For example, a man, when he wants to dress well, perhaps entirely coats both his feet up to the ankles with a crust of red; his whole trunk he sometimes stains uniformly with blue-black, more rarely with red, or covers it with an intricate pattern of lines of either color; he puts a streak of red along the bridge of his nose; where his eyebrows were till he pulled them out he puts two red lines; at the top of the arch of his forehead he puts a big lump of red paint, and probably he scatters other spots and lines somewhere on his face. The women, especially among the Ackawoi, who use more body-paint than other ornament, are more fond of blue-black than of red; and one very favorite ornament with them is a broad band of this, which edges the mouth, and passes from the corners of that to the ears. Some women especially affect certain little figures, like Chinese characters, which look as if some meaning were attached to them, but which the Indians are either unable or unwilling to explain.

Kohl (*a*) says of the Indians met by him around Lake Superior that "The young men only paint—no women. When they become old they stop and cease to pluck out their beards which are an obstacle in painting." It is probable that the custom of plucking the hairs originated in the attempt to facilitate face and body painting.

Herndon (*b*) gives the following report from the valley of the Amazon:

Met a Conibo on the beach. This man was evidently the dandy of his tribe. He was painted with a broad stripe of red under each eye; three narrow stripes of blue were carried from one ear, across the upper lip to the other—the two lower stripes plain, and the upper one bordered with figures. The whole of the lower jaw and chin were painted with a blue chain-work of figures, something resembling Chinese figures.

According to Dr. J. J. von Tschudi (*b*):

The uncivilized Indians of Peru paint their bodies, but not exactly in the tattoo manner; they confine themselves to single stripes. The Sensis women draw two stripes from the shoulder, over each breast, down to the pit of the stomach; the Pirras women paint a band in a form of a girdle round the waist, and they have three of a darker color round each thigh. These stripes, when once laid on, can never be removed by washing. They are made with the unripe fruit of one of the Rubiacaceæ. Some tribes paint the face only; others, on the contrary, do not touch that part; but bedaub with colors their arms, feet, and breasts.

F. J. Mouat, M. D., in Jour. Roy. Geogr. Soc., (*a*) says that Andaman Islanders rub red earth on the top of the head, probably for the purpose of ornamentation. This fashion is similar to that of some North American Indian tribes which rub red pigment on the parting of the hair.

Marcano (*e*) says:

The present Piaroas of Venezuela are in the habit of painting their bodies, but by a different proce; s. They make stamps out of wood, which they apply to their skins after covering them with coloring matter.

Fig. 982 shows examples of these stamps. The most noteworthy thing about them is that they reproduce the types of certain petroglyphs, particularly of those of the upper Cuchivero (see Figs. 152 and 153, supra).

The Piaroas either copied the models they found carved on the rocks by peoples who preceded them, or they are aware of their meaning and preserved the tradition of

FIG. 982.—Piaroa color stamps.

it. The former hypothesis is the only tenable one. Not being endowed with inventive faculties, it seems more natural that they should simply have copied the only models they found. The Indians of French Guiana paint themselves in order to drive away the devil when they start on a journey or for war, whence Crevaux concludes that the petroglyphs must have been carved for a religious purpose. But painting is to the Piaroas a question of ornamentation and of necessity. It is a sort of garment that protects them against insects, and which, applied with extra care, becomes a fancy costume to grace their feasts and meetings.

It is to be noted that at least one instance is found of the converse of the Piaroa practice, by which the face-marks are used as the designs of pictographs on inanimate objects. The Serranos, near Los Angeles, California, formerly cut lines upon the trees and posts marking boundaries of land, these lines corresponding to those adopted by the owner as facial decorations.

A suggestion appropriate to this branch of the topic is presented in the answer communicated in a personal conversation of a Japanese lady who was asked why she blackened her teeth: "Any dog has white

teeth!" An alteration of the physical appearance is itself a distinction, and the greater the difference between the decorated person and the want of decoration in others the greater the distinction. Modern milliners, dressmakers, tailors and hatters, and their patrons pursue the same ends of fashionable distinction which are exhibited in rivalry for priority and singularity. These arbitrary fluctuations of fashion, which are seen equally in the Mandan and the millionaire, the Pueblan and the Parisian, are to be considered with reference to the supposed tribal significance of colors before mentioned. So far as they originated in fashion they changed with fashion, and the studies made in the preparation of this paper tend to a disbelief in their distinctness and stability. The conservatism of religious and of other ceremonial practices and of social customs preserved, however, a certain amount of consistency and continuity.

IDEOCRASY OF COLORS.

It has often been asserted that there was and is an intrinsic significance in the several colors. A traditional recognition of this among the civilizations connected with modern Europe is shown by the associations of death and mourning with black, of innocence and peace with white, danger with red, and epidemic disease officially with yellow. A comparison of the diverse conceptions attached to the colors will show great variety in their several attributions.

The Babylonians represented the sun and its sphere of motion by gold, the moon by silver, Saturn by black, Jupiter by orange, Mars by red, Venus by pale yellow, and Mercury by deep blue. Red was anciently and generally connected with divinity and power both priestly and royal. The tabernacle of the Israelites was covered with skins dyed red, and the gods and images of Egypt and Chaldea were of that color, which to this day is the one distinguishing the Roman Pontiff and the cardinals.

In ancient art each color had a mystic sense or symbolism, and its proper use was an essential consideration. With regard to early Christian art Mrs. Clement (a) furnishes the following account:

White is worn by the Saviour after his resurrection; by the Virgin in representations of the Assumption; by women as the emblem of chastity; by rich men to indicate humility; and by the judge as the symbol of integrity. It is represented sometimes by silver or the diamond, and its sentiment is purity, virginity, innocence, faith, joy, and light.

Red, the color of the ruby, speaks of royalty, fire, divine love, the holy spirit, creative power, and heat. In an opposite sense it symbolized blood, war, and hatred. Red and black combined were the colors of Satan, purgatory, and evil spirits. Red and white roses are emblems of love and innocence or love and wisdom, as in the garland of St. Cecilia.

Blue, that of the sapphire, signified heaven, heavenly love and truth, constancy and fidelity. Christ and the Virgin Mary wear the blue mantle; St. John a blue tunic.

Green, the emerald, the color of spring, expressed hope and victory.

Yellow or gold was the emblem of the sun, the goodness of God, marriage and fruitfulness. St. Joseph and St. Peter wear yellow. Yellow has also a bad signification when it has a dirty, dingy hue, such as the usual dress of Judas, and then signifies jealousy, inconstancy, and deceit.

Violet or amethyst signified passion and suffering or love and truth. Penitents, as the Magdalene, wear it. The Madonna wears it after the crucifixion, and Christ after the resurrection.

Gray is the color of penance, mourning, humility, or accused innocence.

Black with white signified humility, mourning, and purity of life. Alone, it spoke of darkness, wickedness, and death, and belonged to Satan. In pictures of the Temptation Jesus sometimes wears black.

The associations with the several colors above mentioned differ widely from those in modern folk-lore; for instance, those with green and yellow, the same colors being stigmatized in the old song that "green's forsaken and yellow's forsworn."

The Hist. de Dieu, by Didron (d), contains the following:

The hierarchy of colors could well, in the ideas of the Middle Ages, have been allied at the same time to symbolism. The most brilliant color is gold, and here it is given to the greatest saints. Silver, color of the moon, which is inferior to the sun, but its companion, however, should follow; then red, or the color of fire, attribute of those who struggle against passion, and which is inferior to the two metals, gold and silver, to the sun and moon, of which it is but an emanation; next green, which symbolizes hope, and which is appropriate to married people; lastly, the uncertain yellowish color, half white and half yellow, a modified color, which is given to saints who were formerly sinners, but who have succeeded in reforming themselves and are made somewhat bright in the sight of God by penitence.

A note in the Am. Journal of Psychology, Vol. I, November, 1887, p. 190, gives another list substantially as follows:

Yellow, the color of gold and fire, symbolizes reason.

Green, the color of vegetable life, symbolizes utility and labor.

Red, the color of blood, symbolizes war and love.

Blue, the color of the sky, symbolizes spiritual life, duty, religion.

COLOR IN CEREMONIES.

The colors attributed to the cardinal points have been the subject of much discussion. Some of these special color schemes of the North American Indians are now mentioned.

Mr. James Stevenson, in an address before the Anthropological Society of Washington, D. C.; Dr. Washington Matthews, U. S. Army, in the Fifth Ann. Rep. of the Bureau of Ethnology, p. 449; and Mr. Thomas V. Keam, in a MS. contribution, severally report the tribes mentioned below as using in their ceremonial dances the respective colors designated to represent the four cardinal points, viz:

	N.	S.	E.	W.
Stevenson—Zuñi	Yellow.	Red.	White.	Black.
Matthews—Navajo	Black.	Blue.	White.	Yellow.
Keam—Moki	White.	Red.	Yellow.	Blue.

Mr. Stevenson, in his paper on the Ceremonial of Hasjelti Dailjis, in the Eighth Ann. Rep. of the Bureau of Ethnology, agrees with Dr.

Matthews regarding the ceremonial scheme of the Navajo colors symbolic of the cardinal points, as follows: "The eagle plumes were laid to the east, and near by them white corn and white shell; the blue feathers were laid to the south, with blue corn and turquoise; the hawk feathers were laid to the west, with yellow corn and abalone shell; and to the north were laid the whippoorwill feathers, with black beads and corn of all the several colors."

In A Study of Pueblo Architecture, by Mr. Victor Mindeleff, in the Eighth Ann. Rep. of the Bureau of Ethnology, the prayers of consecration by the Pueblos are addressed thus:

```
To the west: Siky'ak ............ oma'uwu......... Yellow cloud.
To the south: Sa'kwa............ oma'uwu......... Blue cloud.
To the east: Pal'a ............... oma'uwu......... Red cloud.
To the north: Kwetsh ........... oma'uwu......... White cloud.
```

Mr. Frank H. Cushing, in Zuñi Fetiches, Second Ann. Rep., Bureau of Ethnology, pp. 16–17, gives the following:

In ancient times, while yet all beings belonged to one family, Po-shai-ang-k'ia, the father of our sacred bands, lived with his children (disciples) in the City of the Mists, the middle place (center) of the medicine societies of the world. When he was about to go forth into the world he divided the universe into six regions, namely, the North (Direction of the swept or barren place); the West (Direction of the Home of the Waters); the South (Direction of the Place of the Beautiful Red); the East (Direction of the Home of Day); the Upper Regions (Direction of the Home of the High); and the Lower Regions (Direction of the Home of the Low).

In the center of the great sea of each of these regions stood a very ancient sacred place—a great mountain peak. In the North was the Mountain Yellow, in the West the Mountain Blue, in the South the Mountain Red, in the East the Mountain White, above the Mountain All-color, and below the Mountain Black.

We do not fail to see in this clear reference to the natural colors of the regions referred to—to the barren North and its auroral hues, the West with its blue Pacific, the rosy South, the white daylight of the east, the many hues of the clouded sky, and the black darkness of the "caves and holes of earth." Indeed these colors are used in the pictographs and in all the mythic symbolism of the Zuñis to indicate the directions or regions respectively referred to as connected with them.

Mr. A. S. Gatschet (a), in Proc. Am. Philos. Soc., gives the symbolic colors of the Isleta Pueblo for the points of the compass, as "white for the east; from there they go to the north, which is black; to the west, which is blue; and to the south, which is red."

Mr. James Mooney, in Seventh Ann. Rep., Bureau Ethnology, p. 342, says that the symbolic color system of the Cherokees is:

```
East—red—success; triumph.
North—blue—defeat; trouble.
West—black—death.
South—white—peace; happiness.
```

In the ceremonies of the Indians of the plains it is common that the smoke of the sacred pipe should be turned first directly upward, second directly downward, and then successively to the four cardinal points, but without absolute agreement among the several tribes as to the order of that succession. In James' Long (i), it is reported that in a special ceremony of the Omaha regarding the buffalo the first whiff of

smoke was directed to them, next to the heavens, next to the earth, and then successively to the east, west, north, and south. The rather lame explanation was given that the east was for sunrise, the west for sunset, the north for cold country, and the south for warm country.

The Count de Charencey, in Des Couleurs considérés comme symboles des Pointes de l'Horizon, etc., and in Ages ou Soleils, gives as the result of his studies that in Mexico and Central America the original systems were as follows:

Quaternary system.	Quinary system.
East—Yellow.	South—Blue.
North—Black.	East—Red.
West—White.	North—Yellow.
South—Red.	West—White.
	Center—Black.

Mr. John Crawfurd (a) says:

In Java the divisions of the horizon and the corresponding colors were named in the following order: first, white and the east; second, red and the south; third, yellow and the west; fourth, black and the north; and fifth, mixed colors and the focus or center.

Boturini (a) gives the following arrangement of the "symbols of the four parts or angles of the world," comparing it with that of Gemelli:

Gemelli.	Boturini.
1. Tochtli—South.	1. Tecpatl—South.
2. Acatl—East.	2. Calli—East.
3. Tecpatl—North.	3. Tochtli—North.
4. Calli—West.	4. Acatl—West.

SYMBOLS OF THE FOUR ELEMENTS.

Gemelli.	Boturini.
1. Tochtli—Earth.	1. Tecpatl—Fire.
2. Acatl—Water.	2. Calli—Earth.
3. Tecpatl—Air.	3. Tochtli—Air.
4. Calli—Fire.	4. Acatl—Water.

Herrera (a) speaks only of the year symbols and colors, and, although he does not directly connect them, indicates his understanding in regard thereto by the order in which he mentions them:

They divided the year into four signs, being four figures; the one of a house, another of a rabbit, the third of a cane, the fourth of a flint, and by them they reckoned the year as it passed on. * * * They painted a sun in the middle from which issued four lines or branches in a cross to the circumference of the wheel, and they turned so that they divided it into four parts and the circumference and each of them moved with its branch of the same color, which were four—green, blue, red, and yellow.

From this statement Prof. Cyrus Thomas, in Notes on certain Maya and Mexican Manuscripts, Third Ann. Rep., Bureau of Ethnology, concludes that Herrera's arrangement would presumably be as follows:

Calli—Green.
Tochtli—Blue.
Acatl—Red.
Tecpatl—Yellow.

Combining these several lists it would appear that Calli, color green, was Fire and West or Earth and East; Tochtli, color blue, was Earth and South or Air and North; Acatl, color red, was Water and East or Water and West; Tecpatl, color yellow, was Air and North or Fire and South.

The foregoing notes leave the symbolic colors of the cardinal points in a state of confusion, and on calm reflection no other condition could be expected. Taking the idea of the ocean blue, for instance, and recognizing the impressive climatic effects of the ocean, the people examined may be in any direction from the ocean and to each of them its topographic as well as color relation differs. If it shall be called blue, the color blue may be north, south, east, or west. So as to the concepts of heat and cold, however presented in colors by the fancy, heat being sometimes red and sometimes yellow, cold being sometimes considered as black by the manifestation of its violent destruction of the tissues and sometimes being more simply shown as white, the color of the snow. Also the geographic situation of the people must determine their views of temperature. The sun in tropical regions may be an object of terror, in Arctic climes of pure beneficence, and in the several seasons of more temperate zones the sun as fire, whether red or yellow, may be destructive or life-giving. Regarding the symbols of the cardinal points it seems that there is nothing intrinsic as to colors, but that the ideograms connected with the topic are local and variant. As the ancient assignments of color to the cardinal points are not established and definite among people who have been long settled in their present habitat, the hope of tracing their previous migration by that line of investigation may not be realized.

The following account of the degree posts of the Grand Medicine Society of the Ojibwa is condensed from an article by Dr. Hoffman in the Am. Anthropologist for July, 1889:

In constructing the inclosure in which the Midē′ priests practice the rites and ceremonies of initiation, a single post, from 4 to 5 feet in height and about 8 inches thick, is planted at a point opposite the main entrance, and about three-fourths the entire distance of the interior from it. This post is painted red, with a band of green about the top, of the width of a palm.

The red and green colors are used to designate the Midē′ society, but for what reason is not positively known. The green appears to have some connection with the south, the sources of heat and abundance of crops; the thunder-bird also comes from that direction in the springtime, bringing rain, which causes the grass and fruits to grow, giving an abundance of food.

For the second degree two posts are erected within the inclosure, the first being like that for the first degree, the second being planted nearer the main entrance, though not far from the opposite end of the structure; this post is painted red and is covered with white spots made by applying white clay with the finger tip. These spots are symbolical of the migis shell, the sacred emblem of the Grand Medicine Society.

The third degree contains three posts, the two preceding ones being used, to which a third is added and planted in a line with them; this post is painted black.

In the fourth degree the additional post is really a cross, a crosspiece of wood be-

ing attached near the top; the lower part of the upright piece is squared, the side on the east being painted white; on the south, green; on the west, red; and on the north, black. The white is the source of light facing the direction of the rising sun, the green, apparently the source of warmth, rains, and abundance of crops, while the north is black, and pertains to the region from which come cold, disease, and desolation. The red is placed upon the western side, but there is a diversity of opinion regarding its significance. The most plausible theory appears to relate to the "road of the dead," referred to in the ritual of the Ghost Society, as the path upon which the departed shadow partakes of the gigantic strawberry which he finds. The upper portion of the cross is white, upon which are placed irregularly red spots.

In the same article is the following account of face coloring in the Midē' degrees:

In connection with the colors of the degree posts, there is a systematic arrangement of facial ornamentation, each style to be characteristic of one of the four degrees, as well as the degree of the Ghost Society.

According to the White Earth (Minnesota) method, the arrangement is as follows:

First degree. One red stripe across the face from near the ears across the tip of the nose.

Second degree. One stripe as above and another across the eyes, temples, and root of the nose.

Third degree. The upper half of the face painted green and the lower half red.

Fourth degree. The forehead and the left side of the face from the outer canthus of the eye downward is painted green; four spots of vermilion are made with the tip of the finger upon the forehead and four upon the green surface of the left cheek.

According to Sikassige, a Mille Lacs Midē' priest, the ornamentation practiced during his youth was as follows:

First degree. A broad band of green across the forehead and a narrow stripe of vermilion across the face just below the eyes.

Second degree. A narrow stripe of vermilion across the temple, eyelids, and the root of the nose, a short distance above which is a similar stripe of green, then another of vermilion, and above this again one of green.

Third degree. Red and white spots are daubed all over the face, the spots averaging three-fourths of an inch each in diameter.

Fourth degree. Two forms are admissible; in the former the face is painted red, with a stripe of green extended diagonally across it from the upper part of the left temporal region to the lower part of the right cheek. In the latter the face is painted red with two short, horizontal parallel green bars across the forehead.

Either of these may be adopted as a sign of mourning by a man whose deceased son had been intended for the priesthood of the Grand Medicine Society.

The religious and ceremonial use of the color red by the New Zealanders is mentioned by Taylor (d):

Closely connected with religion, was the feeling they entertained for the Kura, or Red Paint, which was the sacred color; their idols, Pataka, sacred stages for the dead, and for offerings or sacrifices, Urupa graves, chief's houses, and war canoes, were all thus painted.

The way of rendering anything tapu was by making it red. When a person died, his house was thus colored; when the tapu was laid on anything, the chief erected a post and painted it with the kura; wherever a corpse rested, some memorial was set up, oftentimes the nearest stone, rock, or tree served as a monument; but whatever object was selected, it was sure to be made red. If the corpse were conveyed by water, wherever they landed a similar token was left; and when it reached its destination, the canoe was dragged on shore, thus distinguished, and abandoned. When the hahunga took place, the scraped bones of the chief, thus ornamented, and wrapped

in a red-stained mat, were deposited in a box or bowl, smeared with the sacred color, and placed in a tomb. Near his final resting place a lofty and elaborately carved monument was erected to his memory; this was called he tiki, which was also thus colored.

In former times the chief annointed his entire person with red ocher; when fully dressed on state occasions, both he and his wives had red paint and oil poured upon the crown of the head and forehead, which gave them a gory appearance, as though their skulls had been cleft asunder.

Mr. S. Gason reports in Worsnop, op. cit.:

On the Cooper, Herbert, and Diamentina rivers of the North there are no paintings in caves, but in special corroborees the bodies of the leading dancers are beautifully painted with every imaginable color, representing man, woman, animals, birds, and reptiles, the outlines being nearly faultless, and in proportion, independent of the blending of the colors.

These paintings take about seven or eight hours' hard tedious work for two men, one in front, the other at the back of the man who is to be painted, and when these men who are painted display themselves, surrounded by bright fires and rude torches, it has an enchanting effect to the others. After the ceremony is over, the paintings are allowed to be examined, and the artists congratulated or criticised.

At the other ceremonies, after returning from "Bookatoo" (red ocher expedition), they paint a few of their dancers with all the colors of the rainbow, the outlines showing all the principal species of snakes. They are well drawn and colored, and take many hours of labor to complete.

These paintings of snakes are done for the purpose of having a good harvest of snakes. The women are not allowed to attend at this ceremony, as it is one of their strict secret dances.

A few notes of other ceremonial and religious uses of color are presented.

Capt. John G. Bourke (*f*) says that the Moki employ the colors in prayers—yellow for pumpkins, green for corn, and red for peaches. Black and white bands are typical of rain, and red and blue bands, of lightning.

In James's Long (*k*), it is mentioned of the Omaha that the boy who goes to fast on the hill top to see his guardian spirit, as a preparation rubs his body over with whitish clay, but the same ceremonial among the Ouenebigonghelins near Hudson bay is described by Bacqueville de la Potherie (*d*), with the statement that the postulant paints his face black.

Peter Martyr (*a*) says the natives of the Island of Hispaniola [Haiti] when attending a festival at the religious edifice, go in a procession having their bodies and faces painted in black, red, and yellow colors. Some had feathers of the parrot and other birds, with which they decorated themselves. The women had no decoration.

Pénicaut's Relation, A. D. 1704, in Margry (*f*), gives an account of decorations of the victims who die with the grand chief, or Sun of the Natchez. Their faces were painted vermilion, as the author says, "lest they by paleness should show their fear." Though the practice may have thus originated as a mere expedient, red thus used would become in time a sacrificial color.

But the color red can not always be deduced from such an origin. It is connected with the color of fire and of blood. The Romans on great fes-

tivals painted the face of Jupiter Capitolinus with vermilion. They painted in the same way all the statues of the gods, demi-gods, heroes, fauns, and satyrs. Pan is described by Virgil in Ecl. X, line 27:

> Pan, deus Arcadiæ venit, quem vidimus ipsi
> Sanguineis ebuli baccis minioque rubentem.

These verses are rendered with spirit by R. C. Singleton, Virgil in English Rhythm, London, 1871, though the translator wrote "cinnabar" instead of "red lead" and might as well have used the correct word, "minium," which has the same prosodial quantity as cinnabar.

> Pan came, the god of Arcady, whom we
> Ourselves beheld, with berries bloody red
> Of danewort, and with cinnabar aglow.

In Chapman's translation of Homer's hymn to Pan the god is again represented stained with red, but with the original idea of blood.

> A lynx's hide, besprinkled round about
> With blood, cast on his shoulders.

By imitation of greatness and the semblance of divinity the faces of generals when they rode in triumph, e. g., Camillus as mentioned by Pliny, quoting Verrius, were painted red.

On the tree which supports the Vatican figure of the Apollo Belvedere are traces of an object supposed to be the στέμμα δελφικόν, which was composed of bushy tufts of Delphian laurel bound with threads of red wool into a series of knots and having at each end a tassel. This is an old sign of consecration and is possibly connected with the traditional gipsy sign of mutual binding in love signified by a red knot, as mentioned in a letter from Mr. Charles G. Leland.

The Spaniards distinguished red as the color par excellence, and among many of the savage and barbaric peoples red is the favorite and probably once was the sacred color.

COLOR RELATIVE TO DEATH AND MOURNING.

Charlevoix (a) says of the Micmacs that "their mourning consisted in painting themselves black and in great lamentations."

Champlain (f), in 1603, described the mourning posts of the northeastern Algonquian tribes as painted red.

Keatings' Long (g) tells that the Sac Indians blackened themselves with charcoal in mourning and during its continuance did not use any vermilion or other color for ornamentation.

Some of the Dakota tribes blackened the whole face with charcoal for mourning, but ashes were also frequently employed.

Col. Dodge (a) says that the Sioux did not use the color green in life, but that the corpses were wrapped in green blankets. The late Rev. S. D. Hinman, who probably was, until his death within the last year, the best authority concerning those Indians, contradicts this statement in a letter, declaring that the Sioux frequently use the color green in their face-painting, especially when they seek to disguise themselves,

as it gives so different an expression. If it is not used as generally as blue or yellow the reason is that it is seldom found in the clays which were formerly relied upon and therefore it required compounding. Also they do not use green as painting or designation for the dead, but red, that being their decoration for the "happy hunting ground." But the color for the mourning of the survivors is black.

Thomas L. McKenny (a) says the Chippeway men mourn by painting their faces black.

The Winnebago men blacken the whole face with charcoal in mourning. The women make a round black spot on both cheeks.

Dr. Boas, in Am. Anthrop. (a), says of Snanaimuq, a Salish tribe:

The face of the deceased is painted red and black. After the death of husband or wife the survivor must paint his legs and his blanket red. For three or four days he must not eat anything; then three men or women give him food, and henceforth he is allowed to eat.

In Bancroft (d) it is mentioned that the Guatemalan widower dyed his body yellow.

Carl Bock (b) describes the mourning solemnities in Borneo as being marked chiefly by white, the men and women composing the mourning processions being enveloped in white garments, and carrying white flags and weapons and ornaments, all of which were covered with white calico.

A. W. Howitt (h) says of the Dieri of Central Australia:

A messenger who is sent to convey the intelligence of a death is smeared all over with white clay. On his approach to the camp the women all commence screaming and crying most passionately. * * * Widows and widowers are prohibited by custom from uttering a word until the clay of mourning has worn off, however long it may remain on them. They do not, however, rub it off, as doing so would be considered a bad omen. It must absolutely wear off of itself. During this period they communicate by means of gesture language.

A. C. Haddon (b) tells that among the western tribes of Torres strait plastering the body with gray mud was a sign of mourning.

Elisée Reclus (c) says: "In sign of mourning the Papuans daub themselves in white, yellow, or black, according to the tribes."

D'Albertis (d) reports that the women of New Guinea paint themselves black all over on the death of a relation, but that there are degrees of mourning among the men, e. g., the son of the deceased paints his whole body black, but other less related mourners may only paint the face more or less black. In Vol. II, p. 9, a differentiation is shown, by which in one locality the women daubed themselves from head to foot with mud. The same author says, in the same volume, p. 378, that the skulls preserved in their houses are always colored red and their foreheads frequently marked with some rough design.

In Armenia, as told in The Devil Worshipers of Armenia, in Scottish Geog. Mag., VIII, p. 592, widows dress in white.

In Notes in East Equatorial Africa, Bull. Soc. d'Anthrop. de Brux. (b), it is told that in the region mentioned the women rub flour over their bodies on the death or departure of the husband.

Sir G. Wilkinson (*a*) writes that the ancient Egyptians in their mourning ceremonies wore white fillets, and describes the same use of the color white in the funeral processions painted on the walls of Thebes.

Dr. S. Wells Williams (*a*) reports of the Chinese mourning colors that "the mourners are dressed entirely in white or wear a white fillet around the head. In the southern districts half-mourning is blue, usually exhibited in a pair of blue shoes and a blue silken cord woven in the queue, instead of a red one; in the northern provinces white is the only mourning color seen."

Herr von Brandt, in the Ainos and Japanese, Journal of the Anthrop. Inst. G. B. and I. (*e*), tells that the coffins of the deceased Mikados were covered with red, that is, with cinnabar.

<div align="center">COLORS FOR WAR AND PEACE.</div>

These colors, respecting the Algonquian Indians, are mentioned in 1763, as published in Margry, to the effect that red feathers on the pipe signify war, and that other colors [each of which may have a modifying or special significance] mean peace.

W. W. H. Davis (*b*) recounts that "in 1680 the Rio Grande Pueblos informed the Spanish officers that they had brought with them two crosses, one painted red, which signified war, and the other white, which indicated peace, and they might take their choice between the two."

Capt. de Lamothe Cadiliac (*b*), writing in the year 1696 of the Algonquians of the Great Lake region near Mackinac, etc., describes their decorations for war as follows:

On the day of departure the warriors dress in their best. They color their hair red; they paint their faces red and black with much skill and taste, as well as the whole of their bodies. Some have headdresses with the tail feathers of eagles or other birds; others have them decorated with the teeth of wild beasts, such as the wolf or tiger [wild cat]. Several adorn their heads, in lieu of hats, with helmets bearing the horns of deer, roebuck, or buffalo.

Schoolcraft (*r*) says that blue signifies peace among the Indians of the Pueblo of Tesuque.

The Dakota bands lately at Grand river agency had the practice of painting the face red from the eyes down to the chin when going to war.

The Absaroka or Crow Indians generally paint the forehead red when on the warpath. This distinction of the Crows is also noted by the Dakota in recording pictographic narratives of encounters with the Crows.

Haywood (*e*) says of the Cherokees:

When going to war their hair is combed and annointed with bear's grease and the red root, *Sanguinaria canadensis*, and they adorn it with feathers of various beautiful colors, besides copper and iron rings, and sometimes wampum or peak in the ears; and they paint their faces all over as red as vermilion, making a circle of black about one eye and another circle of white about the other.

H. H. Bancroft (*e*) tells that when a Modoc warrior paints his face black before going into battle it means victory or death, and that he

will not survive a defeat. In the same volume, p. 105, he says that when a Thlinkit arms himself for war he paints his face and powders his hair a brilliant red. He then ornaments his head with a white eagle feather as a token of stern, vindictive determination.

Mr. Dorsey reports that when the Osage men go to steal horses from the enemy they paint their faces with charcoal. [Possibly this may be for disguise, on the same principle that burglars use black crape.] The same authority gives the following description of the Osage paint for war parties:

Before charging the foe the Osage warriors paint themselves anew. This is called the death paint. If any of the men die with this paint on them the survivors do not put on any other paint.

All the gentes on the "Left" side use the "fire paint," which is red. It is applied by them with the left hand all over the face. And they use prayers about the fire: "As the fire has no mercy, so should we have none." Then they put mud on the cheek, below the left eye, as wide as two or more fingers. The horse is painted with some of the mud on the left cheek, shoulder, and thigh.

The following extract is from Belden (b):

The sign paints used by the Sioux Indians are not numerous, but very significant. When the warriors return from the warpath and have been successful in bringing back scalps, the squaws, as well as the men, paint with vermilion a semicircle in front of each ear, The bow of the arc is toward the nose and the points of the half-circle on the top and bottom of the ear; the eyes are then reddened and all dance over the scalps.

John Lawson (a) says of the North Carolina Indians:

When they go to war * * * they paint their faces all over red, and commonly make a circle of black about one eye and another circle of white about the other, while others bedaub their faces with tobacco-pipe clay, lampblack, black lead, and divers other colors, etc.

De Brahm, in documents connected with the History of South Carolina (a), reports that the Indians of South Carolina "painted their faces red in token of friendship and black in expression of warlike intentions."

Rev. M. Eells (a) says of the Twana Indians of the Skokomish reservation that when about to engage in war "they would tamanamus in order to be successful and paint themselves with black and red, making themselves as hideous as possible."

The U. S. Exploring Expedition (b), referring to a tribe near the Sacramento river, tells that the chie. presented them with a tuft of white feathers stuck on a stick about 1 foot long, which was supposed to be a token of friendship.

Dr. Boas, in Am. Anthrop. (b), says of the Snanaimuq that before setting out on war expeditions they painted their faces red and black.

Peter Martyr (b) says of the Ciguaner Indians:

The natives came out of the forest painted and daubed with spots. For it is their custom, when they go to war, to daub themselves from the face to the knee with black and scarlet or purple color in spots, which color they [obtain] from some curious fruits resembling "Pyren," which they plant and cultivate in their gardens with the greatest care. Similarly they also cause the hair to grow in a thousand very curious

shapes, if it is not by nature long or black enough, so that they look not otherwise than if the similar devil or hellish Circe came running out of hell.

Curr (c) tells that the Australians whitened themselves with white clay when about to engage in war. Some African tribes, according to Du Chaillu, also paint their faces white for war.

Haddon (c) says of the western tribe of Torres straits:

When going to fight the men painted their bodies red, either entirely so or partially, perhaps only the upper portion of the body and the legs below the knees, or the head and upper part of the body only. The body was painted black all over by those who were actually engaged in the death dance.

Du Chaillu (c) tells that among the Scandinavians there were peace and war shields, the former white and the latter red. When the white was hoisted on a ship it was a sign for the cessation of hostility, in the same manner that a flag of the same color is now used to procure or mark a truce. The red shield displayed on a masthead or in the midst of a body of men was the sign of hostility.

COLOR DESIGNATING SOCIAL STATUS.

The following extract is translated from Peter Martyr (c):

For the men are in body long and straight, possess a vivid and natural complexion which compares somewhat with a red and genuine flesh color. Their whole body and skin is lined over with sundry paints and curious figures, which they consider as a handsome ornament and fine decoration, and the uglier a man's painting or lining over is the prettier he considers himself to be, and is also regarded as the most noble among their number.

Mr. Dorsey reports of the Osages that all the old men who have been distinguished in war are painted with the decorations of their respective gentes. That of the Tsicu wactake is as follows: The face is first whitened all over with white clay; then a red spot is made on the forehead and the lower part of the face is reddened; then with the fingers the man scrapes off the white clay, forming the dark figures by letting the natural color of the face show through.

H. H. Bancroft (f), citing authorities, says the central Californians (north of San Francisco bay) formerly wore the down of Asclepias (?) (white) as an emblem of royalty; and in the same volume, p. 691, it is told that the natives of Guatemala wore red feathers in their hats, the nobles only wearing green ones.

The notes immediately following are about the significant use of color, not readily divisible into headings.

Belden (c) furnishes the following remarks:

The Yanktons, Sioux, Santees, and Cheyennes use a great deal of paint. A Santee squaw paints her face the same as a white woman does, only with less taste. If she wishes to appear particularly taking she draws a red streak half an inch wide from ear to ear, passing it over the eyes, the bridge of the nose, and along the middle of the cheek. When a warrior desires to be left alone he takes black paint or lampblack and smears his face; then he draws zigzag lines from his hair to his chin by scraping off the paint with his nails. This is a sign that he is trapping, is melancholy, or in love.

A Sioux warrior who is courting a squaw usually paints his eyes yellow and blue and the squaw paints hers red. I have known squaws to go through the painful operation of reddening the eye-balls, that they might appear particularly fascinating to the young men. A red stripe drawn horizontally from one eye to the other means that the young warrior has seen a squaw he could love if she would reciprocate his attachment.

As narrated by H. H. Bancroft, the Los Angeles county Indian girls paint the cheeks sparingly with red ocher when in love. This also prevails among the Arikara, at Fort Berthold, Dakota.

La Potherie (e) says that the Indian girls of a tribe near Hudson bay, when they have arrived at the age of puberty, at the time of its sign, daub themselves with charcoal or a black stone, and in far distant Yucatan, according to Bancroft (h), the young men restricted themselves to black until they were married, indulging afterwards in varied and bright colored figures.

The color green is chiefly used symbolically as that of grass, with reference to which Father De Smet's MS. on the dance of the Tinton Sioux contains these remarks: "Grass is the emblem of charity and abundance; from it the Indians derive the food for their horses and it fattens the wild animals of the plains, from which they derive their subsistence."

Brinton (d) gives the following summary:

Both green and yellow were esteemed fortunate colors by the Cakchiquels, the former as that of the flourishing plant, the latter as that of the ripe and golden ears of maize. Hence, says Coto, they were also used to mean prosperity.

The color white, zak, had, however, by far the widest metaphorical uses. As the hue of light, it was associated with day, dawn, brightness, etc.

Marshall (b) gives as the explanation why certain gracious official documents are sealed with green that the color expresses youth, honor, beauty, and especially liberty.

H. M. Stanley (a) gives the following use of white as a sign of innocence: "Qualla drew a piece of pipeclay and marked a broad white band running from the wrist to the shoulder along each arm of Ngalyema, as a sign to all men present that he was guiltless."

H. Clay Trumbull (a) says:

The Egyptian amulet of blood friendship was red, as representing the blood of the gods. The Egyptian word for "red" sometimes stood for "blood." The sacred directions in the Book of the Dead were written in red; hence follows our word "rubrics." The rabbis say that, when persecution forbade the wearing of the phylacteries with safety, a red thread might be substituted for this token of the covenant with the Lord. It was a red thread which Joshua gave to Rahab as a token of her covenant relations with the people of the Lord. The red thread, in China, to-day, binds the double cup, from which the bride and bridegroom drink their covenant draught of "wedding wine," as if in symbolism of the covenant of blood. And it is a red thread which, in India, to-day, is used to bind a sacred amulet around the arm or the neck. * * * Upon the shrines in India the color red shows that worship is still living there; red continues to stand for blood.

Mr. Mooney, in the Seventh Annual Report, Bureau of Ethnology, shows that to the Cherokee the color blue signifies grief or depression of

spirits, a curious parallel to the colloquial English phrase "has the blues" and wholly opposite to the poetical symbol of blue for hope.

The notes above collected on the general topic of color symbolism might be indefinitely extended. Those presented, however, are typical and perhaps sufficient for the scope of the present work. In regarding ideography of colors the first object is to expunge from consideration all merely arbitrary or fanciful decorations, which is by no means easy, as ancient customs, even in their decadence or merely traditional, preserve a long influence. But as a generalization it seems that all common colors have been used in historic times for nearly all varieties of ideographic expression by the several divisions of men, and that they have differed fundamentally in the application of those colors. Yet there was an intelligent origin in each one of those applications of color. With regard to mourning the color black is now considered to be that of gloom. It was still earlier expressed by casting ashes or earth over the head and frame, and possibly the somber paint was adopted for cleanliness, the concept being preserved and indeed intensified by durable blackness instead of the mere transient dinginess of dirt, although the actual defilement by the latter is thereby only symbolized. This gloom is the expression of the misery of the survivors, perhaps of their despair as not expecting any happiness to the dead or any hope of a meeting in another world. Other lines of thought are shown by blue, considered as the supposed sky or heavenly home of the future, and by green, as suggesting renewal or resurrection, and those concepts determine the mourning color of some peoples. Red or yellow may only refer to the conceptions of the colors of flames, and therefore might simply be an objective representation of the disposition of the corpse, which very often was by cremation. But sometimes these colors are employed as decoration and display to proclaim that the dead go to glory. White, used as frequently by the populations of the world as other funeral colors, may have been only to assert the purity and innocence of the departed, an anticipation of the flattering obituary notices or epitaphs now conventional in civilized lands.

With regard to the color red, it may be admitted that it originally represents blood; but it may be, and in fact is, used for the contradictory concepts of war and peace. It is used for war as suggesting the blood of the enemy, for peace and friendship to signify the blood relation or blood covenant, the strongest tie of love and friendship.

So it would seem that, while colors have been used ideographically, the ideas which determined them were very diverse and sometimes their application has become wholly conventional and arbitrary. A modern military example may be in point which has no connection with the well-known squib of an English humorist. One of the officers of the U. S. Army of the last generation when traveling in Europe was much disgusted to observe that a green uniform was used in some of the armies for the corps of engineers and for branches of the service other

than rifles or tirailleurs. He insisted that the color naturally and necessarily belongs to the Rifles, because the soldiers of that arm when clad with that color were most useful as skirmishers in wooded regions. This reason for the selection of green for the riflemen who composed a part of the early army of the United States is correct, but in the necessity for the distinction of special uniforms for the several component parts of a military establishment, whether in Europe or America, the original and often obsolete application of color was wholly disregarded and colors were selected simply because they were not then appropriated by other branches of the service. So in the late formation of the signal corps of the U. S. Army, the color of orange, which had belonged to the old dragoons, was adopted simply because it was a good color no longer appropriated.

With these changes by abandonment and adoption comes fashion, which has its strong effect. It is even exemplified where least expected, i. e., in Stamboul. Every one knows that the descendants of the Prophet alone are entitled to wear green turbans, but a late Sultan, not being of the blood of Mohammed, could not wear the color, so the emirs who could do so carefully abstained from green in his presence and the color for the time was unfashionable.

As the evolution of clothing commenced with painting and tattooing, it may be admitted that what is now called fashion must have had its effect on the earlier as on the later forms of personal decoration. Granting that there was an ideographic origin to all designs painted on the person, the ambition or vanity of individuals to be distinctive and to excel must soon have introduced varieties and afterward imitations of such patterns, colors, or combinations as favorably struck the local taste. The subject therefore is much confused.

An additional suggestion comes from the study of the Mexican codices. In them color often seems to be used according to the fancy of the scribe. Compare pages 108 and 109 of the Codex Vaticanus, in Kingsborough, Vol. II, with pages 4 and 5 of the Codex Telleriano Remensis, in part 4 of Kingsborough, Vol. I, where the figures and their signification are evidently the same, but the coloration is substantially reversed.

A comparison of Henry R. Schoolcraft's published coloration with the facts found by the recent examination of the present writer is set forth with detail on page 202, supra.

In his copious illustrations colors were exhibited freely and with stated significance, whereas, in fact, the general rule in regard to the birch-bark rolls is that they were never colored at all; indeed, the bark was not adapted to coloration. His colors were painted on and over the true scratchings, according to his own fancy. The metaphorical coloring was also used by him in a manner which, to any thorough student of the Indian philosophy and religions, seems absurd. Metaphysical significance is attached to some of the colored devices, or, as he calls

them, symbols, which could never have been entertained by a people in the stage of culture of the Ojibwa, and those devices, in fact, were ideograms or iconograms.

<center>SECTION 4.</center>

GESTURE AND POSTURE SIGNS DEPICTED.

Among people where a system of ideographic gesture signs has prevailed it would be expected that their form would appear in any mode of pictorial representation used with the object of conveying ideas or recording facts. When a gesture sign had been established and it became necessary or desirable to draw a character or design to convey the same idea, nothing could be more natural than to use the graphic form or delineation which was known and used in the gesture sign. It was but one more step, and an easy one, to fasten upon bark, skins, or rocks the evanescent air pictures of the signs.

In the paper "Sign language among the North American Indians," published in the First Ann. Rep. of the Bureau of Ethnology, a large number of instances were given of the reproduction of gesture lines in the pictographs made by those Indians, and they appeared to be most frequent when there was an attempt to convey subjective ideas. It was suggested, therefore, that those pictographs which, in the absence of positive knowledge, are the most difficult of interpretation were those to which the study of sign-language might be applied with advantage. The topic is now more fully discussed. Many pictographs in the present work, the meaning of which is definitely known from direct sources, are noted in connection with the gesture-signs corresponding with the same idea, which signs are also understood from independent evidence or legitimate deduction.

Dr. Edkins (c) makes the following remarks regarding the Chinese characters, which are applicable also to the picture-writing of the North American Indians, and indeed to that of all peoples among whom it has been cultivated:

The use of simple natural shapes, such as the mouth, nose, eye, ear, hand, foot, as well as the shape of branches, trees, grass, caves, holes, rivers, the bow, the spear, the knife, the tablet, the leaf—these formed, in addition to pictures of animals, much of the staple of Chinese ideographs.

Attention should be drawn to the fact that the mouth and the hand play an exceptionally important part in the formation of the symbols.

Men were more accustomed then than now to the language of signs by the use of these organs. Perhaps three-twentieths of the existing characters are formed by their help as one element.

This large use of the mouth and hand in forming characters is, as we may very reasonably suppose, only a repetition of what took place when the words themselves were made.

There is likely to be a primitive connection between demonstratives and names for the hand, because the hand is used in pointing.

Fig. 983 is a copy of a colored petroglyph on a rock in the valley of Tule river, California, further described on page 52, et seq., supra.

a, a person weeping. The eyes have lines running down to the breast, below the ends of which are three short lines on either side. The arms and hands are in the exact position for making the gesture for rain. See *h* in Fig. 999, meaning eye-rain, and also Fig. 1002. It was probably the intention of the artist to show that the hands in this gesture should be passed downward over the face, as probably suggested by the short lines upon the lower end of the tears. It is evident that sorrow is portrayed.

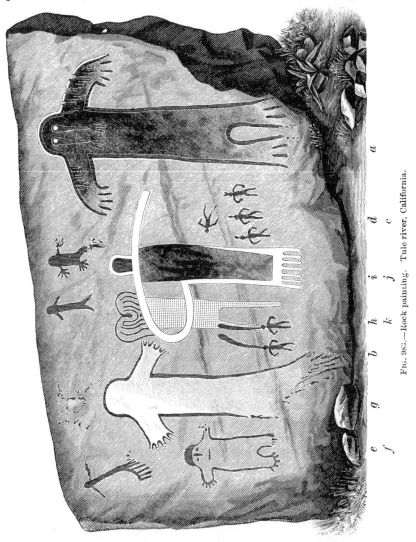

Fig. 983.—Rock painting. Tule river, California.

b, c, d, six persons apparently making the gesture for "hunger" by passing the hands towards and backward from the sides of the body, suggesting a gnawing sensation. The person, *d*, shown in a horizontal position, may possibly denote a "dead man," dead of starvation, this position being adopted by the Ojibwa, Blackfeet, and others as a com-

mon device to represent a dead body. The varying lengths of head ornaments denote different degrees of status as warriors or chiefs.

e, f, g, h, i. Human forms of various shapes making gestures for negation, or more specifically "nothing, nothing here," a natural and universal gesture made by throwing one or both hands outward toward either side of the body. The hands are extended, and, to make the action apparently more emphatic, the extended toes are also shown on *e, f, g,* and *i.* The several lines upon the leg of *i* probably indicate trimmings upon the leggings.

The character at *j* is strikingly similar to the Alaskan pictographs (see *b* of Fig. 460), indicating self with the right hand, and the left pointing away, signifying to go.

k. An ornamented head with body and legs. It may refer to a Shaman, the head being similar to the representations of such personages by the Ojibwa and Iroquois.

Similar drawings occur at a distance of about 10 miles southeast of this locality as well as at other places toward the northwest, and it appears probable that the pictograph was made by a portion of a tribe which had advanced for the purpose of selecting a new camping place, but failed to find the quantities of food necessary for sustenance, and therefore erected this notice to inform their followers of their misfortune and determined departure toward the northwest. It is noticeable that the picture is so placed upon the rock that the extended arm of *j* points toward the north.

The following examples are selected from a large number that could be used to illustrate those gesture signs known to be included in pictographs. Others not referred to in this place may readily be noticed in several parts of the present paper where they appear under other headings.

Fig. 984.—Afraid-of-him. Red-Cloud's Census. The following is the description of a common gesture sign used by the Dakotas for afraid, fear, coward:

FIG. 985.—Coward.

Crook the index, close the other fingers, and, with its back upward, draw the right hand backward about a foot, from 18 inches in front of the right breast. Conception, "Drawing back."

Fig. 985.—Afraid-of-him. Red-Cloud's Census. This is obviously the same device without clear depiction of the arm, which is explained by the preceding.

Fig. 986.—Little-Chief. Red-Cloud's Census. A typical gesture sign for chief is as follows:

FIG. 984.—Coward.

FIG. 986.—Little-Chief.

Raise the forefinger, pointed upwards, in a vertical direction and then reverse both finger and motion; the greater the elevation the "bigger" the chief. In this case the elevation above the head is slight, so the chief is "little."

Fig. 987.—The Dakotas went out in search of the Crows in order to avenge the death of Broken-Leg-Duck. They did not find any Crows, but, chancing on a Mandan village, captured it and killed all the people in it. American-Horse's Winter Count, 1787–'88.

FIG. 987.—Hit. The mark on the tipi is not the representation of a hatchet or tomahawk, but is explained by the gesture sign for " hit by a bullet from a gun," made by the Dakotas as follows:

With the hands in the position of the completion of the sign for discharge of a gun, draw the right hand back from the left, that is, in toward the body; close all the fingers except the index, which is extended, horizontal, back toward the right, pointing straight outward, and is pushed forward against the center of the stationary left hand with a quick motion. Conception, " Bullet comes to a stop. It struck."

Fig. 988. The first stock cattle were issued to them. American-Horse's Winter Count, 1875–'76. The figure represents a cow sur-

rounded by people. A common gesture sign distinguishing the cattle brought by Europeans from the buffalo is as follows:

Make sign for buffalo, then extend the left forefinger and draw the extended in-

FIG. 988.—Cow. dex across it repeatedly at different places.

Literally, spotted buffalo.

Fig. 989.—Kills-two. Red-Cloud's Census. In this figure only the suggestion of number is in point. Two fingers are extended.

Fig. 990.—Four Crow Indians killed by the Minneon-

ΩΩΩΩ jou Dakotas. The-Swan's Winter Count, 1864–'65.

FIG. 990.—Sign for Dakota. The four heads and necks are shown. The pictograph shows the tribe of the conquerors and

FIG. 989.—Two.

not that of the victims. The gesture sign for Dakota is as follows:

Forefinger and thumb of right hand extended (others closed) are drawn from left to right across the throat as though cutting it. The Dakotas have been named the " cut-throats" by some of the surrounding tribes.

Fig. 991.—Noon. Red-Cloud's Census. A Dakotan gesture sign for noon is as follows:

Make a circle with the thumb and index for sun, and then hold the hand overhead, the outer edge uppermost.

Fig. 992.—Hard. Red-Cloud's Census. This is the representation of a stone hammer and coincides with the Dakotan ges-

FIG. 992.—Hard.

FIG. 991.—Noon. ture sign for hard as follows:

Same as the sign for stone, which is: With the back of the arched right hand strike repeatedly in the palm of the left, held horizontal,

back outward, at the height of the breast and about a foot in front; the ends of the fingers point in opposite directions. Refers to the time when the stone hammer was the hardest pounding instrument the Indians knew.

Fig. 993.—Little-Sun. Red-Cloud's Census. The moon is expressed both in gestural and oral language as sun-little.

FIG. 993.—Moon.

Fig. 994. — Old - Cloud. Red-Cloud's Census. Cloud is drawn in blue in the original; old is signified by drawing a staff in the hand of the man. The Dakotan gesture for old is described as follows:

FIG. 994.—Old-Cloud.

With the right hand held in front of right side of body, as though grasping the head of a walking-stick, describe the forward arch movement, as though a person walking was using it for support. "Decrepit age dependent on a staff."

Fig. 995.—Call-for. Red-Cloud's Census. The gesture for come or to call to one's self is shown in this figure. This is similar to that prevalent among Europeans, and so requires no explanation.

FIG. 995.—Call-for.

Fig. 996.—The-Wise-Man was killed by enemies. Cloud-Shield's Winter Count, 1797–'98. The following gesture sign explains this figure:

Touch the forehead with the right index and then make the sign for big directly in front of it. Conception, "Big brain."

In this as in other delineations of gesture the whole of the sign could not be expressed, but only that part of it which might seem to be the most suggestive.

FIG. 996.—Wise-Man.

Fig. 997 is taken from the winter count of Battiste Good and is drawn to represent the sign for pipe, which it is intended to signify. The sign is made by placing the right hand near the upper portion of the breast, the left farther forward, and both held so that the index and thumb approximate a circle, as if holding a pipe-stem. The remaining fingers are closed.

The point of interest in this character is that, instead of drawing a pipe, the artist drew a human figure making the sign for pipe, showing the intimate connection between gesture-signs and pictographs. The pipe, in this instance, was the symbol of peace.

FIG. 998.—Searches-the-Heavens.

FIG. 997.—Sign for pipe.

Fig. 998.—Mahpiya-wakita, Searches-the-Heavens; from the Oglala Roster. The cloud is drawn in

blue, the searching being derived from the expression of that idea in gesture by passing the extended index of one hand (or both) forward from the eye, then from right to left, as if indicating various uncertain localities before the person, i. e., searching for something. The lines from the eyes are in imitation of this gesture.

<div align="center">WATER.</div>

The Chinese character for to give water is *a*, in Fig. 999, which may

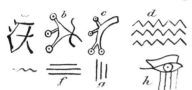

FIG. 999.—Water symbols.

be compared with the common Indian gesture to drink, to give water, viz: "Hand held with the tips of fingers brought together and passed to the mouth, as if scooping up water" (see Fig. 1000), obviously from primitive custom, as with Mojaves, who still drink with scooped hands, throwing the water to the mouth.

Another common Indian gesture sign for water to drink—I want to drink—is: "Hand brought downward past the mouth with loosely extended fingers, palm toward the face." This appears in the Mexican character for drink, *b*, in Fig. 999, taken from Pipart (*a*). Water, i. e., the pouring out of water with the drops falling or about to fall, is shown in Fig. 999, *c*, taken from the same author (*b*), being the same arrangement of them as in the Indian gesture-sign for rain, shown in Fig. 1002, the hand, however, being inverted. Rain in the Mexican picture-writing is sometimes shown by small circles inclosing a dot, as in the last two designs, but not connected together, each having a short line upward marking the line of descent. Several other pictographs for rain are given below.

FIG. 1000.—Gesture sign for drink.

With the gesture sign for drink may be compared Fig. 1001, the

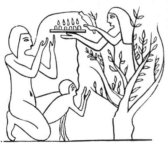

FIG. 1001.—Water, Egyptian.

Egyptian goddess Nu in the sacred sycamore tree, pouring out the water of life to the Osirian and his soul represented as a bird, in Amenti, from a funereal stelē in Cooper's Serpent Myths (*b*).

The common Indian gesture for river or stream—water—is made by passing the horizontal flat hand, palm down, forward and to the left from the right side in a serpentine manner.

The Egyptian character for the same is *d* in Fig. 999, taken from Champollion's Dictionary (*b*). The broken line is held to represent the movement of the water on the surface of the stream. When made with one line less angular and more waving it means water. It is interesting to compare with this the identical character in the syllabary invented by a West African negro, Mormoru Doalu Bukere, for water, *e*, in Fig. 999, mentioned by Dr. Tylor (*b*).

The abbreviated Egyptian sign for water as a stream is *f*, in Fig. 999, taken from Champollion, loc. cit., and the Chinese for the same is as in *g*, same figure.

In the picture writing of the Ojibwa the Egyptian abbreviated character, with two lines instead of three, appears with the same signification.

The Egyptian character for weep, *h*, in Fig. 999, i. e., an eye with tears falling, is also found in the pictographs of the Ojibwa, published by Schoolcraft (*o*), and is also made by the Indian gesture of drawing lines by the index repeatedly downward from the eye, though perhaps more frequently made by the full sign for rain—made with the back of the hand downward from the eye—"eye rain."

FIG. 1002.—Gesture for rain.

The sign is as follows, as made by the Shoshoni, Apache, and other Indians: Hold the hand (or hands) at the height of and before the shoulder, fingers pendent, palm down, then push it downward a short distance, as shown in Fig. 1002. That for heat is the same, with the difference that the hand is held above the head and thrust downward toward the forehead; that for to weep is made by holding the hand as in rain, and the gesture made from the eye downward over the cheek, back of the fingers nearly touching the face.

The upper design in Fig. 1003, taken from the manuscript catalogue of T. V. Keam, is water wrought into a meandering device, which is the conventional generic sign of the Hopitus. The two forefingers are joined as in the lower design in the same figure.

FIG. 1003.—Water sign. Moki.

In relation to the latter, Mr. Keam says: "At the close of the religious festivals the participants join in a parting dance called the 'dance of the linked finger.' They form a double line, and crossing their arms in front of them they lock the forefingers of either hand with those of their neighbors, in both lines, which are thus interlocked together, and then dance, still interlocked by this emblematic grip, singing their parting song. The meandering designs are emblems of this friendly dance."

CHILD.

The Arapaho sign for *child, baby*, is the forefinger in the mouth, i. e., a nursing child, and a natural sign of a deaf-mute is the same. The Egyptian figurative character for the same is seen in Fig. 1004 *a*. Its linear form is *b*, same figure, and its hieratic is *c*, Champollion (*c*).

These afford an interpretation to the ancient Chinese form for *son*, *d* in same figure, given in Journ. Royal Asiatic Society, I, 1834, p. 219, as belonging to the Shang dynasty, 1756–1112 B. C., and the modern Chinese form, *e*, which, without the comparison, would not be supposed to have any pictured reference to an infant with hand or finger at or approaching the mouth, denoting the taking of nourishment. Having now suggested this, the Chinese character for *birth*, *f* in same figure, is understood as a parallel expression of a common gesture among the Indians, particularly reported from the Dakota, for *born, to be born;* viz, place the left hand in front of the body a little to the right, the palm downward and slightly arched, then pass the extended right hand downward, forward, and upward, forming a short curve underneath the left, as in Fig. 1005 *a*. This is based upon the curve followed by the head of the child during birth, and is used generically. The same curve, when made with one hand, appears in Fig. 1005 *b*.

It may be of interest to compare with the Chinese *child* the Mexican abbreviated character for *man*, Fig. 1004 *g*, found in Pipart (*c*). The character on the right is called the abbreviated form of the one by its side.

FIG. 1004.—Symbols for child and man.

The Chinese character for *man* is Fig. 1004 *h*, and may have the same obvious conception as a Dakota sign for the same signification: "Place the extended index pointing upward and forward before the lower portion of the abdomen."

A typical sign made by the Indians for *no, negation*, is as follows:

The hand extended or slightly curved is held in front of the body, a

FIG. 1005.—Gestures for birth.

little to the right of the median line; it is then carried with a rapid sweep a foot or more farther to the right.

The sign for *none, nothing*, sometimes used for simple negation, is made by throwing both hands outward from the breast toward their respective sides.

With these compare the two forms of the Egyptian character for no, negation, the two upper characters of Fig. 1006 taken from Champollion (*d*). No vivid fancy is needed to see the hands indicated at the extremities of arms extended symmetrically from the body on each side.

Also compare the Maya character for the same idea of negation, the lowest character of Fig. 1006, found in Landa (*a*). The Maya word for negation is

FIG. 1006.—Negation.

"*ma*," and the word "*mak*," a six-foot measuring rod, given by Brasseur de Bourbourg in his dictionary, apparently having connection with this character, would in use separate the hands as illustrated, giving the same form as the gesture made without the rod.

Another sign for *nothing, none*, made by the Comanche is: Flat hand thrown forward, back to the ground, fingers pointing forward and downward. Frequently the right hand is brushed over the left thus thrown out.

Compare the Chinese character for the same meaning, the upper character of Fig. 1007. This will not be recognized as a hand without study of similar characters, which generally have a cross-line cutting off the wrist. Here the wrist bones follow under the crosscut, then the metacarpal

FIG. 1007.—Hand. bones, and last the fingers, pointing forward and downward.

Leon de Rosny (*a*) gives the second and third characters in Fig. 1007 as the Babylonian glyphs for "hand," the upper being the later and the lower the archaic form.

Fig. 1008 is reproduced from an ivory drill-bow (U. S. Nat. Mus., No. 24543) from Norton sound, Alaska. The figure represents the gesture sign or signal of discovery. In this instance the game consists of whales, and the signal is made by holding the boat paddle aloft and horizontally.

FIG. 1008.—Signal of discovery.

Fig. 1009, reproduced from Fig. 365, p. 308, Sixth Ann. Rep. Bureau of Ethnology, is a copy of Pl. 53 of the Dresden Codex, and is a good example of the use of gestures in the Maya graphic system. The main figure in the upper division of the plate, probably that of a deity or ruler, holds his right hand raised to the level of the head, with the index prominently separated from the other fingers. This is the first part of a sign common to several of the Indian tribes of North America and signifies affirmation or assent. The Indians close the fingers other than the index more decidedly than in the plate and, after the hand has reached its greatest height, shake it forward and down, but these details, which indeed are not essential, could not well be indicated pic-

Fig. 1009.—Pictured gestures. Maya.

torially. The human figure in the lower division is kneeling and holds

both hands easily extended be-
fore the body, palms down and
index fingers straight, parallel,
and separated from the other
fingers, which are flexed or
closed. This in its essentials is
a common Indian gesture sign
for "the same," "similar," and
also for "companion." A sign
nearly identical is used by the
Neapolitans to mean "union"
or "harmony." If the two di-
visions of the plate are supposed
to be connected, it might be in-
ferred through the principles of
gesture language that the kneel-
ing man was praying to the
seated personage for admission
to his favor and companionship,
and that the latter was respond-
ing by a dignified assent.

Dr. S. Habel (e) thus describes
Fig. 1010, a sculpture in Gua-
matela:

The upper half represents the head,
arms, and part of the breast of a deity,
apparently of advanced age, as indi-
cated by the wrinkles in the face.
The right arm is bent at the elbow,
the finger tips of the outstretched
hand apparently touching the region
of the heart; the left upper arm is
drawn up, the elbow being almost as
high as the shoulder, and the fore
arm and hand hanging at nearly
right angles. From the head and
neck issue winding staves, to which
not only knots or nodes are attached,
but also variously - shaped leaves,
buds, flowers, and fruits. Appar-
rently these are symbols of speech,
eplacing our letters and expressing
the mandate of the deity.

The lower part represents an erect
human figure with the face turned up
toward the deity imploring, and from
the mouth emanates a staff with

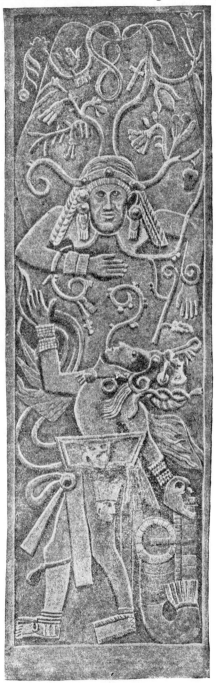

FIG. 1010.—Pictured gestures. Guatemala

nodes variously arranged. The appeal is still further intensified by the raising of the right hand and arm. A human head partly covers the head of the figure, from which hang variously-shaped ribbons, terminating in the body and tail of a fish. Above the right wrist is a double bracelet, apparently formed of small square stones. The left hand is covered, gauntlet-like, by a human skull, and the wrist is ornamented by a double scaly bracelet. The waist is encircled by a stiff projecting girdle, which differs from the general style of this ornament by having attached to it on the side a human head, with another human head suspended from it. From the front of the girdle emanate four lines, which ascend towards the deity, uniting at the top. They seem to symbolize the emotions of the person, not expressed by words. From behind the image issue flames.

CHAPTER XIX.

CONVENTIONALIZING.

Before writing was invented by a people there were attempts in its direction which are mentioned in other chapters of this paper. Human forms were drawn pictorially in the act of making gesture signs and in significant actions and attitudes and combinations of them. Other natural objects, as well as those purely artificial, which represented work or the result of work, were also drawn with many differing significations. When any of these designs had become commonly adopted on account of its striking fitness or even from frequent repetition with a special signification, it became a conventional term of thought-writing, with substantially the same use as when, afterward, the combinations of letters of an alphabet into words became the arbitrary signs of sound-writing. While the designs thus became conventional terms, their forms became more and more abbreviated or cursive until in many cases the original concept or likeness was lost. Sometimes when a specimen of the original form is preserved, its identity in meaning with the current form can be ascertained by correlation of the intermediate shapes.

The original ideography is often exhibited by exaggeration. For instance, a loud voice has been sometimes indicated by a human face with an enormous mouth. Hearing, among the Peruvians, was early expressed by a man with very large ears; then by a head with such ears, and afterwards by the form of the ears without the head. Soon such forms became so conventionalized as to be practically ideographic writing. In the same manner a numeral cipher has become the representation of a mathematical quantity, a written musical note shows a kind and degree of sound, and other pictured signs give values of weights and measures. All of these signs express ideas independent of any language and may be understood by peoples speaking all diversities of language.

So also the idea of smallness and subjection may be conveyed by drawing an object in an obviously diminished size, of which examples are given in this chapter. Another expedient, illustrations of which also appear, is by repetition and combination, with reference to which the following condensed remarks of James Summers (a) are in point:

The earliest Chinese characters were pictorial; but pictures could not be made which would clearly express all ideas. One of the means devised to express concepts that could not be indicated by a simple sketch, was to combine two or more familiar pictures. For instance, a man with a large eye represents "seeing;" two men, "to follow;" three men, "many;" two men on the ground, "sitting."

All other means failing, the present great mass of characters was formed by a principle from which the class is called "phonetic;" because in the characters classed under it, while one part (called the "radical") preserves its meaning, the other part (called the "phonetic" or "primitive") is used to give its own sound to the whole figure. This part does sometimes, however, convey also its symbolic meaning as well as its sound.

But while the original mode of expressing ideas required various devices, when an idea had become established in pictography there always appeared an attempt to simplify the figure and reduce it in size, so as to require less space in the drafting surface and also to lessen the draftsman's labor. This was more obvious in the degree in which the figure was complicated and of frequent employment.

For convenience the subject is divided into: 1. Conventional devices. 2. Syllabaries and alphabets.

<div align="center">SECTION 1.</div>

CONVENTIONAL DEVICES.

PEACE.

Among the North American Indians and in several parts of the world where, as among the Indians, the hand-grasp in simple salutation has not been found, the junction of the hands between two persons of different tribes is the ceremonial for union and peace, and the sign for the same concept is exhibited by the two hands of one person similarly grasped as an invitation to, or signification of, union and peace. The ideogram of clasped hands to indicate peace and friendship is found in pictographs from many localities. The exhibition and presentation of the unarmed hand may have affected the practice, but the concept of union by linking is more apparent.

Fig. 1011.—The Dakotas made peace with the Cheyenne Indians. The-Swan's Winter Count, 1840–'41. Here the hands shown with fingers extended, and therefore incapable of grasping a weapon, are approaching each other. The different coloration of the arms indicates different tribes. The device on the right is a rough form

<div align="center">FIG. 1011.</div>

of the forearm of the Cheyenne marked as mentioned several times in this work.

Fig. 1012.—The Dakotas made peace with the Pawnees. American-Horse's Winter Count, 1858–'59. The man on the left is a Pawnee.

Fig. 1013.—A Mandan and a Dakota met in the middle of the Missouri River, each swimming halfway across. They shook hands there and made peace. The-Flame's Winter Count, 1791–'92.

<div align="center">FIG. 1012.</div>

<div align="center">FIG. 1013.</div>

Mulligan, post interpreter at Fort Buford, says that this was at Fort Berthold, and is an historic fact; also that the same Mandan long afterwards, killed the same Dakota.

Fig. 1014.—The Omahas came and made peace to get their people whom
the Dakotas held as prisoners. Cloud-Shield's
Winter Count, 1804–'05. The attitudes and ex
pressions are unusually artistic. The uniting
line may only intensify the idea of a treaty result-
ing in peace, but perhaps recognizes the fact that
the Omaha (on the left) and Dakota belong to
the same Siouan stock. The marks on the Omaha
are not tribal, but refer to the prisoners—the
marks of their bonds.

FIG. 1014.

Fig. 1015.—The Dakotas made peace with the Crows at Pine Bluff.
American-Horse's Winter Count, 1816–'17. The arrow shows they had
been at war. The Indian at the left is a Crow.
The distinctive and typical arrangement of the
hair of the several tribes in this and the preceding
figure are worthy of note.

FIG. 1015.

Fig. 1016.—The Dakotas
made peace with the Paw-
nees. Cloud-Shield's Win-
ter Count, 1814–'15. The
man with the marked fore-
head, blue in the original,
is a Pawnee, the other is a

FIG. 1016.

Dakota, whose body is smeared with clay. The four arrows show that
they had been at war, and the clasped hands denote peace.

Fig. 1017.—They made peace
with the Gros Ventres. Amer-
ican-Horse's Winter Count,
1803–'04. But one arrow is
shown, indicating that the
subject in question was war,
but that it was not waged at

FIG. 1017.

FIG. 1018.

the time, as would have been shown by two opposed arrows.

Fig. 1018.—Dakotas made peace with the Crow Indians. The-Swan's
Winter Count, 1851–'52. Here the representatives of the two tribes
show their pipes crossed, indicating exchange as is expressed by a com-
mon gesture sign.

Fig. 1019.—Made peace with Gen. Sherman and others at Fort Lara-
mie. The-Swan's Winter Count, 1867–'68. This is the adoption of the
white man's flag, as the paramount symbol
on recognition of which peace was made.

WAR.

Fig. 1020.—The Dakotas were at war
with the Cheyennes. American-Horse's
Winter Count, 1834–'35. The Cheyenne is

FIG. 1019.

FIG. 1020.

the man with stripes on his arm. The two arrows shot in opposite directions form one of the conventional symbols for war.

FIG. 1021.

Fig. 1021 is taken from the Winter Count of Battiste Good for the year 1840–'41. He names it "Came-and-killed-five-of-Little-Thunder's-brothers winter." He explains that the five were killed in an encounter with the Pawnees. The capote or headdress, always but not exclusively worn by Dakota war parties, is shown, and is the special symbol of war as also given in several other places in the same record. The five short vertical lines below the arrow signify that five were killed.

Fig. 1022.—War-Eagle. Red-Cloud's Census. This figure shows a highly abbreviated conventional symbol. The pipe used in the ceremonial manner explained on page 539 et seq. means war and not peace, and the single eagle feather stands for the entire bird often called the war-eagle.

FIG. 1022.

The adoption of a mat or mattress as an emblem of war or a military expedition is discussed and illustrated, supra, p. 553, Fig. 782.

In the Jesuit Relation for 1606, p. 51, it is narrated that "The Huron and Northern Algonkin chiefs, when their respective war parties met the enemy, distributed among their warriors rods which they carried for the purpose, and the warriors stuck them in the earth as a token that they would not retreat any more than the rods would."

In their pictographs the rods became represented by strokes which were not only numerical, but signified warriors.

CHIEF.

Fig. 1023.—Naca-haksila, Chief-Boy. From the Oglala Roster. The large pipe held forward with the outstretched hand is among the Oglalas the conventional device for chief. This is explained elsewhere by the ceremonies attendant on the raising of war parties, in which the pipe is conspicuous. That the human figure is a boy is indicated by the shortness of the hair and the legs.

Fig. 1024, drawn by a Passamaquoddy Indian, shows the manner of representing a war chief by that tribe:

It signifies a chief with 300 braves. The relative magnitude of the leading human figure indicates his rank. In this particular compare Figs. 137, 138, and 142. The device is common in the Egyptian glyphs.

FIG. 1023.—Chief-Boy.

Dr. Worsnop, op. cit., makes the following remarks about a similar device in Australia:

At Chasm island, in the Gulf of Carpentaria, indenting Australia, the third person of a file of thirty-two painted on the rock was twice the height of the others, and held in his hand

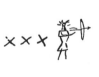

FIG. 1024.—War Chief. Passamaquoddy.

something resembling the waddy, or wooden sword, of the natives of Port Jackson, and was probably intended to represent a chief. They could not as with us, indicate superiority by clothing or ornament, since they wear none of any kind, and therefore, with the addition of a weapon similar to the ancients, they seem to have made superiority of persons the principal emblem of superior power, of which, indeed power is usually a consequence in the very early stages of society.

The exhibition of horns as a part of the head dress, or pictorially displayed as growing from the head, is generally among the tribes of Indians an emblem of power or chieftancy. It is distinctly so asserted by Schoolcraft, vol. I, p. 409, as regards the Ojibwa, and by Lafitau, vol. II, 21, both authors presenting illustrations. The same concept was ancient and general in the eastern hemisphere. The images of gods and heads of kings were thus adorned, as at a later day were the crests of the dukes of Brittany. Some writers have suggested that this symbols was taken from the crescent moon, others that it referred to the vigor of the bull. Col. Marshall (a), however, gives an instance of special derivation. He says that the Todas, when idle, involuntarily twist and split branches of twigs and pieces of cane into the likeness of buffalo horns, because they dream of buffalo, live on and by it, and their whole religion is based on the care of the cow.

COUNCIL.

Fig. 1025 is taken from the Winter Count of Battiste Good for the

FIG. 1025.

year 1851–'52. In that year the first issue of goods was made to the Dakotas, and the character represents a blanket surrounded by a circle to show how the Indians sat awaiting the distribution. The people are represented by small lines running at right angles to the circle.

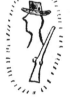

FIG. 1026.

Fig. 1026.—The-Good-White-Man returned and gave guns to the Dakotas. American-Horse's Winter Count, 1799–1800. The

FIG. 1027.

circle of marks represents the people sitting around him, the flint-lock musket the guns.

Fig. 1027.—Council at Spotted-Tail agency. The-Flame's Winter Count, 1875–'76. Here the circle composed of short lines pointing to the center takes the conventional form frequently used to designate a council.

FIG. 1028.

Fig. 1028.—Surrounds-them. Red-Cloud's Census. This figure is introduced in this place to show the

distinction made by an antagonistic "surround" and the peaceable ring depicted immediately before.

Fig. 1029.—The Dakotas had a council with the whites on the Mis-

souri river below the Chey-
enne agency, near the mouth of Bad creek. They had many flags which the Good-White-Man gave them with their guns, and they erected them on poles to show their friendly feelings. American - Horse's Winter Count, 1805–'06. This was per-haps their meeting with the Lewis and Clarke expedition. The curved line is drawn to represent the council lodge, which they made by

FIG. 1029.

FIG. 1030.

opening several tipis and uniting them at their sides to form a semicircle. The small dashes are for the people. This is a compromise between the Indian and the European mode of designating an official assemblage.

PLENTY OF FOOD.

Fig. 1030.—The Dakotas have an abundance of buffalo meat. Cloud-Shield's Winter Count, 1856–'57. This is shown by the full drying pole on which it was the usage after successful hunts to hang the pieces of meat to be dried for preservation.

Fig. 1031.—The Oglalas had an abundance of buffalo meat and shared

it with the Brulés, who were short of food. American-Horse's Winter Count, 1817–'18. The buffalo hide hung on the drying pole, with the buffalo head above it, indicates an abundance of meat, as in the preceding figure.

Fig. 1032 is taken from Battiste Good's Winter Count for the year 1745–'46, in which

FIG. 1031.

FIG. 1032.

the drying-pole is as usual supported by two forked sticks or poles. This is a variant of the two preceding figures.

Fig. 1033.—Immense quantities of buffalo meat. The-Swan's Winter Count, 1845–'46. This is another form of drying-pole in which a tree

is used for one of the supports. The pieces of meat would not be recognized as such without explanation by the preceding figures.

Fig. 1034 is taken from the Winter Count of Battiste Good for the year 1703–'04. The forked stick being one of the supports of the drying pole or scaffold, indicates meat. The irreg-ular circular object means "heap,"

FIG. 1033.

FIG. 1034.

i. e., large quantity, buffalo having been very plentiful that year. The buffalo head denotes the kind of meat stored. This is an abbreviated form of the device before presented, and affords a suggestive comparison with some Egyptian hieroglyphics and Chinese letters, both in their full pictographic origin and in their abbreviation.

Fig. 1035.—The Dakotas had unusual quantities of buffalo. The-Swan's Winter Count, 1816–'17. This representation of a buffalo hide or side is another sign for abundance of meat, and is the most abbreviated and conventional of all, with the same significance, in the collections now accessible.

FIG. 1035.

FIG. 1036.

Fig. 1036.—The Dakotas had unusual abundance of buffalo. The-Swan's Winter Count, 1861–'62. This is another mode of expressing the same abundance. The buffalo tracks, shown by the cloven hoofs, are coming up close to the tipi.

Fig. 1037.—They had an abundance of corn, which they got at the Ree villages. American-Horse's Winter Count, 1823–'24.

The symbol shows the maize growing, and also is the tribal sign for Arikara or Ree.

FIG. 1037.

FIG. 1038.

FAMINE.

Fig. 1038.—The Dakotas had very little buffalo meat, but plenty of ducks in the fall. Cloud-Shield's Winter Count, 1811–'12. The bare, drying pole is easily interpreted, but the reversed or dead duck would not be understood without explanation.

FIG. 1039.

Fig. 1039.—Food was very scarce and they had to live on acorns. Cloud-Shield's Winter Count, 1813–'14. The tree is intended for an oak and the dots beneath it for acorns.

FIG. 1040.

Fig. 1040.—A year of famine. Cloud-Shield's Winter Count, 1787–'88. They, i. e., the Dakotas, lived on roots, which are represented in front of the tipi.

Fig. 1041.—They could not hunt on account of the deep snow, and were compelled to subsist on anything they could get, as herbs (pézi) and roots. American-Horse's Winter Count, 1790–'91.

FIG. 1041.

Fig. 1042.—They had to sell many mules and horses to get food, as

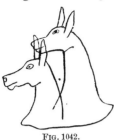

they were starving. Cloud-Shield's Winter Count, 1868–'69. White-Cow-Killer calls it "Mules-sold-by-hungry-Sioux winter." The figure is understood as a conventionalized sign by

Fig. 1042.

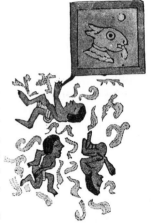

reference to the historic fact mentioned. The line of union between the horses' necks shows that the subject-matter was not a horse trade, but that both of the animals, i. e., many, were disposed of.

Fig. 1043.—Kingsborough (*l*) gives the pictograph recording that "In the year of

Fig. 1043.

One Rabbit and A. D. 1454 so severe a famine occurred that the people died of starvation." It is reproduced in Fig 1043.

STARVATION.

Fig. 1044.—Many horses were lost by starvation, as the snow was so deep they couldn't get at the grass. Cloud-Shield's Winter Count, 1865–'66.

Fig. 1045, from the record of Battiste Good for the year 1720–'21, signifies starvation, denoted by the bare ribs.

This design is abbreviated and conventionalized among the Ottawa and Pottawatomi Indians. Among the latter a single line only is drawn across the breast, shown in Fig. 1046. This corresponds also with one of the Indian gesture-signs for the same idea.

Fig. 1044.

Fig. 1045.

See also the Abnaki sign of starvation, a pot upside down, in Fig. 456, supra.

HORSES.

Fig. 1047.—They caught many wild horses south of the Platte river. American-Horse's Winter Count, 1811–'12. This figure shows a horse in the process of being caught by a lasso.

Fig. 1046.

Fig. 1047.

Fig. 1048.—Many wild horses caught. The-Flame's Winter Count, 1812–'13.

Fig. 1049.—Dakotas first used a lasso for catching wild horses. The-Swan's Winter Count, 1812–'13. In these two figures the lasso is shown without the animal, thus becoming the conventional sign for wild horse.

FIG. 1048.

Fig. 1050.—Crow Indians stole 200 horses from the Minneconjou Dakotas, near Black Hills. The-Swan's Winter Count, 1849–'50. This figure is inserted to show in the present connection the lunules, which signify unshod horses. The Indians never shod their ponies, and the hoof marks may be either of wild horses, herds of which formerly roamed the prairies, or the common horses brought into subjection.

FIG. 1050.

FIG. 1049.

Fig. 1051.—Blackfeet Dakotas stole some American horses having shoes on. Horseshoes seen for the first time. The-Swan's Winter Count, 1802–'03. The horseshoe here depicted is the conventional sign for the white man's horse.

FIG. 1051.

HORSE STEALING.

Fig. 1052.—Runs-off-the-Horse. Red-Cloud's Census. "Runs off" in the parlance of the plains means stealing.

Fig. 1053.—Runs-off-the-Horse. Red-Cloud's Census. This figure explains the one preceding. The man has in his hand a lariat or perhaps a lasso.

Fig. 1054.—Drags-the-Rope. Red-Cloud's Census. This is a variant of the last figure, without, however, the exhibition of anything, such as tracks, to indicate horses.

Fig. 1052.

FIG. 1053.

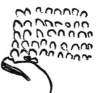

FIG. 1054. FIG. 1055. FIG. 1056.

Fig. 1055.—Dog, an Oglala, stole seventy horses from the Crows. American-Horse's Winter Count, 1822–'23. Each of the seven tracks stands for ten horses. A lariat, which serves the purpose among others of a long whip, and is usually allowed to trail on the ground, is shown in the man's hand.

Fig. 1056.—Sitting-Bear, American-Horse's father, and others, stole two hundred horses from the Flat Heads. American-Horse's Winter Count, 1840–'41. A trailing lariat is in the man's hand.

Fig. 1057.—Brings-lots-of-horses. Red-Cloud's Census. This is a

 further step in conventionalizing. The lariat is but slightly indicated as connected with the horse track on the lower left-hand corner.

FIG. 1057.

Fig. 1058.—The Utes stole all of the Brulé horses. Cloud-Shield's Winter Count, 1874– '75. The mere indication of a number of

FIG. 1058.

horse tracks without any qualifying or determinative object means that the horses are run off or stolen. This becomes the most conventionalized form of the group.

Fig. 1059.—Steals-Horses. Red-Cloud's Census. In this figure the horse tracks themselves are more rude and conventionalized.

The Prince of Wied mentions, op. cit., p. 104, that in the Sac and Fox tribes the rattle of a rattlesnake attached to the end of the feather worn on the head signifies a good horse stealer. The stealthy approach of the serpent, accompanied with latent power, is here clearly indicated.

FIG. 1059.

Fig. 1060.—Making-the-Hole stole many horses from a Crow tipi. Such is the translation in Cloud-Shield's Winter Count, 1849–'50. The man is cutting the hole with a knife. Through the orifice thus made he obtains access to the horse. But it is more probable that the single tipi represents a village into which the horse-thief effected an entrance and ran off the horses belonging to it.

FIG. 1061.

FIG. 1060.

KILL AND DEATH.

Fig. 1061.—Male-Crow, an Oglala, was killed by the Shoshoni. American-Horse's Winter Count, 1844–'45. The bow in contact with the head of the victim is frequently the conventional sign for "killed by an arrow." This is not drawn in the Winter Counts on the

FIG. 1062.

same principle as the touching with a lance or coup stick, elsewhere mentioned in this paper, but is generally intended to mean killed, and to specify the manner of killing, though in fact before the use of firearms the "coup" was often counted by striking with a bow.

Fig. 1062.—Kills-in-tight-place. Red-Cloud's Census. This man has evidently been enticed into an ambush, to which his tracks lead.

Fig. 1063.—Uncpapas kill two Rees. The-Flame's Winter Count, 1799–1800. The object over the heads of the two Rees, projecting from the man figure, is a bow, showing the mode of death. The hair of the Arickaras is repre-sented. This is clearly con-ventional and would not be understood from the mere de-lineation.

FIG. 1063.

FIG. 1064.

Fig. 1064.— Kills-by-the-camp. Red-Cloud's Census.

The camp is shown by the tipi, and the idea of "kill" by the bow in contact with the head of the victim.

Fig. 1065.—Kills-Two. Red-Cloud's Census. Here is the indication of number by upright lines united by a hori-zontal line, as designating the same occasion and the same people, two of whom are struck by the coup stick.

Fig. 1066.—Feather-Ear-Rings was killed by the Shoshoni. American-Horse's Winter Count, 1842–'43. The four lodges and the many blood-stains intimate that he was killed in a battle when four lodges of Shoshoni were killed. Again appears the character for successful gunshot wound, before explained in connection with Fig. 987.

FIG. 1065.

FIG. 1066.

Fig. 1067.—Kills-the-Bear. Red-Cloud's Census. Here there appears to be a bullet mark in the middle of the paw representing the middle of the whole ani-mal. The idea of death may be indicated by the reverse attitude of the paws, which are turned up, corresponding with the slang expression "toes up," to indicate death.

FIG. 1067.

Fig. 1068.—They killed a very fat buffalo bull. American-Horse's Winter Count, 1835–'36. This figure is introduced to show an ingenious differentiation. The rough outline of the buffalo's forequarters is given

sufficiently to show that the arrow penetrates to an unusual depth,

which indicates the mass of fat, into the region of the buffalo's respiratory organs, and therefore there is a discharge of blood not only from the point of entrance of the arrow, but from the nostrils of the animal. No device of an analogous character is found among five hundred of the Dakotan pictographs studied, so that the designation of abnormal fat is made evident.

FIG. 1068.

FIG. 1069.—They killed many Gros Ventres in a village which they assaulted. American-Horse's Winter

FIG. 1069.

Count, 1832–'33. The single scalped head shows the killing. This conventional sign is so common as hardly to require notice.

Fig. 1070, taken from Mrs. Eastman's Dakota (*e*), shows the Dakota pictograph for "killed": *a* is a woman and *b* a man killed, and *c* and *d* a boy and girl killed.

a *b* *c* *d*

FIG. 1070.—Killed, Dakota.

Fig. 1071, taken from Copway (*g*), gives two characters which severally represent life and death, the black disk representing death and the simple circle life.

In Doc. Hist. N. Y. (*d*), is the illustration now copied as Fig. 1072 with the statement that it shows the fashion of painting the dead among the Iroquois; the first two

FIG. 1071.—Life and death. Ojibwa.

are men and the third is a woman, who is distinguished only by the waistcloth that she wears.

The device is further explained by the following paragraphs from the

FIG. 1072.—Dead. Iroquois.

same volume, on p. 6, which add other details:

When they have lost any men on the field of battle they paint the men with the legs in the air and without heads, and in the same number as they have lost; and to denote the tribe to which they belonged, they paint the animal of the tribe of the deceased on its back, the paws in the air, and if it be the chief of the party that is dead, the animal is without the head.

If there be only wounded, they paint a broken gun which, however, is connected with the stock, or even an arrow, and to denote where they have been wounded, they paint the animal of the tribe to which the wounded belong with an arrow piercing the part in which the wound is located; and if it be a gunshot they make the mark of the ball on the body of a different color.

Fig. 1073.—This is drawn by the Arikara for "dead man" and perhaps suggests the concept of nothing inside, i. e., no life, with a stronger emphasis than given to "lean" in Fig. 903, supra. It must be noted, however, that the Hidatsa draw the same character for "man" simply.

FIG. 1073.—Dead man. Arikara.

La Salle, in 1680, wrote that when the Iroquois had killed people they made red strokes with the figure of a man drawn in black with ban-

daged eyes. As this bandaging was not connected with the form of kill-ing, it may be conjectured that it ideographically meant death—the light of life put out.

For other devices to denote "Kill," see Figs. 93 and 94.

SHOT.

In this group the figures show obvious similarity yet seem to be graphic, or at least ideographic, but on examining the text of the several records conventionality is developed.

FIG. 1074. FIG. 1075. FIG. 1076.

Fig. 1074.—Shot-at. Red-Cloud's Census. Here is shown the dis-charge of guns and lines of passage of the bullets, one of which is graphically displayed passing the neck of the human figure, but without either graphic mark of wound or the conventional sign for "hit" or "it struck." He was shot at by many enemies, but was not hit.

Fig. 1075.—Shot. Red-Cloud's Census. There is no doubt that this man, a Dakota, was actually shot with an arrow.

Fig. 1076.—Shot-at-his-horse. Red-Cloud's Census. Here again are the flashes made by the discharge of guns and the horse tracks showing horses, but no spe-cific indication of hitting. The mark within the right-hand horse track may be compared with the passing bul-let in Fig. 1074. The horse was shot at but not hit.

Fig. 1077.—Shot-his-horse. Red-Cloud's Census. This figure is to be correlated with the last one, as it shows actual hitting and blood flowing from the wound.

FIG. 1077.

Fig. 1078.—Shot-in-front-the-lodge. Red-Cloud's Census. Without

explanation derived from the context this figure would not be understood. The right hand character means several bows united. Between these and the tipi is the usual de-vice for blood flowing vertically downwards, meaning a fatal shot, and the device dis-played horizontally and touching the tipi means that the man shot belonged to that tipi or lodge, in front of which he was shot.

FIG. 1078.

COMING RAIN.

FIG. 1079.—Com-
ing rain.

Mr. Keam in his MS. describes Fig. 1079 as two forms of the symbol of Aloseka, which is the bud of the squash. The form seen in the upper part of the figure, drawn in profile, is also used by the Moki to typify the east peak of the San Francisco mountains, the birthplace of the Aloseka; when the clouds circle, it presages the coming rain. In the rock carvings the curving profile is further conventionalized into straight lines and assumes the lower form.

The collection of characters given in Figs. 1080 and 1081 are selected from a list published by Maj. C. R. Conder (*b*). That list includes all the Hittite designs distinctly deciphered which are so far known, and they are divided by the author into two plates, one giving the "Hittite emblems," as he calls them, "of known sound," and which are all compared with the Cypriote, and some with the cuneiform, Egyptian, and other characters; and the other comprising the "Hittite emblems of uncertain sound." The collection is highly suggestive for comparison of the significance of many forms commonly appearing in several lands and also as a study of conventionalizing. In these respects its presentation renders it unnecessary to dwell as much as would otherwise be required upon the collections of Egyptian and cuneiform characters, with which students are more familiar and which teach substantially the same lessons.

HITTITE EMBLEMS OF KNOWN SOUND.

a, a crook. Cypriote *u*.

b, apparently a key. Cypriote *ke*. Compare the cuneiform emblem *ik*, "to open."

c, a tiara. Cypriote *ko*; Akkadian *ku*, "prince;" Manchu *chu*, "lord."

d, another tiara, apparently a variant of *c*.

e, hand and stick. Cypriote *ta*, apparently a causative prefix, like the Egyptian determinative; Chinese *ta*, "beat."

f, an herb. Cypriote *te*; Akkadian *ti*, "live;" Turkish *it*, "sprout;" *ot*, "herb."

g, the hand grasping. Cypriote *to*. Compare the Egyptian, cuneiform and Chinese signs for "touch," "take," "have." Akkadian *tu*, "have."

h, apparently a branch. Cypriote *pa*. Compare Akkadian *pa*, "stick" (Lenormant).

i, apparently a flower. Cypriote *pu*. Compare the Akkadian emblem *pa*, apparently a flower. Akkadian *pu*, "long;" Tartar *boy*, "long," "growth," "grass;" Hungarian *fu*, "herb."

j, a cross. Cypriote *lo*; Carian *h*.

k, a yoke. Cypriote *lo* and *le*; Akkadian *lu*, "yoke."

l probably represents rain. Compare the Egyptian, Akkadian, and Chinese emblems for "rain," "storm," "darkness."

m seems to represent drops of water equivalent to the last. Cypri
ote *re*.

n, possibly the "fire-stick." Cypriote *ri*. Occurs as the name of a
deity. Akkadian *ri*, "bright," the name of a deity.

o, two mountains. Cypriote *me* or *mi*. The emblem for "country."

p resembles the cuneiform sign for "female."

q, this is the sign of opposition in cuneiform, in Chinese and Egyp-
tian. Cypriote *mu* or *no* (*nu*, "not").

r, a pot. Cypriote *a* or *ya*. Compare the Akkadian *a*, "water."

s, a snake. Perhaps the Cypriote *ye*.

t, apparently a sickle. Cypriote *sa*. Compare the Tartar *sa*, *se*,
"knife."

u, the open hand. Cypriote *se*. Akkadian *sa*, "give." Tartar *saa*,
"take."

v resembles the cuneiform and Chinese emblem for "breath," "wind,"
"spirit." Cypriote *zo* or *ze*. Occurs as the name of a god. Akkadian
zi, "spirit."

w resembles the Chinese, cuneiform, and Egyptian emblem for heaven.
Akkadian *u*. It may be compared with the Carian letter *u* or *o*.

x, the foot, used evidently as a verb, and resembles the cuneiform *du*.
Probably may be sounded as in Akkadian and used for the passive (*du*,
"come" or "become").

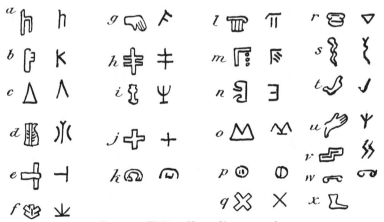

FIG. 1080.—Hittite emblems of known sound.

HITTITE EMBLEMS OF UNCERTAIN SOUND.

y, a serpent. Occurs in the name of a god.

z, perhaps a monument. It recalls the Cypriote *ro*.

aa, apparently a monument.

bb, probably the sun (*ud* or *tam*).

cc, apparently a house.

dd, perhaps the sole of the foot.

ee, a donkey's head. Probably the god Set.

ff, a ram's head. Probably with the sound *gug* or *guch* and the meaning "fierce," "mighty."

gg, a sheep's head. Probably *lu* or *udu*.

hh, a dog or fox head.

ii, a lion's head. Only on seals.

jj, a demon's head. Used specially in a text which seems to be a magic charm.

kk, two legs. Resembles the cuneiform *dhu*, and means probably "go" or "run."

ll, two feet. Probably "stand;" or "send," as in Chinese.

mm, apparently an altar.

nn, perhaps a bundle or roll.

oo, apparently a knife or sword; perhaps *pal*.

pp, apparently a tree.

qq, apparently the sacred artificial tree of Asshur.

rr, a circle. Compare the cuneiform *sa*, "middle."

ss, twins. As in Egyptian.

tt resembles the Chinese emblem for "small."

uu, a pyramid or triangle.

vv, apparently a hand or glove, pointing downwards. Possibly *tu* or *dun* for "down."

ww, apparently a ship, like the cuneiform *ma*. Appears only on seals.

xx, only once found on the Babylonian bowl, and seems to represent the inscribed bowl itself.

Fig. 1081.—Hittite emblems of uncertain sound.

SECTION 2.

SYLLABARIES AND ALPHABETS.

It is worthy of observation that the Greeks used the same word, γράφειν, to mean drawing and writing, suggesting their early identity. Drawing was the beginning of writing, and writing was a conventionalized drawing. The connection of both with gesture signs has been noticed above. A gesture sign is a significant but evanescent motion, and a drawing is produced by a motion which leaves significant marks. When man became proficient in oral language, and desired to give per-

manence to his thoughts, he first resorted to the designs of picture-writing, already known and used, to express the sounds of his speech.

The study of different systems of writing—such as the Chinese, the Assyrian, and the Egyptian—shows that no people ever invented an arbitrary system of writing or originated a true alphabet by any fixed predetermination. All the known graphic systems originated in picture-writing. All have passed through the stage of conventionalism to that commonly called the hieroglyphic, while from the latter, directly or after an intermediate stage, sprang the syllabary which used modifications of the old ideograms and required a comparatively small number of characters. Finally, among the more civilized of ancient races the alphabet was gradually introduced as a simplification of the syllabary, and still further reduced the necessary characters.

The old ideograms were, or may be supposed to have been, intelligible to all peoples without regard to their languages. In this respect they resembled the Arabic and Roman numerals which are understood by many nations of diverse speech when written while the sound of the words figured by them is unintelligible. Their number, however, was limited only by the current ideas, which might become infinite. Also each idea was susceptible of preservation in different forms, and might readily be misinterpreted; therefore the simplicity and precision of alphabetic writing amply compensated for its exclusiveness.

The high development of pictorial writing in Mexico and Central America is well known. Some of these peoples had commenced the introduction of phonetics into their graphic system, especially in the rendering of proper names, which probably also was the first step in that direction among the Egyptians. But Prof. Cyrus Thomas (b) makes the following remark upon the Maya system, which is of general application:

> It is certain, and even susceptible of demonstration, that a large portion, perhaps the majority, of the characters are symbols.
>
> The more I study these characters the stronger becomes the conviction that they have grown out of a pictographic system similar to that common among the Indians of North America. The first step in advance appears to have been to indicate, by characters, the gesture signs.

It is not possible now to discuss the many problems contained in the vast amount of literature on the subject of the Mexican and Central American writing, and it is the less necessary because much of the literature is recent and easily accessible. With regard to the Indian tribes north of Mexico, it is not claimed that more than one system of characters resembling a syllabary or alphabet was invented by any of them. The Cherokee alphabet, so called, was adopted from the Roman by Sequoya, also called George Gist, about A.D. 1820, and was ingenious and very valuable to the tribe, but being an imitation of an old invention it has no interest in relation to the present topic. The same is manifestly true regarding the Cree alphabet, which was of missionary origin.

The exception claimed is that commonly, but erroneously, called the Micmac hieroglyphics. The characters do not partake of the nature of hieroglyphs, and their origin is not Micmac.

THE MICMAC "HIEROGLYPHICS."

The Micmac was an important tribe, occupying all of Nova Scotia, Cape Breton island, Prince Edward island, the northern part of New Brunswick, and the adjacent part of the province of Quebec, and ranging over a great part of Newfoundland. According to Rev. Silas T. Rand, op. cit., Megum is the singular form of the name which the Micmacs use for themselves. Rev. Eugene Vetromile (a) translates "Micmacs" as "secrets practicing men," from the Delaware and old Abnaki word malike, "witchcraft," and says the name was given them on account of their numerous jugglers; but he derives Mareschite, which is an Abnaki division, from the same word and makes it identical with Micmac. The French called them Souriquois, which Vetromile translates "good canoe men." They were also called Acadians, from their habitat in Acadie, now Nova Scotia.

The first reference in literature with regard to the spontaneous use by Indians of the characters now called the "Micmac hieroglyphs" appears in the Jesuit Relations of the year 1652, p. 28. In the general report of that year the work of Father Gabriel Druillettes, who had been a missionary to the Abnaki (including under this term the Indians of Acadia, afterwards distinguished as Micmacs), is dwelt upon in detail. His own words, in a subordinate report, appear to have been adopted in the general report of the Father Superior, and, translated, are as follows:

Some of them wrote out their lessons in their own manner. They made use of a small piece of charcoal instead of a pen, and a piece of bark instead of paper. Their characters were novel, and so particuliers [individual or special] that one could not know or understand the writing of the other; that is to say, that they made use of certain marks according to their own ideas as of a local memory to preserve the points and the articles and the maxims which they had remembered. They carried away this paper with them to study their lesson in the repose of the night.

No further remark or description appears.

It is interesting to notice that the abbé J. A. Maurault, (a) after his citation of the above report of Father Druillettes, states in a footnote translated as follows:

We have ourselves been witnesses of a similar fact among the Têtes-de-Boule Indians of the River St. Maurice where we had been missionaries during three years. We often saw during our instructions or explanations of the catechism that the Indians traced on pieces of bark, or other objects very singular hieroglyphs. These Indians afterward passed the larger part of the following night in studying what they had so written, and in teaching it to their children or their brothers. The rapidity with which they by this manner learnt their prayers was very astonishing.

The Indians called by the Abbé Maurault the Têtes-de-Boule or Round Heads, are also known as Wood Indians, and are ascertained

to have been a band of the Ojibwa, which shows a connection between the practice of the Ojibwa and that of the Micmacs, both being of the Algonquian stock, to mark on bark ideographic or other significant inscriptions which would assist them to memorize what struck them as of special interest and importance, notably religious rites. Many instances are given in the present paper, and the spontaneous employment of prayer sticks by other persons of the same stock is also illustrated in Figs. 715 and 716.

The next notice in date is by Père Chrétien Le Clercq (a), a member of the Recollect order of Franciscans who landed on the coast of Gaspé in 1675, learned the language of the Micmacs and worked with them continuously for several years.

It would appear that he observed and took advantage of the pictographic practice of the Indians, which may have been continued from that reported by Father Druillettes a few years earlier with reference to the same general region, or may have been a separate and independent development in the tribe with which Father Le Clercq was most closely connected.

His quaint account is translated as follows:

Our Lord inspired me with this method the second year of my mission, when, being greatly embarrassed as to the mode in which I should teach the Indians to pray, I noticed some children making marks on birch bark with coal, and they pointed to them with their fingers at every word of the prayer which they pronounced. This made me think that by giving them some form which would aid their memory by fixed characters, I should advance much more rapidly than by teaching on the plan of making them repeat over and over what I said. I was charmed to know that I was not deceived, and that these characters which I had traced on paper produced all the effect I desired, so that in a few days they learned all their prayers without difficulty. I can not describe to you the ardor with which these poor Indians competed with each other in praiseworthy emulation which should be the most learned and the ablest. It costs, indeed, much time and pains to make all they require, and especially since I enlarged them so as to include all the prayers of the church, with the sacred mysteries of the trinity, incarnation, baptism, penance, and the eucharist.

There is no description whatever of the characters.

The next important printed notice or appearance of the Micmac characters is in the work of Rev. Christian Kauder, a Redemptorist missionary, the title page of which is given in Fig. 1082. It was printed in Vienna in 1866 and therefore was about two centuries later than the first recorded invention of the characters. During those two centuries the French and therefore the Roman Catholic influences had been much of the time dormant in the habitat of the Micmacs (the enforced exodus of the French from Acadie being about 1755). Father Kauder was one of the most active in the renewal of the missions. He learned the Micmac language, probably gathered together such " hieroglyphs" on rolls of bark as had been preserved, added to them parts of the Greek and Roman alphabet and other designs, and arranged the whole in systematic and grammatic form. After about twenty years of work upon

them he procured their printing in Vienna. A small part of the edition,

FIG. 1082.—Title page of Kauder's Micmac Catechism.

which was the first printed, reached the Micmacs. The main part,
shipped later, was lost at sea in the transporting vessel.

Fig. 1083 shows the version of the Lord's Prayer, published by Dr.
J. G. Shea (a) in his translation of Le Clercq's First Establishment of
the Faith in New France, this and the preceding figure being taken
from the Bibliography of the Languages of the N. A. Indians by Mr.
J. C. Pilling, of the Bureau of Ethnology.

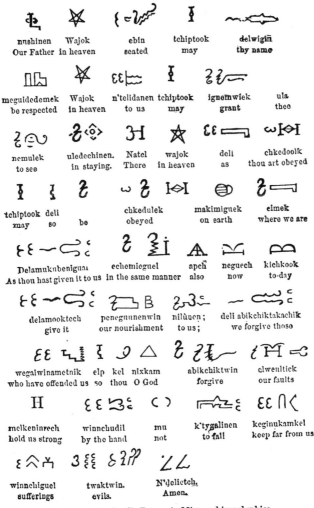

FIG. 1083.—The Lord's Prayer in Micmac hieroglyphics.

The publication of Father Kauder was a duodecimo in three parts:
Catechism, 144 pages; religious reflections, 109 pages; and hymnal,
208 pages. They are very seldom found bound together, and a perfect
copy of either of the parts or volumes is rare. On a careful examina-
tion of the hieroglyphs, so called, it seems evident that on the original
substratum of Micmac designs or symbols, each of which represented
mnemonically a whole sentence or verse, a large number of arbitrary

designs have been added to express ideas and words which were not American, and devices were incorporated with them intended to represent the peculiarities of the Micmac grammar as understood by Kauder, and it would seem of a universal grammar antedating Volapük. The explanation of these additions has never been made known. Kauder died without having left any record or explanation of the plan by which he attempted to convert the mnemonic characters invented by the Indians into what may be considered an exposition of organized words (not sounds) in grammatical form. An attempt which may be likened to this was made by Bishop Landa in his use of the Maya characters, and one still more in point was that of the priests in Peru, mentioned in connection with Figs. 1084 and 1085, infra.

The result is that in the several camps of Micmacs visited by the present writer in Cape Breton island, Prince Edward island, and Nova Scotia, fragments of the printed works are kept and used for religious worship, and also many copies on various sheets and scraps of paper have been made of similar fragments, but their use is entirely mnemonic, as was that of their ancient bark originals. Very few of the Indians who in one sense can "read" them currently in the Micmac language, have any idea of the connection between any one of the characters and the vocables of the language. When asked what a particular character meant they were unable to answer, but would begin at the commencement of the particular prayer or hymn, and when arrested at any point would then for the first time be able to give the Micmac word or words which corresponded with that character. This was not in any religious spirit, as is mentioned by Dr. Washington Matthews, in his Mountain Chant, Fifth Ann. Rep. Bureau of Ethnology, with reference to the Navajo's repeating all, if any, of the chant, but because they only knew that way to use the script. In that use they do as is mentioned of the Ojibwa, supra. The latter often by their bark script keep the memory of archaic words, and the Micmac keep that of religious phrases not well understood. A few, and very few, of the characters, which were constantly repeated, and were specially conspicuous, were known as distinct from the other characters by one only of the Indians examined. It apparently had never occurred to any of them that these same characters, which in their special mnemonic connection represented Micmac words, could be detached from their context and by combination represent the same words in other sentences. Therefore, the expression "reading," used in reference to the operation, is not strictly correct. In most cases the recitation of the script was in a chant, and the musical air of the Roman Catholic Church belonging to the several hymns and chants was often imitated. The object, therefore, which has been expressed in the above quoted accounts of Fathers Druillettes and Le Clercq had been accomplished regarding the then extant generation of Indians two hundred years before Father Kauder's publication. That object was for Indians under their immediate charge to learn in the most speedy manner certain

formulæ of the church, by the use of which it was supposed that they would gain salvation. The formation of an alphabet, or even a sylla-bary, by which the structure of the language should be considered and its vocal expression recorded, was not the object. It is possible that there was an objection to the instruction of the Indians in a modern alphabet by which they might more readily learn either French or English, and at the same time be able to read profane literature and thereby become perverted from the faith. These missionaries cer-tainly refrained, for some reason, not only from instructing the heathen in any of the languages of civilization, but also from teaching them the use of an alphabet for their own language.

It is probable that Father Kauder had some idea of reducing the language of the Micmacs to a written form, based not upon verbal or even syllabic notation, but upon some anomalous compromise between their ideographic original or substratum and a grammatic superstruc-ture. If so, he entirely failed. The interesting point with regard to this remarkable and unique attempt is, that there is undoubtedly a basis of Indian designs and symbols included and occluded among the differentiated devices in the three volumes mentioned, which arbitrarily express thoughts and words by a false pictographic method, instead of sentences and verses. But the change from the pictorial forms to those adopted, if not as radical as that from the Egyptian hieroglyphs to the Roman text, resembles that from the archaic to the modern Chinese. Therefore it would follow that the present form of the characters is not one which the Indians would learn more readily than an alphabet or a syllabary, and that is the ascertained fact. At Cow bay, a Micmac camp, about 12 miles from Halifax, an aged chief who in his boyhood at Cape Breton island was himself instructed by Father Kauder in these characters, explained that Kauder taught them to the boys by drawing them on a blackboard and by repetition, very much in the manner in which a schoolmaster in civilized countries teaches the al-phabet to children. The actual success of the Cherokees in the free and general use of Sequoya's Syllabary, which was not founded on pictographs, but on signs for sounds, should be noted in this connection.

Among the thousands of scratchings on the Kejemkoojik rocks, many of which were undoubtedly made by the Micmac, only two characters were found resembling any in Kauder's volumes, and those were com-mon symbols of the Roman Catholic Church, and might readily have been made by the Frenchmen, who also certainly left scratchings there. Altogether after careful study of the subject it is considered that the devices in Father Kauder's work are so intrinsically changed, both in form and intent, from the genuine Micmac designs that they can not be presented as examples of Indian pictography.

Connected with this topic is the following account in the Jesuit Rela-tions of 1646, p. 31, relative to the Montagnais and other Algonquians of the St. Lawrence river, near the Saguenay: "They confess themselves with admirable frankness; some of them carry small sticks to remind

them of their sins; others write, after their manner, on small pieces of bark." This is but the application of the ideographic writing on birch bark by the converts to the ceremonies and stories of the Christian religion, as the same art had been long used for their aboriginal traditions.

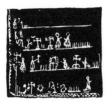
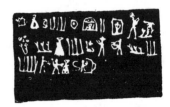

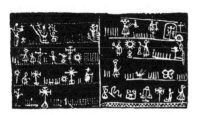
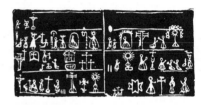

FIG. 1084.—Religious story. Sicasica.

Examples of pictographic work, done in a spirit similar to that above mentioned, are given by Wiener (*g*), describing the illustrations of which Figs. 1084 and 1085 are copies, one-fifth real size.

In the most distant part of Peru, in the valley of Paucartambo, at Sicasica, the history of the passion of Christ was found written in the same ideographic system that the Indians of Ancon and the north of the coast were acquainted with before the conquest. (Fig. 1084.) The drawings were made with a pencil, probably first dipped in a mixture of gum and mandioc flour. This tissue is of a dark brown and the designs are of a very bright red.

The second series, Fig. 1085, which was found at Paucartambo, was written in an analogous system on old Dutch paper. The designs are red and blue.

FIG. 1085.—Religious story. Sicasica.

In an article by Terrien de Lacouperie (*f*) is the following condensed

account, part of which relates to Fig. 1086, and may be compared with the priestly inventions above mentioned:

Père Desgodins was able, in 1867, to make a copy of eleven pages from a manuscript written in hieroglyphics, and belonging to a tom-ba or tong-ba, a medicine man among the Mo-sos. These hieroglyphics are not, properly speaking, a writing,

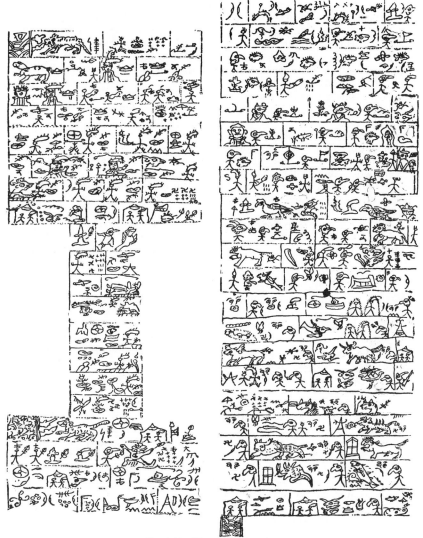

FIG. 1086.—Mo-so MS.　Desgodins.

still less the current writing of the tribe. The sorcerers or tong-bas alone use it when invited by the people to recite these so-called prayers, accompanied with ceremonies and sacrifices, and also to put some spells on somebody, a specialty of their own. They alone know how to read them and understand their meaning; they alone are acquainted with the value of these signs, combined with the numbers

of the dice and other implements of divination which they use in their witchcraft. Therefore, these hieroglyphics are nothing else than signs more or less symbolical and arbitrary, known to a small number of initiated who transmit their knowledge to their eldest son and successor in their profession of sorcerers. Such is the exact value of the Mo-so manuscripts; they are not a current and common writing; they are hardly a sacred writing in the limits indicated above.

However, they are extremely important for the general theory of writing, inasmuch as they do not pretend to show in that peculiar hieroglyphical writing any survival of former times. According to these views, it was apparently made up for the purpose by the tom-bas or medicine men. This would explain, perhaps, the anomalous mixture of imperfect and bad imitations of ancient seal characters of China, pictorial figures of animals and men, bodies and their parts, with several Tibetan and Indian characters and Buddhist emblems.

It is not uninteresting to remark here that a kind of meetway or toomsah, i. e., priest, has been pointed out among the Kakhyens of Upper Burma. The description is thus quoted:

"A formal avenue always exists as the entrance to a Kakhyen village. * * * On each side of the broad grassy pathway are a number of bamboo posts, 4 feet high or thereabouts, and every 10 paces or so, taller ones, with strings stretching across the path, supporting small stars of split rattan and other emblems. There are also certain hieroglyphics which may constitute a kind of embryo picture-writing but are understood by none but the meetway or priest."

PICTOGRAPHS IN ALPHABETS.

Mr. W. W. Rockhill, in Am. Anthrop., IV, No. 1, p. 91, notices the work of M. Paul Vial, missionary, etc., De la langue et de l'écriture indigènes au Yûnân, with the following remarks:

Père Vial has published a study upon the undeciphered script of the Lolos of Western China, of which the first specimen was secured some twelve years ago by E. Colborne Baber. Prof. Terrien de Lacouperie endeavored to establish a connection between these curious characters and the old Indian script known as the southern Ashoka alphabet. The present, Père Vial's, work gives them a much less glorious origin. He says of them: "The native characters were formed without key, without method. It is impossible to decompose them. They are written not with the strokes of a brush, but with straight, curved, round, or angular lines, as the shape chosen for them requires. As the representation could not be perfect, they have stopped at something which can strike the eye or mind—form, motion, passion, a head, a bird's beak, a mouth, right or left, lightness or heaviness; in short, at that portion of the object delineated which is peculiarly characteristic of it. But all characters are not of this expressive kind; some even have no connection with the idea they express. This anomaly has its reason. The native characters are much less numerous than the words of the language, only about thirty per cent. Instead of increasing the number of ideograms, the Lolos have used one for several words. As a result of this practice the natives have forgotten the original meaning of many of their characters."

A summary of the original cuneiform characters, numbering one hundred and seventy, gives many of them as recognizable sketches of objects. The foot stands for "go," the hand for "take," the legs for "run," much as in the Egyptian and in the Maya and other American systems. The bow, the arrow, and the sword represent war; the vase, the copper tablet, and the brick represent manufacture; boats, sails, huts, pyramids, and many other objects are used as devices.

W. St. Chad Boscawen (*a*) says:

Man's earliest ventures in the art of writing were, as we are well aware, of a purely pictorial nature, and even to this day such a mode of ideography can be seen among some of the Indian tribes. * * * There is no reasonable doubt but that all the principal systems of paleography now in vogue had their origin at some remote period in this pictorial writing. In so primitive a center as Babylonia we should naturally expect to find such a system had been in vogue, and in this we are not disappointed.

Fig. 1087 is presented as a brief exhibit of the pictographs in some inchoate alphabets.

Pictorial	Hieratic	Cursive.	Chinese.	Egyptian	
					Sun.
					Hand.
					Fish.
					Corpse.
					Wood.
					Cave.
					Home.
					Place.
					Boundary
					God.
					Ear.
					Water.
					Horn.
					Half.
					Door or Gate.

FIG. 1087.—Pictographs in alphabets.

CHAPTER XX.

SPECIAL COMPARISONS.

The utility of the present work depends mainly upon the opportunity given by the various notes and illustrations collected for students to make their own comparisons and deductions. This chapter is intended to assist in that study by presenting some groups of comparisons which have seemed to possess special interest. For that reason descriptions and illustrations are collected here which logically belong to other headings.

Many of the pictographs discussed and illustrated in this chapter and in the one following are the representation of animals and other natural objects. It would therefore seem that they could be easily identified, but in fact the modes of representation of the same object among the several peoples differed, and when conventionalizing has also become a factor the objects may not be recognized without knowledge of the typical style. Sometimes there was apparently no attempt at the imitation of natural objects, but marks were used, such as points, lines, circles, and other geometric forms. These were combined in diverse modes to express concepts and record events. Those marks and combinations originated in many centers and except in rare instances of "natural" ideograms those of one people would not correspond with those of other peoples unless by conveyance or imitation. Typical styles therefore appear also in this class of pictographs and, when established, all typical styles afford some indication with regard to the peoples using them.

This chapter is divided under the headings of: 1. Typical Style. 2. Homomorphs and Symmorphs. 3. Composite forms. 4. Artistic skill and methods.

SECTION 1.

TYPICAL STYLE.

Fig. 1088 is presented as a type of eastern Algonquian petroglyphs. It is a copy of the "Hamilton picture rock," contributed by Mr. J. Sutton Wall, of Monongahela city, Pennsylvania. The drawings are on a sandstone rock, on the Hamilton farm, 6 miles southeast from Morgantown, West Virginia. The turnpike passes over the south edge of the rock.

Mr. Wall furnishes the following description of the characters:

a, outline of a turkey; *b*, outline of a panther; *c*, outline of a rattlesnake; *d*, outline of a human form; *e*, a "spiral or volute;" *f*, impression of a horse foot; *g*, impression of a human foot; *h*, outline of the top portion of a tree or branch; *i*, im-

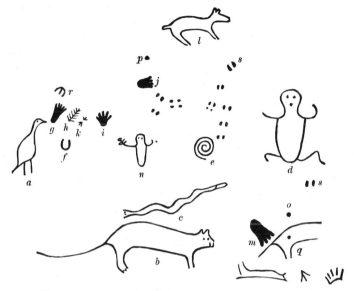

FIG. 1088.—Algonquian petroglyph. Hamilton farm, West Virginia.

pression of a human hand; *j*, impression of a bear's forefoot, but lacks the proper number of toe marks; *k*, impression of two turkey tracks; *l*, has some appearance of a hare or rabbit, but lacks the corresponding length of ears; *m*, impression of a bear's hindfoot, but lacks the proper number of toe marks; *n*, outline of infant human form, with two arrows in the right hand; *o, p*, two cup-shaped depressions;

FIG. 1089.—Algonquian petroglyphs. Safe Harbor, Pennsylvania.

q, outline of the hind part of an animal; *r* might be taken to represent the impression of a horse's foot were it not for the line bisecting the outer curved line; *s* represent buffalo and deer tracks.

The turkey *a*, the rattlesnake *c*, the rabbit *l*, and the "footprints" *j*, *m*, and *q*, are specially noticeable as typical characters in Algonquian pictography.

Mr. P. W. Sheafer furnishes, in his Historical Map of Pennsylvania, Philadelphia, 1875, a sketch of a pictograph on the Susquehanna river, Pennsylvania, below the dam at Safe Harbor, part of which is reproduced in Fig. 1089. This appears to be purely Algonquian, and has more resemblance to Ojibwa characters than any other petroglyph in the eastern United States yet noted.

See also Figs. 106, et seq., supra, under the heading of Pennsylvania, as showing excellent types of eastern Algonquian petroglyphs and resembling those on the Dighton rock.

Fig. 1090 is reproduced from Schoolcraft (*p*), and is a copy taken in 1851 of an inscription sculptured on a rock on the south side of Cunningham's island, Lake Erie. Mr. Schoolcraft's explanation, given in great detail, is fanciful. It is perhaps only necessary to explain that the dotted lines are intended to divide the partially obliterated from the more distinct portions of the glyph. The central part is the most obscure.

It is to be remarked that this petroglyph is in some respects similar in general style to those before given as belonging to the eastern Algonquian type, but is still more like some of the representations of the Dighton rock inscription, one of them being Fig. 49, supra, and others, which it still more closely resembles in the mode of drawing human figures, are in the copies of Dighton rock on Pl. LIV, Chap. XXII. In some respects this Cunningham's island glyph occupies a typical position intermediate between the eastern and western Algonquian.

A good type of western Algonquian petroglyphs was discovered by the party of Capt. William A. Jones (*b*), in 1873, with an illustration here reproduced as Fig. 1091, in which the greater number of the characters are shown, about one-fifth real size.

An abstract of his description is as follows:

* * * Upon a nearly vertical wall of the yellow sandstones, just back of Murphy's ranch, a number of rude figures had been chiseled, apparently at a period not very recent, as they had become much worn. * * * No certain clue to the connected meaning of this record was obtained, although Pínatsi attempted to explain it when the sketch was shown to him some days later by Mr. F. W. Bond, who copied the inscriptions from the rocks. The figure on the left, in the upper row, somewhat resembles the design commonly used to represent a shield, with the greater part of the ornamental fringe omitted, perhaps worn away in the inscription. We shall possibly be justified in regarding the whole as an attempt to record the particulars of a fight or battle which once occurred in this neighborhood. Pínatsi's remarks conveyed the idea to Mr. Bond that he understood the figure [the second in the upper line] to signify cavalry, and the six figures [three in the middle of the upper line, as also the three to the left of the lower line] to mean infantry, but he did not appear to recognize the hieroglyphs as the copy of any record with which he was familiar.

Throughout the Wind river country of Wyoming many petroglyphs

have been found and others reported by the Shoshoni Indians, who
say that they are the work of the "Pawkees," as they call the Black-
feet, or, more properly, Satsika, an Algonquian tribe which formerly

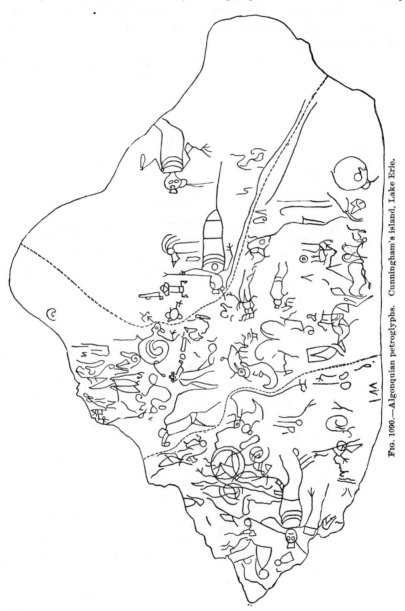

FIG. 1090.—Algonquian petroglyphs. Cunningham's island, Lake Erie.

occupied that region, and their general style bears strong resemblance
to similar carvings found in the eastern portion of the United States,
in regions known to have been occupied by other tribes of the Algon-
quian linguistic stock.

The four specimens of Algonquian petroglyphs presented here in
Figs. 1088–91 and those referred to, show gradations in type. In
connection with them reference may be made to the numerous Ojibwa
bark records in this work; the Ottawa pipestem, Fig. 738; and they
may be contrasted with the many Dakota, Shoshoni, and Innuit draw-
ings also presented.

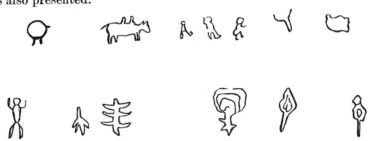

FIG. 1091.—Algonquian petroglyphs. Wyoming.

The petroglyphs found scattered throughout the states and terri-
tories embraced within the area bounded by the Rocky mountains on
the east and the Sierra Nevada on the west, and generally south of
the forty-eighth degree of latitude, are markedly similar in the class of
objects represented and the general
style of their delineation, without ref-
erence to their division into pecked
or painted characters; also in many
instances the sites selected for petro-
glyphic display are of substantially
the same character. This type has
been generally designated as the
Shoshonean, though many localities
abounding in petroglyphs of the type
are now inhabited by tribes of other
linguistic stocks.

Mr. G. K. Gilbert, of the U. S.
Geological Survey, has furnished a
small collection of drawings of Sho-
shonean petroglyphs from Oneida,
Idaho, shown in Fig. 39, supra.

Five miles northwest from this
locality and one-half mile east from
Marsh creek is another group of
characters on basalt bowlders, appar-

FIG. 1092.—Shoshonean petroglyphs. Idaho. ently totemic, and drawn by Sho-
shoni. A copy of these, also contributed by Mr. Gilbert, is given in
Fig. 1092.

All of these drawings resemble the petroglyphs found at Partridge

creek, northern Arizona, and in Temple creek canyon, southeastern Utah, mentioned supra, pages 50 and 116, respectively.

Mr. I. C. Russell, of the U. S. Geological Survey, has furnished drawings of rude pictographs at Black Rock spring, Utah, represented in Fig. 1093. Some of the other characters not represented in the figure consist of several horizontal lines, placed one above another, above which are a number of spots, the whole appearing like a numerical record having reference to the figure alongside, which resembles, to a slight extent, a melon with tortuous vines and stems. The left-hand upper figure suggests the masks shown in Fig. 713.

Mr. Gilbert Thompson, of the U. S. Geological Survey, has discovered pictographs at Fool creek canyon, Utah, shown in Fig. 1094, which strongly resemble those still made by the Moki of Arizona.

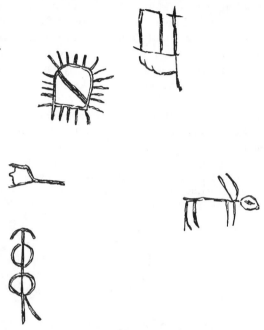

FIG. 1093.—Shoshonean petroglyphs. Utah.

Several characters are identical with those last mentioned, and represent human figures, one of which is drawn to represent a man, shown by a cross, the upper arm of which is attached to the perinæum. These are all drawn in red color and were executed at three different periods. Other neighboring pictographs are pecked and unpainted, while others are both pecked and painted.

Both of these pictographs from Utah may be compared with the Moki pictographs from Oakley springs, Arizona, copied in Fig. 1261.

Dr. G. W. Barnes, of San Diego, California, has kindly furnished sketches of pictographs prepared for him by Mrs. F. A Kimball, of National city, California, which were copied from records 25 miles northeast of the former city. Many of them found upon the faces of large rocks are almost obliterated, though sufficient remains to permit

FIG. 1094.—Shoshonean rock-painting. Utah.

tracing. The only color used appears to be red ocher. Many of the characters, as noticed upon the drawings, closely resemble those in New Mexico, at Ojo de Benado, south of Zuñi, and in the canyon leading from the canyon at Stewart's ranch, to the Kanab creek canyon, Utah. This is an indication of the habitat of the Shoshonean stock apart from the linguistic evidence with which it agrees.

From the numerous illustrations furnished of petroglyphs found in Owens valley. California, reference is here made to Pl. II *a*, Pl. III *h*, and Pl. VII *a* as presenting suggestive similarity to the Shoshonean forms above noted, and apparently connecting them with others in New Mexico, Arizona, Sonora, and Central and South America.

Mr. F. H. Cushing (*a*) figured three petroglyphs, now reproduced in Figs. 1095 and 1096, from Arizona, and referred to them in connection with figurines found in the ruined city of Los Muertos, in the Salado valley, as follows:

Beneath the floor of the first one of these huts which we excavated, near the ranch of Mr. George Kay Miller, were discovered, disposed precisely as would be a modern sacrifice of the kind in Zuñi, the paraphernalia of a Herder's sacrifice, namely, the paint line, encircled, perforated medicine cup, the Herder's amulet stone

FIG. 1095.—Arizona petroglyph.

of chalcedony, and a group of at least fifteen remarkable figurines. The figurines alone, of the articles constituting this sacrifice, differed materially from those which would occur in a modern Zuñi "New Year Sacrifice" of the kind designed to propitiate the increase and prosperity of its herds. While in Zuñi these figurines invariably represent sheep (the young of sheep mainly; mostly also females), the figurines in the hut at "Los Guanacos," as I named the place, represented with rare fidelity * * * some variety, I should suppose, of the auchenia or llama of South America.

Summing up the evidence presented by the occurrence of numerous "bola stones" in these huts and within the cities; by the remarkably characteristic forms of these figurines; by the traditional statement of modern Zuñis regarding "small hairy animals" possessed by their ancestors, no less than by the statements of Marcus Nizza, Bernal Diaz, and other Spanish writers to the same effect, and adding to this sum the facts presented in sundry ritualistic pictographs, I concluded, very boldly, * * * that the ancient Pueblos-Shiwians, or Aridians, * * * must have had

domesticated a North American variety of the auchenia more nearly resembling, it would seem, the guanaco of South America than the llama.

It is ascertained that the petroglyphs copied by Mr. Cushing as above are pecked upon basaltic rock in the northern face of Maricopa mountains, near Telegraph pass, south of Phœnix, Arizona.

The following information is obtained from Dr. H. Ten Kate (a):

FIG. 1096.—Arizona petroglyph.

In several localities in the sierra in the peninsula of California and Sonora are rocks painted red. These paintings are quite rude and are inferior to many of the pictographs of the North American Indians. Figs. 1097 and 1098 were found at Rincon de S. Antonio. The right-hand division of Fig. 1097 is a complete representation, and the figures copied appear on the stone in the order in which they are here given. The left-hand division of the same figure represents only the most distinct objects, selected from among a large number of others, very simi-

FIG. 1097.—Petroglyphs, Lower California.

lar, which cover a block of marble several meters in height. The object in the upper left-hand corner of Fig. 1097 measures 20 to 21 centimeters; the others are represented in proportion.

FIG. 1098.—Petroglyphs in Lower California.

These two figures resemble petroglyphs reported from the Santa Inez range, west of Santa Barbara, Lower California.

The same author, op. cit., p. 324, says:

Fig. 1098 represents symbols which were the most easily distinguished among the great number of those which cover two immense granite blocks at Boca San Pedro. The rows of dots (or points) which are seen at the left of this figure measure 1.50 meters, the parallel lines traced at the right are about 1 meter.

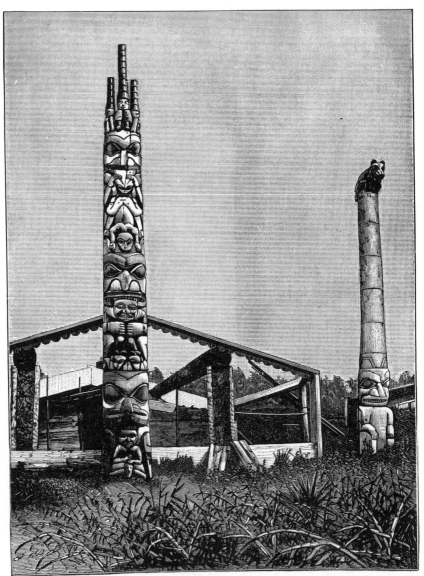

FIG. 1099.—Haida Totem Post.

This figure is like another found farther east (see Fig. 31) from Azuza canyon, California.

A number of Haida pictographs are reproduced in other parts of this

work. In immediate connection with the present topic Fig. 1099 is presented. It shows the carved columns in front of the chief's house at Massett, Queen Charlotte island.

The following illustrations from New Zealand are introduced here for comparison.

Dr. F. von Hochstetter (*b*) writing of New Zealand, says:

The dwellings of the chiefs at Ohinemutu are surrounded with inclosures of pole fences, and the Whares and Wharepunis, some of them exhibiting very fine specimens of the Maori order of architecture, are ornamented with grostesque wood carvings. Fig. 1100 is an illustration of some of them. The gable figure with the lizard having six feet and two heads is very remarkable. The human figures are not idols, but are intended to represent departed sires of the present generation.

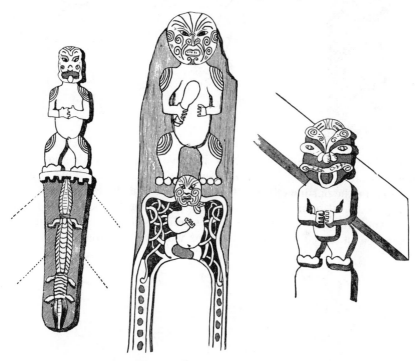

FIG. 1100.—New Zealand house posts.

Niblack (*c*) gives a description of the illustration reproduced as Fig. 1101.

Tiki. At Raroera Pah, New Zealand. From Wood's Natural History, page 180. Of this he says: "This gigantic tiki stands, together with several others, near the tomb of the daughter of Te Whero-Whero, and, like the monument which it seems to guard, is one of the finest examples of native carving to be found in New Zealand. The precise object of the tiki is uncertain, but the protruding tongue of the upper figure seems to show that it is one of the numerous defiant statues which abound in the islands. The natives say that the lower figure represents Maui the Auti who, according to Maori tradition, fished up the islands from the bottom of the sea."

Dr. Bransford (*b*) gives an illustration, copied here as the left-hand character of Fig. 1102, with the description of the site, viz: "On a hill-

side on the southern end of the island of Ometepec, Nicaragua, about a mile and a half east of Point San Ramon." On a rough, irregular stone of basalt, projecting 3 feet above ground, was the following figure on the south side:

This suggests comparison with some of the Moki and British Guiana figures.

The same authority gives on page 66, from the same island and neighborhood, the illustration copied as the right-hand character of the same figure.

FIG. 1101.—New Zealand tiki.

FIG. 1102.—Nicaraguan petroglyphs.

By comparing some of the New Mexican, Zuñi, and Pueblo drawings with the above figure the resemblance is obvious. This is most notable in the outline of the square abdomen and the widespread legs.

Fig. 1103, also mentioned and figured by Dr. Bransford as found with the preceding in Nicaragua, resembles some of the petroglyphs presented in the collection from Owens valley, California.

FIG. 1103.—Nicaraguan petroglyphs.

The carvings in Fig. 1104 are from British Guiana, and are reproduced from im Thurn (i):

Most of these figures so strongly resemble some from New Mexico, and perhaps Arizona, as to appear as if they were made by the same people. This is specially noticeable in the lowermost characters, and more particularly so in the last two, resembling the usual Shoshonean type for toad or frog.

The petroglyph of Boca del Infierno, a copy of which is furnished by Marcano (*f*), reproduced as Fig. 1105, is thus described:

In the strange combination that surmounts it, *a*, there are seen at the lower part two figures resembling the eyes of jaguars, but asymmetric. Still the difference is apparent rather than real. These eyes are always formed of three circumferences, the central one being at times replaced by a point, as in the eye at the left; the one at the right shows its three circumferences, but the outermost is continuous with

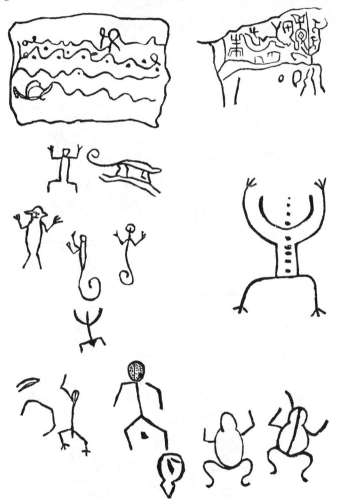

Fig. 1104.—Deep carvings in Guiana.

the rest of the drawing. The two eyes are joined together by superposed arches, the smallest of which touches only the left eye, while the larger one, which is not in contact with the left eye, forms the circumference of the right eye. The whole is surrounded by 34 rays, pretty nearly of the same size, except one, which is larger, Is there question of a jaguar's head seen from in front with its bristling mane, or is it a sunrise? All conjecture is superfluous, and it is useless to search for the interpretation of these figures, whose value, entirely conventional, is known only by those who invented them.

In *b* of the same pictograph, alongside of a tangle of various figures, always formed of geometric lines, we distinguished, at the left, three points; in the middle a collection of lines representing a fish. Let us note, finally, the dots which, as in the preceding case, run out from certain lines.

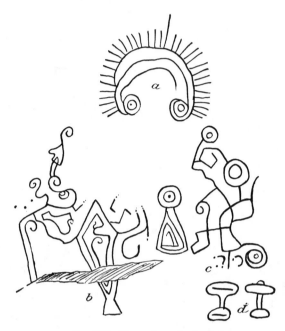

Fig. 1105.—Venezuelan petroglyphs.

The design of *c*, while quite as complex, has quite another arrangement. At the left we see again the figure of the circumferences surrounding a dot, and these are surmounted by a series of triangles; at the bottom there are two little curves terminated by dots. At *d* two analogous objects are represented; they may be what Humboldt took to be arms or household implements.

In the above figure, the uppermost character, *a*, is similar to various representations of the "sky," as depicted upon the birch-bark midē′

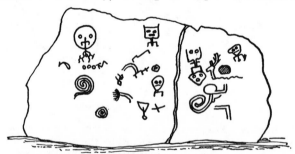

Fig. 1106.—Venezuelan petroglyphs.

records of the Ojibwa. The lower characters are similar to several examples presented under the Shoshonean types, particularly to those in Owens valley, California.

Dr. A. Ernst in Verhandl. der Berliner, Anthrop. Gesell. (*c*) gives a description of Fig. 1106, translated and condensed as follows:

The rock on which the petroglyph is carved is 41 kilometers WSW. of Caracas, and 27 kilometers almost due north of La Victoria, in the coast mountains of Venezuela. The petroglyph is found on two large stones lying side by side and leaning against other blocks of leptinite, though resembling sandstone. The length of the two stones is 3.5 m., their height 2 m. The stones lie beside the road from the colony of Tovar to La Maya, on the border of a clearing somewhat inclined southward not far from the woods. The surface is turned south. Concerning the meaning of the very fragmentary figures I can not even express a conjecture.

Araripe (*c*) furnishes the following description of Fig. 1107:

In the district of Inhamun, on the road from Carrapateira to Cracará, at a distance of half a league, following a footpath which branches off to the left, is a small lake called Arneiros, near which is a heap of round and long stones; on one of the round ones is an inscription, here given in the order in which the figures appear, on the face toward the north, engraved with a pointed instrument, the characters being covered with red paint.

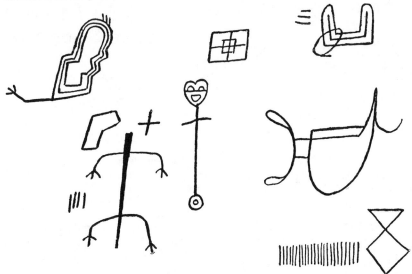

FIG. 1107.—Brazilian petroglyphs.

The same authority, p. 231, gives the following description of the lower group in Fig. 1108. It is called Indian writing in Vorá, in Faxina, province of São Paulo.

From a rock which is more than 40 meters in height, a large mass has been detached leaving a greater inclination of 10 meters. This incline, together with the wall formed by the detached portion, constitutes a sheltered place which was used by the Indians as a resting place for their dead.

On the walls of this grotto are figures engraved in the stone and painted with "indellible" colors in red and black. It would seem that the Indians had engraved in these figures the history of the tribe. The designs are as follows:

A human figure with ornaments of feathers on the head and neck; a palm tree rudely engraved and painted; a number of circular holes, 24 or more or less, in a straight line; a circle with a diameter of 15 inches, having dentated lines on the

edge; two concentric circles resembling a clock face, with 60 divisions; immediately following this the figure of an idol, and various marks all painted in a very firm black;

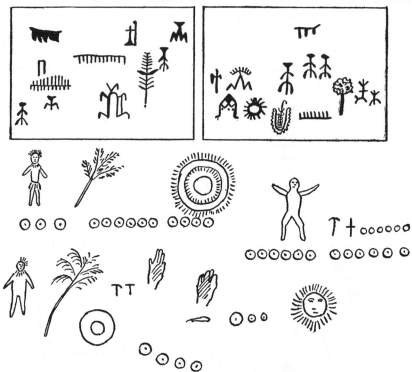

FIG. 1108.—Spanish and Brazilian petroglyphs.

a figure of the sun with a +; a T; six more circles; a human hand and foot well carved, etc. In the wall are fragments of bones.

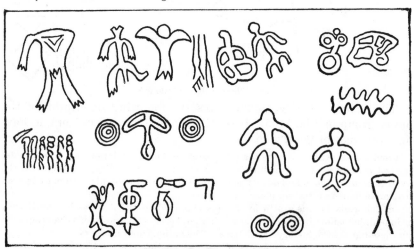

FIG. 1109.—Brazilian petroglyphs.

The two upper groups are copies of petroglyphs in Fuencaliente, Andalusia, Spain, which are described in Chap. IV, sec. 3, and are

introduced here for convenient comparison with characters in the lower group of this figure, and also with others in Figs. 1097 and 1107.

Dr. Ladisláu Netto (c) gives an account of characters copied from the inscriptions of Cachoeira Savarete, in the valley of the Rio Negro, here reproduced as Fig. 1109. They represent men and animals, concentric circles, double spirals, and other figures of indefinite form. The design in the left hand of the middle line evidently represents a group of men gathered and drawn up like soldiers in a platoon.

FIG. 1110.—Brazilian petroglyphs.

The same authority, p. 552, furnishes characters copied from rocks near the villa of Moura in the valley of the Rio Negro, here reproduced as Fig. 1110. They represent a series of figures on which Dr. Netto remarks as follows:

It is singular how frequent are these figures of circles two by two, one of which seems to simulate one of the meanders that in a measure represent the form of the Buddhic cross. This character, represented by the double cross, is very common in many American inscriptions. It probably signifies some idea which has nothing to do with that of nandyavarta.

The same authority, p. 522, gives carvings copied from the rocks of the banks of the Rio Negro, from Moura to the city of Mañaus, some of which are reproduced as Fig. 1111. The group on the left Dr. Netto believes to represent a crowned chief, having by his side a figure which may represent either the sun or the moon in motion, but which, were it carved by civilized men, would suggest nothing more remarkable than a large compass.

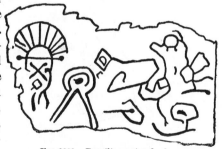

FIG. 1111.—Brazilian petroglyphs.

The same authority, p. 553, presents characters copied from stones on the banks of the Rio Negro, Brazil, here reproduced as Fig. 1112.

They are rather sketches or vague tracings and attempts at drawing than definite characters. The human heads found in most of the figures observed at this locality resemble the heads carved in the inscriptions of Central America and on the banks of the Colorado river. The left-hand character, which here appears to be simply a rude drawing of a nose and

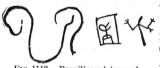

FIG. 1112.—Brazilian pictograph.

the eyes belonging to a human face, may be compared with the so-called Thunderbird from Washington, contributed by Rev. Dr. Eels (see Fig. 679).

Dr. E. R. Heath (*b*), in his Exploration of the River Beni, introducing Fig. 1113, says:

Periquitos rapids connects so closely with the tail of "Riberáo" that it is difficult to say where one begins and the other ends. Our stop at the Periquitos rapids was short yet productive of a few figures, one rock having apparently a sun and moon on it, the first seen of that character.

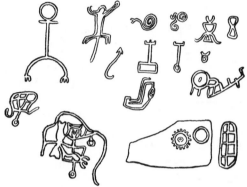

FIG. 1113.—Brazilian petroglyphs.

He further says:

On some solid water-worn rocks, at the edge of the fall, are the following figures [Fig. 1114]. There were many fractional parts of figures which we did not consider of sufficient value to copy.

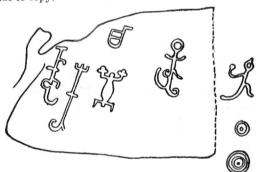

FIG. 1114.—Brazilian petroglyphs.

SECTION 2.

HOMOMORPHS AND SYMMORPHS.

It has already been mentioned that characters substantially the same, or homomorphs, made by one set of people, have a different signification among others. The class of homomorphs may also embrace the cases common in gesture signs, and in picture writing, similar to the homophones in oral language, where the same sound has several meanings among the same people.

It would be very remarkable if precisely the same character were not used by different or even the same persons or bodies of people with wholly distinct significations. The graphic forms for objects and ideas are much more likely to be coincident than sound is for similar expressions, yet in all oral languages the same precise sound, sometimes but not always distinguished by different literation, is used for utterly diverse meanings. The first conception of different objects could not have been the same. It has been found, indeed, that the homophony of words and the homomorphy of ideographic pictures is noticeable in opposite significations, the conceptions arising from the opposition itself. The same sign and the same sound may be made to convey different ideas by varying the expression, whether facial or vocal, and by the manner accompanying their delivery. Pictographs likewise may be differentiated by modes and mutations of drawing. The differentiation in picturing or in accent is a subsequent and remedial step not taken until after the confusion had been observed and had become inconvenient. Such confusion and contradiction would only be eliminated from pictography if it were far more perfect than is any spoken language.

This heading, for convenience, though not consistently with its definition, may also include those pictographs which convey different ideas and are really different in form of execution as well as in conception, yet in which the difference in form is so slight as practically to require attention and discrimination. Examples are given below in this section, and others may be taken from the closely related sign-language, one group of which may now be mentioned.

The sign used by the Dakota, Hidatsa, and several other tribes for "tree" is made by holding the right hand before the body, back forward, fingers and thumb separated; then pushing it slightly upward, Fig. 1115; that for "grass" is the same, made near the ground; that for "grow" is made like "grass," though, instead of holding the back of the hand near the ground, the hand is pushed upward in an interrupted manner, Fig. 1116. For "smoke" the hand (with the back down, fingers pointing upward as in grow) is then thrown upward several times from the same place instead of continuing the whole motion upward. Frequently the fingers are thrown forward from under the thumb with each successive upward motion. For "fire" the hand is employed as in the gesture for smoke, but the motion is frequently more waving, and in other cases made higher from the ground.

FIG. 1115.—Tree.

Symmorphs, a term suggested by the familiar "synonym," are designs not of the same form, but which are used with the same significance or so nearly the same as to have only a slight shade of distinction and which sometimes are practically interchangeable. The comprehen-

FIG. 1116.—Grow.

sive and metaphorical character of pictographs renders more of them interchangeable than is the case with words; still, like words, some pictographs with essential resemblance of meaning have partial and subordinate differences made by etymology or usage. Doubtless the designs are purposely selected to delineate the most striking outlines of an object or the most characteristic features of an action; but different individuals and likewise different bodies of people would often disagree in the selection of those outlines and features. In an attempt to invent an ideographic, not an iconographic, design for "bird," any one of a dozen devices might have been agreed upon with equal appropriateness, and, in fact, a number have been so selected by several individuals and tribes, each one, therefore, being a symmorph of the other. Gesture language gives another example in the signs for "deer," designated by various modes of expressing fleetness, also by his gait when not in rapid motion, by the shape of his horns, by the color of his tail, and sometimes by combinations of those characteristics. Each of these signs and of the pictured characters corresponding with them may be indefinitely abbreviated and therefore create indefinite diversity. Some examples appropriate to this line of comparison are now presented.

<p style="text-align:center">SKY.</p>

The Indian gesture sign for sky, heaven, is generally made by passing the index from east to west across the zenith. This curve is apparent

<p style="text-align:center">Fig. 1117.—Sky.</p>

in the Ojibwa pictograph, the left-hand character of Fig. 1117, reported in Schoolcraft (q), and is abbreviated in the Egyptian character with the same meaning, the middle character of the same figure, from Cham-

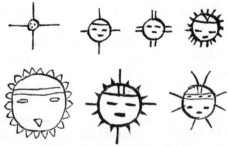

<p style="text-align:center">Fig. 1118.—Sun. Oakley springs.</p>

pollion (e). A simpler form of the Ojibwa picture sign for sky is the right-hand character of the same figure, from Copway (h).

<p style="text-align:center">SUN AND LIGHT.</p>

Fig. 1118 shows various representations of the sun taken from a petroglyph at Oakley springs.

The common Indian gesture sign for sun is: Right
hand closed, the index and thumb curved, with tips touch-
ing, thus approximating a circle, and held toward the sky,
the position of the fingers of the hand forming a circle
as is shown in Fig. 1119. Two of the Egyptian charac-
ters for sun, the left-hand upper characters of Fig. 1120
are the common conception of the disk. The rays ema-
nating from the whole disk appear in the two adjoining

FIG. 1119.—Sun.
Gesture sign.

characters on the same figure, taken from the rock etchings of the
Moki pueblos in Arizona. From the same locality are the two remain-
ing characters in the same figure, which may be distinguished from
several similar etchings for "star," Fig. 1129, infra, by their showing
some indication of a face, the latter being absent in the characters
denoting "star."

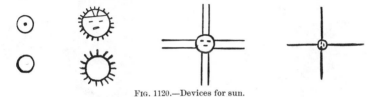

FIG. 1120.—Devices for sun.

With the above characters for sun compare the left-hand character
of Fig. 1121, found at Cuxco, Peru, and taken from Wiener (*h*).

In the pictorial notation of the Laplanders the sun bears its usual
figure of a man's head, rayed. See drawings in Scheffer's History of
Lapland, London, 1704.

FIG. 1121.—Sun and light.

The Ojibwa pictograph for sun is seen in the second
character of Fig. 1121, taken from Schoolcraft (*r*). The
sun's disk, together with indications of rays, as shown in
the third character of the same figure, and in its linear form,
the fourth character of that figure, from Champollion, Dict.,
constitutes the Egyptian character for light.

Fig. 1122.—Light. Red-Cloud's Census. This is to be
compared with the rays of the sun as above shown, but
still more closely resembles the old Chinese character for
light, or more specifically "light above man," in the left-
hand character of Fig. 1123, reported by Dr. Edkins.

The other characters of the same figure are given by
Schoolcraft (*s*) as Ojibwa symbols of the sun.

FIG. 1122.--Light.

The left-hand character of Fig. 1124, from Proc. U. S. Nat. Museum

(*a*), shows the top of an heraldic column of the Sentlae (Sun) gens of the Kwakiutl Indians in Aleɪt bay, British Columbia, which represents

the sun surrounded by wooden rays. A simpler form is seen in the right character of the same figure where the face of the sun is also fastened to the top of a pole. The author, Dr.

FIG. 1123.—Light and sun.

Boas, states that Fig. 1125 is the sun mask used by the same gens in their dance. This presents another mode in which the common symbolic connection of the eagle (the beak of which bird is apparently shown) with the sun is indicated.

FIG. 1124.—Sun. Kwakiutl.

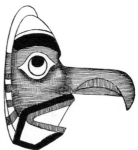

FIG. 1125.—Sun mask. Kwakiutl.

Prof. Cyrus Thomas, in Aids to the Study of the Manuscript Troano, Sixth Ann. Rep. Bur. Ethn., p. 348, gives the left-hand character in Fig. 1126 as representing the sun.

FIG. 1126.—Suns.

General Forlong (*a*) states that the middle device of the same figure represents the sun as Mihr, the fertilizer of the seed.

Dr. Edkins (*e*) gives the right-hand device of the same figure as a picture of the sun. Originally it was a circle with a stroke or dot in the middle.

<center>MOON.</center>

A common Indian gesture sign for moon, month, is the right hand closed, leaving the thumb and index extended, but curved to form a half circle and the hand held toward the sky, in a position which is illustrated in Fig. 1127, to which curve the Moki drawing, the upper left-hand device in Fig. 1128, and the identical form in the ancient Chinese have an obvious resemblance.

FIG. 1127.—Gesture for moon.

The crescent, as Europeans and Asiatics commonly figure the satellite, appears also in the Ojibwa pictograph, the lower left-hand character in Fig. 1128, taken from Schoolcraft (*t*), which is the same, with a slight addition, as the Egyptian figurative character.

FIG. 1128.—Moon.

The middle character in Fig. 1128 is the top of an upright post of a house of the moon gens of the Kuakiutl Indians taken from Boas (*g*). It represents the moon.

Schoolcraft (*u*) gives the right-hand character of the same figure for the moon, i. e., an obscured sun, as drawn by the Ojibwa.

STARS.

Fig. 1129 shows various forms of stars, taken from a petroglyph at

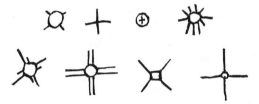

FIG. 1129.—Stars.

Oakley Springs, Arizona. Most of them show the rays in a manner to suggest the points of stars common in many parts of the world.

DAYTIME AND KIND OF DAY.

Fig. 1130, copied from Copway (*h*), presents respectively the characters for sunrise, noon, and sunset.

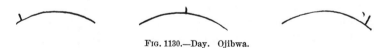

FIG. 1130.—Day. Ojibwa.

An Indian gesture sign for "sunrise," "morning," is: Forefinger of right hand crooked to represent half of the sun's disk and pointed or extended to the left, slightly elevated. In this connection it may be noted that when the gesture is carefully made in open country the pointing would generally be to the east, and the body turned so that its left would be in that direction. In a room in a city, or under circumstances where the points of the compass are not specially attended to, the left side supposes the east, and the gestures relating to sun, day, etc., are made with such reference. The half only of the disk represented in

the above gesture appears in the Moki pueblo drawings for morning and sunrise.

Fig. 1131.—Morning. Arizona.

Fig. 1131 shows various representations of sunrise from Oakley Springs, Arizona.

J. B. Dunbar (*b*), in The Pawnee Indians, says:

As an aid to the memory the Pawnees frequently made use of notches cut in a stick or some similar device for the computation of nights (for days were counted by nights), or even of months and years. Pictographically a day or daytime was represented by a six or eight pointed star as a symbol of the sun. A simple cross (a star) was a symbol of a night and a crescent represented a moon or lunar month.

Fig. 1132.—Day. A common Indian gesture for day is when the index and thumb form a circle (remaining fingers closed) and are passed from east to west.

Fig. 1132 shows a pictograph found in Owens valley, California, a similar one being reported in the Ann. Rep. Geog. Survey West of the 100th Meridian for 1876, Washington, 1876, pl. opp. p. 326, in which the circle may indicate either day or month (both these gestures having the same execution), the course of the sun or moon being represented perhaps in mere contradistinction to the vertical line, or perhaps the latter signifies one.

Fig. 1133 is a pictograph made by the Coyotero Apaches, found at Camp Apache, in Arizona, reported in the Tenth Ann. Rep. U. S. Geol. and Geogr. Survey of the Terr., Washington, 1878, Pl. LXXVII. The sun and the ten

Fig. 1133.—Days. Apache.

spots of approximately the same shape represent the days, eleven, which the party passed in traveling through the country. The separating lines are the nights, and may include the conception of covering over and consequent obscurity referred to in connection with the pictographs for night.

The left-hand character in Fig. 1134, copied from Copway (*h*), represents smooth water or clear day.

The right-hand character in the same figure, from the same authority, p. 135, represents storm or a windy day.

FIG. 1134.—Clear, stormy. Ojibwa.

NIGHT.

Fig. 1135.—Kills-the-Enemy-at-Night. Red-Cloud's Census. Night is indicated by the black circle around the head, suggesting the covering over with darkness, as is shown in the common gesture for night, made by passing both flat hands from their respective sides, inward and downward, before the body. The sign for kill is denoted here by the bow in contact with the head, in accordance with a custom among the

FIG. 1135.

Dakota of striking the dead enemy with the bow or coup stick.

Fig. 1136.— Kills - Enemy - at - Night. Red-Cloud's Census. This drawing is similar to the preceding. The differentiation is sufficient to allow of a distinction between the two characters, each representing the same name, though belonging to two different men.

Fig. 1137. — Smokes - at - Night. Red-Cloud's Census. Again the concept is expressed by the covering over with darkness.

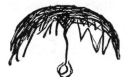

FIG. 1136.

Fig. 1138.—Kills-at-Night.

FIG. 1137.

Red-Cloud's Census. Night is here shown by the curve for sky and the suspension, beneath it, of a star, or more probably in Dakotan expression, a night sun, i. e., the moon.

Fig. 1139.—A Crow chief, Flat-Head, comes into the tipi of a Dakota chief, where a council was assembled. Flame's Winter Count, 1852–'53. The night is shown by the black top of the tipi.

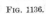

FIG. 1138.

FIG. 1140.—Ojibwa.

Fig. 1140 is taken from Copway (f). It represents "night."

A typical Indian gesture for night, illustrated by Fig. 1141, is: Place the flat hands horizontally about 2 feet apart, move them quickly in an upward curve toward one another until the right lies across the left. "Darkness covers all."

The conception of covering executed by delineating the object covered beneath the middle point of an arch or curve, appears also clearly in the Egyptian characters for night, Fig. 1142, Champollion (*f*).

FIG. 1142.—Night. Egyptian.

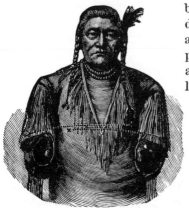

FIG. 1141.—Sign for night.

FIG. 1143.—Night. Mexican.

In Kingsborough (*m*) is the painting reproduced as Fig. 1143.

This painting expresses the multitude of eyes, i. e., stars in the sky, and signifies the night. Eyes in Mexican paintings are painted exactly in this manner.

<div style="text-align:center">CLOUD.</div>

Fig. 1144.—Cloud shield. Red-Cloud's Census. This figure shows in conjunction with the disk, probably a shield but possibly the sun, a dim

Fig. 1144.—Cloud shield.

cloud, and below is a line apparently holding up clouds from which the raindrops have not yet begun to fall. This may be collated with the pictographs for rain and also for snow, as figured below.

A Cheyenne sign for cloud is as follows: (1) Both hands partially closed, palms facing and near each other, brought up to level with or slightly above but in front of the head; (2) suddenly separated sidewise, describing a curve like a scallop; this scallop motion is repeated for "many clouds." The same conception is in the Moki etchings, the

FIG. 1145.—Clouds, Moki.

three left-hand characters of Fig. 1145 (Gilbert MS.), and in variants from Oakley Springs, the two right-hand characters of the same figure.

FIG. 1146.—Cloud, Ojibwa.

The Ojibwa pictogragh for cloud, reported in Schoolcraft (*n*), is more elaborate, Fig. 1146. It is composed of the sign for sky to which that for clouds is added, the latter being reversed, as compared with the Moki etchings, and picturesquely hanging from the sky.

RAIN.

Fig. 1147.—From Copway, loc. cit., represents rain, cloudy.

FIG. 1147.—Rain. Ojibwa.

The gesture sign for rain is illustrated in Fig. 1002. The pictograph, Fig. 1148, reported as found in New Mexico, by Lieut. Simpson, in Ex. Doc. No. 64, 31st Congress, 1st session, 1850, p. 9, is said to represent Montezuma's adjutants sounding a blast to him for rain. The small character inside the curve which represents the sky, corresponds with the gesturing hand, but may be the rain cloud appearing.

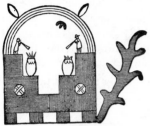
FIG. 1148.—Rain. Pueblo.

The Moki drawing for rain, i. e., a cloud from which the drops are falling, is given in Fig. 1149, in six variants taken from a petroglyph at Oakley Springs.

FIG. 1149.—Rain. Moki.

Edkins (ƒ) gives Fig. 1150 as the Chinese character for rain. It is a picture of rain falling from the clouds. He adds, p. 155:

FIG. 1150.—Rain. Chinese.

Rain was anciently without the upper line, and instead of the vertical line in the middle there were four, but all shorter. Above each of them and within the concave was a dot. These four dots were raindrops, the four lines were the direction of their descent, and the concave was the firmament.

LIGHTNING.

Among the northern Indians of North America the concept of lightning is included in that of thunder, and is represented by the thunder bird, see Chap. XIV, sec. 2, supra.

Fig. 1151 shows three ways in which lightning is represented by the Moki. They are copied from a petroglyph at Oakley Springs, Arizona. In the middle character the sky is shown, the changing direction of the streak and clouds with rain falling. The part

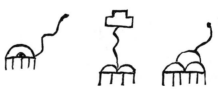
FIG. 1151.—Lightning. Moki.

relating specially to the streak is portrayed in an Indian gesture sign

as follows: Right hand elevated before and above the head, forefinger pointing upward, brought down with great rapidity with a sinuous, undulating motion, finger still extended diagonally downward toward the right.

Fig. 1152 is a copy from a vase in the collection of relics of the an-

FIG. 1152.—Lightning. Moki.

cient builders of the southwest table lands in the MS. Catalogue of Mr. Thomas V. Keam, and represents the body of the mythic Um-tak-ina, the Thunder. This body is a rain cloud with thunder [lightning] darting through it, and is probably of ancient Moki workmanship.

Fig. 1153, also from Keam's MS., gives three other representations of the Moki characters for lightning. The middle one shows the lightning sticks which are worked by the hands of the dancers.

Fig. 1154 also represents lightning, taken by Mr. W. H. Jackson, photographer of the late U. S. Geol. and Geogr. Survey, from the decorated walls of an estufa in the Pueblo de Jemez, New Mexico. The former is blunt, for harmless, and the latter termi-

FIG. 1153.—Lightning. Moki.

nates in an arrow or spear point, for destructive or fatal lightning.

Connected with this topic is the following extract from Virgil's Æneis, Lib. VIII, 429:

Tres imbris torti radios, tres nubis aquosæ
Addiderant, rutili tres ignis et alitis austri.

The "radii" are the forks or spikes by which lightning is designated,

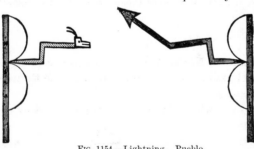

FIG. 1154.—Lightning. Pueblo.

especially on medals. It consisted o f t w e l v e wreathed spikes or darts extended like the radii of a circle. The wings denote the lightning's rapid motion and the spikes or d a r t s its penetrating quality. The four different kinds of spikes refer to the four seasons. The "tres imbristorti radii" or the three spikes of hail, are the winter when hail storms abound. The "tres nubis aquosæ radii," the three spikes of a watery cloud, denote the spring. The "tres rutili ignis radii," the three spikes of sparkling fire, are the summer when lightning is frequent and the "tres alitis austri radii," or the three spikes of winged wind, are for autumn with its many wind storms.

HUMAN FORM.

Fig. 1155.—*a* among the Arikara signifies men. The characters are used in connection with horse-shoes, to denote "mounted men" *b*. In other pictographs such spots or dots are merely numerical. *c* is drawn by the Kiatéxamut branch of the Innuits for man. It is an

FIG. 1155.—Human form.

abbreviated form and rare. *d*, drawn by the Blackfeet, signifies "Man-dead." This is from a pictograph in Wind River mountains, taken from Jones's (*c*) Northwestern Wyoming. *e* is also a Kiatéxamut Innuit drawing for man. This figure is armless; generally represents the person addressed.

Fig. 1156.—*a* is also a Kiatéxamut Innuit drawing for man. The

FIG. 1156.—Human form.

person makes the gesture for nega-tion. *b* and *c*, from a Californian petroglyph, are men also gestur-ing negation. *d*, from School-craft (*v*), is the Ojibwa "symbol" for disabled man.

Fig. 1157.—*a* is the Kiatéxamut Innuit drawing for Shaman. *b*, used by the same tribe, represents man supplicating. *c*, reproduced from Schoolcraft (*u*), is the Ojibwa representative figure or man.

FIG. 1157.—Human form.

Fig. 1158.—*a*, from Schoolcraft, loc. cit., is an Ojibwa drawing of a

FIG. 1158.—Human form.

headless body. *b*, from the same, is another Ojibwa figure for a head-less body, perhaps female. *c*, con-tributed by Mr. Gilbert Thomp-son, is a drawing for a man, made

by the Moki in Arizona. *d*, reproduced from Schoolcraft (*w*), is a draw-ing from the banks of the River Yenesei, Siberia, by Von Strahlen-berg (*a*). *e* is given by Dr. Edkins, op. cit., p. 4, as the Chinese char-acter for, and originally a picture of, a man.

The representation of a headless body does not always denote death. An example is given in Fig. 1159, *a*, taken from an ivory drill-bow in the collection of the Alaska Commercial Company, of San Francisco, California. It was made by the Aigaluxamut natives of Alaska. As the explanation gives no suggestion of a fatal casualty, the concept may be that the hunter got lost or "lost his head," according to the colloquial phrase.

The figures of men in a canoe are represented by the Kiatéxamut Innuit of Alaska, as shown in the same figure, *b*. The right-hand up-ward stroke represents the bow of the boat, while the two lines below

the horizontal stroke denote the paddles used by the men, who are shown as the first and second upward strokes above the canoe; in the same figure, *c* shows the outline of human figures, copied from a walrus ivory drill-bow (U. S. Nat. Mus., No. 44398) from Cape Nome, Alaska. The second pair closely resemble forms of the thunder-bird as drawn

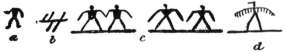

FIG. 1159.—Human form. Alaska.

by various Algonquian tribes and as found in petroglyphs upon rocks in the northeastern portion of the United States; in the same figure, *d*, selected from a group of human forms, is incised upon a walrus ivory drill-bow obtained at Port Clarence, Alaska, by Dr. T. H. Bean, of the National Museum. The specimen is numbered 40054. The fringe-like appendages on the arms may indicate the garment worn by some of the Kenai or other inland Athabascan Indians of Alaska.

FIG. 1160.—Bird-man. Siberia.

Fig. 1160, from Strahlenberg, op. cit., was found in Siberia, and is identical with the character which, according to Schoolcraft, is drawn by the Ojibwa to represent speed and the power of superior knowledge by exaltation to the regions of the air, being, in his opinion, a combination of bird and man.

It is to be noticed that some Ojibwa recently examined regard the character merely as a human figure with outstretched arms, and fringes pendent therefrom. It has, also, a strong resemblance to some of the figures in the Lone-Dog Winter Counts (those for 1854–'55 and 1866–'67, pages 283 and 285, respectively), in which there is no attempt understood to signify anything more than a war-dress.

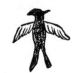

FIG. 1161.—American. Ojibwa.

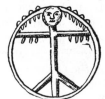

FIG. 1162.—Man. Yakut.

Fig. 1161, according to Schoolcraft (*t*), is the Ojibwa drawing symbolic for an American.

Bastian (*a*), in Ethnologisches Bildebuch, says:

Upon a shaman's drum, from the Yakuts of Siberia, is the figure of a human form greatly resembling some forms of the American types. The appendages beneath the arms, given in Fig. 1162, suggest also some forms of the thunder-bird as drawn by the Ojibwa.

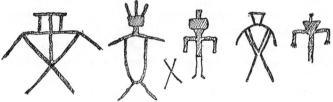

FIG. 1163.—Human forms. Moki.

Fig. 1163 is a copy of human forms found by Mr. Dellenbaugh in

petroglyphs in Shinumo canyon, Utah. They probably are of Moki workmanship.

Fig. 1164, from Mr. Stevenson's paper in the Eighth Annual Report of the Bureau of Ethnology, p. 283, is the form of a man, drawn in the sand in the Hasjelti ceremony of the Navajo.

The left-hand character of Fig. 1165 is described in Keam's MS. as follows:

FIG. 1164.—Human form. Navajo.

This is a conventional design of dragon flies, and is often found among rock etchings throughout the plateau [Arizona]. The dragon flies have always been held in great veneration by the Mokis and their ancestors, as they have been often sent by Oman to reopen springs which Muingwa had destroyed and to confer other benefits upon the people.

This form of the figure, with little vertical lines added to the transverse lines, connects the Batolatci with the Ho-bo-bo emblems. The youth who was sacrificed and translated by Ho-bo-bo reappeared a long time afterwards, during a season of great drought, in the form of a gigantic dragon fly, who led the rain clouds over the lands of Ho-pi-tu, bringing plenteous rains.

FIG. 1165.—Man and woman. Moki.

Describing the middle character of the figure, he says: "The figure represents a woman. The breath sign is displayed in the interior. The simpler design in the right-hand character consists of two triangles, one upon another, and is called the 'woman's head and body.'"

Fig. 1166, reproduced by permission from the Century Magazine for October, 1891, p. 887, is a representation of a golden breastplate found in the United States of Colombia, and now in the Ruiz-Randall collection. The human figure is nearly identical with some of those described and illustrated in the present work as found in other localities.

Crevaux, quoted by Marcano, (g) in speaking of the photographs of French Guyana, makes these useful suggestions:

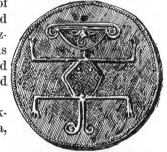

FIG. 1166.—Human form. Colombia.

The drawings of frogs found by Brown on the Esesquibo are nothing else than human figures such as the Galibis, the Roucouyennes, and the Oyampis represent them every day on their pagaras, their pottery, or their skin. We ourselves, on examining these figures with legs and arms spread out, thought that they were meant for frogs, but the Indians told us that that was their manner of representing man.

In Necropolis of Ancon in Peru, by W. Reiss and A. Stubel, (a) are descriptions of figures a to g in Pl. L, all being painted sepulcher tablets one-seventh of the actual size. The descriptions are condensed. The general characteristics of the tablets are that they are in a tabular form, made of reeds, and covered with a white cotton fabric, the edges of

which are stitched together behind and attached to a pole, short at top, and projecting to a greater length downwards. On the front is a slightly sketched design in red and black lines, while a winding or undulating border usually runs around the sides. Nearly all the space within this border is occupied by a human figure surrounded by isolated symbols or ornaments. The head and features of the conventionalized figure is out of all proportion to the small body, which is often merely suggested by a few strokes.

a. The features and high headdress of a human figure, represented by concentric black and red lines. To the short arms are attached out-stretched three-fingered hands, the right holding some object, while body and legs are arbitrarily indicated. The legs are twice reproduced in black and red lines. The space between the figure and border is occupied by six simple designs, two black and one red on either side.

b. The human figure, comparatively simple and distinct, distinguished by large ear ornaments, with designs similar to those of the preceding figure, but varying in number and disposition.

c. Highly fantastic figure with diverse ornamentations; the space in the corners cut off by designs, of which the upper two show a bird motive, such as frequently occurs on earthenware and woven fabrics.

d. This is doubtless meant to represent a figure clothed down to the feet.

e. Here the human figure is formed of black lines, connected at right angles with complementary red lines. A wide top-piece covers the head, which consists of two small rectangles, leaving room only to indicate the eyes, while the mouth, placed rather too low down, is suggested by a red stroke. The arms are bent downwards; hands and feet with triple articulation. Within the red and black frame the figure is encircled by crosses, dots, and a conventional star.

f. Human figure filling most of the space, which is inclosed only by a narrow edging. Surface painting distinguishes the wide body, which is rounded off below and to which the triangular head is fitted above. Hands with five, feet with three, articulations; crenelled head gear; necklace suggested by dots; the corners of the ground-surface filled in with rectangular sharply-edged ornaments.

g. Human figure consisting of two disconnected parts; triangular head and body; hands and feet with two articulations; frame of red and black dovetailed teeth.

Wiener (*i*), describing illustrations reproduced here as Fig. 1167, says:

The tissue found at Moché, *a*, represents a man with flattened head, exaggerated ears, and the thumb of the right hand too much developed. When correlated with that from Ancon, *b*, with its coarse paintings, it becomes a sort of caligraphy in which all the letters are traced with the greatest care, while *b*, and also the sepulchral inscription *c*, found at the same place, become cursive.

The design *a* of this series presents peculiarities found in Zuñi drawings on pottery. The appendages from the side of the head among the

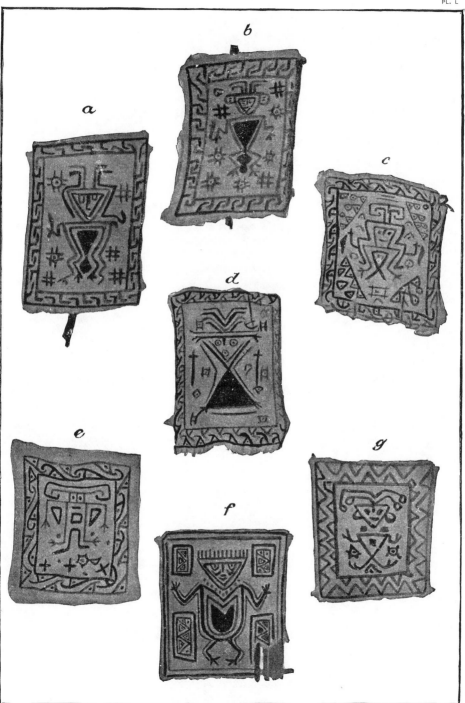

TABLETS AT ANCON, PERU.

latter denote large coils of hair so arranged by tying. Their significance
is that the wearer is an unmarried woman. The remaining designs
also resemble types of human figures found upon Zuñi and Pueblo
pottery, being rather of a decorative character than having special
significance.

FIG. 1167.—Human form. Peru

HUMAN HEAD AND FACE.

A large number of human faces as drawn by members of different
tribes and stocks of North American Indians appear in the present
paper. Some of them are iconographic and others are highly conven-
tionalized. Other examples from other regions of the world are also
presented under various headings.

In the present connection it may be useful to examine a series of
drawings from the prehistoric pottery of Brazil in the National Museum

at Rio Janeiro. Although the U. S. National Museum contains many specimens of a similar character, some of which have been copied and published, the Brazilian types show an instructive peculiarity in the reduction of the face to certain main lines and finally to the eyes, so that the latter are placed apart and independent in a symmetric field.

The following Figs. 1168 to 1174 are reproduced from Dr. Ladisláu Netto (*d*), all of them being from Brazil and from paintings and carvings on Marajo ware.

Fig. 1168 shows broken lines without the aid of curves, but gracefully attached to an instrument, either lance or trident, which present the outline of the contours of a face.

FIG. 1168.—Human face. Brazil.

The characters in Fig. 1169 are somewhat more elaborate. The eyes are decorated with lines and the contour of the face is round.

FIG. 1169.—Human faces. Brazil.

The characters in Fig. 1170 are carved human faces, some of which would not be recognized as such unless shown in the series.

FIG. 1170.—Human faces. Brazil.

The face in Fig. 1171 represents the horizontal projection or plan of a double-faced head. The central ⊟ represents in this case the top of the head, each of the shafts of the H being neither more nor less than the double arch of the eyebrows, joined to which the representation of the nose in a triangular figure may be recognized. The most noticeable point is that if this surface be applied in imagination to

FIG. 1171.—Double-faced head. Brazil.

the cranium of the bifrontal head, of which it seems to be the covering or skin, the features of the double-faced heads of the Marajo idols are immediately recognized, including the orifices by which those idols are hung on cords, which orifices are seen in the dividing line of the two faces.

Fig. 1172 presents the general form of decoration found upon vases bearing figures of the face as above mentioned. It is a funeral urn, carved and engraved, from Marajo, reduced to one-fifth.

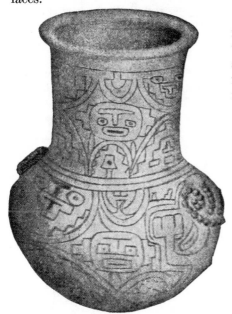

Fig. 1172.—Funeral urn. Marajo.

Fig. 1173.—Marajo vase.

Frequently the face is produced in relief, in which a larger portion of a vessel is taken to produce more lifelike imitation, as in Fig. 1173. It is the neck of an anthropomorphic vase of Marajo ornamented with grooves and lines, red on a white ground, reduced to one-half.

Fig. 1174 a, real size, is the neck of a Marajo vase, representing a human head. The nose and chin are very prominent, the eyes horizontal and slit in the same direction. This head is remarkable for the relief of the eyebrows which, after reaching the height of the ears, form these organs, describing above a second curve in the inverse direction of the curve of the brow, each brow thus forming an S. There are other heads in which the eyebrows are prolonged to form the relief of the ears at the outer extremity. In these cases the whole relief represents a semicircle more or less irregular, while on the contrary this relief forms the figure S.

Same figure, b, real size, is the neck of an ornithomorphic, anthropocephalous vase. It has on the face the classic and conventional T to represent the nose and brows. The eyes are formed by the symbolic figure equally conventional in the ceramics of the mound-builders of Marajo, and the ears differ very little from the characters seen in other figures.

Same figure, c, four-fifths real size, is the neck of a Marajo vase representing, by engraving and painting, all the conventional characters of the different parts of the human face employed by the mound-builders of Marajo. This vase preserves perfectly the primitive colors, which show vermilion lines on a white ground. A double protuberance from each ear, the design which forms the eyes, and that which surrounds and outlines the mouth, the nose, and the ears, are characteristic traces of the decorative art of the human face which few heads present in such perfection.

Same figure, d, four-fifths real size, is the neck of a Marajo vase more simple than the preceding one, but with more regular and distinct features.

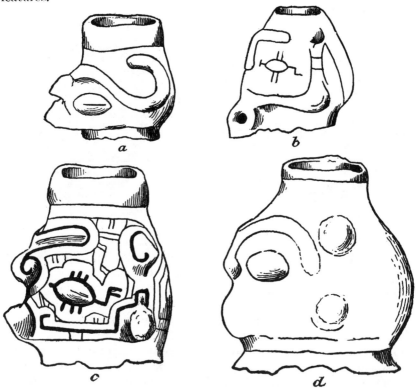

FIG. 1174.—Marajo vases.

The Brazilian system above illustrated, which reduces the face to certain main lines and finally to the eyes, in such manner that the eyes are placed apart and each is put by itself in a symmetric field, has its parallel in North America. This is the practice of the Bella Coola Indians and their neighbors at the present day. They divide the surface, to be ornamented into zones and fields, by means of broad horizontal and vertical lines, each field containing, according to its position, now a complete face, now only an indication of it, the especial indication

being made by the eye. The eyes themselves are given different shapes, according to the different animals represented, being now large and round, now oblong and with pointed angles. These peculiarities, which have become conventional, are retained when the eye is represented alone, so that by this method it may still be easy to recognize which animal—for example, a raven or a bear, is intended to be portrayed.

The left-hand character in Fig. 1175, from Champollion (*g*), is the Egyptian character for a human face. The pre dominance of the ears probably has some special significance.

Schoolcraft (*u*) gives the right-hand character of the same figure as a man's head, with ears open to conviction, as made by the Ojibwa.

FIG. 1175.—Human heads.

Both of these may be compared with the exaggerated ears in Fig. 1167.

HAND.

The impression, real or represented, of a human hand is used in several regions in the world with symbolic significance.

Among the North American Indians the mark so readily applied is of frequent occurrence, with an ascertained significance, which, however, differs in several tribes.

Fig. 1176, taken from Copway (*b*), represents the hand, and also expresses "did so." This signification of "do," or action, and hence "power," is also given to the same character in the Egyptian and Chinese ideograms.

FIG. 1176.—Hand. Ojibwa.

Among several Indian tribes a black hand on a gar ment or ornament means "the wearer of this has killed an enemy." The decoration appears upon Ojibwa bead belts, and the Hidatsa and Arikara state that it is an old custom of showing bravery. The character was noticed at Fort Berthold, and the belt bearing it had been received from Ojibwa Indians of northern Minnesota. The mark of a black hand drawn of natural size or less, and sometimes made by the impress of an actually blackened palm, was also noticed, with the same significance, on articles among the Hidatsa and Arikara in 1881.

Schoolcraft (*x*) says of the Dakota on the St. Peters river that a red hand indicates that the wearer has been wounded by his enemy, and a black hand that he has slain his enemy.

Irving (*b*) remarks, in Astoria, of the Arikara warriors: "Some had the stamp of a red hand across their mouths, a sign that they had drunk the life-blood of a foe."

In other parts of the present paper the significance of the mark is mentioned and may be briefly summarized here.

Among the Sioux a red hand painted on a warrior's blanket or robe means that he has been wounded by the enemy, and a black hand that

he has been in some way unfortunate. Among the Mandan a yellow hand on the breast signifies that the wearer had captured prisoners.

Among the Titon Dakota a hand displayed meant that the wearer had engaged in a hand-to-hand struggle with an enemy. The impress of a hand, stained or muddy, upon the body or horse was the Winnebago mark that the wearer had killed a man.

The drawing of linked fingers or joined hands has been before discussed, p. 643, and in several petroglyphs illustrated in this paper the single hand appears. It is a common device on rocks, and doubtless with varieties of signification, as above mentioned in other forms of pictograph.

It will suffice now to add that the figure of a hand with extended fingers is very common in the vicinity of ruins in Arizona as a rock etching, and is also frequently seen daubed on the rocks with colored

FIG. 1177.—Joined hands. Moki.

pigments or white clay. But Mr. Thomas V. Keam explains the Arizona drawings of hands on the authority of the living Moki. In his MS., in describing Fig. 1177, he says:

The outline of two outstretched hands joined at the wrists and figure of a hand with extended fingers is very common as a rock etching.

These are vestiges of the test formerly practiced among young men who aspired for admission to the fraternity of Salyko. The Salyko is a trinity of two women and a woman from whom the Hopitu obtained the first corn. The first test above referred to was that of putting their hands in the mud and impressing them upon the rock. Only those were chosen as novices the imprints of whose hands had dried on the instant.

Le Plongeon (a) tells that the tribes of Yucatan have the custom of printing the impress of the human hand, dipped in a red-colored liquid, on the walls of certain sacred edifices.

A. W. Howitt, in manuscript notes on Australian pictographs, says:

In very many places there are representations of a human hand imprinted or delineated upon the rocks or in caverns. In the mountains on the western side of the Darling river, in New South Wales, I have observed such, and the aborigines whom I questioned upon the subject said that these representations were made in sport. This reply would, however, be also given were any white man to find and draw their attention to one of the figures which are made in connection with the initiation ceremonies. The representations of hands are made in two ways. In one the hand is smeared with red ocher and water, and impressed upon the rock surface. In the other the hand, being placed upon the rock, a mouthful of red ocher or pipe-clay and water is squirted over it. The hand being then removed there remains its representation surrounded and marked out by the colored wash.

Thomas Worsnop (b) says:

Mr. Winnecke, in 1879, saw several drawings on rocks and in caves, [Fig. 1178], and describes them as follows:

There are found in several large caves near Mount Skinner and Ledans hill, in latitude 22° 30' south and longtitude 134° 30' east. The natives appear to have selected the smooth surface of granite rocks inside several large caves, which spots are not subject to the influence of wind or rain. These caves are resorted to by the natives during excessive rainy seasons, as indicated by their camp preparations, and

it is beyond doubt that these drawings have been performed during these periods of forced inactivity by some artistically inclined native. Those I am alluding to are somewhat numerous in these particular localities and present a uniform appearance.

a, apparently represents a heart pierced in the center by a spear. The outline of the object representing the heart has been delineated with red ocher, whilst the spear has been drawn with a burnt stick or piece of coal. I have only seen this particular sketch in one instance, where four distinct drawings of the same object exactly below and equidistant from each other have been made in anything but a crude manner, the outline having been carefully and very distinctly traced on the rocks, showing a degree of perfection scarcely to be anticipated from these wild inhabitants. The breadth of the heart is about 5 inches and its length about 6 inches. The length of the spear portion is about 3 feet. [The device reminds of St. Valentine's day.]

FIG. 1178.—Cave painting, Australia.

b, consists of two parallel lines about 6 inches apart, with regular marks between, and probably represents the native's notion of a creek with emu tracks traversing its bed. This drawing has been made with a coal, and is found depicted on smooth rocks in various localities.

c, has been drawn both with coal and red ocher. It is found in many places, and seems to be a favorite drawing of the natives. I have found it depicted in several localities in the interior of Australia. It is generally supposed to represent a hand.

d. This figure is made by the natives in the following manner: Placing their extended hand against a smooth rock, after having previously moistened the same, they fill their mouths with powdered charcoal, which they then blow violently along the

outline of their extended hand, thus leaving the portions of rock covered perfectly clean, whilst the space between their fingers and elsewhere around about becomes covered with the black substance. This drawing is not very common. I found several specimens near the Sabdover river. I have, however, been informed that it has been seen in other and distant parts of Australia.

Renan (a) says in the chapter on the Nomad Semites:

The real monuments of the period were, as in the case with all people who can not write, the stones which they reared, the columns erected in memory of some event, and upon which was often represented a hand, whence the name of *iad* [finger post].

Major Conder (c) writes that in Jerusalem a rough representation of a hand is marked by the native races on the wall of every house while building. Some authorities connect it with the five names of God, and it is generally considered to avert the evil eye. The Moors generally, and especially the Arabs in Kairwan, apply paintings of red hands above the doors and on the columns of their houses as talismans to drive away the envious. Similar hand prints are found in the ruins of El Baird near Petra. Some of the quaint symbolism connected with horns is supposed to originate from such hand marks. The same people make the gesture against the evil eye by extending the five fingers of the left hand.

H. Clay Trumbull (b) gives the following:

It is a noteworthy fact that among the Jews in Tunis, near the old Phenician settlement of Carthage, the sign of a bleeding hand is still an honored and a sacred symbol as if in recognition of the covenant-bond of their brotherhood and friendship. "What struck me most in all the houses," says a traveler (Chevalier de Hesse-Wartegg) among these Jews, "was the impression of an open bleeding hand on every wall of each floor. However white the walls, this repulsive (yet suggestive) sign was to be seen everywhere."

The following is extracted from Panjab Notes and Queries, Vol. I, No. 1 (October, 1883), p. 2:

At the Temple of Balasundarí Deví at Tilokpúr, near Náhan, the priests stamp a red hand on the left breast of the coat of a pilgrim who visits the temple for the first time to show that he has, as it were, paid for his footing. If the pilgrim again visits the temple and can show the stamp he pays only 4 annas as his fee to the priests.

Gen. A. Hontum-Schindler, Teheran, Persia, in a letter of December 19, 1888, tells:

All through Persia, principally in villages though, a rough representation of a hand, or generally the imprint of a right hand, in red, may be seen on the wall or over the door of a house whilst in building, or on the wall of a mosque, booth, or other public building. It is probably an ancient custom, although the Persians connect it with Islam, and they say that the hand represents that of Albas, a brother of Husain (a grandson of the prophet Mohammed), who was one of the victims at the massacre of Kerbela in 680, and who had his right hand cut off by el Abrad ibn Shaibán. In India I have noticed similar marks, hands, or simply red streaks.

In Journal of the Proc. Royal Soc. Antiq., Ireland, I, 3, fifth series, 1890, p. 247, is the following:

The hand an emblem of good luck in Ireland.—In Maj. Conder's "Syrian Stone Lore," published for the Palestine Exploration Committee by Bentley & Son (1886), p. 71, occurs the following passage: "Among other primitive emblems used by the

Phenicians is the hand occurring on votive steles at Carthage, sometimes in connection with the sacred fish. This hand is still a charm in Syria, called Kef Miriam, 'the Virgin Mary's hand,' and sovereign against the evil eye. The red hand is painted on walls, and occurs, for instance, in the Hagia Sophia at Constantinople and elsewhere. It is common also in Ireland and in India (Siva's hand) and on early scepters, always as an emblem of good luck." What actual foundation is there for the above statement as regards Ireland? About twenty years ago the first Monday in January was known in the south of Ireland as "Handsel Monday," and looked upon as in some way indicating the prosperity the year succeeding was to bring forth. But whether, as the name would seem to imply, this had any connection with the hand as an emblem of good luck I am unaware.—J. C.

Gen. Forlong (b) makes the following remarks:

The "red hand of Ireland" is known alike to Turanians, Shemites, and Aryans, and from the Americas to farthest Asia. The hand, being an organ peculiar to man, is in the East a sign of Siva, and seems to have been identified with his emblem even by the Medes. All men have usually worshiped and plighted their troth or sworn by manual signs, so the hand naturally stands as the sign of man himself; but more than this, Easterns attach a significance to it as an organ without which the procreating one is useless. In Germany, says J. Grimm, the hand was *Tyr*, or the son of Odin, "the one-handed," for he lost one limb by the biting wintry wolf—that is, he became powerless to produce. He was then the "golden-handed," fertilizer, whom

FIG. 1179.—Irish cross.

ancient Irans denoted by their name Zerdosht, and Irish Kelts placed as a talisman on their Ulster shield. The Irish solo-phalik idea is seen in the "crosses" of Clon-Mac-Noise and Monasterboise, where, as in Fig. 1179, all the fingers are carefully placed in the center of the circle of fertility. The Vedas constantly speak of Savatar as "the golden-handed sun," who lost this limb owing to his efforts when at sacrifice, and who remained impotent until the deity restored to him a hand of gold.

Hindus, like the high Asian tribes and the old Mexicans, usually impress a hand covered with blood or vermilion on the door posts of their temple—that is, on the Delpheus or "door of life;" and the great Islamite, Mahmood, when he captured Constantinople, rode up to the holy feminine shrine of St. Sophia, and reaching up as high as he could, there unwittingly imprinted this bloody sign of Great Siva. We must remember how often the hand appears with other significant objects on the arms of men and nations, and notably so on Roman standards. Fig. 1180.

In the old shrines of America, Leslie says, the "sacred hand was a favorite subject of art," and Stevens in his Yucatan says, "The red hand stared us in the face over all the ruined buildings of the country, . . . not drawn or printed, but stamped by the living hand, the pressure of the palm upon the stone being quite distinct, the thumb and fingers being extended as we see in the Irish and Hindu hands.

FIG. 1180.—Roman standard.

FEET AND TRACKS.

In the two first illustrations of this group the respective figures of the man and the eagle are in the act of forming tracks on the ground. Such tracks are shown in the next two figures, but without the context

might not be recognized as such. The fifth figure is more distinctly ideographic, showing the foot and leg as in the act

FIG. 1181. FIG. 1182. FIG. 1183.

of making the impress, and the eagle's feather to indicate the kind of track which would have been made by a running eagle.

Fig. 1181.—Goes-Walking. Red-Cloud's Census.

Fig. 1182.—Running-Eagle. Red-Cloud's Census.

Fig. 1183.—Tracks. Red-Cloud's Census.

Fig. 1184.—Walking-Bull-Track. Red-Cloud's Census.

Fig. 1185.—Eagle-Track. Red-Cloud's Census.

Fig. 1186, copied from Copway (b), gives three characters of which the first represents "ran," the second "walked" or "passed," and the third "stand," characters similar both to the tracks and the feet found on many petroglyphs in North America.

They are also found in the terraces of temples of Thebes, of Karnak, and especially at Nakhaur in South Bihar.

FIG. 1184.

FIG. 1185.

P. le Page Renouf (a), in An Elementary Grammar of the Ancient Egyptian Language, gives the right-hand character of the same figure as the generic determinative implying motion.

FIG. 1186.—Feet.

BROKEN LEG.

This group gives several modes of expressing, pictorially, broken legs.

Fig. 1187.—Many were thrown from their horses while surrounding buffalo, and some had their legs broken. Cloud-Shield's Winter Count, 1847–'48. The legs are distorted and the line may refer to the slippery ice touched by the toes.

FIG. 1187. Fig. 1188.—Lone-Horn's father broke his

FIG. 1188.

leg. The-Flame's Winter Count, 1832–'33. This is a strongly marked representation.

Fig. 1189.—A Minneconjou Dakota named Broken-Leg died. The-Flame's Winter Count, 1846–'47. The-Flame's representation is objective, but Battiste Good gives another more ideographic. The arm in his character, given in Fig. 1190, is lengthened so as nearly to touch the broken leg, which is shown distorted, instead of indicating the injury by the mere distortion of the leg itself. The bird over the head, and connected by a line with it, probably represents the teal as a name-totem. Perhaps he was called Broken-Leg after the injury.

FIG. 1189. Fig. 1191.—There were a great many acci- FIG. 1190.
dents and some legs were broken, the ground being covered with ice.

American-Horse's Winter Count, 1847–'48. Here the fracture is very obvious—too much so to be intended as objective—rather delineating the idea of the breaking and separation of the bone.

Fig. 1192.—Broken-Leg was killed by the Pawnees. His leg had been broken by a bullet in a previous fight with the Pawnees.

FIG. 1191. let in a previous fight with the Pawnees. FIG. 1192.
American-Horse's Winter Count, 1807–'08. Here the leg is entirely removed from its normal position.

a

Dr. Edkins (*g*) gives Fig. 1193, *a*, as a picture of a bent leg broken, and adds, "The true radical and phonetic for which this stands as representative is rather *b*, 'fault,' 'move.'"

b

VOICE AND SPEECH.

FIG. 1193.—Broken This group relates to sounds issuing from the mouth,
leg. Chinese. that is, to voice and speech:

Fig. 1194.—The- Elk- that- Holloes- Walking. The-Swan's Winter Count, 1860–'61. Interpreter A. Lavary said, in 1867, that The-Elk-that-Holloes-Walking, then chief of the Minneconjous, was then at Spotted-Tail's camp. His father was Red-Fish. He was the elder brother of Lone-Horn. His name is given as A-hag-a-hoo-man-ie, FIG. 1194.
translated The-Elk's-Voice-Walking, compounded of he-ha-ka, elk, and omani, walk; this according to Lavary's literation. The correct literation of the Dakota word meaning elk is heqaka; voice, ho; and to walk, walking, mani. Their compound would be heqaka ho mani, the translation being the same as above given.

Fig. 1195.—Elk-walking-with-his-Voice. Red-Cloud's Census. This is explained by the following figure.

Fig. 1196 is taken from the manuscript drawing book of an Indian prisoner at St. Augustine, Florida, now in the Smithsonian Institution,

No. 30664. It represents an antelope and the whistling sound pro-
duced by the animal on being surprised or alarmed. It also shows the
tracks, and supplies the idea of walking not exhibited by the preced-
ing two figures.

FIG. 1195. FIG. 1196.

Fig. 1197.—Dog-with-good-voice. Red-Cloud's Census. The pecu-
liar angular divisions of the line may indicate the explosive character
of a dog's bark as distinct from a long-drawn howl. Among the many
lines indicating voice which appear in the Dakota pictographs none has
been found identical with this, and therefore it probably has special
significance.

FIG. 1197. FIG. 1198.

Fig. 1198.—Bear-that-growls. Red-Cloud's Census. This figure gives
a marked differentiation. The sound of growling does not appear to
come from the mouth, but from the lower part of the neck or the
upper part of the chest, from which the lines here are drawn to ema-
nate. They are also confined by a surrounding line, to suggest the
occluded nature of the sound.

Fig. 1199, from Copway (*b*), represents "speak."

The Mexican pictograph, Fig. 1200, taken from Kingsborough (*n*), is illustrative of the sign made by the Arikara and Hidatsa for "tell" and "conversation." "Tell me" is: Place the flat right hand, palm upward, about 15 inches in front of the right side of the face, fingers pointing to the left and front; then draw the hand inward toward and against the bottom of the chin. For "conversation," talking between two persons, both hands are held before the breast, pointing forward, palms up, the edges being moved several times toward one another. Perhaps, however, the picture in fact only means the common poetical image of "flying words."

FIG. 1199.—Speech.
Ojibwa.

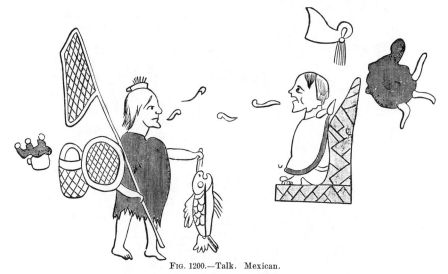

FIG. 1200.—Talk. Mexican.

Fig. 1201 is from Landa (*b*) and suggests one of the gestures for "talk," and more especially that for "sing," in which the extended and separated fingers are passed forward and slightly downward from the mouth—"many voices." Although late criticisms of the bishop's work are unfavorable to its authenticity, yet even if it were prepared by a Maya, under his supervision, the latter would probably have given him some genuine native conceptions, and among them gestures would be likely to occur.

FIG. 1201.—Talk.
Maya.

Gustav Eisen (*a*), in describing Fig. 1202, says:

The original, from near Santa Lucia, Guatemala, represents a sepulchral tablet, on which are seen the portraits of perhaps man and wife, their different headdresses, etc., indicating decidedly their different sexes. From the mouths of the respective portraits extend as usual curved figures with notes or nodes.

DWELLINGS.

Irving (*c*) noticed fifty years ago that each tribe of Indians has a different mode of shaping and arranging lodges, and especially that the

Omaha make theirs gay and fanciful with undulating bands of red and yellow or with dressed and painted buffalo skins.

The left-hand upper characters of Fig. 1203 represents Dakota lodges as drawn by the Hidatsa. These characters when carelessly or rudely drawn can only be distinguished from personal marks by their position and their relation to other characters.

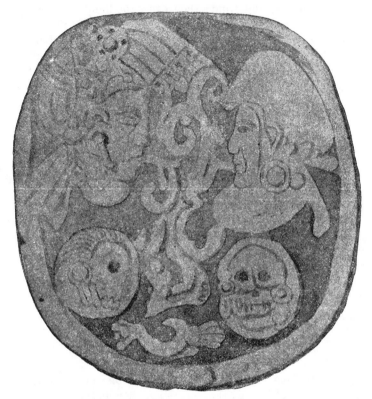

Fig. 1202.—Talk. Guatemala.

The right-hand upper characters of the same figure signify, among the Hidatsa, earth lodges. The circles represent the ground plan of

the lodges, while the central markings are intended to represent the upright poles, which support the roof on the interior. Some of these are similar to the Kadiak drawing for island, Fig. 439.

The left-hand lower character of the figure represents buildings erected by civilized men; the character is generally used by the Hidatsa to designate government buildings and traders' stores.

Fig. 1203.—Dwellings.

The remaining character is the Hidatsati, the home of the Hidatsa; an inclosure having earth lodges within it.

Fig. 1204.—Dakotas and Rees meet in camp together and are at peace. The-Flame's Winter Count, 1792–'93. The two styles of dwellings, viz, the tipi of the Dakotas and the earth lodge of the Arikaras, are depicted.

Fig. 1205.—The Dakotas camped on the Missouri river, near the Gros Ventres, and fought with them a long time. Cloud-Shield's Winter Count,

FIG. 1204.

FIG. 1205.

1792–'93. The Dakota tipi and the Gros Ventre lodge are shown in the figure. The gun shows that war was raging.

Fig. 1206.—The Dakotas camped near the Rees and fought with them. Cloud-Shield's Winter Count, 1795–'96. This figure is a variant of the one foregoing.

FIG. 1206.

Fig. 1207.—Some of the Dakotas

FIG. 1207.

built a large house and lived in it during the winter. Cloud-Shield's Winter Count, 1815–'16. White-Cow-Killer calls it "Made-a-house-winter." It would seem to be a larger dwelling than the ordinary tipi, and that wood entered into its construction. This is made more clear by the figure next following.

FIG. 1208. Fig. 1208.—They lived in the same house that they did last winter. Cloud-Shield's Winter Count, 1816–'17.

FIG. 1209.

Fig. 1209.—Adobe houses were built by Maj. J. W. Wham, Indian agent (afterwards pay-master, U. S. Army), on the Platte river, about 30 miles below Fort Laramie. Cloud-Shield's Winter Count, 1871–'72. White-Cow-Killer calls it "Major-Wham's-house-built-on-Platte-river winter."

Fig. 1210.—American-Horse's Win-ter Count, 1815–'16. The figure is in-

FIG. 1210. tended to represent a white man's

FIG. 1211.—Dwelling. Moki.

house. Other forms are shown in Lone-Dog's Winter Count, Chap. x, sec. 2.

Fig. 1211 shows different representations of Moki houses copied from a petroglyph at Oakley Springs, Arizona.

Prof. Cyrus Thomas, in A Study of the Manuscript Troano, Contrib. N. A. Ethn., Vol. v, p. 128, gives the following description of Fig. 1212:

The side wall in Fig. 1212 appears to be composed of blocks of some kind placed one upon another, probably of stone, each bearing the *Muluc* character. The charac-ter at the top of the wall with a cross in it, somewhat resembling that in the symbol

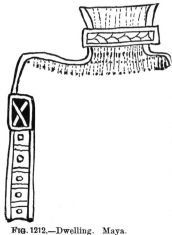

for *Ezanab*, is very common in these figures. This probably marks the end of the beam which was placed on the wall to support the roof. The curved line running from this to the top portion probably represents the rafter; the slender thread-like lines (yellow in the original) the straw or grass with which the roof was thatched.

The checkered part may represent a matting of reeds or brushwood on which the straw was placed.

Champollion (*h*) gives the Egyptian characters for house, reproduced in Fig. 1213.

FIG. 1212.—Dwelling. Maya.

FIG. 1213.—House. Egyptian.

ECLIPSE OF THE SUN.

Fig. 1214.—Dakotas witnessed eclipse of the sun; they were terribly frightened. The sun is a dark globe and the stars appear. The-Swan's Winter Count, 1869–'70.

The left-hand design on the lower line of Pl. XLIX is reproduced from Kingsborough. "In this year there was a great eclipse of the sun."

Humboldt infers from this painting that the Mexicans were informed of the real cause of the eclipses; which would not be at all surprising

FIG. 1214.—Eclipse of the sun. considering the many other curious things with which they were acquainted, the knowledge of which they must have derived from the West. It is proper to observe that on the 127th page of the Vatican MS., where a representation of the same eclipse occurs, the disk of the moon does not appear to be projecting over that of the sun. The Vatican MS. appears to have been copied from a Mexican painting similar to but not the same as that which Pedro de las Rios copied, whose notes and interpretations the Italian interpreter had before his eyes and strictly followed.

METEORS.

This group shows the pictorial representation of meteors by the Dakotas. The translations as well as the devices are suggestive.

Fig. 1215.—A large roaring star fell. It came from the east and shot out sparks of fire along its course. Cloud-Shield's Winter Count, 1821–'22. Its track and the sparks are shown in the figure. White-Cow-Killer says "One-star-made-a-great-noise winter."

This and the three following figures evidently refer to the fall of a single large meteor in the land of the Dakotas some time in the winter of 1821–'22.

FIG. 1215. The fact can not be verified by scientific records. FIG. 1216.

There were not many correspondents of scientific institutions in the upper Missouri region at the date mentioned.

Fig. 1216.—Large ball of fire with hissing noise (aerolite). The-Flame's Winter Count, 1821–'22.

Fig. 1217.—Dakota Indians saw an immense meteor passing from southeast to northwest, which exploded with great noise. The-Swan's Winter Count, 1821–'22.

Battiste Good says for the same phenomenon: "Star-passed-by-with-loud-noise winter." His device is shown in Fig. 1218, showing the meteor, its pathway, and the clouds from which it came.

FIG. 1217.

FIG. 1218.

The five winter counts next cited all undoubtedly refer to the magnificent meteoric display of the morning of November 13, 1833, which was witnessed throughout North America and which was correctly assigned to the winter corresponding with that of 1833–'34. All of them represent stars having four points, except The-Swan, who draws a globular object followed by a linear track.

FIG. 1219.

FIG. 1220.

Fig. 1219.—It rained stars. Cloud-Shield's Winter Count, 1833–'34. White-Cow-Killer calls it "Plenty-stars winter."

Fig. 1220.—The stars moved around. American-Horse's Winter Count, 1833–'34. This shows one large four-pointed star as the characterizing object and many small stars, also four-pointed.

Fig. 1221.—Many stars fell. The-Flame's Winter Count, 1833–'34. The character shows six stars above the concavity of the moon.

FIG. 1221.

Fig. 1222.—Dakotas witnessed magnificent meteoric showers; much terrified. The-Swan's Winter Count, 1833–'34.

Battiste Good calls it "Storm-of-stars winter," and gives as the device a tipi with stars falling around it. This is presented in Fig. 1223 The tipi is colored yellow in the original and so represented in the figure according to the heraldic scheme.

Fig. 1224 is taken from Kingsborough, I, Pls. XXIX and XXX. The description, given in Codex Tell.-Rem., VI, p. 148, et seq., is as follows: Regarding the left-hand

FIG. 1222.

FIG. 1223.

device figure, " In the year of Three Rabbits, or in 1534, Don Antonio de Mendoça arrived as Viceroy of New Spain. They say that the star smoked."

Regarding the lower figure: " In the year of Eleven Houses, or in 1529, Nuño de Guzman set out for Yalisco on his march to subdue that

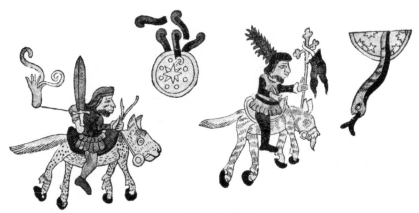

FIG. 1224.—Meteors. Mexican.

territory; they pretend that a serpent descended from the sky, exclaiming that troubles were preparing for the natives since the Christians were directing their course thither."

THE CROSS.

Referring to the numerous forms of cross delineated in the work of Mr. W. H. Holmes (d), it is to be noted that most of them are equilateral or the Greek pattern, and that similar ornaments or instruments now used by the Dakotas are always worn so that the cross upon them stands as if resting on one foot only and not on two, as is the mode in which St. Andrew's cross is drawn.

The "Greek" cross represents to the Dakota the four winds, which issue from the four caverns in which the souls of men existed before their incarnation in the human body. All "medicine-men," i. e., conjurers and magicians, recollect their previous dreamy life in those places and the instructions then received from the gods, demons, and sages. They recollect and describe their preexistent life, but only dream and speculate as to the future life beyond the grave.

The top of the cross is the cold all-conquering giant, the North-wind, most powerful of all. It is worn on the body nearest the head, the seat of intelligence and conquering devices. The left arm covers the heart; it is the East-wind, coming from the seat of life and love. The foot is the melting burning South-wind, indicating, as it is worn, the seat of fiery passion. The right arm is the gentle West-wind, blowing from the spirit land, covering the lungs, from which the breath at last goes

out, gently, but into unknown night. The center of the cross is the earth and man, moved by the conflicting influences of the gods and winds. This cross is often illustrated as in Fig. 1225. It is sometimes drawn and depicted in beadwork and also on copper, as in Fig. 1226, extracted from the Second Ann.

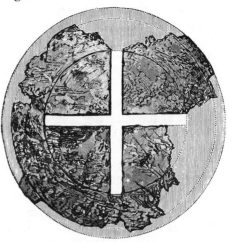

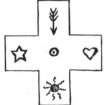

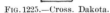

FIG. 1225.—Cross. Dakota. FIG. 1226.—Cross. Ohio mound.

Rep. Bur. Ethn., Pl. LII, Fig. 4, where it appears cut out of a copper plate found in an Ohio mound.

But among some of the Indian tribes the true Latin cross is found, viz, upright with three members of equal length, and the fourth, the foot, much longer. The use of this symbol antedates the discovery of America, and is carried far back in tradition and myth. When a missionary first asked a Dakota the name of this figure, which he drew for him in the sand, wishing to use the information in his translation of Bible and Creed, the Dakota promptly replied Sus-be-ca, and retraced the figure saying "That is a Sus-be-ca." It was therefore promptly transferred to Scripture and Creed where it still reads " He was nailed to the Susbeca," etc. "God forbid that I should glory save in the Susbeca of our Lord Jesus Christ." To the good missionary this was plain and satisfactory; for the Dakota had demonstrated by tracing it in the sand that Susbeca was the name of the figure called in English, "cross." The foregoing statement is made on the excellent authority of Rev. S. D. Hinman.

But when the Dakota read his new Bible or Creed, he must have been puzzled or confused to find, " He was nailed to a mosquito-hawk," or, " God forbid that I should glory save in the mosquito-hawk of our Lord Jesus Christ."

The same disposition of straight lines which is called the Latin cross was and is used by the Dakota to picture or signify both in pictograph and gesture sign, the mosquito-hawk, more generally called dragon fly. The Susbeca or mosquito-hawk is a supernatural being. He is gifted with speech. He warns men of danger. He approaches the ear of the man moving carelessly or unconcernedly through the deep grass of the meadow or marsh—approaches his ear silently and at right angles, as shown in Fig. 1227a, and says to him, now alarmed, "Tci"-"tci"-"tci!"—which is an interjection

FIG. 1227.—Dragon fly.

equivalent to "Look out!" "You are surely going to destruction!" "Look out!" "Tci"-"tci"-"tci!"

Now the mosquito-hawk is easily knocked down and caught and has a temptingly small neck. But woe to the man or woman or child who with the cruelty commonly practiced on all living things by Indians of all ages and states, dares to wring off his head. Whoever shall do this before the winter comes shall be beheaded by the detested Ojibwa. It is true, for long ago a reckless young warrior feeling annoyed or insulted by the infernal " Tci "-"tci"-"tci!" so unceremoniously uttered in explosive breaths near his ear, tried it, and his headless trunk was found ere he escaped from the swamp.

The cross has its proper significance in this use not only in representing quite faithfully the shape of the insect but also the angle of his approach. It is variously drawn, but usually as in Fig. 1227, a, or b, and in painting or embroidery, c, and sometimes d.

One reason for the adoption of the dragon fly as a mysterious and supernatural being, is on account of its sudden appearance in large numbers. When in the still of the evening, before the shades of darkness come, there is heard from the meadow a hum as of the sound of crickets or frogs, but indistinct and prolonged; on the morrow the Susbeca will be hovering over it; it is the sound of their coming, but whence no man kens. See also Fig. 1165 and remarks.

Among the Ojibwa of northern Minnesota the cross is one of the sacred symbols of the society of the Midē or shamans, and has special reference to the fourth degree. A neophyte who has been advanced to the third initiation or degree, is instructed in ritualistic chants purporting to relate the struggle between Mi′nabō′zho, the mediator between the Ojibwa and Ki′tshi Ma′nidō, and the malevolent Bear spirit, which contest occurred when Mi′nabō′zho entered the fourth degree structure at the time when the first Indian was inducted therein for initiation.

The structure as erected at this day is built in the form of an oblong square having openings or doors at the four cardinal points. At these openings Mi′nabō′zho appeared and shot into the inclosure charmed arrows, to expel the horde of demons occupying the sacred place, and the Bear spirit was the last to yield to his superior powers. The openings being opposite to one another, north and south and east and west, suggested to Mi′nabō′zho the cross, which is now erected whenever a third degree Midē receives this last and highest honor.

The cross is made of saplings, the upright pole reaching the height of 4 to 6 feet, the transverse arms being somewhat shorter, each being of the same length as that part of the pole between the arms and the top. The upper parts are painted white, or besmeared with white clay, over which are spread small spots of red, the latter suggesting the sacred shell or mēgis, the symbol of the order. The lower arm or pole is squared, the surface toward the east being painted white, to denote

the source of light and warmth. The face on the south is green, denoting the source of the thunder bird who brings the rains and causes the appearance of vegetation; the surface toward the west is covered with vermilion and relates to the land of the setting sun, the abode of the dead. The north is painted black, as that faces the direction from which come affliction, cold, and hunger.

Illustrations and additional details on this topic are presented in the paper of Dr. Hoffman (a).

In the chart presented in that paper, Pl. B, a midē′ structure is also shown, within which are a number of crosses, each of which designates the spirit of a deceased midē priest.

Upon several birch-bark scrolls received from Ojibwa midē priests are characters resembling rude crosses which are merely intended to designate wigwams, resembling in this respect similar characters made by Hidatsa to designate Sioux lodges as shown in Fig. 1203.

Groups of small crosses incised upon ivory bow drills and representing flocks of birds, occur on Eskimo specimens, Nos. 45020 and 44211, in the collection of the U.S. National Museum. They are reproduced in Fig. 1228. In Figs. 429 and 1129, representing petroglyphs at Oakley Springs, Arizona, are crosses which are mentioned by Mr. G. K. Gilbert as signifying stars. The simple cross appears to be the simplest type of character to represent stellar forms. See Figs. 1219, 1220, 1221 and 1223.

Fig. 1228.—Crosses. Eskimo.

Fig. 28, supra, represents a cross copied from the Najowe Valley group of colored pictographs, 40 miles west of Santa Barbara, California. The cross measures 10 inches in length, the interior portion being painted black, while the outside or border is of a dark red tint. This drawing, as well as numerous others in close connection, is painted on the walls of a shallow cave or rock-shelter in the limestone formation.

Fourteen miles west of Santa Barbara, on the summit of the Santa Ynez mountains, are caverns having a large opening, facing the northwest and north, in which crosses occur of the types given in Fig. 33, supra.

The interior portion of the cross is of a dull, earthy red, while the outside line is of a faded black tint. The cross measures nearly a foot in extent.

At Tulare Indian agency, Tulare valley, California, is an immense bowlder of granite which has become broken in such a manner that one of the lower quarters has moved away from the larger mass sufficiently to leave a passageway 6 feet wide and nearly 10 feet high. The interior walls are well covered with large,

Fig. 1229.—Cross. Tulare valley, California.

painted figures, while upon the ceiling are numerous forms of animals, birds, and insects. Among this latter group is a white cross measuring about 18 inches in length, Fig. 1229, presenting a unique appearance, for the reason that white coloring matter applied to petroglyphs is, with this single exception, entirely absent in that region.

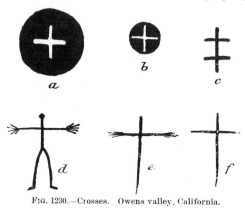

FIG. 1230.—Crosses. Owens valley, California.

One of the most interesting series of rock sculpturings in groups is that in Owens valley, south of Benton, California. Among these various forms of crosses occur, and circles containing crosses of various simple and complex types, as shown in Pls. I to XI and in Mojave desert, California, illustrated in Fig. 19, but the examples of most interest in the present connection are the two shown herewith in Fig. 1230, a and b.

The larger one, a, occurs upon a large bowlder of trachyte, blackened by exposure, located 16 miles south of Benton, at a locality known as the Chalk Grade. The circle is a depression about 1 inch in depth, the cross being in high relief within. Another smaller cross, b, found 3 miles north of the one above-mentioned, is almost identical, each of the arms of the cross, however, extending to the rim of the circle.

In this locality occurs also the form of the cross c, in the same figure, and some examples having more than two cross arms. Other simple forms clearly represent the human form, but by erosion the arms and body have become partially obliterated so as to lose all trace of resemblance to humanity.

In the same figure, d, from a rock in the neighborhood, exhibits the outline of the human form, while in e parts of the extremities have been removed by erosion so that the resemblance is less striking; in f a simple cross occurs, which may also have been intended to represent the same, but through disintegration the extremities have been so greatly changed or erased that their original forms can not be determined.

Rev. John McLean (a) says: "On the sacred pole of the sun lodge of the Blood Indians two bundles of small brushwood taken from the birch tree were placed in the form of a cross. This was an ancient symbol evidently referring to the four winds."

Among the Kiatéxamut, an Innuit tribe, a cross placed on the head, as in Fig. 1231, signifies a Shaman's evil spirit or demon. This is an

imaginary being under control of the Shaman to execute the wishes of the latter.

Many of the mescal eaters at the Kaiowa mescal cere-mony wear the ordinary Roman Catholic crucifixes, which they adopt as sacred emblems of the rite, the cross repre-senting the cross of scented leaves upon which the conse-crated mescal rests during the ceremony, while the human figure is the mescal goddess.

FIG. 1231.—Cross. Innuit.

Concerning Fig. 1232, Keam, in his MS., says:

The Maltese cross is the emblem of a virgin; still so recognized by the Moki. It is a conventional development of a more common emblem of maidenhood, the form in which the maidens wear their hair arranged as a disk of 3 or 4 inches in diameter upon each side of the head. This discoidal arrangement of their hair is typical of the emblem of fructification worn by the virgin in the Muingwa festival, as exhib-ited in the head-dress illustration a. Sometimes the hair, instead of being worn in the complete discoid form, is dressed from two curving twigs and presents the form of two semicircles upon each side of the head. The partition of these is sometimes horizontal and sometimes vertical. A combination of both of these styles, b, pre-sents the form from which the Maltese cross was conventionalized. The brim dec-orations are of ornamental locks of hair which a maiden trains to grow upon the sides of the forehead.

The ceremonial employment of the cross by the Pueblo is detailed in Mr. Stevenson's pa-per entitled Ceremonial of Hasjelti Dailjis and Mythical Sand-painting of the Navajo Indi-ans, in the Eighth Ann. Rept. Bur. Ethn., p. 266, where it denotes the scalp-lock.

a b

FIG. 1232.—Crosses. Moki.

In the present paper the figure of the cross among the North Amer-ican Indians is presented under other headings with many differing significations. Among other instances it appears on p. 383 as the tribal sign for Cheyenne; on p. 582 as Dakota lodges; on p. 613 as the char-acter for trade or exchange; on p. 227 as the conventional sign for prisoner; on p. 438 for personal exploits; while elsewhere it is used in simple numeration.

But, although this device is used with a great variety of meanings, when it is employed ceremonially or in elaborate pictographs by the Indians both of North and South America, it represents the four winds. The view long ago suggested that such was the signifi-cance of the many Mexican crosses, is sustained by Prof. Cyrus Thomas, in his Notes on Maya and Mexican MSS., Second Ann. Rep. Bur. Ethn., p. 61, where strong confirm-atory evidence is produced by the arms of the crosses having the appearance of conventionalized wings, simi-lar to some representations of the thunder-bird by more northern tribes. Yet the same author, in his paper on the Study of the MS. Troano, Contrib. N. A. Ethn., v, 144, gives Fig. 1233 as the symbol for wood, thus further showing the manifold con-cepts attached to the general form.

FIG. 1233. Crosses. Maya.

Bandelier (*a*) thinks that the crosses which were frequently used before the conquest by the aborigines of Mexico and Central America were merely ornaments and were not objects of worship, while the so-called crucifixes, like that on the "Palenque tablet," were only the symbol of the "new fire" or close of a period of fifty-two years. He believes them to be merely representations of "fire-drills," more or less ornamented.

Mr. W. H. Holmes (*e*) shows by a series representing steps in the simplification of animal characters that in Chiriqui a symmetrical cross was developed from the design of an alligator.

FIG. 1234.—Crosses. Nicaragua.

Carl Bovallius (*a*) gives an illustration, copied here as Fig. 1234, of pictographs in the island of Ceiba, Nicaragua.

Zamacois (*a*) says that "the cross figured in the religion of various tribes of the peninsula of Yucatan and that it represented the god of rain."

Dr. S. Habel (*f*), describing Fig. 1235, says:

On it is a person in a reclining position, with a single band tied around his forehead, forming a knot with two pendent tassels. From his temple rises an ornament resembling the wing of a bird. The emaciated face, as well as the recumbent position of the body, indicates a state of sickness. The hair is interwoven behind with many ribbons forming loops, which are bound together by a clasp, and then spread out in the shape of a fan. The ear is ornamented with a circular disk, to the center of which are attached a plume and a twisted ornament similar to a queue. On the

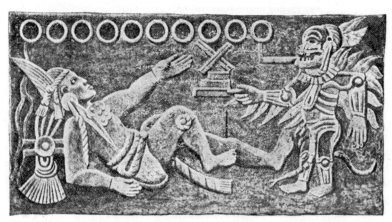

FIG. 1235.—Cross. Guatemala.

breast is a kind of brooch, which is hollow like a shell, and in which are imbedded seven pearls. Around the waist are three rows of a twisted fabric, which is knotted in front in a bow, the ends descending between the thighs. Another band, of a different texture, stretches out horizontally from the region of the above-mentioned knot. Attached to this girdle is another fabric, of a scaly texture, which surrounds the thighs. The right leg, below the knee, is encircled with a ribbon and a rosette.

This would seem to be the undress substitute for the band and pendant. In front of the recumbent person stands the representation of a skeleton, quite well executed. Other points noticeable about this skeleton are the hair on the head and the fact that its hands are fleshy and the fingers and toes have nails. Like all representations by these sculptures, the skeleton is also embellished with ornaments.

From the back of the head emanate two objects similar to horns, which, if they were not differently ribbed, might represent flames. The ear is ornamented with a circular disk, with a pendant from its center. A double-ruffled collar surrounds the neck and a serpent encircles the loins. Both the shoulders and arms are enveloped in flames. From the mouth emanates a bent staff, touching the first of a row of ten circles. Beneath the second and third circles are five bars, three of which are horizontal. The lowest one is the longest, while the two upper ones are shorter and of different lengths. On the uppermost of these bars rest two others, crossing each other obliquely, and touching with their upper ends two of the aforesaid circles. From the last of these circles descend serpentine lines, which touch the ground behind the recumbent person.

Gustav Eisen, op. cit., describing Fig. 1236, says:

From near Santa Lucia, Guatemala, is a stone tablet, most likely a sepulchral tablet, having in its center a forced dead head, with outstretched tongue. Above the same are seen two crossed bars, perhaps meant to represent two crossed bones.

FIG. 1236.—Cross. Guatemala.

W. F. Wakeman (a) makes the following remarks:

A cross was used by the people of Erin as a symbol of some significance at a period long antecedent to the mission of St. Patrick or the introduction of Christianity to this island. It is found, not unfrequently, amongst the scribings picked or carved upon rock surfaces and associated with a class of archaic designs, to the meaning of which we possess no key. * * * It may be seen on prehistoric monuments in America, on objects of pottery found by Dr. Schliemann at Hissarlik and at Mycenæ, and, in more than one form, on pagan Roman altars still preserved in Germany and

Britain. With the Chinese it was for untold ages a symbol of the earth. The Rev. Samuel Beal, B. A., rector of Flastone, North Tyrone, professor of Chinese in University College, London, writes: "Now, the earliest symbol of the earth was a plain cross, denoting the four cardinal points; hence we have the word chaturanta, i. e., the four sides, both in Pâli and Sanscrit, for the earth; and on the Nestorian tablet, found at Siganfu some years ago, the mode of saying "God created the earth" is simply this: "God created the +.""

A writer in the Edinburgh Review in an article entitled "The Pre-Christian Cross," January, 1870, p. 254, remarks: "The Buddhists and Brahmins who together constitute nearly half the population of the world, tell us that the decussated figure of the cross, whether in a simple or complex form, symbolizes the traditional happy abode of their primeval ancestors."

Rudolf Cronau (c), describing Fig. 1237, says that in the Berlin Zeughause are swords of the fifteenth and sixteenth centuries, bearing the marks shown in a, b, c, and d, while those having the marks e and f are from swords in the Historical Museum at Dresden.

FIG. 1237.—Crosses. Sword-maker's marks.

The remarkable resemblance of some of these characters to forms on petroglyphs in the three Americas, presented in this paper, will at once be noticed.

D'Alviella (c), remarks:

One of the most frequent forms of the cross is called the gamma cross, because its four arms are bent at a right angle so as to form a figure like that of four Greek gammas turned in the same direction and joined at the base. We meet it among all the peoples of the Old World, from Japan to Iceland, and it is found in the two Americas. There is nothing to prevent us from supposing that in the instance it was spontaneously conceived everywhere, like the equilateral crosses, circles, triangles, chevrons, and other geometrical ornaments so frequent in primitive decoration. But we see it, at least among the peoples of the Old Continent, invariably passing for talisman, appearing in the funeral scenes or on the tombstones of Greece, Scandinavia, Numidia, and Thibet, and adorning the breasts of divine personages—of Apollo and Buddha—without forgetting certain representations of the Good Shepherd in the Catacombs.

It is, however, impossible within the present limits, to attempt even a summary of the vast amount of literature on this topic. Perhaps one symbolic use of the form which is not commonly known is of sufficient interest to be noted. Travelers say that crosses are exhibited in the curtains of the monasteries of the Thibetan Buddhists, to mean peace and quietness. With the same conception the loopholes of the Japanese forts were in time of peace covered with curtains embroidered with crosses, which when war broke out were removed.

It is also impossible to refrain from quoting the following, translated with condensation, from de Mortillet (a). The illustration referred to is reproduced in the present paper by Fig. 1238, the right-hand figure

being from the vase, and that on the left the recognized monogram of Christ:

There can no longer be any doubt as to the use of the cross as a religious symbol long before the advent of Christianity. The worship of the cross, extensive throughout Gaul before the conquest, already existed during the bronze age, more than a thousand years before Christ.

FIG. 1238.—Cross. Golasecca.

It is especially in the sepulchres of Golasecca that this worship is revealed in the most complete manner, and there, strange to say, has been found a vessel bearing the ancient monogram of Christ, designed perhaps 1,000 years before the coming of Jesus Christ. Is the isolated presence of this monogram of Christ in the midst of numerous crosses, an entirely accidental coincidence?

Another curious fact, very interesting to prove, is that this great development of the worship of the cross before the coming of Christ seems to coincide with the absence of idols and indeed of any representation of living objects. Whenever such objects appear, it may be said that the crosses become more rare and finally disappear altogether. The cross has then been, in remote antiquity, long before Christ, the sacred emblem of a religious sect which repudiated idolatry.

The author, with considerable naiveté, has evidently determined that the form of the cross was significant of a high state of religious culture, and that its being succeeded by effigies, which he calls idols, showed a lapse into idolatry. The fact is simply that, next after one straight line, the combination of two straight lines forming a cross is the easiest figure to draw, and its use before art could attain to the drawing of animal forms, or their representation in plastic material, is merely an evidence of crudeness or imperfection in designing. It is worthy of remark that Dr. Schliemann, in his "Troja," page 107, presents as his Fig. 38 a much more distinct cross than that given by M. de Mortillet, with the simple remark that it is "a geometrical ornamentation."

Probably no cause has more frequently produced archeologic and ethnologic blunders than the determination of Christian explorers and missionaries to find monograms of Christ in every monument or inscription where the cross figure appears. The early missionaries to America were obliged to explain the presence of this figure there by a miraculous visit of an apostle, St. Thomas being their favorite. Other generations of the same good people were worried in the same manner by the cross pattée or Thor hammer of the Scandinavians, and by the conventionalized clover leaf of the Druids. This figure often has been a symbol and as often an emblem or a mere sign, but it is so common in every variety of application that actual evidence is necessary to show in any special case what is its real significance.

Gen. G. P. Thruston (a) gives the following account of Pl. LI, which suggests several points of comparison with figures under other headings in this paper:

There has been discovered in Sumner county, Tennessee, near the stone graves and mounds of Castalian springs, a valuable pictograph, the ancient engraved stone which we have taken the liberty to entitle a Group of Tennessee Mound Builders.

This engraved stone, the property of the Tennessee Historical Society, is a flat, irregular slab of hard limestone, about 19 inches long and 15 inches wide. It bears every evidence of very great age. * * * The stone was found on Rocky creek, in Sumner county, and was presented, with other relics, to the Tennessee Historical Society about twelve years ago. * * *

It is evidently an ideograph of significance, graven with a steady and skillful hand, for a specific purpose, and probably records or commemorates some important treaty or public or tribal event. * * * Indian chiefs fully equipped with the insignia of office, are arrayed in fine apparel. Two leading characters are vigorously shaking hands in a confirmatory way. The banner or shield, ornamented with the double serpent emblem and other symbols, is, doubtless, an important feature of the occasion. Among the historic Indians, no treaty was made without the presence or presentation of the belt of wampum. This, the well-dressed female of the group appears to grasp in her hand, perhaps as a pledge of the contract. The dressing of the hair, the remarkable scalloped skirts, the implements used, the waistbands, the wristlets, the garters, the Indian leggings and moccasins, the necklace and breastplates, the two banners, the serpent emblem, the tattoo stripes, the ancient pipe, all invest this pictograph with unusual interest. * * * The double serpent emblem or ornament upon the banner may have been the badge or totem of the tribe, clan, or family that occupied the extensive earthworks at Castalian springs in Sumner county, near where the stone was found. The serpent was a favorite emblem or totem of the Stone Grave race of Tennessee, and is one of the common devices engraved on the shell gorgets taken from the ancient cemeteries. * * * The circles or sun symbol ornaments on the banners and dresses are the figures most frequently graven on the shell gorgets found near Nashville.

The following summary of the translation, kindly furnished by Mr. Pom K. Soh of an article, "Pictures of Dokatu or so-called bronze bell," by Mr. K. Wakabayashi (*a*), in the Bulletin of the Tōkyō Anthropological Society, refers to Pl. LII. The author saw the bell described at the town of Takoka, Japan, in August, 1891. The "pictures" on it were fourteen in number, cast in the metal of the bell, each one occupying a separate compartment and running around the bell in several bands. The author took rubbings of the pictures, lithographs of which are published as illustrations of his article, and from these the eight pictures now presented in actual size are selected, the remainder being of the same general character, and some of them nearly identical with those selected. The information obtained is that the bell, which is iron and not bronze, was procured before, and perhaps long before, the present century from Jisei, in the village of Sasakura in the state of Yetsin, and had been excavated from a mountain at Samki. Copies of the markings upon it were taken in 1817 to a high authority at Yedo, now Tōkyō. It is believed that the markings illustrate or are related to a national story, "Kanden Ko Hitsu," written by Ban Kokei. A few similar bells or fragments of them, some being bronze, have been found in various parts of the Japanese empire. One, which is bronze, height about 3½ feet, and diameter somewhat more than 1 foot, was dug up in Hanina in the year A. D. 821.

The interest of the drawings on Pl. LII, in the present connection, consists in their remarkable similarity, both in form and apparent motive, with several of those found in the western continent and figured

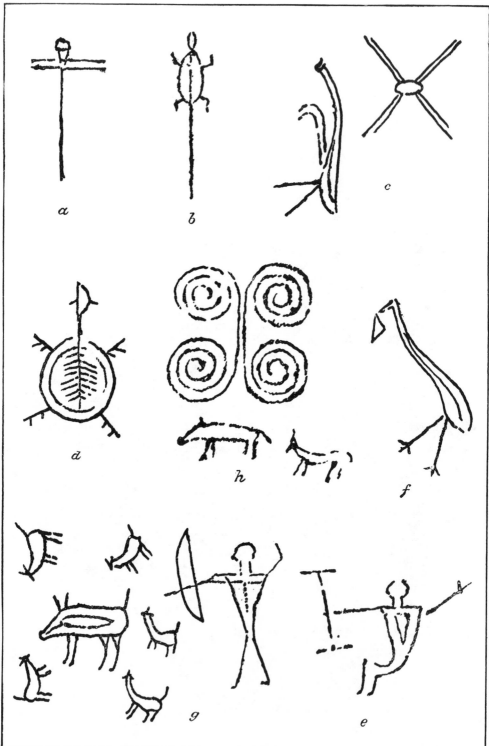

PICTURES ON DŌTAKU, JAPAN.

in the present work. Thus, *a* is to be compared with characters on Figs. 437 and 1227 and others referring to the human form, the cross, and the dragon-fly; *b* with Figs. 57, 165 *b* and 1261 *l*; the two characters in *c*, respectively, with Fig. 1262; the mantis, and Fig. 1129, one form of star; *d* with a common turtle form, as in Fig. 50; *e* with Fig. 166, an Ojibwa human form, and also exhibiting gesture, and Fig. 113 a Brazilian petroglyph; and *f* with Fig. 657, a north-eastern Algonquian drawing. The three last-mentioned pictures, *e* and *f* and *g*, exhibit the peculiar internal life organ (often the conventionalized heart), noticed in Figs. 50, 700, and 701, and it is to be remarked that the largest quadruped in *g* has the life organ connected with the mouth, while the other quadrupeds, and those in *h*, show no depiction of internal organs. The human figure in *g* is noticeable for the American form of bow, and the upper character of *h* is to be compared with Figs. 104 and 148.

SECTION 3.

COMPOSITE FORMS.

The figures in this group are selected from a larger number in which the union of two animals of different kinds or that of an animal and another object indicates the union of the several qualities or attributes supposed to belong to those animals or objects. The form and use of such composite figures are familiar from the publication of the inscriptions on Egyptian monuments and papyri.

FIG. 1239.

FIG. 1240.

Fig. 1239.—Eagle-Elk. Red-Cloud's Census. Here are the branching antlers of the elk and the tail of the eagle.

Fig. 1240.—Eagle - Horse. Red - Cloud's Census. Eagle feathers replace the horse's mane.

Fig. 1241.—Eagle-Horse. Red-Cloud's Census. This is a variant of the preceding, the change being shown in the tail.

Fig. 1242. — Eagle - Swallow. Red-Cloud's Census. The characteristics of the two birds are obvious.

Fig. 1243.—Eagle-Bear. Red-Cloud's Census.

Fig. 1244.—Weasel-Bear. Red-Cloud's Census. With only hasty view the really characteristic form of the weasel might be mistaken for a rudely drawn gun.

FIG. 1241.

FIG. 1242.

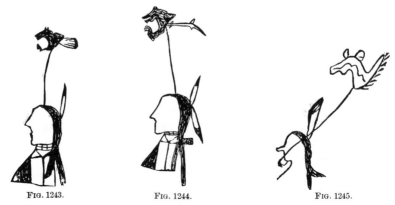

FIG. 1243. FIG. 1244. FIG. 1245.

Fig. 1245.—Horned-Horse. Red-Cloud's Census.

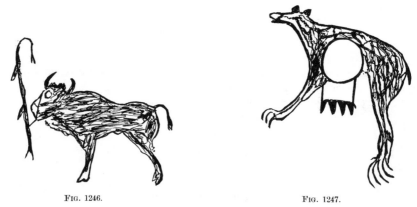

FIG. 1246. FIG. 1247.

Fig. 1246.—Bull-Lance. Red-Cloud's Census. The object attached to the bull's muzzle is the common ornamented lance of the Plains tribes.

Fig. 1247.—Shield-Bear. Red-Cloud's Census. The ornamented shield is borne on the bear's body.

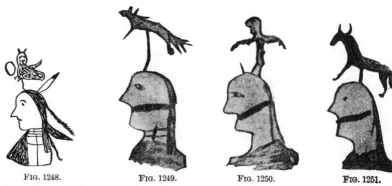

FIG. 1248. FIG. 1249. FIG. 1250. FIG. 1251.

Fig. 1248.—Ring-Owl. Red-Cloud's Census.

Fig. 1249.—Sunka-wanbli, Dog-Eagle; from the Oglala Roster. The

mingling of the attributes of the dog and the eagle with special reference
to swiftness may be suggested.

Fig. 1250.—Zintkala-wicasa, Bird-Man; also from the Oglala Roster.
An indication of a bird gens is suggested without information, but per-
haps it is only a representation of the usual vision required from and
therefore obtained by boys before reaching manhood.

Fig. 1251.—Sunkakan-heton, Horse-with-horns; also from the Oglala
Roster. Perhaps this is not intended as a composite animal, but as a
horse possessing special and mystic power, as is indicated by the gesture
sign for wakan, and, as elsewhere in pictographs, by lines extending
from each side of the head. The same sub-chief appears in Red-Cloud's
Census with the name translated into English as Horned-Horse.

This union of the human figure with that of other animals is of inter-
est in comparison with the well-known forms of sim-
ilar character in the art of Egypt and Assyria.

The feet of the accompanying Fig. 1252, reproduced
from Bastian (b) on the Northwest Coast of America,
can not be seen, being hidden in the head of the figure
beneath. It is squatting, with its hands on its knees,
and has a wolf's head. Arms, legs, mouth, jaws, nos-
trils, and ear-holes are scarlet; eyebrows, irises, and
edges of the ears black.

The drawing Fig. 1253 was made by Mr. J. G.
Swan while on a visit to the Prince of Wales archi-
pelago, where he found two carved figures with pan-
thers' heads, and claws upon the fore feet, and human
feet attached to the hind legs. These mythical ani-
mals were placed upon either side of a corpse which
was lying in state, awaiting burial.

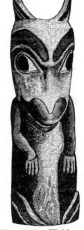

FIG. 1252.—Wolf-man.
Haida.

The Egyptians represented the evil Typhon by the
hippopotamus, the most fierce and savage of their animals; the hawk
was the symbol for power, and the serpent that for life. Plutarch, in

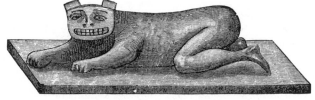

FIG. 1253.—Panther-man. Haida.

Isis and Osiris, 50, says that in Hermopolis these symbols were united,
a hawk fighting with a serpent being placed on the hippopotamus, thus
accentuating the idea of the destroyer. The Greeks sometimes substi-
tuted the eagle for the hawk, and pictured it killing a hare, the most
prolific of quadrupeds, or fighting a serpent, the same attribute of de-

struction being portrayed. But the eagle when alone meant simply power, as did the hawk in Egypt. The Scandinavians posited the eagle on the head of their god Thor and the bull on his breast to express a similar union of attributes.

<div align="center">SECTION 4.</div>

<div align="center">ARTISTIC SKILL AND METHODS.</div>

Dr. Andree (*d*), in Das Zeichnen bei den Naturvölkern, makes the following remarks, translated with condensation:

The great ability of the Eskimo and their southern neighbors, the natives of northwest America (Koliushes, Thlinkits, etc.), in representative art is well known and needs no further insisting. Among all primitive peoples they have made the greatest advances in the conventionalization of figures, which indicates long practice in painting. The totem figures, carved both in stone and in wood and tattooed on the body, show severe conventionalization and have perfect heraldic value. Ismailof, one of the earliest Russian explorers that came in contact with the Koliushes, relates that European paintings and drawings did not strike them with the least awe. When a chief was shown portraits of the Russian imperial family he manifested no astonishment. That chief was accompanied by his painter, who examined everything very closely, in order to paint it afterward. He was able in particular "to paint all manner of objects on wooden tablets and other material (leather)," using blue iron earth, iron ocher, colored clays, and other mineral colors. Among these peoples, too, painting is employed as a substitute for writing, in order to record memorable things.

Far below the artistic achievements of the Eskimo and of the natives of the American northwest (Haida, Thlinkit, etc.) are those of the redskins east of the Rocky mountains. They are, however, very productive in figure drawing; nay, that art has advanced to a kind of picture writing, which, it is true, is not distinguished by artistic finish. That "fling" which, depending on good observation of nature, appears in the drawings of Australians, Bushmen, etc., and the good characterization of the figures, are lacking among the Indians; and though, as is frequently the case, their animals are better represented than the men, yet they can not compare with the animal figures of the Eskimo or Bushmen. Dr. Capitan, who had drawings made by the Omahas shown in 1883 in the Jardin d'acclimatation of Paris, says concerning them: "It is singular to note that by the side of very rudimentary representations of human figures the pictures of horses are drawn with a certain degree of correctness. If the Indians take pains in anything it is in the painting of their buffalo skins, which are often worn as mantles. On red-brown ground are seen black figures, especially of animals; on others, on white ground, the heroic deeds and life events of distinguished Indians, represented in black or in other colors. You see the wounded enemies, the loss of blood, the killed and the captives, stolen horses, all executed in the peculiar manner of an art of painting still in the stage of infancy, with earth colors black, red, green, and yellow. Almost all the Missouri tribes practice painting on buffalo skins; the most skillful are the Pawnees, Mandans, Minitaris, and Crows. Among the Mandans, Wied met individuals who possessed "a very decided talent" for drawing.

The same author, in the same connection, reasserts the old statement that there is an established difference in artistic capacity between the so-called mound-builders and the present Indians, so great that it either shows a genetic difference between them or that the Indians had degenerated in that respect. This statement is denied by the Bureau

of Ethnology, but the point to be now considered is whether it is true that the historic North American Indians are as low in artistic skill as is alleged.

The French traveler Crevaux, as quoted by Marcano (g), says that he had the happy idea of giving pencils to the Indians, in order to see whether they were capable of producing the same drawings. The young Yumi rapidly drew for him sketches of man, dog, tiger; in brief, of all the animals of the country. Another Indian reproduced all sorts of arabesques, which he was wont to paint with genipa. Crevaux saw that these savages, who are accused of being absolutely ignorant of the fine arts, all drew with extraordinary facility.

The same idea, i. e., of testing the artistic ability of Indians in several tribes, occurred to the present writer and to many other travelers, who generally have been surprised at the skill in free-hand drawing and painting exhibited. It would seem that the Indians had about the same faults and decidedly more talent than the average uninstructed persons of European descent who make similar attempts. An instance

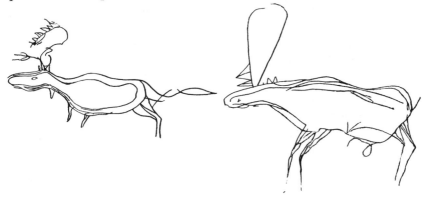

Fig. 1254.—Moose, Kejimkoojik.

of special skill in portrait painting is given by Lossing (a), where a northern tribe in 1812 made a bark picture of Joseph Barron, a fugitive, to obtain his identification by sending copies of it to various tribes. The portrait given as an illustration in the work cited is very distinct and lifelike. This, however, was a special task prompted by foreign influence. While the Indians had no more knowledge of perspective than the Japanese, they were unable or indisposed to attempt the accurate imitation of separate natural objects in which the Japanese excel. Before European instruction or example they probably never produced a true picture. Some illustrations in the present work, which show a continuous series of men, animals, and other objects, are no more pictures than are the consecutive words of a printed sentence, both forms, indeed, being alike in the fact that their significance is expressed by the relation between the separate parts. The illustration which at a first glance seems to be most distinctively picturesque

is Fig. 659, but it will be noticed that the personages are repeated, the scene changed, and the time proceeds, so that there is no view of specified objects at any one time and place.

Fig. 1254 shows two drawings from Kejimkoojik, N. S., reduced to one-fourth, each supposed to represent a moose, though possibly one of them is a caribou, and the mode of execution vividly suggests some of the examples of prehistoric art found in Europe and familiar by repeatedly published illustrations.

Fig. 1255 is the etching of a hand from the Kejimkoojik rocks, re-

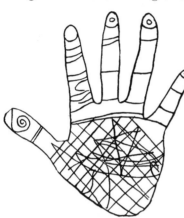

FIG. 1255.—Hand, Kejimkoojik.

duced one-half. Its peculiarity consists in the details by which the lines of the palm and markings on the balls of the thumb and fingers are shown. If this is the real object of the design it shows close observation, though it is not suggested that any connection with the psuedo-science of palmistry is to be inferred.

In connection with this drawing the following translated remarks in Verhandl. Berlin. Gesellsch. für Anthrop. (d), may be noted:

The frequency with which partial representations of the eye are met with appeared to me so striking that I requested Mr. Jacobsen to ask the Bella Coola Indians whether they had any special idea in employing the eye so frequently. To my great surprise the person addressed pointed to the palmar surface of his finger tips and to the fine lineaments which the skin there presents; in his opinion a rounded or longitudinal field, such as appears between the converging or parallel lines, also means an eye, and the reason of this is that originally each part of the body terminated in an organ of sense, particularly an eye, and was only afterward made to retrovert into such rudimentary conditions.

The lower character in Pl. LIII is copied from Rudolph Cronau (c) Geschichte der Solinger Klingenindustrie, where it is presented as an illustration of the knights of the thirteenth century, after a sketch in a MS. of the year 1220, in the library of the University of Leipsig.

The upper character in the same plate is a copy of a drawing made in 1884 by an Apache Indian at Anadarko, although the insignia of the riders are more like those used by the Cheyenne than those of the Apache. A striking similarity will be noticed in the motive of the two sketches of the mounted warriors and their steeds as well as in their decorations, from which in Europe the devices called heraldic were differentiated. Doubtless still better examples could be obtained to compare the degree of artistic skill attained by the several draftsmen, but these are used as genuine, convenient, and typical. See also the Mexican representation of horses and riders under the heading of meteors, Fig. 1224.

A

B

GERMAN KNIGHTS AND APACHE WARRIORS.

These horses are far less skillfully portrayed than they are by the Plains tribes, which may be explained by the fact that the Mexicans had not yet become familiar with the animal.

A story told by Catlin to the general effect that the Siouan stock of Indians did not understand the drawing of human faces in profile has been repeated in various forms. The last is by Popoff (a):

When Catlin was drawing the profile of a chief named Matochiga, the Indians around him seemed greatly moved, and asked why he did not draw the other half of the chief's face. "Matochiga was never ashamed to look a white man square in the face." Matochiga had not till then seemed offended at the matter, but one of the Indians said to him sportively, "The Yankee knows that you are only half a man, and he has only drawn half of your face because the other half is not worth anything."

Another variant of the story is that Catlin was accused of practicing magic, by which the half of the subject's head should get into his power, and he was forced to stop his painting and flee for his life. The explorer and painter who tells the story is not considered to be altogether free from exaggeration, and he may have invented the tale to amuse his auditors in his lectures and afterwards his readers, or he may have been the victim of a practical joke by the Indians, who are fond of such banter, and the well-known superstitions about sorcerers gaining possession of anything attached to the person would have rendered their anger plausible. But certain it is that the people referred to, before and after and at the time of the visit of Catlin to them, were in the habit of drawing the human face in profile, and, indeed, much more frequently than the full or front face. This is abundantly proved by many pictures in existence at that time and place which have been seen by this writer, and a considerable number of them are copied in the present work. Thus much for one of the oft-cited fictions on which the allegation of the Indian's stupidity in drawing has been founded.

Another false statement is copied over and over again by authors, to the effect that from a similar superstition the Indians are afraid to, and therefore do not, make delineations of the whole human figure. The present work shows their drawing of front, side, and rear views of the whole human figure, presenting as each view may allow, all the limbs and features. This, however, is rare, not from the fear charged, but because the artists directed their attention, not to iconography, but to ideography, seizing some special feature or characteristic for prominence and disregarding or intentionally omitting all that was unnecessary to their purpose.

On the other hand the Indians have sometimes been unduly praised for acumen in observation and for skill in their iconography. For instance, in the lectures of Mr. Edward Muybridge, explaining the highly interesting photographs of consecutive movements of animals from which he formulates the novel science of zoöpraxography, the lecturer attributes to the Indians a scientific and artistic method of drawing horses in motion which has excelled in that respect all the most famous

painters and sculptors. But Mr. Muybridge bases his statement upon
a small number of Indian drawings, apparently seen by him in Europe,
the characteristics of which do not appear in the many drawings of
horses in the possession of the present writer, a considerable number
of which are published in this work. The position of the legs in the
drawings praised is doubtless fortuitous. The Indian in his delineation
of horses cared little more than to show an animal with the appropriate
mane, tail, and hoofs, and the legs were extended without the slightest
regard to natural motion. The drawing of the Indians closely resem-
bles the masterly abstractions of the living forms devised by the early
heraldic painters which later were corrupted by an attempt to compro-
mise with zoölogy, resulting in a clumsy naturalism if not caricature.

A comparison of artistic rather than of pictographic skill may fre-
quently be made, for instance the art of the Haida in carving, which
shows remarkable similarity to that in Central and South America,
and made public by Habel, op. cit., and H. H. Bancroft (i).

The style of drawing is strongly influenced by the material on which
it is made. This topic must receive some consideration here, though
too extensive for full treatment. The substances on which and the in-
struments by which pictographs are made in America are discussed in
Chaps. VII and VIII of this work, and the remarks and illustrations
there presented apply generally to other forms of drawing and paint-
ing. Examples of drawing on every kind of material known to the
American aborigines appear in this work. Carving, pecking, and
scratching of various kinds of rock are illustrated, also paintings on
skins and on wood. The Innuit carving on walrus ivory, of which
numerous illustrations are furnished, is notable for its minuteness as
well as distinctness. The substance was precious, the working surface
limited, and the workmanship required time and care. Birch bark, com-
mon in the whole of thenorthern Algonquian region, was an attractive
material. It was used much more freely and was worked more easily
than walrus ivory, and in two modes, one in which outlines are drawn
by any hard-pointed substance on the inner side of the bark when it
is soft and which remain permanent when dry, the other made by
scraping on the rough outer surface, thus producing a difference in color.
Many examples of the first-mentioned method are shown throughout
this work, and of the latter in Pl. XVI and Fig. 659. Having before
them this large collection of varied illustrations readers can judge for
themselves of the effect of the material in determining the style among
people who had substantially the same concepts.

It is universally admitted that the material used, whether papyrus
or parchment, stone or wood, palm leaves or metal, wax or clay, and
the appropriate instruments, hammer, knife, graver, brush or pen, de-
cided the special style of incipient artists throughout the world. The
Chinese at first worked with knives on bamboo and stone, and even
after they had obtained paper, ink, and fine hair pencils, the influence

of the old method continued. The cuneiform characters are due to the shape of the wooden style used to impress the figures on unbaked clay. It may generally be remarked that in materials having a decided "grain," of which bamboo is the most obvious instance, the early stage of art with its rude implements was forced to work in lines running with the grain.

Dr. Andree (e) gives the illustration presented here as Fig. 1256 with these remarks:

The advances made by the Kanakas of New Caledonia in drawing are illustrated by the bamboo staves covered with engraved drawings, which they carry about as objects of fashion, somewhat as we do our walking sticks, and a number of which are preserved in the ethnographic museum of Paris (Trocadero). They have been described by E. T. Hamy. In these finely incised drawings ornaments of the simplest kind (straight lines and zigzag models) are combined with figures and tree groups. The artistic execution is a rather primitive one, yet the figures by no means lack character and vividness. There are seen on the bamboo the pointed-roofed huts of the chieftains, turtles, fowl, lizards, and between them scenes from the life of the Kanakas. A man beats his wife, men discharge their bows, others stand idle in rank and file, adorned with the cylindric straw hat described by Cook, which at this day has almost entirely disappeared.

FIG. 1256.—Engravings on bamboo, New Caledonia.

The explanation of many peculiar forms of Indian drawing and painting is to be found in the stage of mythologic sophiology reached by the several tribes. For instance, Mr. W. H. Holmes, op. cit., discovered that in Chiriqui all the decorations originated in life forms of animals, none being vegetal and none clearly expressive of the human figure or attempting the portrayal of physiognomy. This peculiarity doubtless arose from the exclusively zoomorphic character of the religion of the people. Other mythologic concepts have given a special trend to the art of other tribes and peoples. This results in conventionalism. The sculptures of Persia chiefly express the power and glory of the God-King, and the Egyptian statues are canonical idealizations of an abstract human being, type of the race. It is to be noticed that Indians also show conservatism and conventionalization in their ordinary pictures. Within what may be called a tribal, or more properly stock, system, every Indian draws in precisely the same manner. The figures of a man, of a horse, and of every other object delineated are made by everyone who attempts to make any such figure, with seeming desire for all the identity of which their mechanical skill is capable, thus

showing their conception and motive to be the same. In this respect the drawing of the Indians may be likened to that of boys at a public school, who are always drawing, and drawing the same objects and with constant repetition of the same errors from one school generation to another.

In discussing artistic skill only in its relation to picture-writing the degree of its excellence is not intrinsically important, though it may be so for comparison and identification. The figures required were the simplest. Among these were vertical and horizontal straight lines and their combinations, circles, squares, triangles, a hand, a foot, an ax or a bow, a boat or a sledge. Both natural and artificial objects were drawn by a few strokes without elaboration. The fewer the marks the more convenient was the pictograph, if it fulfilled its object of being recognized by the reader. The simple fact without esthetic effect was all that the pictographic artists wanted to show, and when an animal was represented it was not by imitation of its whole form, but by emphasis of some characteristic which must be made obvious, even if it distorted the figure or group and violated every principle of art as now developed.

CHAPTER XXI.

MEANS OF INTERPRETATION.

The power of determining the authorship of pictographs made on materials other than rocks, by means of their general style and type, can be estimated by a comparison of those of the Abnaki, Ojibwa, Dakota, Haida, Innuit, Shoshoni, Moki, etc., presented in various parts of this paper.

Everard F. im Thurn (*k*), in reference to Fig. 1257, remarks:

Wherever a peculiar, complex, and not very obvious figure occurs in many examples it is legitimate to assume that this had some ulterior object and meaning. Now this figure, occurring in the shallow engravings of Guiana, is of such kind. It is not a figure which an Indian would be likely to invent in an idle moment even once, for such a man very seldom, probably never, except in these particular figures, has been known to draw straight lines. Moreover, even if it were a figure that one Indian might idly invent, it is certainly highly improbable that this would be copied by many other Indians in various places. And, lastly, a figure strikingly like the one in question, if, indeed, it is not identical, occurs in certain Mexican picture writings. For example, in the Mexican MSS. [reproduced in Kingsborough, *op. cit.*, I, from Sir Thomas Bodley's MSS., pp. 22, 23, and from the Selden MSS., also in the Bodleian, p. 3] several figures occur so like that of the shallow engravings of Guiana that there can be but little doubt of their connection. The recurrence of this peculiar figure in these writings is surely sufficient evidence of the fact that they are not without intention. If it were possible to obtain a clue to the meaning of the Mexican figures it might serve as a key to decipher the hieroglyphic writings of Guiana.

Fig. 1257.—Typical character. Guiana.

With regard to the study of the individual characters themselves to identify the delineators of pictographs, the various considerations of fauna, religion, customs, tribal signs, indeed most of the headings of this paper, will be applicable.

It is convenient to divide this chapter into: 1. Marked characters of known significance. 2. Distinctive costumes, weapons, and ornaments. 3. Ambiguous characters, with ascertained meaning.

SECTION 1.

MARKED CHARACTERS OF KNOWN SIGNIFICANCE.

It is obvious that before attempting the interpretation of pictographs concerning which no direct information is to be obtained, there should be a collection, as complete as possible, of known characters, in order that through them the unknown may be learned. When any considerable number of objects in a pictograph are actually known the

remainder may be ascertained by the context, the relation, and the position of the several designs, and sometimes by the recognized principles of the art.

The present writer has been engaged, therefore, for a considerable time in collating a large number of characters in a card-catalogue arranged primarily by similarity in forms, and in attaching to each character any significance ascertained or suggested. As before explained, the interpretation upon which reliance is mainly based is that which has been made known by direct information from Indians who themselves were actually makers of pictographs at the time of giving the interpretation. Apart from the comparisons obtained by this collation, the only mode of ascertaining the meaning of the characters, in other words, the only key yet discovered, is in the study of the gesture sign included in many of them.

A spiral line frequently seen in petroglyphs is explained by the Dakota to be a snail shell, and, furthermore, this device is seen in Pl. xx, and fully described in that connection as used in the recording and computation of time.

The limits of this paper do not allow of presenting a complete list of the characters in the pictographs which have become known. But some

FIG. 1258.—Moki devices.

of the characters in the petroglyphs, Figs. 1258, 1259, and 1260, which are not discussed under various headings, supra, should be explained. The following is a selection of those which were interpreted to Mr. Gilbert.

The left hand device of Fig. 1258 is an inclosure, or pen, in which ceremonial dances are performed. That on the right is a headdress used in ceremonial dances.

Compare the drawing from Fairy Rocks, N. S., Fig. 549.

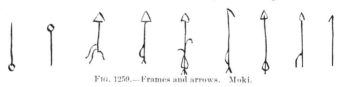
FIG. 1259.—Frames and arrows. Moki.

Fig. 1259 gives sketches of the frames or sticks used in carrying wood on the back: also shows different forms of arrows.

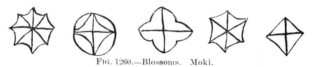
FIG. 1260.—Blossoms. Moki.

Fig. 1260 represents the blossoms of melons, squashes.

The appearance of objects showing the influence of European civilization and christianization should always be carefully noted. An

instance where an object of that character is found among a multitude of others not liable to such suspicion is in the heart surmounted by a cross, in the upper line of Fig. 437. This suggests missionary teaching and corresponding date.

Maximilian of Wied (*g*) says:

Another mode of painting their robes by the Dakotas is to represent the number of valuable presents they have made. By these presents, which are often of great value, they acquire reputation and respect among their countrymen. On such robes we observed long red figures with a black circle at the termination placed close to each other in transverse rows; they represent whips, indicating the number of horses given, because the whip belonging to the horse is always bestowed with the animal. Red or dark-blue transverse figures indicate cloth or blankets given; parallel transverse stripes represent firearms, the outlines of which are pretty correctly drawn.

It may be desirable also to note, to avoid misconception, that where, throughout this work, mention is made of particulars under the headings of customs, religion, etc., which might be made the subject of graphic illustration in pictographs, and for that reason should be known as preliminary to the attempted interpretation of the latter, the suggestion is not given as a mere hypothesis. Such objective marks and conceptions of the character indicated which can readily be made objective, are in fact frequently found in pictographs and have been understood by means of the preliminary information to which reference is made. When interpretations obtained through this line of study are properly verified, they can take places in the card catalogue little inferior to those of interpretations derived directly from aboriginal pictographers.

The interpretation by means of gesture-signs has already been discussed, Chap. XVIII, Sec. 4.

Capt. Carver (*b*) describes how an Ojibwa drew the emblem of his own tribe as a deer, a Sioux as a man dressed in skins, an Englishman as a human figure with a hat on his head, and a Frenchman as a man with a handkerchief tied around his head.

In this connection is the quotation from the Historical Collections of Louisiana, Part III, 1851, p. 124, describing a pictograph, as follows: " There were two figures of men without heads, and some entire. The first denoted the dead and the second the prisoners. One of my conductors told me on this occasion that when there are any French among either, they set their arms akimbo, or their hands upon their hips, to distinguish them from the savages, whom they represent with their arms hanging down. This distinction is not purely arbirary; it proceeds from these people having observed that the French often put themselves in this posture, which is not used among them."

It is also said suggestively, by C. H. Read (*f*) in Jour. of the Anthrop. Inst. of Gr. Br. and I., that in the carvings of the West African negroes, the typical white man is constantly figured with a brandy bottle in one hand and a large glass in the other.

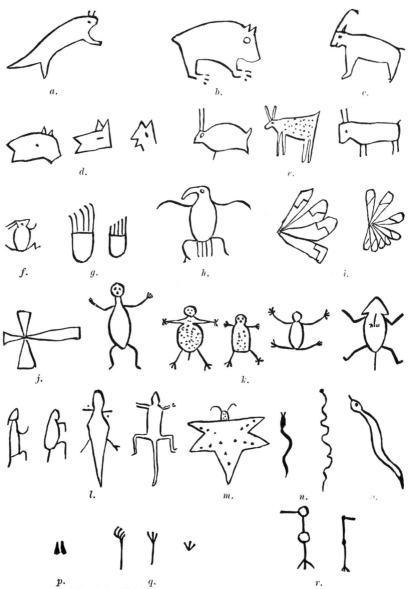

Fig. 1261.—Moki characters. The following is the explanation:

a. A beaver.
b. A bear.
c. A mountain sheep (*Ovis montana*).
d. Three wolf heads.
e. Three jackass rabbits.
f. Cottontail rabbit.
g. Bear tracks.
h. An eagle.
i. Eagle tails.

j. A turkey tail.
k. Horned toads (*Phryosoma* sp. ?).
l. Lizards.
m. A butterfly.
n. Snakes.
o. A rattlesnake.
p. Deer track.
q. Three bird tracks.
r. Bitterns (wading birds).

Instructive particulars regarding pictographs may be discovered in the delineation of the fauna in reference to its present or former habitat in the region where the representation of it is found.

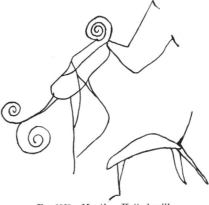

As an example of the number and kind of animals pictured as well as of their mode of representation, the foregoing Fig. 1261, comprising many of the Moki inscriptions at Oakley Springs, Arizona, is presented by Mr. G. K. Gilbert. These were selected by him from a large number of etchings for the purpose of obtain-

FIG. 1262.—Mantis. Kejimkoojik.

ing the explanation, and they were explained to him by Tubi, an Oraibi chief living at Oraibi, one of the Moki villages.

The large object in Fig. 1262, scratched on the Kejimkoojik rocks, Nova Scotia, is probably intended for a mantis or "rear-horse," but

FIG. 1263.—Animal forms. Sonora.

strongly reminds the observer of the monkey forms in the petroglyphs of Central and South America.

Ten Kate (b) shows in Fig. 1263 those animal forms which were not obliterated from the face of the rock of El-Sauce, Sonora; they were very nearly in the order in which they are represented. The fish at the upper right hand is 20 centimeters long.

SECTION 2.

DISTINCTIVE COSTUMES, WEAPONS, AND ORNAMENTS.

On examining the relics of ancient peoples or their modern representatives, the instruments and arms accompanying them and the clothing upon them mark the social status of the individual. In the social life of past generations, and still to-day, certain garments with

their adjuncts indicate certain functions. The lawyer, the mechanic, the priest, and the soldier are easily recognizable. These garments do not only give general indications, but minute details, so in looking upon a certain soldier it is known what country he serves, how many men are under his orders, and how many chiefs are above him. It is known if he marches on horseback or afoot, if he handles the rifle or the saber, works the cannon, designs fortifications, or builds bridges. Also, by looking on his decorated breast, it is shown if he has made campaigns and participated in historic battles, and whether or not he has gained distinction. This is told by the color, cut, and ornaments of his clothes and by the weapon he bears. Some details are also furnished by the cut of the hair, and even the style of foot-gear. The above remarks apply to the highest civilization, but all kinds of personal and class designations by means of distinctive costumes, weapons, and adornments were and still are most apparent and important among the less cultured peoples.

The American Indians seldom clothed themselves, except in very cold weather, save for purposes of ornament. They habitually wore no other garment than the breech-cloth, but in their ceremonies and social dances they bedecked themselves with full and elaborate costumes, often regulated with special punctilio for the occasion. The boreal tribes, such as the Alaskan, Athapascan, and Chippewayan, who were obliged to protect themselves for a large part of the year by furs and skins, developed characteristic forms of dress which in pictography take the place occupied by painting and tattooing among tribes where the person was more habitually exposed. Among the southern tribes there was need of protection against the rays of the sun, as in Mexico, where cotton and other fibers were used. In general some of the forms of wearing apparel, if only varieties in the make of moccasins or sandals, designated the tribe of the wearers, and therefore often became adopted as pictorial signs. Ceremonial clothing is often elaborately decorated with beads, porcupine quills, claws and teeth of animals, shells, and feathers. Many of these garments are further ornamented with paintings of a totemic or mythologic character, or bear the insig-

nia of the wearer's rank and social status. Metal ornaments, such as armlets, bracelets, anklets, earrings and bells, were also worn, the material and quantity being in accordance with the wearer's ability and pecuniary condition. Upon both social and ceremonial occasions the headgear displayed eagle feathers and the plumes of other species of birds, and tufts of hair dyed in red or other colors. Necklaces were made of claws,

FIG. 1264. shells, deer and antelope hoofs, the teeth of FIG. 1265.

various animals, snake-skins, and even human fingers.

Immediately following are some of the Dakota designations in the particulars mentioned:

Fig. 1264. — Shield. Red Cloud's Census. The shield here is without device, though frequently one is painted on the war shields. Such painting may be the pictograph of the gens or of the personal designation, or may show the marks of rank.

Fig. 1265.—Wahacanka, Shield. The Oglala Roster. The marks or bearings on the shield probably are personal and similar to those commonly called heraldic, but in this drawing are too minute for accurate blazonry.

Fig. 1266.—Black - Shield "says his prayers" (in the interpreter's phrase;

FIG. 1266.

FIG. 1267.

that is, he performed the rites elsewhere explained); and takes the warpath to avenge the death of two of his sons who had been killed by the Crows. Cloud-Shield's Winter Count, 1859–'60.

Fig. 1267.—Eagle-Feather. Red-Cloud's Census. This is probably the same name as translated Lone-Feather in the following figure, in which the feather also comes from an eagle's tail:

Fig. 1268.—Lone-Feather said his prayers and took the warpath to avenge the death of some relatives. Cloud-Shield's Winter Count, 1842–'43.

Fig. 1269. — Feathers. Red - Cloud's Census. This figure and the next refer to some special ornamentation.

FIG. 1268.

FIG. 1269.

Fig. 1270.—Feathers. Red-Cloud's Census.

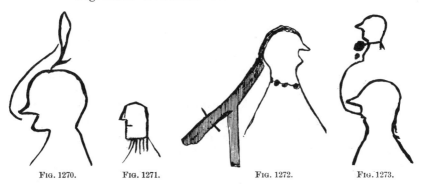

FIG. 1270.　　　FIG. 1271.　　　FIG. 1272.　　　FIG. 1273.

Fig. 1271.—Bone-Necklace. Red-Cloud's Census. This figure and the three following show special kinds of neck ornaments.

Fig. 1272.—Beads. Red-Cloud's Census.

Fig. 1273.—Stone-Necklace. Red-Cloud's Census.

Fig. 1274.—Feather-Necklace. Red-Cloud's Census.

Fig. 1275.—Wolf-Robe was killed by the Paw-nees. American-Horse's Winter Count, 1850–'51.

He is killed and scalped while wearing a robe of wolf-skin.

FIG. 1274. FIG. 1275. FIG. 1276.

Fig. 1276.—Wears-the-Bonnet. Red-Cloud's Census. This is the ornamented war bonnet of the Dakotas.

Fig. 1277.—Garter. Red-Cloud's Census.

Fig. 1278.—Wicanapsu-owin, Wears-human-fingers as ear-rings. The Oglala Roster.

The place for the fingers to be worn is indi-cated by the line terminating in a loop.

The Indian accumulated no wealth except in things useful during his life. His ornaments were made from shells which in their natural shape are innumerable; from the skins of ani-mals which require only skill to take and dress them; and from stone and copper, demanding only strength to procure and transport them.

FIG. 1277.

FIG. 1278.

The value of an Indian ornament is in the skill, care and patience re-quired in making it. Thus the wampum-bead became of intrinsic value, similar in that to gold and silver in civilization; the stone carefully wrought into the fashion of a pipe became the emblem of authority and the instrument of worship; and copper, slowly and toilfully delved and fashioned with the rudest of tools and appliances, became almost a fetich of superstition. So likewise the quill of the porcupine, worked into a design in embroidery with the most exquisite care, was an orna-ment fit for warriors and chiefs. But on the cradle or basket-nest for the expected or new-born child, upon the gown or woman's dress of the favorite daughter, and upon the moccasins and trappings for the growing son, hand and head and heart were employed for months and even years.

The Dakotan bride, swayed by the yearning of expectant maternity, perhaps also by ambition to excel in the sole permitted mode of its display, adorned her lodge with ornamented cradles, each new one becoming in design more beautiful and intricate than the last, until her yearning was answered, when the cradles not needed were ex-changed for horses and ornaments, which became the endowment of the new-born child.

Some note should be made of the sense of correspondence and contrast of colors which the Dakota, at least, exhibits; the rules which he originates and observes forming that which is called artistic taste. The Indian's use of colors corresponds more nearly than that of most barbarians with that common in high civilization, except that he perceives so little distinction between blue and green that but one name generally suffices for both colors. It is remarkable that among the wilder and plains tribes of Dakotas dead colors in beads are preferred and arranged with good effect, and that among these, specially, the use of neutral tints is common. Probably both of these results were produced from the old and exclusive employment of clays for pigments—clays of almost all colors and shades being found in the country over which the Dakotas roamed.

The peculiarities of dress or undress would seem to have first struck the people of the eastern hemisphere as well adapted to pictorial representation. Singularly enough to modern ideas, the braccæ or trousers were to the Romans the symbol of barbarism, whereas now the absence of the garments, called even "indispensable," has the same significance. Maj. C. R. Conder (d) gives this good lesson literally "a propos de bottes:"

A curious peculiarity of dress also serves to indicate the racial connection. In Cappadocia and in Anatolia the monuments represent figures with a boot or shoe curled up in front. An Assyrian representation of an Armenian merchant shows the same boot. Sir C. Wilson first compared it with the boot now worn by the peasantry of Asia Minor. Perrot compares it with the cavalry boot worn in Syria and with what we call a Turkish slipper. The Etruscans wore a similar shoe called calceus repandus by the Romans. On the monuments at Karnak the Hittites are represented wearing the same shoe, and although it is not of necessity a mark of race, it is still curious that this curly-toed boot was common to the various Turanian peoples of Syria, Asia Minor, Armenia, and Italy.

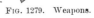

FIG. 1279. Weapons.

Schoolcraft (t) gives the characters on the left hand of Fig. 1279 as two Ojibwa war clubs, and the right-hand character in the same figure is represented in a Wyoming petroglyph as a bow.

Many other weapons distinctive to their draughtsmen are shown in this paper.

It may be well to insert here Fig. 1280, showing the wommeras and clubs of the Australians, taken from Curr (d), not only on account of their forms but of the pictorial designs on some of them, which should be compared with those of the Moki and other Indian tribes.

A large number of pictographic figures distinguishing bodies of Indians by different mode of head dress have already been given. Some additional detail may be added about the Absaroka who have in this regard been imitated by the Hidatsa and Arikara.

They wear horse hair taken from the tail, attached to the back of their heads and allowed to hang down their backs. It is arranged in eight or ten strands, each about as thick as a finger and laid parallel with

spaces between them of the width of a single strand. Pine gum is then mixed with red ocher or vermilion and by means of other hair, or fibers of any kind laid crosswise, the strands are secured and around each intersection of hair a ball of gum is plastered to hold it in place, secured to the real growth of hair on the back of the head. About four inches further down a similar row of gum balls and cross strings is

Fig. 1280. Australian wommeras and clubs.

placed, and so on down to the end. The Indians frequently incorporate the false hair with their own so as to lengthen the latter without any marked evidence of the deception. Nevertheless the transverse fastenings with their gum attachments are present. In picture-writing this is shown upon the figure of a man by parallel lines drawn downward from the back of the head, intersected by cross lines, the whole

appearing like small squares or a piece of net. See Figs. 484 and 485, supra.

A quaint account of social designation by the arrangement of the hair among the Northeastern Algonquins is recorded in the Jesuit Relations of 1639, pp. 44–5:

When a girl or woman favors some one who seeks her, she cuts the hair in the fashion adopted by the maidens of France, hanging over the forehead, which is an ugly style as well in this country as in France; St. Paul forbidding women to show their hair. The women here wear their hair in bunches at the back of the head, in the form of a truss, which they decorate with beads when they have them. If, after marying some one, a woman leaves him without cause, or if, being promised and having accepted some present, she fails to keep her word, the presumptive husband sometimes cuts her hair, which renders her very despicable and prevents her from getting another spouse.

There is a differentiation of this usage among the Pueblos generally, who, when accurate and particular in delineation, designate the women of that tribe by a huge coil of hair over either ear. This custom prevails also among the Coyotèro Apaches, the women wearing the hair in a coil to denote a virgin, while the coil is absent in the case of a married woman.

Regarding the apparent subject matter of pictographs an obvious distinction may be made between hunting and land scenes such as would be familiar to interior tribes and those showing fishing and aquatic habits common to seaboard and lacustrine peoples. Similar and more perspicuous modes of discrimination are available. The general scope of known history, traditions, and myths may also serve in identification. Known habits and fashions of existing or historically-known tribes have the same application, e. g., the portrayal on a drawing of a human face of labrets or nose rings limits the artist to defined regions, and then other considerations may further specify the work.

When the specific pictorial style of distinctive peoples is ascertained its appearance on rocks may give evidence of their habitat and migrations, and on the other hand their authorship of the petroglyphs being received as a working hypothesis, the latter may be confirmed and the characters interpreted through the known practices and habits of the postulated authors.

SECTION 3.

AMBIGUOUS CHARACTERS WITH ASCERTAINED MEANING.

Under this heading specimens of the card catalogue before mentioned are presented. The characters would not probably be recognized for the objects they are intended to represent and many of them might be mistaken for attempts to delineate other objects. A much larger number of similar delineations are to be found under other headings in this work, especially in Chap. XIII on Totems, titles, and names.

Prof. C. Thomas (c) gives a, b, c, and d, in Fig. 1281 as representing the turtle.

That they do so is shown by the head of the animal, *e*, taken from the Cortesian Codex. This is one of the many examples in which the significance of drawings can be ascertained from a series of conventionalized forms. Other instances are given in the present paper, and

FIG. 1281.—Turtle. Maya.

more in the works of Mr. W. H. Holmes, published in several of the Annual Reports of the Bureau of Ethnology.

Fig. 1282 is given in the last cited volume and page as the symbol of the armadillo of Yucatan.

FIG. 1282.—Armadillo. Yucatan.

The drawings of which Fig. 1283 presents copies were made by Dakota tribesmen: *a*, fox; *b*, black fox; *c*, wolf; *d*, black deer; *e*, beaver; *f*, spotted horse; *g*, porcupine; *h*, white hawk;

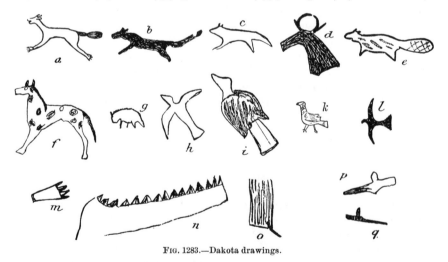

FIG. 1283.—Dakota drawings.

i, bald eagle; *k*, crow; *l*, swallow; *m* and *n*, war bonnet; *o*, leggins; *p*, gun; *q*, pipe.

The characters in Fig. 1284 are Ojibwa drawings. With the excep-

tion of the last one they are copies of selected sketches made by Gaga Sindebi at White Earth, Minn., in 1891, as parts of a Midē' song.

a, a wolf. The dark chest markings and the large tail are in imitation of those parts of the timber wolf. The coyote is not now found in the region where the author of the song lives; but is more particularly a prairie animal.

b, a wolf. The pronounced jaw indicates his carniverous nature.

c, a badger. Although the form resembles that of the bear the difference is shown by the darkened body to imitate the gray fur.

d, a bear.

e, a bear. This style of drawing is not common, it being rather short and stout, while the legs and ears are unusually pronounced.

FIG. 1284.—Ojibwa drawings.

f, the figure of a bear manido, to which is attached a feather denoting the mythic character of the animal.

g, the figure represents a "lean bear," as is specified by the appearance of the ribs showing his lean condition.

h, a lizard. The ribs are ridges, which are found upon some forms of *Siredon*, one species of which occurs in the ponds and small lakes of Minnesota.

i, a toad.

k, a raccoon. The bands of color are indicated in the drawing.

l, a porcupine. Resembles some forms of the sacred bear manido as the latter is sometimes drawn.

m, the crane. The three round spots over the head represent three songs sung by the midē' to the crane manido.

n, the thunder-bird or eagle, having four heads. This character appears to be unique, as it has at no time been noticed upon any of the

numerous midē′ records in the possession of the Bureau of Ethnology.

o, the character represents a man using the rattle, as in the ceremony of incantation. The projections above the head denote his superior powers.

p, a midē′, holding in his right hand a bear's paw medicine bag, and in his left hand an arrow. The character resembles similar drawings to denote vessels in which herbs are boiled and from the top of which vapor is issuing.

q, a midē′ medicine sack. The character appears like similar drawings of the otter; in the present instance, however, the ornamentation upon the skin shows it to be not a living animal.

r, a beaver's tail, from Schoolcraft (*y*). Many other illustrations of this general nature are given by Mr. Schoolcraft, nearly all colored according to his fancy.

CHAPTER XXII.

CONTROVERTED PICTOGRAPHS.

No large amount of space need be occupied in the mention of detected pictographic frauds, their present and future importance being small, but much more than is now allowed would be required for the full discussion of controverted cases.

There is little inducement, beyond the amusement derived from hoaxing, to commit actual frauds in the fabrication of petroglyphs. It must, however, be remembered that coloration and carving of a deceptive character are sometimes produced by natural causes, e. g., pictured rocks on the island of Monhegan, Maine, figured by School-craft (z), are classed in "Science" VI, No. 132, p. 124, as freaks of surface erosion. Mica plates were found in a mound at Lower Sandusky, Ohio, which, after some attempts at interpretation, proved to belong to the material known as graphic or hieroglyphic mica, the discolorations having been caused by the infiltration of mineral solution between the laminæ.

The instances where inscribed stones from mounds have been ascertained to be forgeries or fictitious drawings are to be explained as sometimes produced by simple mischief, sometimes by craving for personal notoriety, and in other cases by schemes either to increase the marketable value of land supposed to contain more of the articles or to sell those exhibited.

With regard to more familiar and more portable articles, such as engraved pipes, painted robes, and like curios, it is well known that the fancy prices paid for them by amateurs have stimulated their unlimited manufacture by Indians at agencies who make a business of sketching upon ordinary robes or plain pipes the characters in common use by them, without regard to any real event or person, and selling them as significant records. Some enterprising traders have been known to furnish the unstained robes, plain pipes, paints, and other materials for the purpose, and simply pay a skillful Indian for his work, when the fresh antique or imaginary chronicle is delivered.

As the business of making and selling archæologic frauds has become so extensive in Egypt and Palestine, it can be no matter of surprise that it has been attempted by enterprising people of the United States, about whom the wooden-nutmeg imputation still clings. The Bureau of Ethnology has discovered several centers of the manufacture of antiquities.

It was once proclaimed that six inscribed copper plates had been found in a mound near Kinderhook, Pike county, Illinois, which were

reported to bear a close resemblance to Chinese. This resemblance seemed not to be extraordinary when it was ascertained that the plate had been engraved by the village blacksmith, copied from the lid of a Chinese tea-chest.

The following recent notice of a case of alleged fraud is quoted from Science, Vol. III, No. 58, March 14, 1884, page 334:

> Dr. N. Roe Bradner exhibited [at the Academy of Natural Sciences, Philadelphia, Pennsylvania] an inscribed stone found inside a skull taken from one of the ancient mounds at Newark, Ohio, in 1865. An exploration of the region had been undertaken, in consequence of the finding of stones bearing markings somewhat resembling Hebrew letters, in the hope of finding other specimens of a like character. The exploration was supposed to have been entirely unproductive of such objects until Dr. Bradner had found the engraved stone, now exhibited, in a skull which had been given to him.

This was supplemented by an editorial note in No. 62 of the same publication, page 467, as follows:

> A correspondent from Newark, Ohio, warns us that any inscribed stones said to originate from that locality may be looked upon as spurious. Years ago certain parties in that place made a business of manufacturing and burying inscribed stones and other objects in the autumn, and exhuming them the following spring in the presence of innocent witnesses. Some of the parties to these frauds afterwards confessed to them; and no such objects, except such as were spurious, have ever been known from that region.

The correspondent of Science probably remembered the operations of David Wyrick, of Newark, who, to prove his theory that the Hebrews were the mound-builders, discovered in 1860 a tablet bearing on one side a truculent " likeness" of Moses with his name in Hebrew, and on the other a Hebrew abridgment of the ten commandments. A Hebrew bible afterwards found in Mr. Wyrick's private room threw some light on the inscribed characters.

A grooved stone ax or maul, first described by the late Dr. John Evans, of Pemberton, New Jersey, was reproduced by Dr. Wilson (a). Several characters are cut in the groove and on the blade. They are neither Runic, Scandinavian, nor Anglo-Saxon. It was found near Pemberton, New Jersey, prior to 1859. Dr. E. H. Davis, who saw the stone, does not regard the inscription as ancient. The characters had been retouched before he saw them.

A grooved stone ax or maul, sent to Col. Whittlesey in 1874, from Butler county, Ohio, about the size of the Pemberton ax, was covered with English letters so fresh as to deceive no one versed in antiquities. The purport of this inscription is that in 1689 Capt. H. Argill passed there and secreted two hundred bags of gold near a spring.

It was claimed that an inscribed stone had been plowed up on the eastern shore of Grand Traverse bay, Michigan, and an imperfect cast of it was among the collections of the state of Michigan at the Centennial Exhibition. The original is or was in the cabinet of the Kent county Institute, Grand Rapids, Michigan. It is imperfectly exe-

cuted, probably with a knife, and evidently of recent make, in which Greek, Bardic, and fictitious letters are jumbled together without order.

In 1875 a stone maul was discovered in an ancient mine pit near Lake Desor, Isle Royal, Lake Superior, on which were cut several lines that were at first regarded as letters.

An instructive paper by Mr. Wm. H. Holmes "On Some Spurious Mexican Antiquities and their Relation to Ancient Art," is published in the Report of the Smithsonian Institution for 1886, Pt. 1, pp. 319–334.

SECTION 1.

THE GRAVE CREEK STONE.

An inscribed stone found in Grave creek mound, near the Ohio river, in 1838, has been the subject of much linguistic contention among persons who admitted its authenticity. Twenty-four characters on it have been considered by various experts to be alphabetic, and one is a supposed hieroglyphic sign. Mr. Schoolcraft says that twenty-two of the characters are alphabetic, but there has been a difference of opinion with regard to their origin. One scholar finds among them four characters which he claims are ancient Greek; another claims that four are Etruscan; five have been said to be Runic; six, ancient Gaelic; seven, old Erse; ten, Phenician; fourteen, old British; and sixteen, Celtiberic. M. Levy Bing reported at the Congress of Americanists at Nancy, in 1875, that he found in the inscription twenty-three Canaanite letters, and translated it: "What thou sayest, thou dost impose it, thou shinest in thy impetuous clan and rapid chamois." (!) M. Maurice Schwab in 1857 rendered it: "The Chief of Emigration who reached these places (or this island) has fixed these statutes forever." M. Oppert, however, gave additional variety by the translation, so that all tastes can be suited: "The grave of one who was assassinated here. May God to avenge him strike his murderer, cutting off the hand of his existence."

Col. Chas. Whittlesey (a) gives six copies of the Grave creek stone, all purporting to be facsimiles, which have been published and used in the elaborate discussions held upon its significance. Of these, three are here reproduced with Col. Whittlesey's remarks, as follows:

Copy No. 1 is reproduced as Fig. 1285, drawn by Capt. Eastman.

Capt. Seth Eastman was a graduate and teacher of drawing at West Point. He was an accomplished draftsman and painter detailed by the War Department to furnish the illustrations for "Schoolcraft's Indian Tribes," published by the Government. This copy was made in his official capacity, with the stone before him, and therefore takes the first rank as authority. There are between the lines twenty-two characters, but one is repeated three times and another twice leaving only twenty. The figure, if it has any significance, is undoubtedly pictorial.

FIG. 1285.—Grave creek stone.

Copy No. 3, now Fig. 1286, was used by Monsieur Jomard at Paris, 1843.

FIG. 1286.—Grave creek stone.

From this copy M. Jomard considered the letters to be Lybian, a language derived from the Phenician. At the right of the upper line one is omitted and another bears no resemblance to the original. The fifth character of the second line is equally defective and objectionable. The second, fifth, and sixth of the lower line are little better. In the rude profile of a human face beneath an eye has been introduced and the slender cross lines attached to it have assumed the proportions of a dagger or sword. For the linguist or ethnologist this copy is entirely worthless.

Copy No. 4, now Fig. 1287, was sent to Prof. Rafn, Copenhagen, 1843.

This is so imperfect and has so many additions that it is little better than a burlesque upon the original. No one will be surprised that the learned Danish antiquarian could find in it no resemblance to the Runic, with which he was thoroughly familiar.

FIG. 1287.—Grave creek stone.

A mere collocation of letters from various alphabets is not an alphabet. Words can not be formed or ideas communicated by that artifice. When a people adopts the alphabetical signs of another it adopts the general style of the characters and more often the characters in detail. Such signs had already an arrangement into syllables and words which had a vocalic validity as well as known significance. A jumble of letters from a variety of alphabets bears internal evidence that the manipulator did not have an intelligent meaning to convey by them, and did not comprehend the languages from which the letters were selected. In the case of the Grave creek inscription the futile attempts to extract a meaning from it on the theory that it belongs to an intelligent alphabetic system show that it holds no such place. If it is genuine it must be treated as pictorial and ideographic, unless, indeed, it is cryptographic, which is not indicated.

SECTION 2.

THE DIGHTON ROCK.

In this connection some allusion must be made to the learned discussions upon the Dighton rock before mentioned, p. 86. The originally Algonquian characters were translated by a Scandinavian antiquary as an account of the party of Thorfinn, the Hopeful. A distinguished Orientalist made out clearly the word "melek" (king). Another scholar triumphantly established the characters to be Scythian, and still another identified them as Phenician. But this inscription has been so manipulated that it is difficult now to determine the original details.

An official report made in 1830 by the Rhode Island Historical Society and published by the Royal Society of Northern Antiquaries,

PLATE LIV

I. *Dr. Danforth's Drawing 1680*

II. *Dr. Cotton Mather's 1712*

III. *Dr. Greenwood's 1730*

IV. *Mr. Stephen Sewell's 1768*

V. *Mr. James Winthrop's 1788*

DIGHTON ROCK

PLATE LIV (continued)

VI. *Mr. Kendall's 1807*

VII. *Mr. Job Gardner's 1812*

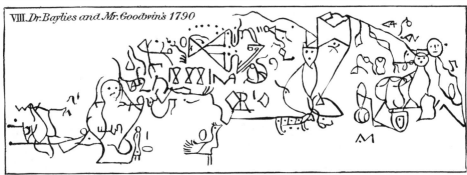

VIII. *Dr. Baylies and Mr. Goodwin's 1790*

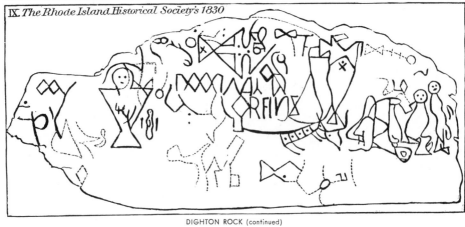

IX. *The Rhode Island Historical Society's 1830*

in "Antiquitates Americanæ," by C. C. Rafn (*e*), presents the best account known concerning the Dighton rock and gives copies made from time to time of the inscription, which are here reproduced, Pl. LIV. The text is condensed as follows, but in quoting it the statement that the work was not done by the Indians is without approval.

It is situated about 6½ miles south of Taunton, on the east side of Taunton river, a few feet from the shore, and on the west side of Assonet neck, in the town of Berkley, county of Bristol, and commonwealth of Massachusetts; although probably from the fact of being generally visited from the opposite side of the river, which is in Dighton, it has always been known by the name of the Dighton Writing Rock. It faces northwest toward the bed of the river, and is covered by the water 2 or 3 feet at the highest, and is left 10 or 12 feet from it at the lowest tides; it is also completely immersed twice in twenty-four hours. The rock does not occur in situ, but shows indubitable evidence of having occupied the spot where it now rests since the period of that great and extensive disruption which was followed by the transportation of immense bowlders to, and a deposit of them in, places at a vast distance from their original beds. It is a mass of well characterized, fine grained graywacke. Its true color, as exhibited by a fresh fracture, is a bluish gray. There is no rock in the immediate neighborhood that would at all answer as a substitute for the purpose for which the one bearing the inscription was selected, as they are aggregates of the large conglomerate variety. Its face, measured at the base is 11½ feet, and in height it is a little rising 5 feet. The upper surface forms with the horizon an inclined plane of about 60 degrees. The whole of the face is covered to within a few inches of the ground with unknown hieroglyphics. There appears little or no method in the arrangement of them. The lines are from half an inch to an inch in width; and in depth, sometimes one-third of an inch, though generally very superficial. They were, inferring from the rounded elevations and intervening depressions, pecked in upon the rock and not chiseled or smoothly cut out. The marks of human power and manual labor are indelibly stamped upon it. No one who examines attentively the workmanship will believe it to have been done by the Indians. Moreover, it is a well attested fact that nowhere throughout our widespread domain is a single instance of their recording or having recorded their deeds or history on stone.

"The committee also examined the various drawings that have been made of this inscription.

"The first was made by Cotton Mather as early as 1712; and may be found in No. 338, vol. 28, of the Philosophical Transactions, pp. 70 and 71; also in vol. 5, Jones's abridgment, under article fourth.

"Another was made by James Winthrop in 1788, a copy of which may be found in the Memoirs of the American Academy, vol. 2, part 2, p. 126.

"Dr. Baylies and Mr. Goodwin made another drawing in 1790, a copy of which is inclosed.

"Mr. E. A. Kendall in 1807 took another which may be found in the Memoirs of the American Academy, vol. 3, part 1, p. 165.

"And one has been more recently [1812] made by Mr. Job Gardner, a lithograph from which is also inclosed.

"Dr. Isaac Greenwood exhibited a drawing of the inscription before the Society of Antiquarians of London bearing the date of 1730. The drawing by the Historical Society of Rhode Island bears the date of 1830.

"We send you a copy of the inscription, as given on said representation of the rock, being what you probably desire; but having made an accurate drawing of the rock itself for your special use, we have not deemed it necessary to forward the one above referred to. We also send a copy of Judge Winthrop's drawing contained in the same work, and of one taken by Stephen Sewell in 1768.

"You will likewise find among the drawings a copy of what purports to be 'a faithful and accurate representation of the inscription,' taken by Dr. Danforth in 1680. This is not sent with any idea that it will prove serviceable in your present inquiry, but simply to show what strange things have been conjured up by travelers and sent to Europe for examination. We are, indeed, at times almost compelled to believe there must have been some other inscription rock seen; and yet from the accompanying accounts it would appear that all refer to the same one; besides, there is a degree of similarity in the complicated triangular figures which appear on all."

See, also, the illustration from Schoolcraft, Fig. 49, supra, with further account. The fact was mentioned on p. 87 that the characters on the Dighton Rock strongly resembled those on the Indian God Rock, Pennsylvania, and some others specified. Lately some observers have noticed the same fact with a different deduction. They presuppose that the Dighton inscription is Runic, and therefore that the one in Pennsylvania was carved by the Norsemen. This logic would bring the Vikings very far inland into West Virginia and Ohio.

SECTION 3.

IMITATIONS AND FORCED INTERPRETATIONS.

From considerations mentioned elsewhere, and others that are obvious, any inscriptions purporting to be pre-Columbian, showing apparent use of alphabetic characters, signs of the zodiac, or other evidences of a culture higher than that known among the North American Indians, must be received with caution, but the pictographs may be altogether genuine, and their erroneous interpretation may be the sole ground for discrediting them.

The course above explained, viz, to attempt the interpretation of all unknown American pictographs by the aid of actual pictographers among the living Indians, should be adopted regarding all remarkable "finds." This course was pursued by Mr. Horatio N. Rust, of Pasadena, California, regarding the much-discussed Davenport Tablets, in the genuineness of which he believes. Mr. Rust exhibited the drawings to Dakotas with the result made public at the Montreal meeting of the American Association for the Advancement of Science, and also in a letter, an extract from which is as follows:

As I made the acquaintance of several of the older and more intelligent members of the tribe, I took the opportunity to show them the drawings. Explaining that they were pictures copied from stones found in a mound, I asked what they meant. They readily gave me the same interpretation (and in no instance did either interpreter know that another had seen the pictures, so there could be no collusion). In Plate I, of the Davenport Inscribed Tablets [so numbered in the Proceedings of the Davenport Academy, vol. II], the lower central figure represents a dome-shaped lodge, with smoke issuing from the top, behind and to either side of which appears a number of individuals with hands joined, while three persons are depicted as lying upon the ground. Upon the right and left central margins are the sun and moon, the whole surmounted by three arched lines, between each of which, as well as above them, are numerous unintelligible characters. * * * The central figure, which has been supposed by some to represent a funeral pile, was simply the picture of a

dirt lodge. The irregular markings apparently upon the side and to the left of the lodge represent a fence made of sticks and brush set in the ground. The same style of fence may be seen now in any Sioux village.

The lines of human figures standing hand-in-hand indicate that a dance was being conducted in the lodge. The three prostrate forms at right and left sides of the lodge represent two men and a woman who, being overcome by the excitement and fatigue of the dance, had been carried out in the air to recover. The difference in the shape of the prostrate forms indicates the different sexes.

The curling figures or rings above the lodge represent smoke, and indicate that the dance was held in winter, when fire was used.

An amusing example of forced interpretation of a genuine petroglyph is given by Lieut. J. W. Gunnison (a), and is presented in the present work in connection with Fig. 81, supra.

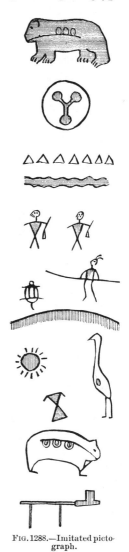

FIG. 1288.—Imitated picto-
graph.

Fig. 1288 is a copy of a drawing taken from an Ojibwa pipestem, obtained by Dr. Hoffman from an officer of the United States Army, who had procured it from an Indian in St. Paul, Minnesota. On more minute examination, it appeared that the pipestem had been purchased at a shop in St. Paul, which had furnished a large number of similar objects—so large as to awaken suspicion that they were in the course of daily manufacture. The figures and characters on the pipestem were drawn in colors. In the present figure, which is without colors, the horizontal lines represent blue and the vertical red, according to the heraldic scheme. The outlines were drawn in a dark neutral tint, in some lines approaching black; the triangular characters, representing lodges, being also in a neutral tint, or an ashen hue, and approaching black in several instances. The explanation of the figures, made before there was any suspicion of their authenticity, is as follows:

The first figure is that of a bear, representing the person to whom the record pertains. The heart above the line, according to an expression in gesture language, would signify a brave heart, increased numbers indicating much or many, so that the three hearts mean a large brave heart.

The second figure, a circle inclosing a triradiate character, refers to the personal totem. The character in the middle somewhat resembles the pictograph sometimes representing stars, though in the latter the lines center upon the disks and not at a common point.

The seven triangular characters represent the lodges of a village to which the person referred to belongs.

The serpentine lines immediately below these signify a stream or river, near which the village is situated.

The two persons holding guns in their left hands, together with another holding a spear, appear to be the companions of the speaker or recorder, all of whom are members of the turtle gens, as shown by that animal.

The curve from left to right is a representation of the sky, the sun having appeared upon the left or eastern horizon. The drawing, so far, might represent the morning when a female member of the crane gens, was killed—shown by the headless body of a woman.

The lower figure of a bear is the same apparently as the upper, though turned to the right. The hearts are drawn below the line, i. e., down, to denote sadness, grief, remorse, as it would be expressed in gesture language, and to atone for the misdeed committed the pipe is brought and offering made for peace.

Altogether the act depicted appears to have been accidental, the woman belonging to the same tribe, as can be learned from the gens of which she was a member. The regret or sorrow signified in the bear, next to the last figure, corresponds with that supposition, as such feelings would not be manifested on the death of an enemy.

The point of interest in this drawing is, that the figures are very skillfully copied from the numerous characters of the same kind representing Ojibwa pictographs, and given by Schoolcraft. The arrangement of these copied characters is precisely what would be common in the similar work of Indians. In fact, the group constitutes an intelligent pictograph and affords a good illustration of the manner in which one can be made. The fact that it was sold under false representations is its objectionable feature.

Another case brought officially to the Bureau of Ethnology shows evidence of a more determined fraud. In 1888 and earlier a so-called "Shawnee doctor" had displayed as a chart in the nature of an aboriginal diploma, a brightly colored picture 36 by 40 inches, a copy of which was sent, to be deciphered, to the Bureau by a gentleman who is not supposed to have been engaged in fraud or hoax. The mystic chart is copied in Fig. 1289. There was little difficulty in its explanation.

The large figures on the border can not be pretended to be of Indian origin. The smaller interior figures constituting the body of the chart are all, with trifling exceptions, exact copies of figures published and fully explained in G. Copway's "Traditional History, etc., of the Ojibway Nation." op. cit. Several of the same figures appear above in the present work. The principal exceptions are, first, a modern knife; second, a bird with a decidedly un-Indian human head, and, third, a cross with two horizontal arms of equal length. The figures from Copway are not in the exact order given in his list and it is possible

that they may have been placed in their present order to simulate the appearance of some connected narrative or communication, which could readily be done in the same manner as the words of a dictionary could be cut out and pasted in some intelligent sequence.

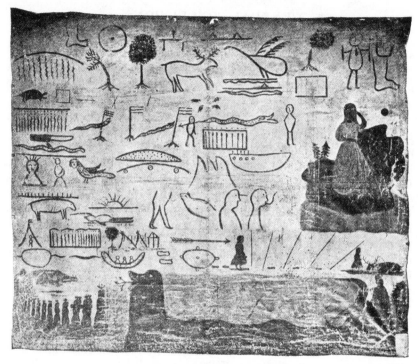

FIG. 1289.—Fraudulent pictograph.

Among the curiosities of literature in connection with the interpretation of pictographs may be mentioned La Vèritè sur le Livre des Sauvages, par L'Abbé Em. Domenech, Paris, 1861, and Researches into the Lost Histories of America, by W. S. Blacket, London and Philadelphia, 1884.

The following remarks of Dr. Edkins (h) are also in point:

The early Jesuits were accustomed to interpret Chinese characters on the wildest principles. They detected religious mysteries in the most unexpected situations. Kwei "treacherous," is written with Kieu "nine," and above it one of the covering radicals, Fig. 1290a. This, then, was Satan at the head of the nine ranks of angels. The character, same Fig., b, c'hwen "a boat," was believed to contain an allusion to the deluge. On the left side is the ark and on the right are the signs for eight and for persons. The day for this mode of explaining the Chinese characters has gone by.

FIG. 1290.—Chinese characters.

CHAPTER XXIII.

GENERAL CONCLUSIONS.

The result of the writer's studies upon petroglyphs as distinct from other forms of picture writing may now be summarized.

Perhaps the most important lesson learned from these studies is that no attempt should be made at symbolic interpretation unless the symbolic nature of the particular characters under examination is known, or can be logically inferred from independent facts. To start with a theory, or even a hypothesis, that the rock writings are all symbolic and may be interpreted by the imagination of the observer or by translation either from or into known symbols of similar form found in other regions, were a limitless delusion. Doubtless many of the characters are genuine symbols or emblems, and some have been ascertained through extrinsic information to be such. Sometimes the more modern forms are explained by Indians who have kept up the pictographic practice, and the modern forms occasionally throw light upon the more ancient. But the rock inscriptions do not evince mysticism or esotericism, cryptography, or steganography. With certain exceptions they were intended to be understood by all observers either as rude objective representations or as ideograms, which indeed were often so imperfect as to require elucidation, but not by any hermeneutic key. While they often related to religious ceremonies or myths, such figures were generally drawn in the same spirit with which any interesting matter was portrayed.

While the interpretation of petroglyphs by Indians should be obtained if possible, it must be received with caution. They very seldom know by tradition the meaning of the older forms, and their inferences are often made from local and limited pictographic practices. There is no more conscientious and intelligent Indian authority than Frank La Flêche, an Omaha, and he explains the marks on a rock in Nebraska as associated with the figures of deceased men and exhibiting the object which caused their death, such as an arrow or ax. This may be a local or tribal practice, but it certainly does not apply to similar figures throughout the Algonquian and Iroquoian areas, where, according to the concurrent testimony for more than two centuries, similar figures are either designations of tribes and associations, or in their combinations are records of achievements.

Lossing (b) gives the following explanation of markings on a well known rock:

Among the brave warriors in the battle [of Maumee] who were the last to flee before Wayne's legion, was Me-sa-sa, or Turkey-foot, an Ottawa chief, who lived on Blanchards Fork of the AuGlaize River. He was greatly beloved by his people.

768

His courage was conspicuous. When he found the line of dusky warriors giving way at the foot of Presque Isle hill, he leaped upon a small bowlder, and by voice and gesture endeavored to make them stand firm. He almost immediately fell, pierced by a musket ball, and expired by the side of the rock. ˟ ˟ ˟ They carved many rude figures of a turkey's foot on the stone, as a memorial of the English name of the lamented Me-sa-sa. The stone is still there, by the side of the highway at the foot of Presque Isle hill, within a few rods of the swift-flowing Maumee. Many of the carvings are still quite deep and distinct, while others have been obliterated by the abrasion of the elements.

This tale may be true, but it surely does not account for the turkey-foot marks which are so common in the northeastern Algonquian region, extending from Dighton rock to Ohio, that they form a typical characteristic of its pictographs. They have been considered to be the sign for the bird, the turkey, which was a frequent totem. Lossing's story is an example of the readiness of an Indian, when in an amiable and communicative mood, to answer queries in a manner which he supposes will be satisfactory to his interviewer. He will then give any desired amount of information on any subject without the slightest restriction by the vulgar bounds of fact. It is dangerous to believe explanations on such subjects as are now under consideration, unless they are made without leading questions by a number of Indian authorities independently.

Specially convenient places for halting and resting on a journey, either by land or water, such as is mentioned supra, on Machias bay, generally exhibit petroglyphs if rocks of the proper character are favorably situated there. The markings may be mere graffiti, the product of leisure hours, or may be of the more serious descriptions mentioned below.

Some points are ascertained with regard to the motives of the painters and sculptors on rocks. Some of the characters were mere records of the visits of individuals to important springs or to fords on regularly established trails. In this practice there may have been in the intention of the Indians very much the same spirit which induces the civilized man to record his name or initials upon objects in the neighborhood of places of general resort. But there was real utility in the Indian practice, which more nearly approached to the signature in a visitor's book at a hotel or public building, both to establish the identity of the traveler and to give the news to friends of his presence and passage. At Oakley springs, Arizona territory, totemic marks have been found, evidently made by the same individual at successive visits, showing that on the number of occasions indicated he had passed by those springs, probably camping there, and the habit of making such record was continued until quite recently by the neighboring Indians. The same repetition of totemic names has been found in great numbers in the pipestone quarries of Minnesota, on the rocks near Odanah, Wisconsin, and also at some old fords in West Virginia. These totemic marks are so designed and executed as to have intrinsic significance and value, wholly different in this respect from

names in alphabetic form, which grammatically are proper but practically may be common.

Rock carvings are frequently noticed at waterfalls and other points on rivers and on lake shores favorable for fishing, which frequency is accounted for by the periodical resort of Indians to such places. Sometimes they only mark their stay, but occasionally there also appear to be records of conflict with rival or inimical tribes which sought to use the same waters.

Evidence is presented in the present work that the characters on rock pictures sometimes were pointers or "sign-posts" to show the direction of springs, the line of established trails, or of paths that would shorten distances in travel. It has been supposed that similar indications were used guiding to burial mounds and other places of peculiar sanctity or interest, but the evidence of this employment is not conclusive. Many inquiries have been made of the Bureau of Ethnology concerning Indian marks supposed to indicate the sites of gold, silver, and copper mines and buried treasure generally, which inquiries were answered only because it was recognized as the duty of an office of the government to respond, so far as possible, to requests for information, however silly, which are made in good faith.

Petroglyphs are now most frequently found in those parts of the world which are still, or recently have been, inhabited by savage or barbarian tribes. Persons of these tribes when questioned about the authorship of the rock drawings have generally attributed them to supernatural beings. Statements to this effect from many peoples of the three Americas and of other regions, together with the names of rockwriting deities, are abundantly cited in the present work. This is not surprising, nor is it instructive, except as to the mere fact that the drawings are ancient. Man has always attributed to supernatural action whatever he did not understand. Also, it appears that in modern times shamans have encouraged this belief and taken advantage of it to interpret for their own purposes the drawings, some of which have been made by themselves. But notwithstanding these errors and frauds, a large proportion of the petroglyphs in America are legitimately connected with the myths and the religious practices of the authors. The information obtained during late years regarding tribes such as the Zuñi, Moki, Navajo, and Ojibwa, which have kept up on the one hand their old religious practices and on the other that of picture writing, is conclusive on this point. The rites and ceremonies of these tribes are to some extent shown pictorially on the rocks, some of the characters on which have until lately been wholly meaningless, but are now identified as drawings of the paraphernalia used in or as diagrams of the drama of their rituals. Unless those rituals, with the creeds and cosmologies connected with them had been learned, the petroglyphs would never have been interpreted. The fact that they are now understood does not add any new information, except that perhaps in

some instances their age may show the antiquity and continuity of the present rites.

A potent reason for caution in making deductions based only on copies of figures published incidentally in works of travel is that it can seldom be ascertained with exactness what is the true depiction of those figures as actually existing or as originally made. The personal equation affects the drawings and paintings intended to be copies from the rock surfaces and also the engravings and other forms of reproductions, and the student must rely upon very uncertain reproductions for most of his material. The more ancient petroglyphs also require the aid of the imagination to supply eroded lines or faded colors. Travelers and explorers are seldom so conscientious as to publish an obscure copy of of the obscure original. It is either made to appear distinct or is not furnished at all, and if the author were conscientious the publisher would probably overrule him.

Thorough knowledge of the historic tribes, including their sociology, sophiology, technology, and especially their sign language, will probably result in the interpretation of many more petroglyphs than are now understood, but the converse is not true. The rock characters studied independently will not give much primary information about customs and concepts, though it may and does corroborate what has been obtained by other modes of investigation. A knowledge of Indian customs, costumes, including arrangement of hair, paint, and all tribal designations, and of their histories and traditions, is essential to the understanding of their drawings; for which reason some of those particulars known to have influenced pictography have been set forth in this work and objects have been mentioned which were known to have been portrayed graphically with special intent.

Other objects are used symbolically or emblematically which, so far as known, have never appeared in any form of pictographs, but might be found in any of them. For instance, Mr. Schoolcraft says of the Dakotas that "some of the chiefs had the skins of skunks tied to their heels to symbolize that they never ran, as that animal is noted for its slow and self-possessed movements." This is one of the many customs to be remembered in the attempted interpretations of pictographs. The present writer does not know that a skunk skin or a strip of skin which might be supposed to be a skunk skin attached to a human heel has ever been separately used pictorially as the ideogram of courage or steadfastness, but with the knowledge of this objective use of the skins, if they were found so represented pictorially, the interpretation would be suggested without any direct explanation from Indians.

A partial view of petroglyphs has excited hope that by their correlation the priscan homes and migrations of peoples may be ascertained. Undoubtedly striking similarities are found in regions far apart from as well as near to each other. A glance at the bas-reliefs of Boro Boudour in Java, now copied and published by the Dutch authorities, at once recalls figures of the lotus and uræus of Egypt, the horns of Assyria, the

thunderbolt of Greece, the Buddhist fig tree, and other noted characters common in several parts of the world. If the petroglyphs of America are considered as the texts with which all others may be compared, it is believed that the present work shows illustrations nearly identical with many much-discussed carvings and paintings on the rocks of the eastern hemisphere, those in Siberia being most strongly suggestive of connection. But from the present collection it would seem that the similarity of styles in various regions is more worthy of study than is the mere resemblance or even identity of characters, the significance of which is unknown and may have differed in the intent of the several authors. Indeed it is clear that even in limited areas of North America, diverse significance is attached to the same figure and differing figures are made to express the same concept.

The present work shows a surprising resemblance between the typical forms among the petroglpyhs found in Brazil, Venezuela, Peru, Guiana, part of Mexico, and those in the Pacific slope of North America. This similarity includes the forms in Guatemala and Alaska, which, on account of the material used, are of less assured antiquity. Indeed it would be safe to include Japan and New Zealand in this general class. In this connection an important letter from Mr. James G. Swan, respecting the carved wooden images of the Haidas, accentuates the deduction derived only from comparison. Mr. Swan says that he showed to the Indians of various coast tribes the plates of Dr. Habel's work on sculptures in Guatemala, and that they all recognized several of the pictures which he notes. They also recognized and understood the pictures of the Zuñi ceremonials, masks, and masquerades scenes published by Mr. F. H. Cushing.

Without entering upon the discussion whether America was peopled from east to west, or from either, or from any other part of the earth, it is for the present enough to suggest that the petroglyphs and other pictographs in the three Americas indicate that their pre-Columbian inhabitants had at one time frequent communication with each other, perhaps not then being separated by the present distances of habitat. Styles of drawing and painting could thus readily be diffused, and, indeed, to mention briefly the extralimital influence, if as many Japanese and Chinese vessels were driven upon the west American coast in prehistoric times as are known by historic statistics to have been so driven, the involuntary immigrants skilled in drawing and painting might readily have impressed their styles upon the Americans near their landing place to be thence indefinitely diffused. This hypothesis would not involve migration.

Interest has been felt in petroglyphs, because it has been supposed that if interpreted they would furnish records of vanished peoples or races, and connected with that supposition was one naturally affiliated that the old rock sculptures were made by peoples so far advanced in culture as to use alphabets or at least syllabaries, thus supporting

the theory about the mythical mound builders or some other suppositious race. All suggestions of this nature should at once be abandoned. The practice of pictography does not belong to civilization and declines when an alphabet becomes popularly known. Neither is there the slightest evidence that an alphabet or syllabary was ever used in pre-Columbian America by the aborignes, though there is some trace of Runic inscriptions. The fact that the Maya and Aztec peoples were rapidly approaching to such modes of expressing thought, and that the Dakota and Ojibwa had well entered upon that line of evolution, shows that they had proceeded no farther, and it is admitted that they were favorable representatives of the tribes of the continent in this branch of art. The theory mentioned requires the assumption, without a particle of evidence, that the rock sculptures are alphabetic, and therefore were made by a supposititious and extinct race. Topers of the mysterious may delight in such dazing infusions of perverted fancy, but they are repulsive to the sober student.

The foregoing remarks apply mainly to rock inscriptions and not to pictographs on other substances, the discussion and illustration of which occupy the greater part of the present work. In that division there is no need of warning against wild theories or uncertain data. The objects are in hand and their current use as well as their significance is understood. Their description and illustration by classes is presented in the above chapters with such detail that further discussion here would be mere repetition.

One line of thought, however, is so connected with several of the classifications that it may here be mentioned with the suggestion that the preceding headings, with the illustrations presented under each, may be reviewed in reference to the methodical progress of pictography toward a determined and convenient form of writing. This exhibition of evolution was arrested by foreign invasion before the indirect signs of sound had superseded the direct presentments of sight for communication and record. Traces of it appear throughout the present paper, but are more intelligently noticed on a second examination than in cursory reading. In the Winter Counts of Battiste Good there are many characters where the figure of a human being is connected with an object, which shows his tribal status or the disease of which he died, and the characters representing the tribe or disease are purely determinative.

The discrimination which is made between animals and objects portrayed simply as such, and as supernatural or mystic, is shown in the many illustrations of Ojibwa and Zuñi devices, in which the heart is connected with a line extending to the mouth, and those of the Ojibwa and the Dakota, where the spirals indicate spirit or wakan. Animals are often portrayed without such lines, in which cases it is understood that they are only the animals in natural condition, but with the designations or determinatives they are intended to be supernatural. Among

the Ojibwa animals connected with certain ceremonies are represented as encircled by a belt or baldric, an ornamented baldric of the same character being used by the participants in the ceremonial chant dance; so that the baldric around the animal determines that the figure is that of a supernatural and mystic, not an ordinary, animal. This is an indication of the start from simple pictography towards an alphabet by the use of determinatives as was done by the Chinese.

It is not believed that much information of historical value will be obtained directly from the interpretation of the petroglyphs in America. The greater part of those already known are simply peckings, carvings, or paintings connected with their myths or with their everyday lives. It is, however, probable that others were intended to commemorate events, but the events, which to their authors were of moment, would be of little importance as history, if, as is to be expected, they were selected in the same manner as is done by modern Indian pictographers. They referred generally to some insignificant fight or some season of plenty or of famine, or to other circumstances the interest in which has long ago died away.

The question may properly be asked, why, with such small prospect of gaining historic information, so much attention has been directed to the collection and study of petroglyphs. A sufficient answer might be submitted, that the fact mentioned could not be made evident until after that collection and study, and that it is of some use to establish the limits of any particular line of investigation, especially one largely discussed with mystical inferences to support false hypotheses. But though the petroglyphs do not and probably never will disclose the kind of information hoped for by some enthusiasts, they surely are valuable as marking the steps in one period of human evolution and in presenting evidence of man's early practices. Also though the oʹ urrences interesting to their authors and therefore recorded or indicated by them are not important as facts of history, they are proper subjects of examination, simply because in fact they were the chief objects of interest to their authors, and for that reason become of ethnologic import. It is not denied that some of the drawings on rocks were made without special purpose, for mere pastime, but they are of import even as mere graffiti. The character of the drawings and the mode of their execution tell something of their makers. If they do not tell who those authors were, they at least suggest what kind of people they were as regards art, customs, and sometimes religion. But there is a broader mode of estimating the quality of known pictographs. Musicians are eloquent in lauding of the great composers of songs without words. The ideography, which is the prominent feature of picture writing, displays both primordially and practically the higher and purer concept of thoughts without sound.

The experience of the present writer induces him to offer the following suggestions for the benefit of travelers and other observers who may meet with petroglyphs which they may desire to copy and describe.

As a small drawing of large rock inscriptions must leave in doubt the degree of its finish and perhaps the essential objects of its production, it is requisite, in every instance, to affix the scale of the drawing, or to give a principal dimension to serve as a guide. A convenient scale for ordinary petroglyphs is one-sixteenth of actual size. The copy should be with sufficient detail to show the character of the work. It is useful to show the lithologic character of the rock or bowlder used; whether the drawing has been scratched into the face of the rock, or incised more deeply with a sharp implement, and the depth of such incision; whether the design is merely outlined, or the whole body of the figures pecked out, and whether paint has been applied to the pecked surface, or the design executed with paint only. The composition of paint should be ascertained when possible. The amount of weathering or erosion, together with the exposure, or any other feature bearing on the question of antiquity, might prove important. If actual colors are not accessible for representation the ordinary heraldic scheme of colors can be used.

That sketches, even by artists of ability, are not of high value in accuracy, is shown by the discrepant copies of some of the most carefully studied pictographs, which discrepancies sometimes leave in uncertainty the points most needed for interpretation. Sketches, or still better, photographs are desirable to present a connected and general view of the characters and the surface upon which they are found. For accuracy of details "squeezes" should be obtained when practicable.

A simple method of obtaining squeezes of petroglyphs, when the lines are sufficiently deep to receive an impression, is to take ordinary manilla paper of loose texture, and to spread the sheet, after being thoroughly wetted, over the surface, commencing at the top. The top edge may be temporarily secured by a small streak of starch or flour paste. The paper is then pressed upon the surface of the rock by means of a soft bristle brush, so that its texture is gently forced into every depression. Torn portions of the paper may be supplied by applying small patches of wet paper until every opening is thoroughly covered. A coating of ordinary paste, as above mentioned, is now applied to the entire surface, and a new sheet of paper, similarly softened by water, is laid over this and pressed down with the brush. This process is continued until three or four thicknesses of paper have been used. Upon drying, the entire mold will usually fall off by contraction. The edge at the top, if previously pasted to the rock, should be cut. The entire sheet can then be rolled up, or if inconveniently large can be cut in sections and properly marked for future purposes. This process yields the negative. To obtain the positive the inner coating of the negative may be oiled, and the former process renewed upon the cast.

The characters when painted with bright tints and upon a light-colored surface, may readily be traced upon tracing linen, such as is employed by topographers. Should the rock be of a dark color, and the characters indistinct, a simple process is to first follow the charac-

ters in outline with colored crayons, red chalk, or dry colors mixed with water and applied with a brush, after which a piece of muslin is placed over the surface and pressed so as to receive sufficient coloring matter to indicate general form and relative position. After these impressions are touched up, the true position may be obtained by painting the lines upon the back of the sheet of muslin, or by making a true tracing of the negative.

An old mode of securing the outline was to clear out the channels of the intaglios, then, after painting them heavily, to press a sheet of muslin into the freshly painted depressions. The obvious objection to this method is the damage to the inscription. Before such treatment, if the only one practicable, all particulars of the work to be covered by paint should be carefully recorded.

The locality should be reported with detail of State (or territory), county, township, and distance and direction from the nearest post-office, railway station, or country road. In addition the name of any contiguous stream, hill, bluff, or other remarkable natural feature should be given. The name of the owner of the land is of temporary value, as it is liable to frequent changes. The site or station should be particularly described with reference to its natural characteristics and geological history. When petroglyphs are in numbers and groups, their relation to each other to the points of the compass or to topographical features, should be noted, if possible, by an accurate survey, otherwise by numeration and sketching.

The following details should be carefully noted: · The direction of the face of the rock; the presence of probable trails and gaps which may have been used in shortening distances in travel; localities of mounds and caves, if any, in the vicinity; ancient camping grounds, indicated by fragments of pottery, flint chips or other refuse; existence of aboriginal relics, particularly flints which may have been used in pecking (these may be found at the base of the rocks upon which petroglyphs occur); the presence of small mortar-holes which may have served in the preparation of colors.

With reference to pictographs on other objects than rock it is important to report the material upon which they appear and the implements ascertained to be used in their execution examples of which are given in other parts of this work.

With reference to all kinds of pictographs, it should be remembered that mere descriptions without graphic representations are of little value. Probable age and origin and traditions relating to them should be ascertained. Their interpretation by natives of the locality who themselves make pictographs or who belong to people who have lately made pictographs is most valuable, especially in reference to such designs as may be either conventional, religious, or connected with lines of gesture-signs.

LIST OF WORKS AND AUTHORS CITED.

The object of this alphabetical list is to permit convenient reference to authorities without either deforming the pages of the present work by footnotes or cumbering the text with more or less abbreviated indications of editions, volumes, and pages, as well as titles and names, which in some cases would have required many repetitions. The list is by no means intended as a bibliography of the subject, nor even as a statement of the printed and MS. works actually studied and consulted by the present writer in the preparation of his copy. The details and niceties of bibliographic description are not attempted, the titles being abbreviated, except in a few instances where they are believed to be of special interest. The purpose is to include only the works which have been actually quoted or cited in the text, and, indeed, not all of those, as it was deemed unnecessary to transfer to the list some well-known works of which there are no confusing numbers of editions. When a publication is cited in the text but once, sufficient reference is sometimes made at the place of citation. When it would seem that the reference should be more particular the work is mentioned in the text, generally by the name of the author, followed by an italic letter of the alphabet in a parenthesis, which letter is repeated in the same form under the author's name in the alphabetical list followed by mention of the edition from which the citation was taken, the number of the volume when there is more than one volume of that edition, and the page; also a reference, when needed, to the illustration reproduced or described.

Example: When the voluminous official publication of Schoolcraft is first quoted on p. 35, the reference is to p. 351 of his first volume, and the name " Schoolcraft" is followed by (*a*). On turning to that name in the list there appears under it a note of the work and the letter (*a*) is followed by "I, p. 351." The references to this author are so many that all the letters of the alphabet are successively employed—indeed, some of them do duty several times, as several references in the text are to the same page or plate. The references to this single author would therefore have required at least thirty footnotes, or corresponding words in the text, instead of thirty italic letters divided between the several places of citation.

The abbreviation and simplicity of the plan is shown where there are many editions of the work cited. One of the most troublesome for reference of all publications is that of the Travels, etc., of Lewis and Clarke. The letter (*a*) after those names on p. 419, repeated under the same names in the list, refers to p. 66 of the edition specified.

When the italic letter in parenthesis precedes the title of a work in the list, reference is made to that work as a whole without specific quotation. So also when no such italic letter appears. Occasionally the title and imprint of a magazine or other continuous publication appears in the list without note of volume and page. This occurs where the authority is noted elsewhere, generally more than once, with only curt reference to the serial publication, and is intended to avoid repetition.

The simple scheme is designed, while avoiding bibliographic prolixity, to give practical assistance to the reader in finding the authorities cited, when desired. Scientific pretense has sometimes been sacrificed for simplicity and convenience.

LIST.

ADAIR (James).

The History of the American Indians; particularly those Nations adjoining to the Mississippi, East and West Florida, Georgia, South and North Carolina, and Virginia. * * * By James Adair, Esquire, a Trader with the Indians, and Resident in their Country for Forty Years. London; 1775. 4°.

(a) p. 389.

AMERICAN ANTHROPOLOGIST.

The American Anthropologist, published quarterly under the auspices of the Anthropological Society of Washington. Washington, D. C. Vol. I[-vi]. 8°.

(a) II, 1889, No. 4, p. 323. (b) ibid., p. 524.

AMERICAN NATURALIST.

The American Naturalist, a monthly journal devoted to the natural sciences in their widest sense. Philadelphia. Vol. I[-xxvii]. 8°.

AMERICAN PHILOSOPHICAL SOCIETY.

Proceedings of the American Philosophical Society, held at Philadelphia, for promoting useful knowledge. Philadelphia (Penna.). Vol. I[-xxx]. 8°.

(a) XXIX, p. 216.

ANDREE (Dr. Richard).

Das Zeichnen bei den Naturvölkern. Separatabdruck aus den Mittheilungen der Anthropologischen Gesellschaft in Wien. Bd. XVII, der neuen Folge Bd. VII. Wien; 1887. 8°.

(a) p. 6. (b) p. 4. (c) ib. (d) p. 8. (e) p. 5.

Ethnographische Parallelen und Vergleiche, von Richard Andree. Mit 6 Tafeln und 21 Holzschnitten. Stuttgart; 1878. 8°.

(a) p. 260. (b) p. 194.

ANTHROPOLOGICAL INSTITUTE OF GREAT BRITAIN AND IRELAND.

The Journal of the Anthropological Institute of Great Britain and Ireland. London; 1872[-1892]. 8°.

(a) XIX, May, 1890, p. 368. (b) XVI, Feb., 1887, p. 309. (c) I, 1872, p. 334. (d) X, Feb., 1880, p. 104. (e) III, Feb., 1873, p. 131. (f) XVII, Nov., 1887, p. 86.

ANTHROPOLOGICAL SOCIETY OF TŌKYŌ.

See Tōkyō Anthropological Society of.

ANTHROPOLOGIE.

See L'Anthropologie.

ANTHROPOLOGISCHE GESELLSCHAFT IN BERLIN.

See Berliner Gesellschaft für Anthropologie.

ANTHROPOLOGISCHE GESELLSCHAFT IN WIEN.

Mittheilungen der Anthropologischen Gesellschaft in Wien. In Commission bei Alfred Hölder, k. k. Hof- und Universitäts-Buchhändler. Wien; 4°.

(a) XVI, iii. and iv. Heft, 1886, Tafel X.

APPUN (C. F.).

Südamerikanischen, mit Sculpturen bedeckten Felsens. In Verhandlungen der Berliner Gesellschaft für Anthropologie, Ethnologie und Urgeschichte. Berlin; Mai. 1877.

(a) pp. 6 and 7, Pl. XVI.

ARARIPE (Tristão de Alencar).

Cidades Petrificades e Inscripções Lapidares no Brazil. By Tristão de Alencar Araripe In Revista Trim. do Inst. Hist. e Geog. Brazil, Tome L, 2° folheto. Rio de Janeiro; 1887.

(a) p. 275 et seq. (b) p. 291. (c) p. 277.

ARCHAIC ROCK INSCRIPTIONS.

Archaic Rock Inscriptions; an Account of the Cup and Ring Markings on the Sculptured Stones of the Old and New Worlds. * * * A Reader, Orange Street, Red Lion Square, London; 1891. Sm. 8°.

AUSLAND, *Das*

Das Ausland. Wochenschrift für Erd- und Völkerkunde. Herausgegeben von Siegmund Günther. Stuttgart. Verlag der J. G. Cotta'schen Buchhandlung, Nachfolger. 4°.

(*a*) 1884, No. 1, p. 12.

BANCROFT (Hubert Howe).

The Native Races of the Pacific States of North America. By Hubert Howe Bancroft. San Francisco; 1882. Vol. I[–v]. 8°.

(*a*) I, p. 379. (*b*) I, p. 48. (*c*) I, p. 332. (*d*) II, p. 802. (*e*) I, p. 333. (*f*) I, p. 387. (*g*) I, p. 403. (*h*) II, p. 374. (*i*) IV, pp. 40–50.

BANDELIER (A. F.).

Report of an Archæological Tour in Mexico in 1881. By A. F. Bandelier. Papers of the Archæological Institute of America. American Series, II. Boston; 1884. 8°.

(*a*) p. 184.

BARTLETT (John Russell).

Personal Narrative of Explorations and Incidents in Texas, New Mexico, California, Sonora, and Chihuahua, connected with the United States and Mexican Boundary Commission, during the years 1850, '51, '52, and '53. By John Russell Bartlett, United States Commissioner during that period. New York; 1854. 2 vols. 8°.

(*a*) II, pp. 192–206. (*b*) ibid., pp. 170–173.

BASTIAN (A.).

(*b*) Amerika's Nordwest-Küste. Neueste Ergebnisse ethnologischer Reisen. Aus den Sammlungen der königlichen Museen zu Berlin. Herausgegeben von der Direction der ethnologischen Abtheilung. Berlin; 1884. Folio.

Ethnologisches Bilderbuch (mit erklärendem Text), 25 Tafeln. Von Adolf Bastian. Berlin; 1887. Folio.

(*a*) Pl. VI.

BELDEN (G. P.).

Belden, the White Chief, or Twelve Years among the Wild Indians of the Plains. From the diaries and manuscripts of George P. Belden. * * * Edited by Gen. James S. Brisbin, U. S. A. Cincinnati and New York; 1870. 8°.

(*a*) p. 277. (*b*) p. 145. (*c*) p. 144.

BERLINER GESELLSCHAFT FÜR ANTHROPOLOGIE.

Verhandlungen der Berliner Gesellschaft für Anthropologie, Ethnologie und Urgeschichte. Redigirt von Rud. Virchow. Berlin. 8°.

(*a*) No. 20, March, 1886. (*b*) Sitzung 16, November, 1889, p. 655. (*c*) ibid., p. 651. (*d*) March 20, 1886, p. 208.

BERTHELOT (S.).

Notice sur les Caractères Hiéroglyphiques Gravés sur les Roches Volcaniques aux îles Canaries. In Bulletin de la Société de Géographie, rédigé avec le Concours de la Section de Publication par les Secrétaires de la Commission Centrale. Sixième Série, Tome Neuvième, année 1875. Paris; 1875.

(*a*) p. 117 et seq. (*b*) p. 189.

BERTHOUD (*Capt.* E. L.).

(*a*) In Kansas City Review of Science and Industry, VII, 1883, No. 8, pp. 489, 490.

BLOXAM (G. W.).

Aroko, or Symbolic Letters. In Journal Anthrop. Inst. Great Britain and Ireland. 1887.

(*a*) pp. 291 et seq. (*b*) p. 295. (*c*) p. 298.

BOAS (*Dr.* FRANZ).

Report on the Northwestern Tribes of the Dominion of Canada. In Report of the Fifty-ninth Annual Meeting of the British Association for the Advancement of Science. London; 1889.

(*c*) p. 12. (*e*) pp. 852, 853. (*f*) p. 841.

Felsenzeichnung von Vancouver Island. In Verhandlungen der Berliner Gesellschaft für Anthropologie, ausserordentliche Sitzung am 14. Februar 1891.

(*a*) p. 160. Fig. p. 161.

The Houses of the Kwakiutl Indians, British Columbia. In Proceedings of the U. S. National Museum for 1888. Washington. 8°.

(*b*) pp. 197 et seq. (*d*) p. 212, Pl. XL. (*g*) p. 208.

BOBAN (EUGÈNE).

Documents pour servir à l'Histoire du Mexique. Catalogue raisonné de la Collection de M. E.-Eugène Goupil (Ancienne coll. J.-M.-A. Aubin). Manuscrits figuratifs et autres sur papier indigène d'agave Mexicana et sur papier européen antérieurs et postérieurs à la Conquête du Mexique. (XVIᵉ siècle). Avec une introduction de M. E.-Eugène Goupil et une lettre-préface de M. Auguste Génin. Paris; 1891. 2 vols. 4°, and atlas folio.

(*a*) II, p. 273. (*b*) II, pp. 331, 342.

BOCK (CARL).

The Head-Hunters of Borneo: A narrative of travel up the Mahakkam and down the Barrito; also journeyings in Sumatra. By Carl Bock. London; 1881. 8°.

(*a*) p. 67. (*b*) p. 41.

BOLLER (HENRY A.).

Among the Indians. Eight years in the Far West: 1858–1866. Embracing sketches of Montana and Salt Lake. By Henry A. Boller. Philadelphia; 1868. 12°.

(*a*) p. 284.

BOSCAWEN (W. ST. CHAD).

The Prehistoric Civilization of Babylonia. In Journal of the Anthropological Institute of Great Britain and Ireland, Vol. VIII, No. 1; August, 1878.

(*a*) p. 23.

BOSSU (*Capt.*).

Travels through that part of North America formerly called Louisiana. By Mr. Bossu, captain in the French marines. Translated from the French by John Rheinhold Forster. Illustrated with Notes, relative chiefly to Natural History. London; 1771. 2 vols. 8°.

(*a*) I, p. 164.

BOTURINI (BENADUCI).

Idea de una Nueva Historia General de la América Septentrional, fundada sobre material copioso de Figuras, Symbolos, Caracteres y Geroglíficos, Cantares y Manuscritos de Autores Indios, ultimamente descubiertos. Dedicada al Rey Nᵗʳᵒ Señor en su real y supremo consejo de las Indias el Cavallero Lorenzo Boturini Benaduci, Señor de la Torre, y de Pono. Madrid; 1746. 4°.

(*a*) pp. 54–56.

BOURKE (*Capt.* JOHN G.).

The Snake-Dance of the Moquis of Arizona; being a Narrative of a Journey from Santa Fé, New Mexico, to the Villages of the Moqui Indians of Arizona, etc. By John G. Bourke, Captain, Third U. S. Cavalry. New York; 1884. 8°.

(*f*) p. 120.

The Medicine Men of the Apaches. By John G. Bourke, Captain, Third Cavalry, U. S. Army. In the Ninth Annual Report of the Bureau of Ethnology.

(*a*) p. 550 et seq. (*b*) p. 562. (*c*) ib. (*d*) p. 580. (*e*) p. 588. (*f*) ib.

BOVALLIUS (CARL).

Nicaraguan Antiquities. By Carl Bovallius; pub. by Swed. Soc. Anthrop. and Geog. Stockholm; 1886. 8°.

(*a*) Pl. 39.

BOYLE (DAVID).

4th Ann. Rep. Canadian Institute, 1890.

(*a*) p. 23. (*b*) ib.

BRANSFORD (*Dr.* J. F.).

Archæological Researches in Nicaragua. By J. F. Bransford, M. D., Passed Assistant Surgeon, U. S. Navy. [Constitutes No. 383, Smithsonian Contributions to Knowledge.] Washington; 1881.

(*a*) p. 64, fig. 123. (*b*) p. 65.

BRASSEUR DE BOURBOURG (*Abbé* CHARLES ÉTIENNE).

See *Landa*.

BRAZILEIRO, REVISTA TRIMENSAL.

See *Revista Trimensal do Instituto Hist. e Geog. Brazileiro.*

BRINTON (*Prof.* DANIEL G.).

On the "Stone of the Giants." In Report of the Proceedings of the Numismatic and Antiquarian Society of Philadelphia for the years 1887–1889. Philadelphia; 1891.

(*a*) p. 78 et seq. (*c*) ib.

On the Ikonomatic Method of Phonetic Writing, with special reference to American Archæology. Read before the Am. Philosoph. Soc. Oct. 1, 1886.

(*b*) p. 3.

The Names of the Gods in the Kiche Myths, Central America. By Daniel G. Brinton, M. D. Separate and in Proc. Am. Philos. Soc. 8°

(*d*) XIX, p. 613.

(*e*) The Maya Chronicles. Edited by Daniel G. Brinton, M. D. Philadelphia; 1882. 8°. Number 1 of Brinton's Library of Aboriginal American Literature.

(*f*) The Lenape and their Legends, with the complete text and symbols of the Walam Olum. By Daniel G. Brinton, M. D. Philadelphia; 1885. 8°.

(*g*) The Myths of the New World. A treatise on the symbolism and mythology of the red race of America. By D. G. Brinton. New York; 1876. 8°.

BROWN (CHAS. B.).

The Indian Picture Writing in British Guiana. By Charles B. Brown. In Journal of the Anthropological Inst. of Gt. Britain and Ireland.

(*a*) II, 1873, pp. 254–257.

BROWN (EDWARD).

The Pictured Cave of La Crosse Valley, near West Salem, Wisconsin. In Report and Collections of the State Historical Society of Wisconsin for the years 1877, 1878, and 1879, Vol. VIII, Madison; 1879.

(*a*) pp. 174–181, Figs. 2, 5, 9, 14.

BRUXELLES, SOCIÉTÉ D'ANTHROPOLOGIE DE.

See *Société d'Anthropologie de Bruxelles.*

BUCKLAND (*Miss* A. W.).

On Tattooing. In Journal Anthrop. Inst. Gt. Britain and Ireland, XVII, No. 4. May, 1888.

(*a*) p. 318 et seq.

BUREAU OF ETHNOLOGY.

Annual Reports of the Bureau of Ethnology to the Secretary of the Smithsonian Institution. Washington. Roy. 8°. I[-x].

First Annual Report [for 1879-'80]. 1881. Sign Language among North American Indians compared with that among other peoples and deaf mutes. By Garrick Mallery. pp. 263-552.

(*a*) p. 498.

Same Report. A Further Contribution to the Study of the Mortuary Customs of the North American Indians. By Dr. H. C. Yarrow, Act. Asst. Surg. U. S. A. pp. 87-203.

(*a*) p. 195.

Fourth Annual Report [for 1882-'83]. 1886. Pictographs of North American Indians. A Preliminary Paper. By Garrick Mallery. pp. 3-256.

References to other authors in this series appear under their respective names.

CADILLAC (*Capt.* DE LAMOTHE).

(*a*) Collier qui doit être porté à Montréal. In Margry, Part V, pp. 290-291.

(*b*) In Margry, Part V, p. 90.

CANADA, ROYAL SOCIETY OF.

Proceedings and Transactions of the Royal Society of Canada. I[-IX]. Montreal and Toronto. Large 4°.

CANADA, Report of the Deputy Superintendent-General of Indian Affairs of. Ottawa; 1879. 8°.

(*a*) p. 113.

CANADIAN INSTITUTE.

Proceedings of the Canadian Institute of Toronto, being a continuation of the Canadian Journal of Science, Literature, and History. 20 vols. in 3 series, commencing 1852. Toronto. First series 4°, last series 8°.

CARNE (PERRIER DU).

(*a*) In L'Anthropologie, II, 1891, No. 2, p. 269.

CARPENTER (EDWARD).

From Adam's Peak to Elephanta. Sketches in Ceylon and India. By Edward Carpenter. London; 1892. 8°.

(*a*) p. 129.

CARTAILHAC (ÉMILE).

La France préhistorique d'après les sépultures et les monuments. Par Émile Cartailhac. Paris; 1889. 8°.

(*a*) p. 234.

CARVER (*Capt.* JONATHAN).

Travels through the Interior Parts of North America, in the years 1766, 1767, and 1768. By J. Carver, esq., captain of a company of Provincial troops during the late war with France. Illustrated with copper plates. London; 1778. 8°.

(*a*) p. 418. (*b*) ib. (*c*) p. 357.

CATLIN (GEORGE).

Letters and Notes on the Manners, Customs, and Condition of the North American Indians. Fourth edition. London; 1844. 2 vols. 8°.

(*a*) II, p. 98.

CHAMPLAIN (*Le Sieur* SAMUEL DE).

Les voyages de la Novvelle France occidentale, dicte Canada, faits par le Sr de Champlain Xainctongeois, Capitaine pour le Roy en la Marine du Ponant, & toutes les Descouuertes qu'il a faites en ce païs depuis l'an 1603 iusques en l'an 1629. Où se voit comme ce pays a esté premierement descouuert par les François, sous l'authorité de nos Roys tres-Chrestiens, iusques au regne de sa Majesté à present regnante Lovis XIII. Roy de France & de Nauarre. Auec vn traitté des qualitez & conditions requises à vn bon & parfaict Nauigateur pour cognoistre la diuersité des Estimes qui se font en la Nauigation; Les Marques & enseignments que la prouidence de Dieu a mises dans les Mers pour redresser les Mariniers en leur routte, sans lesquelles ils tomberoient en de grands dangers, Et la maniere de bien dresser Cartes marines auec leurs Ports, Rades, Isles, Sondes & autre chose necessaire à la Nauigation. Ensemble vne Carte generalle de la description dudit pays faicte en son Meridien selon la declinaison de la guide Aymant, & vn Catechisme ou Instruction traduicte du François au langage des peuples Sauuages de quelque contree, auec ce qui s'est passé en ladite Nouuelle France en l'année 1631. Paris; 1632. Sm. 4°.

Œuvres de Champlain publiées sous le patronage de l'Université Laval par l'abbé C. H. Laverdière, M. A., professor d'histoire à la faculté des arts et bibliothécaire de l'université; Seconde édition. Québec; 1870. [6 vols. Sm. 4° (the fifth in two parts), paged consecutively at bottom. 2 p. ll., pp. i-lxxvi, 1-1478, 1 l. The pagination of the original edition appears at the top. Vol. v is a reprint in facsimile as to arrangement, of the 1632 edition of Les Voyages].

(*a*) v, 1st pt., p. 159. (*b*) ib. 157. (*c*) III, p. 57. (*d*) v, 2d pt., p. 40. (*e*) III, p. 194. (*f*) II, p. 19.

CHAMPOLLION (JEAN FRANCOIS, *le jeune*).

Grammaire Egyptienne, ou principes généraux de l'écriture sacrée égyptienne appliquées à la représentation de la langue parlée. Publiée sur le manuscrit autographe. Paris; 1836-'41. Sm. folio.

(*a*) p. 113. (*d*) p. 519. (*g*) p. 91. (*h*) p. 57.

Dictionnaire Egyptien, en écriture hiéroglyphique; publié d'après les manuscrits autographes, par M. Champollion-Figeac. Paris; 1842-'44. Folio.

(*b*) p. 429. (*c*) p. 31. (*e*) p. 1. (*f*) p. 3.

CHARENCEY (*Count* HYACINTHE DE).

(*a*) Des Couleurs considérées comme Symboles des points de l'Horizon chez les Peuples. From Actes de la Société Philologique. Tome VI, No. 3, Oct., 1876; Paris; 1877.

Essai sur la symbolique des points de l'horizon dans l'extrême orient. Hyacinthe de Charencey. Caen; 1876. 8°.

CHARLEVOIX (*Père* F. X. DE).

History and General Description of New France. By the Rev. Père François Xavier de Charlevoix. Translated with Notes by John Gilmary Shea. New York; 1866-1872. 2 vols. Imperial 8°.

(*a*) I, p. 266.

CHAVERO (ALFREDO).

La piedra del Sol. Estudio arqueológico por Alfredo Chavero. In Anales del Museo Nacional de México.

(*a*) III, p. 124.

CLEMENT (CLARA ERSKINE).

A Handbook of Legendary and Mythological Art. By Clara Erskine Clement. Boston; 1883. Small 8°.

(*a*) p. 7.

COALE (CHARLES B.).

Life and Adventures of William Waters. By Charles B. Coale. Richmond; 1878. 12°.

(a) p. 136.

COMMISSION SCIENTIFIQUE AU MEXIQUE.

See *Mexique, Mission Scientifique au.*

CONDER (*Maj.* CLAUDE R.)

Hittite Ethnology. In Journal Anthropological Institute of Great Britain and Ireland. XVII, pt. 2, Nov., 1887.

(d) p. 141.

Palestine Exploration Fund. Quarterly Statement for July, 1881. London; 1881.

(a) pp. 214–218. (c) p. 16.

On the Canaanites. In Journal of the Transactions of the Victoria Institute, Vol. XXIV, No. 93. London; 1889, pp. 56–62.

(b) p. 57.

CONGRÈS INTERNATIONAL DES AMÉRICANISTES.

Compte-rendu de la cinquiéme session, Copenhague, 1883. Copenhague, 1884. 8°.

CONTRIBUTIONS TO NORTH AMERICAN ETHNOLOGY.

Vol. I[–VI]. Washington. Government Printing Office; 1877[–1890]. 4°.

(Department of the Interior. U. S. Geographical and Geological Survey of the Rocky Mountain Region. J. W. Powell in charge.)

COOPER (W. R.).

The Serpent Myths of Ancient Egypt. By W. R. Cooper, F. R. S. L. London; 1873. 8°.

(a) p. 24. (b) p. 43.

COPE (*Prof.* E. D.).

Report on the Remains of Population observed in Northwestern New Mexico. By Prof. E. D. Cope. In Report upon United States Geographical Surveys west of the one hundredth meridian, in charge of First Lieut. Geo. M. Wheeler. 7 vols. Washington, 4°.

(a) VII, 1879, p. 358.

COPWAY (G.).

The Traditional History and characteristic sketches of the Ojibway Nation. By G. Copway, or Kah-gi-ga-gah-bowh, chief of the Ojibway Nation. London; 1850. Sm. 8°.

(a) p. 134. (b) p. 136. (c) pp. 135, 136. (d) p. 135. (e) p. 134. (f) p. 135. (g) p. 134. (h) ibid.

CRANE (*Miss* AGNES).

Ancient Mexican Heraldry. By Agnes Crane. In Science, Vol. XX, No. 503.

(a) p. 175.

CRAWFURD (JOHN).

History of the Indian Archipelago. By John Crawfurd * * *. Edinburgh; 1820. 3 vols. 8°.

(a) I, p. 290.

CRONAU (RUDOLF).

Geschichte der Solinger Klingenindustrie. Von Rudolf Cronau. Stuttgart; 1885. Folio.

(b) p. 17. (c) pp. 18, 19.

Im Wilden Westen. Eine Künstlerfahrt durch die Prairien und Felsengebirge der Union. Von Rudolf Cronau. * * * Braunschweig; 1889. 8°.

(a) p. 85.

CUMMING (R. GORDON).

Sporting Adventures in South Africa. By Gordon Cumming. London; 1856. 2 vols. 8°.

(*a*) I, p. 207.

CURR (EDWARD M.).

The Australian Race. By Edward M. Curr. London; 1886. 3 vols. 8°, and folio atlas.

(*a*) I, p. 149 et seq. (*b*) ibid., p. 94. (*c*) III, p. 544. (*d*) I, plate facing p. 145.

CUSHING (FRANK HAMILTON).

Preliminary Notes on the origin, working hypothesis and primary researches of the Hemenway Southwestern Archæological Expedition. In Congrès International des Américanistes. Compte-rendu de la septième session. Berlin; 1890.

(*a*) p. 151.

D'ALBERTIS (L. M.).

New Guinea; What I did and what I saw. By L. M. D'Albertis. Boston; 1881. 2 vols. 8°.

(*a*) II, p. 66. (*b*) ibid., p. 301. (*c*) I, pp. 213, 215, 519. (*d*) I, 262 and 264.

DALL (WILLIAM H.).

On Masks, Labrets and certain aboriginal customs, with an inquiry into the bearing of their geographical distribution. In Third Annual Report of the Bureau of Ethnology, Washington, 1885; pp. 67–202.

(*d*) p. 75. (*e*) p. 111.

Contributions to North American Ethnology, I.

(*a*) p. 79. (*f*) p. 86.

Alaska and its Resources. London; 1870. 8°.

(*a*) p. 142. (*b*) p. 412. (*c*) p. 95.

D'ALVIELLA (*Count* GOBLET).

The Migration of symbols. By the Count Goblet D'Alviella. In Popular Science Monthly; 1890. (Sept. and Oct) (Trans. from Révue des Deux Mondes; Paris; May 1, 1890, p. 121.)

(*a*) pp. 674, 779. (*b*) p. 676. (*c*) p. 677.

DAVIDSON (ALEXANDER) AND **STRUVÉ** (BERNARD).

History of Illinois from 1673 to 1884, by Alexander Davidson and Bernard Struvé. Springfield, Ill.; 1884. 8°.

(*a*) p. 62.

DAVIS (W. W. H.).

The Spanish Conquest of New Mexico. By W. W. H. Davis. Doylestown, Pa.; 1869. 8°.

(*a*) p. 405. (*b*) p. 292.

DAWSON (*Dr.* GEORGE M.).

Notes on the Shuswap people of British Columbia. By George M. Dawson, LL. D., F. R. S., Assistant Director Geological Society of Canada. In Transactions of Royal Soc. of Canada, Section II, 1891.

(*a*) p. 14.

DE CLERCQ (F. S. A.).

Ethnographische Beschrijving van de West- en Noordkust van Nederlandsch Nieuw-Guinea door F. S. A. De Clercq, met medewerking van J. D. E. Schmeltz. Leiden; 1893. 4°.

(*a*) p. 31.

DELLENBAUGH (F. S.).

The Shinumos. A Prehistoric People of the Rocky Mountain Region. By F. S. Dellenbaugh. In Bull. Buffalo Soc. Nat. Sciences; Buffalo, N. Y.; Vol. III, 1875–1877.

(*a*) p. 172.

DE SMET (*Rev.* PETER).
See *Smet* (*Père* Peter *de*).

DE SCHWEINITZ (*Bishop* EDMUND).
The life and times of David Zeisberger, the western pioneer and apostle of the Indians. By Edmund De Schweinitz. Philadelphia; 1870. 8°.
(*a*) p. 160.

DETROIT (SIEGE OF, DIARY OF THE).
Diary of the Siege of Detroit in the War with Pontiac. Albany; 1860. 4°.
(*a*) p. 29.

DIDRON (M.).
Iconographie Chrétienne. Histoire de Dieu. Par M. Didron, de la Bibliothèque Royale, Secrétaire du Comité Historique des Arts et Monuments. Paris; 1843. 4°.
(*a*) p. 338. (*b*) p. 330. (*c*) p. 343. (*d*) p. 145.

DODGE (*Col.* R. I.).
Our Wild Indians; Thirty-three years' personal experience among the Red Men of the Great West. * * * By Colonel Richard Irving Dodge, U. S. Army. Hartford; 1882. 8°.
(*a*) p. 163.

DORMAN (RUSHTON M.).
The Origin of Primitive Superstitions and their development into the worship of spirits and the doctrine of spiritual agency among the aborigines of America. By Rushton M. Dorman. Philadelphia; 1881. 8°.

DORSEY (*Rev.* J. OWEN).
Teton Folk-lore. In American Anthropologist, Vol. II, No. 2. Washington; 1889.
(*a*) p. 144. (*b*) p. 147.

DU CHAILLU (PAUL B.).
The Viking Age. The early history, manners, and customs of the ancestors of the English-speaking nations. By Paul B. Du Chaillu. * * * New York; 1889. 2 vols. 8°.
(*a*) II, p. 116 et seq. (*b*) ibid., p. 133. (*c*) ibid., p. 10.

DUNBAR (JOHN B.).
The Pawnee Indians. Their History and Ethnology. In Magazine of American History. New York and Chicago; 1881.
(*a*) IV, No. 4, p. 259. (*b*) VIII, p. 744.

DUPAIX (M.).
In Kingsborough's Mexican Antiquities. See *Kingsborough*.
(*a*) V, p. 241. Pl. in IV, Pt. 2, No. 44.

DURAN (*Fr.* DIEGO).
Historia de las Indias de Nueva-España y Islas de Tierra Firma. Por El Padre Fray Diego Duran. México; 1867. 4°.

EASTMAN (MARY).
Dahcotah; or, Life and Legends of the Sioux around Fort Snelling. By Mrs. Mary Eastman; with Preface by Mrs. C. M. Kirkland. New York; 1849. 8°.
(*a*) p. 72. (*b*) p. 207. (*c*) p. 262. (*d*) p. xxvi. (*e*) p. xxviii.

EDKINS (*Rev. Dr.* J.).
Introduction to the Study of the Chinese Characters. By J. Edkins, D. D. London; 1876. 8°.
(*a*) p. 26. (*b*) p. 42. (*c*) p. 41. (*d*) Append. A, p. 3. (*e*) p. 20. (*f*) p. 35. (*g*) p. 14. (*h*) p. viii.

EDWARDS (*Mrs.* A. B.).
A Thousand Miles up the Nile. By Mrs. A. B. Edwards. London; 1889. 8°.
(*a*) p. 205.

EELLS (*Rev.* M.).

Twana Indians of the Skokomish Reservation in Washington Terr. In Bull. U. S. Geolog. Survey, Vol. III, pp. 57–114. Washington; 1877. 8°.

EISEN (GUSTAV).

Some Ancient Sculptures from the Pacific Slope of Guatemala. In Mem. of the California Academy of Sciences, Vol. II, No. 2. San Francisco; July, 1888.

(*a*) p. 17.

EMORY (*Lt. Col.* WILLIAM HELMSLEY).

Notes of a Military Reconnoissance from Fort Leavenworth, in Missouri, to San Diego, in California, etc. By Lieut. Col. W. H. Emory, made in 1846–'47. [Thirtieth Congress, first session; Ex. Doc. No. 41.] Washington; 1848. 8°.

(*a*) p. 89. (*b*) p. 63.

ETHERIDGE (R., *jr.*).

The Aboriginal Rock-Carvings at the Head of Bantry Bay. In Records of the Geological Survey of New South Wales, Vol. II, Pt. 1; 1890.

(*a*) p. 26 et seq.

ETHNOLOGY, CONTRIBUTIONS TO NORTH AMERICAN.

See *Contributions to North American Ethnology.*

ETHNOLOGY (BUREAU OF).

See *Bureau of Ethnology.*

EWBANK (THOMAS).

North American Rock-writing and other aboriginal modes of recording and transmitting thought. By Thomas Ewbank, Vice-President of the Ethnological Society. Morrisania, N. Y.; 1866. Pamph., pp. 49.

EXPLORING EXPEDITION (United States).

See *Wilkes* (*Commodore* Charles.

FABER (ERNEST).

Prehistoric China. By Ernest Faber. In Journal of the China Branch of the Royal Asiatic Society, n. s., XXIV.

FEWKES (*Dr.* J. WALTER).

Journ. of Amer can Folk Lore; Oct.–Dec., 1890.

(*a*) p. 10.

Am. Anthrop., v, No. 1, 1892.

(*b*) p. 9.

Journ. Am. Ethnol. and Archæol., II.

(*c*) p. 159.

FLETCHER (*Dr.* ROBERT).

Tattooing among civilized people. In Transactions of the Anthropological Society of Washington, II, p. 411.

FORLONG (*Gen.* J. G. R.).

River of Life, or Sources and Streams of the Faiths of Man in all Lands. * * * By Maj.-Gen. J. G. R. Forlong. London; 1883. 2 vols. 4°.

(*a*) I, p. 509. (*b*) II, p. 434.

FRAZER (*Prof.* PERSIFOR, *jr.*).

The Geology of Lancaster County. In Second Geological Survey of Pennsylvania: Report of Progress in 1877. CCC, Harrisburg; 1880.

(*a*) pp. 92, 94, 95. (*b*) p. 62.

GATSCHET (ALBERT S.).

A Migration Legend of the Creek Indians, with a linguistic, historic, and ethnographic introduction. By Albert S. Gatschet. * * * Philadelphia; 1884. 2 vols. 8°. [Printed in Brinton's Library of Aboriginal American Literature. No. IV.]

GIBBS (*Dr.* GEORGE).

Tribes of Western Washington and Northern Oregon. In Contributions to North American Ethnology, Vol. I, pp. 159–240. Washington; 1877. 4°.

(*a*) p. 222. (*b*) ib.

GILDER (WILLIAM H.).

Schwatka's Search. Sledging in the Arctic in quest of the Franklin records. By William H. Gilder. New York; 1881. 8°.

(*a*) p. 250.

GONGORA Y MARTINEZ (MANUEL DE).

Antiguedades Prehistóricas de Andalucía, monumentos, inscripciones, armas, utensilios y otros importantes objetos pertenecientes á los tiempos mas remotos de su poblacion. Por Don Manuel de Gongora y Martinez. * * * Madrid; 1868. 8°.

(*a*) p. 64.

GREEN (HENRY).

Shakespeare and the Emblem Writers; an exposition of their similarities of thought and expression. Preceded by a view of emblem-literature down to A. D. 1616. By Henry Green, M. A. London; 1870. 8°.

(*a*) pp. 4–12. (*b*) p. 13.

GREGG (JOSIAH).

Commerce of the Prairies, or the Journal of a Santa Fé Trader, during eight expeditions across the Great Western Prairies and a residence of nearly nine years in Northern Mexico. By Josiah Gregg. Second ed. New York; 1845. 2 vols. 12°.

(*a*) II, p. 286.

GUNNISON (*Lieut.* J. W.).

The Mormons, or Latter-Day Saints in the Valley of the Great Salt Lake; a History of the Mormons. By Lieut. J. W. Gunnison of the Topographical Engineers. Philadelphia; 1852. 12°.

(*a*) pp. 62–63.

GÜNTHER (C.).

Die anthropologische Untersuchung der Bella-Coola. In Verhandlungen der Berliner Gesellschaft für Anthropologie, Ethnologie und Urgeschichte. Sitzung vom 20. März 1886. Berlin; 1886.

(*a*) pp. 208, 209.

HAAST (*Dr.* JULIUS VON).

Some Ancient Rock Paintings in New Zealand. Journal Anthropological Institute of Great Britain and Ireland. Vol. VIII. 1878.

(*a*) p. 50 et seq.

HABEL (*Dr.* S.).

The Sculptures of Santa Lucia Cosumal-Whuapa in Guatemala. By S. Habel. Washington; 1879. Constitutes No. 269 of Smithsonian Contributions to Knowledge, 1878, Vol. XXII.

(*a*) pp. 64–66. (*b*) p. 85. (*c*) p. 66. Sculp. No. 1, Pl. I. (*d*) Sculp. No. 4. Pl. II, p. 68. (*e*) pp. 67–68. (*f*) p. 77.

HABERLANDT (M.).

Ueber Schrifttafeln von der Osterinsel. In Mittheilungen der anthropologischen Gesellschaft in Wien. XVI. Band (der neuen Folge VI. Band), III. und IV. Heft. 1886.

HADDON (ALFRED C.).

The Ethnography of the Western Tribe of Torres Straits. In Journal of the Anthropological Institute of Great Britain and Ireland. Vol. XIX, No. 3. 1890.

(*a*) p. 366. (*b*) p. 365. (*c*) ib.

HAKLUYT (RICHARD).

Collection of the Early Voyages, Travels, and Discoveries of the English Nation. A new edition, with additions. London; 1809[-1812]. 5 vols. and supplement. 4°.

(a) III, 1810, p. 372. (b) ib., p. 276. (c) ib., p. 415. (d) ib., p. 369. (e) ib., p. 40. (f) ib., p. 508. (g) ib., p. 615.

HARIOT (THOMAS).

A brief and true report of the new found land of Virginia, of the commodities and of the nature and manners of the naturall inhabitants. * * * By Thomas Hariot. Frankfurti ad Mœnvm. De Bry, anno 1590. Reprinted in facs. by J. Sabin & Sons. New York; 1872. 4°.

(a) Pl. XXIII.

HARTMAN (*Prof.* R.).

(a) p. 6 of the session of May 26, 1877, of the Berliner Gesellschaft für Anthropologie.

HAYWOOD (JOHN).

The Natural and Aboriginal History of Tennessee up to the first Settlements therein by the White People in the year 1768. By John Haywood. Nashville; 1823. 8°.

(a) p. 113. (b) p. 160. (c) p. 169. (d) pp. 322–323. (e) p. 228.

HEATH (*Dr.* E. R.).

The Exploration of the River Beni. In Journal of the American Geographical Society of New York, Vol. XIV. pp. 157–164. New York; 1882.

(a) p. 157. (b) p. 161.

HERNDON (*Lieut.* WM. LEWIS) AND GIBBON (*Lieut.* LARDNER).

Exploration of the Valley of the Amazon, made under direction of the Navy Department. By Wm. Lewis Herndon and Lardner Gibbon, Lieutenants United States Navy. Washington; 1853. 2 vols. 8°. [Ex. Doc. 36, Senate, 32d Cong., 2d Sess.]

(a) I, p. 319. (b) ibid., p. 201.

HERRERA (ANTONIO DE).

The General History of the Vast Continent and Islands of America Commonly call'd the West-Indies, from the First Discovery thereof; with the best Account the People could give of their Antiquities. Collected from the Original Relations sent to the Kings of Spain. By Antonio de Herrera, Historiographer to his Catholic Majesty. Translated into English by Capt. John Stevens. * * * Second edition, London; 1740. 6 vols. 8°.

(a) Decade II, B. 10, Chap. 4.

HIND (HENRY YOULE).

Explorations in the Interior of the Labrador Peninsula, etc. By Henry Youle Hind. London; 1863; 2 vols. 8°.

(a) II, p. 105. (b) I, p. 270.

HOCHSTETTER (*Dr.* FERDINAND VON).

New Zealand, its physical geography, geology and natural history. By Dr. Ferdinand von Hochstetter, Professor at the Polytechnic Inst. of Vienna, etc. Stuttgart; 1867. 8°.

(a) p. 437. (b) p. 423.

HOFFMAN (*Dr.* W. J.)

(a) The Midewiwin or "Grand Medicine Society" of the Ojibwa. In Seventh Annual Report of the Bureau of Ethnology; Washington; 1891; pp. 143–300.

(b) Pictography and Shamanistic Rites of the Ojibwa. In The American Anthropologist; Washington; July, 1888; pp. 209–229.

HOLM (G.).

Ethnologisk Skizze af Angmagsalikerne (Særtryk af Meddelelser om Grønland. X.) Kjøbenhavn; 1887. 8°.

(*a*) p. 101. (*b*) p. 108.

HOLMES (WILLIAM HENRY).

Report on the Ancient Ruins of Southwestern Colorado, examined during the summers of 1875 and 1876. Washington; 1879. [Extract from 10th Ann. Rep. of U. S. Geological Survey, 1879.]

(*a*) pp. 401–405, Pls. XLII and XLIII.

Ancient Art of the Province of Chiriqui, United States of Colombia, by William H. Holmes. Washington; 1888. 8°. In the Sixth Annual Report of the Bureau of Ethnology.

(*b*) p. 21. (*e*) p. 181.

Art in Shell of the Ancient Americans. In Second Ann. Report of the Bureau of Ethnology.

(*c*) p. 253 et seq. (*d*) Pl. LII.

HOLUB (*Dr.* Emil).

On the Central South African Tribes from the South Coast to the Zambesi. In Journal of the Anthropological Institute of Great Britain and Ireland, Vol. X, No. 1. August, 1880.

(*a*) p. 6. (*b*) p. 7.

HOUZÉ (*Dr.* E.) AND **JACQUES** (*Dr.* VICTOR).

Étude d'anthropologie. Les Australiens du Musée du Nord. By Dr. E. Houzé and Dr. Victor Jacques. Bruxelles; 1885. 8°.

(*a*) p. 92.

HOWITT (ALFRED W.).

On Some Australian Ceremonies of Initiation. By A. W. Howitt, F. G. S. London; 1884. 8°.

(*a*) p. 17. (*d*) p. 8. (*f*) p. 2.

Notes on Songs and Song Makers of Some Australian Tribes. By A. W. Howitt, F. G. S. London; 1887. 8°.

(*b*) p. 328.

The Dieri and other kindred Tribes of Central Australia. In Journal of the Anthrop. Inst. of Great Britain and Ireland, Vol. XX, No. 1. 1890.

(*c*) p. 71. (*e*) p. 72. (*g*) ib. (*h*) ib.

HUMBOLDT (ALEXANDER *von*).

Aspects of Nature. By Alexander von Humboldt. London; 1850. 2 vols. 8°.

(*a*) I, pp. 196–201.

IMPERIAL ACADEMY OF SCIENCES.

Scientific papers of the Imperial Academy of Sciences, Vol. III, pt. 5. St. Petersburg; 1855.

IM THURN (EVERARD F.).

Among the Indians of Guiana; being Sketches chiefly Anthropologic from the Interior of British Guiana. London; 1883. 8°.

(*a*) p. 391 et seq. (*b*) p. 410. (*c*) p. 316. (*d*) p. 39. (*e*) p. 319. (*f*) p. 195. (*g*) p. 219. (*h*) p. 196. (*i*) pp. 392, 393, Figs. 25 and 26. (*k*) p. 405.

INDIAN AFFAIRS.

Canada, Report of the Deputy Superintendent-General of. (See *Canada*.)

IRVING (WASHINGTON).

Astoria; or Anecdotes of an enterprise beyond the Rocky Mountains. By Washington Irving. Philadelphia; 1836. 2 vols. 8°.

(*a*) I, p. 226. (*b*) ib., p. 227. (*c*) ib., p. 169.

JACQUES (V.) AND **STORMS** (É.).
　　Notes sur l'Ethnologie de la Partie Orientale de l'Afrique Équatoriale.　By V.
　　Jacques and É. Storms.　In Bull. Soc. d'Anthrop. de Bruxelles.　Tome v.
　　Bruxelles; 1887.

JAGOR (F.).
　　Die Badagas im Nilgiri-Gebirge.　In Verhandlungen der Berliner Gesellschaft
　　für Anthropologie, etc.　Jahrgang 1876.　p. 195.
　　Über die Hieroglyphen der Osterinsel und über Felseinritzungen in Chile.　In
　　Verhandl. der Berliner Gesellsch. für Anthrop., etc.　Jahrgang 1876, pp. 16,
　　17, Figs. 2, 3.
　　　　(a) Verhandl. der Berliner Gesellsch. für Anthrop., etc., Jahrgang 1882, p. 170.

JAMES (*Dr.* EDWIN).
　　See *Tanner* (John).

JAMES' LONG'S EXPEDITION.
　　See *Long* (*Major* Stephen Harriman).

JAPAN.
　　Transactions of the Asiatic Society of Yokohama.　＊　＊　＊　Tōkyō.　8°.

JEMISON (MARY).
　　See *Seaver* (James E.).

JESUIT RELATIONS.
　　Relations des Jésuites; contenant ce qui s'est passé de plus remarquable dans
　　les Missions des pères de la Compagnie de Jésus, dans la Nouvelle France.
　　Québec; 1858; 3 vols.　8°.
　　　　(a) II, 1646, p. 48.

JOHNSTON (H. H.).
　　The River Congo, from its mouth to Bolobo; with a general description of the
　　natural history and anthropology of its western basin.　By H. H. Johnston,
　　F. F. S., F. R. G. S.　＊　＊　＊　Second ed.　London; 1884.　8°.
　　　　(a) p. 420.

JONES (A. D.).
　　Illinois and the West.　By A. D. Jones.　Boston; 1838.　8°.
　　　　(a) p. 59.

JONES (CHARLES C., *jr.*).
　　Antiquities of the Southern Indians, particularly of the Georgia Tribes.　By
　　Charles C. Jones, jr.　New York, 1873.　8°.
　　　　(a) pp. 377–379.　(b) ib.

JONES (*Rev.* PETER).
　　History of the Ojebway Indians.　By Rev. Peter Jones.　London; 1861.　12°.
　　　　(a) p. 121.　(b) p. 94.

JONES (*Capt.* WILLIAM A.).
　　Report upon the Reconnaissance of Northwestern Wyoming.　By William A.
　　Jones, U. S. A.　Washington; 1875.　8°.
　　　　(a) p. 268.　(b) p. 269.　(c) p. 207, fig. 33.

KANE (PAUL).
　　Wanderings of an artist among the Indians of North America.　＊　＊　＊　London;
　　1859.
　　　　(a) p. 393.

KEATING'S LONG'S EXPEDITION.
　　See *Long* (*Major* Stephen Harriman).

KELLER (FRANZ).
　　The Amazon and Madeira Rivers.　Sketches and descriptions from the note-book
　　of an explorer.　By Franz Keller, engineer.　Philadelphia; 1875.　Large 8°.
　　　　(a) p. 65 et seq.　(b) p. 159 et seq.

KENDALL (Edward Augustus).

Travels through the northern parts of the United States, in the years 1807 and 1808. By Edward Augustus Kendall, Esq. New York; 1809. 3 vols. 8°.

KINGSBOROUGH (Edward King, Lord).

Antiquities of Mexico: Containing fac-similes of Ancient Mexican Paintings and Hieroglyphics * * * together with the Monuments of New Spain, by M. Dupaix. London; 1831–'48. 9 vols. Imp. folio.

(*a*) Vol. VI, Codex Telleriano Remensis, p. 150 (vol. I, Codex T. R., pt. 4, Pl. 33). (*b*) VI, Codex T. R., p. 135 (vol. I, Codex T. R., pt. 4, Pl. 4). (*c*) VI, Codex T. R., p. 141 (I, Codex T. R., pt. 4, Pl. 19). (*d*) VI, Codex T. R., p. 148 (I, Codex T. R., pt. 4, Pl. 29). (*e*) VI, Codex T. R., p. 150 (I, Codex T. R., pt. 4, Pl. 32). (*f*) VI, Coll. Mendoza, p. 74 (I, Coll. Mendoza, Pl. 67). (*g*) VI, Codex T. R., p. 136 (I, Codex T. R., pt. 4, Pl. 7). (*h*) VI, Codex T. R., p. 141 (I, Codex T. R., pt. 4, Pl. 20). (*i*) VI, Coll. Mend., p. 86 (I, Coll. Mend., Pl. 71, Fig. 30). (*k*) VI, Codex Vaticanus, p. 222 (II, Codex Vat., Pl. 75). (*l*) VI, Codex T. R., p. 136 (I, Codex T. R., pt. 4, Pl. 7). (*m*) VI, Coll. Mend., p. 69 (I, Coll. Mend., Pl. 64, Fig. 5). (*n*) (II, Codex Vat., Pl. 100.) (*o*) VI, Codex T. R., p. 142 (I, Codex T. R., pt. 4, Pl. 22). (*p*) VI, Coll. Mend., p. 71 (I Coll. Mend., Pl. 75).

In the above citations the double references, one in and one not in parentheses, are necessary because the text and the copies of paintings are in different volumes. The above references not in parentheses refer to the text alone. The several parts of the volumes containing the plates are mentioned because the pagination of those volumes is not continuous.

KOHL (J. G.).

Kitchi-Gami. Wanderings round Lake Superior. By J. G. Kohl. London; 1860. 8°.

(*a*) p. 18.

LACOUPERIE (*Prof. Dr.* Terrien de).

Beginnings of Writing in and around Thibet. In Journ. Royal Asiatic Society. New series, Vol. XVII, Pt. III. London; 1885.

(*a*) p. 442 et seq. (*b*) ib. (*c*) p. 443. (*d*) p. 424. (*e*) p. 428. (*f*) p. 459.

LAFITAU (*Père* Joseph François).

Mœurs des Sauvages Amériquaines, Comparées aux Mœurs des Premiers Temps. By le Père Lafitau. Paris; 1724. 2 vols. 4°.

(*a*) II, p. 261. (*b*) II, p. 43. (*c*) ib. (*d*) ib., p. 266.

LAHONTAN (*Baron*).

New Voyages to North America. Containing an Account of the Several Nations of that vast continent, etc. By the Baron Lahontan, Lord Lieutenant of the French Colony at Placentia in Newfoundland. * * * London; 1703. 2 vols. 8°.

(*a*) II, p. 82. (*b*) ib., p. 84. (*c*) ib., p. 246. (*d*) ib., p. 225.

LAMOTHE. See *Cadillac*.

LANDA (Diego de).

Relation des Choses de Yucatan de Diego de Landa; Texte Espagnol et Traduction Française en regard, comprenant les Signes du Calendrier et de l'Alphabet Hiéroglyphique de la Langue Maya, accompagné de documents divers historiques et chronologiques, avec une Grammaire et un Vocabulaire Abrégés Français-Maya, précédés d'un essai sur les sources de l'histoire primitive du Mexique et de l'Amérique Centrale, etc., d'après les monuments Égyptiens et de l'Histoire primitive de l'Égypte d'après les monuments Américains. Par l'Abbé Brasseur de Bourbourg, Ancien Administrateur ecclésiastique des Indians de Rabinal (Guatémala), Membre de la Commission scientifique du Mexique, etc. Paris and Madrid; 1864. 8°.

(*a*) p. 316. (*b*) ib.

LANDRIN (ARMAND).

(*a*) Écriture figurative et Comptabilité en Bretagne; par Armand Landrin, Conservateur du Musée d'Ethn. In Revue d'Ethnographie. Tome premier, No. 5, Sept.–Oct. Paris; 1882.

LANGEN (A.).

Key-Inseln und die dortigen Geistergrotten. In Verhandlungen der Berliner Gesellschaft für Anthropologie, Ethnologie und Urgeschichte. Sitzung vom 17. October 1885. 1885.

(*a*) pp. 407–409. Taf. XI.

L'ANTHROPOLOGIE.

L'Anthropologie. Paraissant tous les deux mois sous la direction de MM. Cartailhac, Hamy, Topinard. * * * Paris; 1890. 8°. [The present journal is a consolidation of "Matériaux pour l'histoire de l'homme," "Revue d'Anthropologie," and "Revue d'Ethnographie."]

(*a*) II, No. 6, p. 693. (*b*) I, No. 5, p. 566. (*c*) II, No. 2, 1891, p. 150. (*d*) II, No. 2, Mar.–Avr. 1891, p. 148.

LA PLATA. See *Museo de la Plata.*

LAUDONNIÈRE (*Capt.* RÉNÉ).

The Second voyage into Florida made and written by Captain Laudonnière, which fortified and inhabited there two summers and one whole winter. In Hakluyt's Collection of the Early Voyages, Travels, and Discoveries of the English nation, q. v.

(*a*) III, pp. 384–419.

LAWSON (A. C.).

Ancient Rock Inscriptions on the Lake of the Woods. In The American Naturalist, Vol. XIX, Philadelphia, 1885. pp. 654–657.

(*a*) Pl. XIX and Fig. 1.

LAWSON (JOHN).

The History of Carolina, containing the exact Description and Natural History of that country, together with the Present State thereof and a Journal of a Thousand miles traveled through several Nations of Indians. Giving a particular Account of their Customs, Manners, etc. By John Lawson, Gent., Surveyor-General of North Carolina. London; 1714. 12°.

(*a*) p. 190.

LE CLERCQ (*Père* CHRÉTIEN).

Nouvelle Relation de la Gaspesie, qui contient les Mœurs & la Religion des Sauvages Gaspesiens Porte-Croix, adorateurs du Soleil, & d'autres Peuples de l'Amérique Septentrionale, dite le Canada. Dediée à Madame la Princesse d'Epinoy. Par le Père Chrétien Le Clercq, Missionnaire Recollet de la Province de Saint Antoine de Pade en Artois, & Guardian du Convent de Lens. Paris; 1691. 16°.

(*a*) p. 139.

LELAND (CHARLES G.).

The Algonquin Legends of New England. * * * By Charles G. Leland. Boston; 1884. 8°.

(*a*) p. 40. (*b*) p. 44.

LEMLY (*Lieut.* H. R.).

Who was El Dorado? By Lieut. H. R. Lemly, U. S. Army. In Century Magazine for October, 1891.

(*a*) p. 889.

LE PAGE DU PRATZ.

Histoire de la Louisiane. Contenant la Découverte de ce vaste Pays. Par M. Le Page du Pratz. Paris; 1758. 3 vols. 12°.

(*a*) II, p. 432. (*b*) III, p. 241.

LE PLONGEON (*Dr.* AUGUSTUS).

Vestiges of the Mayas; or, Facts tending to prove that communications and intimate relations must have existed in very remote times between the inhabitants of Mayab and those of Asia and Africa. By Augustus Le Plongeon, M. D. New York; 1881. 8°.

(*a*) p. 29.

LEWIS (*Capt.* MERIWETHER) AND **CLARKE** (*Capt.*).

Travels to the source of the Missouri River, etc., and across the American Continent to the Pacific Ocean, * * * in the years 1804, 1805, and 1806. By Captains Lewis and Clarke. Published from the Official Report. * * * London; 1814. 8°.

(*a*) p. 66. (*b*) p. 375. (*c*) p. 379.

LEWIS (T. H.).

Incised Bowlders in the upper Minnesota Valley. In The American Naturalist for July, 1887.

(*a*) p. 642. (*b*) p. 639 et seq. (*c*) ib.

(*d*) Sculptured Rock at Trempeleau, Wisconsin. By T. H. Lewis. In The American Naturalist for September, 1889, pp. 782, 783.

LONG (JOHN).

Voyages and Travels of an Indian Interpreter and Trader, Describing the Manners and Customs of the North American Indians; with an Account of the Posts situated on the river St. Lawrence, Lake Ontario, etc. To which is added, A Vocabulary of the Chippeway Language. * * * By J. Long, London; 1791. 4°.

(*a*) p. 47.

LONG (*Maj.* STEPHEN HARRIMAN).

Account of an expedition from Pittsburgh to the Rocky Mountains in 1819 and 1829, under command of Major Stephen H. Long. Compiled by Edwin James. Phila.; 1823. 2 vols. 8°. [Commonly known as James' Long's Expedition].

(*b*) I, p. 478. (*c*) ib., p. 287. (*d*) ib., p. 207. (*f*) ib., p. 125. (*h*) ib., p. 296. (*i*) ib., p. 208. (*k*) ib., p. 240.

Narrative of an expedition to the source of St. Peter's River, etc., performed in the year 1823 under the command of Stephen H. Long, Major U. S. T. E. Compiled by William H. Keating. Phila.; 1824. 2 vols. 8°. [Commonly called Keating's Long's Expedition.]

(*a*) I, p. 217. (*e*) ib., p. 334. (*g*) ib., p. 226.

LOSSING (BENSON J.).

The American Revolution and the war of 1812; or, Illustrations by pen and pencil of the History, Biography, Scenery, Relics, and Traditions of our wars with Great Britain. By Benson J. Lossing. New York Book Concern; 1875. 3 vols. Large 8°.

(*b*) III, p. 55.

The Pictorial Field-Book of the War of 1812. * * * By Benson J. Lossing. New York; 1868.

(*a*) p. 191, footnote.

LUBBOCK (*Sir* JOHN).

Prehistoric Times as illustrated by ancient remains and the manners and customs of modern savages. By Sir John Lubbock, Bart., M. P., etc. London; 1878. 8°.

(*a*) p. 11.

LYND (JAMES W.).

The Religion of the Dakotas. In Collections of the Minnesota Historical Society. St. Paul; 1860. 3 vols. 8°.

(*a*) II, pt. 2, pp. 79, 80. (*b*) ib., pp. 59, 60. (*c*) ib., p. 68. (*d*) ib., p. 80.

MACKENZIE (*Sir* ALEXANDER).
Voyages from Montreal on the River St. Lawrence, through the Continent of North America, to the Frozen and Pacific Oceans; in the years 1789 and 1793. * * * By Sir Alexander Mackenzie. Philadelphia; 1802. 8°.
(*a*) p. 236. (*b*) p. 33. (*c*) p. 173.

MADISON (*Rt. Rev.* JAMES).
On the supposed fortifications of the western country. In Transactions of the American Philosophical Society, VI, pt. 1, 1804.
(*a*) pp. 141, 142.

MAGNAT (CASIMIR).
Traité du Langage Symbolique, emblématique et religieux des Fleurs. Par Casimir Magnat. Paris; 1855. 8°.

MAINE HISTORICAL SOCIETY.
Collections of the Maine Historical Society. * * * Portland [and Bath;] 1831[-1876]. 7 vols. 8°.
(*a*) VII, p. 393.

MALLERY (*Col.* GARRICK).
See *Bureau of Ethnology*.

MARCANO (*Dr.* G.).
Ethnographie Précolombienne du Vénézuéla. Région des Raudals de l'Orénoque. In Mémoires de la Société d'Anthropologie de Paris; 2e Série, Tome Quatrième, Deuxième Fascicule. Paris; 1890. pp. 99–218.
(*a*) p. 197. (*b*) p. 203. (*c*) p. 199. (*d*) p. 210. Pl. XXX, Fig. 25. (*e*) p. 200. (*f*) p. 210.

MARCOY (PAUL).
Travels in South America. By Paul Marcoy. New York; 1875. 2 vols. 8°.
(*a*) II, p. 353. (*b*) *ib.*

MARGRY (PIERRE).
Découvertes et établissements des Français dans l'ouest et dans le sud de l'Amérique septentrionale (1614–1754). Mémoires et documents originaux recuillis et publiés par Pierre Margry. Paris; 1875–1886. 6 vols. 8°.
(*a*) VI, p. 518. (*b*) IV, p. 172. (*c*) III, p. 363. (*d*) I, p. 159. (*e*) II, p. 325. (*f*) V, p. 454. (*g*) I, p. 264.

MARSHALL (FREDERIC).
Curiosities of Ceremonies. By Frederic Marshall. London; 1880. 8°.
(*a*) p. 190. (*b*) p. 65.

MARSHALL (*Lieut.-Col.* WILLIAM E.).
Travels amongst the Todas, or the Study of a Primitive Tribe in South India. By William E. Marshall, Lieutenant-Colonel of her Majesty's Bengal Staff Corps. London; 1873. 8°.
(*a*) p. 109. (*b*) p. 65.

MARTYR (PETER).
The History of the West Indies, * * * By Peter Martyr. Benzoni's trans. Basel; 1582.
(*a*) Lib. I, Chap. XXVI. (*b*) II, p. cccx.
Histori von der Franzosen Zug in die Landschafft Floridam.
(*c*) Cap. III, Die Neue Welt, Basel; 1583.

MASON (*Prof.* OTIS T.).
Basket-work of the North American aborigines. In Report of the Smithsonian Institution, for 1884. Washington; 1885. Pt. II, pp. 591–306.
(*a*) p. 296.

MATÉRIAUX pour l'Histoire primitive et naturelle de l'Homme. Revue Mensuelle Illustrée dirigée par M. Émile Castailhac. Toulouse et Paris. 8°

MATTHEWS (*Dr.* WASHINGTON, U. S. A.).

The Mountain Chant. A Navajo ceremony. By Dr. Washington Matthews, U. S. A. In the Fifth Annual Report of the Bureau of Ethnology. pp. 379–467.

MAURAULT (*Abbé* J. A.).

Histoire des Abenaquis depuis 1605 jusqu'à nos jours. Par l'Abbé J. A. Maurault. Quebec. Gazette de Sorel; 1866. 8°.

(*a*) p. 138.

MAXIMILIAN (PRINCE OF WIED).

See *Wied-Neuwied* (Maximilian, Prince of).

McADAMS (WM.).

Records of Ancient Races in the Mississippi Valley; being an account of some of the pictographs, sculptured hieroglyphics, symbolic devices, emblems, and traditions of the prehistoric races of America, with some suggestions as to their origin. * * * By Wm. McAdams. St. Louis; 1887. 8°.

McGUIRE (JOSEPH D.). Materials, Apparatus, and Processes of the Aboriginal Lapidary. By Joseph D. McGuire. In The American Anthropologist, April, 1892, Vol. v, No. 2.

(*a*) p. 165.

McKENNEY (THOMAS L.).

Sketches of a Tour to the Lakes; of the Character and Customs of the Chippeway Indians; and of the Incidents connected with the Treaty of Fond du Lac. By Thomas L. McKenney, of the Indian Department. * * * Baltimore; 1827. 8°.

(*a*) p. 293.

McLEAN (*Rev.* JOHN).

(*a*) The Blackfoot Sun Dance. By Rev. John McLean. Toronto; 1889. 8°.

MEMOIRES DE LA SOCIETE D'ANTHROPOLOGIE DE PARIS.

See *Paris* (Mémoires de la Société d'Anthropologie de).

MEXICO (ANALES DEL MUSEO NACIONAL DE).

Anales del museo nacional de México. Mexico. Vol. i [–v] 1887 ? 4°.

MEXICO (DOCUMENTOS PARA LA HISTORIA DE).

Memorias para la Historia Natural de California; escritas por un religioso de la Provincia del Santo Evangelio de México. In Documentos para la Hist. de México; Tomo v, p. 220. Mexico; 1857. 80.

(*a*) p. 254.

MEXIQUE (MISSION SCIENTIFIQUE AU.)

Mission Scientifique au Mexique et dans l'Amérique Centrale. Publiée par ordre du Ministre de l'Instruction Publique [France]. Paris and Madrid; 1864. Folio.

MILNE (*Prof.* JOHN).

Notes on stone implements from Utaru and Hakodate, with a few general remarks on the prehistoric remains of Japan. In Trans. of the Asiatic Society, Japan; VIII, Pt. I.

(*a*) p. 64.

MINING AND SCIENTIFIC PRESS. San Francisco, Cal.

(*a*) Nov. 29, 1880. p. 247.

MONTAGU (*Lady* MARY WORTLEY).

The Letters and Works of Lady Mary Wortley Montagu; edited by Lord Wharncliffe. London; 1837. 3 vols. 8°.

(*a*) II, p. 31.

MORE (JAMES F.).

The History of Queen's County, N. S. By James F. More, Esq. Halifax; 1873. 8°.

(*a*) p. 213.

MORENO (F. P.).

Esploracion Arqueologica de la Provincia de Catamarca. Estracto del informe anual correspondiente, Museo de la Plata, á 1890-'91. q. v.

(a) p. 8.

MORSE (*Prof.* Edward S.).

Some recent Publications on Japanese Archeology. In the American Naturalist, September, 1880.

(a) p. 658.

MORTILLET (Gabriel *de*).

Le Signe de la Croix avant le Christianisme. By Gabriel de Mortillet. Paris; 1866. 8°.

(a) p. 173.

MÜLLER (F. Max).

Lectures on the Origin and Growth of Religion. London and New York; 1879. 8°. Hibbert Lectures for 1878.

MURDOCH (John).

Ethnological Results of the Point Barrow Expedition. In Ninth Annual Report of the Bureau of Ethnology.

(a) p. 390. (b) p. 138.

MUSEO DE LA PLATA.

Revista del Museo de la Plata. Dirijida por Francisco P. Moreno, Fundador y Director del Museo. Tomo I. La Plata. Talleres de publicaciones del Museo. 1890-'91. Large 8°.

NATIONAL MUSEUM (Proceedings of).

Proceedings of the United States National Museum. Vols. 1[-13], 1875[-1890]. Washington. 8°.

NATIONAL MUSEUM (Reports of).

Report of the National Museum under the direction of the Smithsonian Institution. With Ann. Reports Smithsonian Institution, 1881, pub. 1883 [-1889, pub. 1891]. Washington. 8°.

NEBEL (*Don* Carlos).

Viaje Pintoresco y Arqueolojico sobre la parte mas interesante de la República Mejicana, en los años transcurridos desde 1829 hasta 1834. Por el arquitecto Don Carlos Nebel. Paris y Mejico; 1840. Fol.

NETTO (*Dr.* Ladisláu).

Investigações sobre a Archeologia Brazileira. In Archivos do Museu Nacional do Rio de Janeiro; Vol. VI, 1°, 2°, 3°, e 4° Trimestres, Correspondente a 1881, Consagrado a Exposição Anthropologica Brazileira, realisada no Museu Nacional a 29 de Julho de 1882. Rio de Janeiro; 1885. 4°.

(a) p. 551. (b) p. 552. Pl. XIII. (c) p. 551. (d) p. 306.

NEW YORK (The Documentary History of the State of).

See *O'Callahan* (E. B.).

NEW YORK (Documents relating to the Colonial History of the State of).

Albany; irregularly issued; 1853 to 1883. 14 vols. 8°.

(a) IX, pp. 46 and 385. (b) XII, p. 49, and XIII, p. 398.

NIBLACK (*Ensign* Albert P., *U. S. N.*).

The Coast Indians of Southern Alaska and Northern British Columbia. By Albert P. Niblack, Ensign, U. S. Navy. In Report of the U. S. Nat. Museum, 1887-'88, pp. 225-386. Washington; 1890. Pll. I-LXX.

(a) p. 321. (b) p. 272. (c) p. 278. (d) p. 324. (e) Pl. LV.

NORDENSKJÖLD (ADOLF ERICK).

Vega-Expeditionens Vetenskapliga Iakttagelser. By A. E. Nordenskjöld. Stockholm; 1882–87. 5 vols. 8°.

Contains:

Nordqvist (Oscar). Bidrag till Kännedomen om Tschuktscherna.

NORDQVIST (OSCAR).

Bidrag till Kännedomen om Tschuktscherna. In Nordenskjöld (Adolf Erick). Vega-Expeditionens Vetenskapliga Iakttagelser.

(*a*) II, p. 241.

NORTHWEST COAST OF AMERICA (THE).

Being results of recent ethnological researches from the Collections of the Royal Museums at Berlin; published by the Directors of the Ethnological department. Translated from the German. New York; 1884. Fol.

(*a*) Pl. 7, Fig. 3.

O'CALLAGHAN (*Dr*. E. B.).

The Documentary History of the State of New York; arranged under the direction of the Hon. Christopher Morgan, Secretary of State. By E. B. O'Callaghan, M. D. Albany; 1849. 4 vols. 8°.

(*a*) I, 1849, pp. 4, 5. (*b*) ibid., p. 7. (*c*) ib., p. 5. (*d*) ib., p. 78.

OHIO STATE BOARD OF CENTENNIAL MANAGERS.

Final Report of the Ohio State Board of Centennial Managers to the General Assembly of the State of Ohio. Columbus; 1877. 8°.

PACIFIC RAILROAD EXPEDITION.

See *Whipple* (Lieut. A. W.).

PARIS (MÉMOIRES DE LA SOCIÉTÉ D'ANTHROPOLOGIE DE).

Paris; 1873–1892. Publié par la Société d'Anthropologie. 7 vols. in two series. Large 8°.

Bulletins de la Société d'Anthropologie de Paris. Paris. 8°. Publiés par fascicules trimestriels.

PARKMAN (*Dr*. FRANCIS).

The Conspiracy of Pontiac and the Indian war after the conquest of Canada. By Francis Parkman. Boston; 1883. 2 vols. 8°.

(*a*) II, p. 265.

La Salle and the Discovery of the Great West. By Francis Parkman. Twelfth edition. Boston; 1883. 8°.

(*a*) p. 59.

PATTIE (JAMES O.).

The personal narrative of James O. Pattie, of Kentucky, during an expedition from St. Louis through the vast regions between that place and the Pacific Ocean, and thence back through the City of Mexico to Vera Cruz, during journeyings of six years; in which he and his father, who accompanied him, suffered unheard-of hardships and dangers; had various conflicts with the Indians, and were made captives, in which captivity his father died. * * * Cincinnati; 1833. 12°.

(*a*) pp. 15 and 22.

PEET (*Rev*. S. D.).

(*a*) The Emblematic Mounds of Wisconsin; Animal effigies, their shapes and attitudes. [A paper read before the American Association for the Adv. of Science.] In Am. Antiquarian. Chicago; 1884. 8°.

PEIXOTO (ROCHA).

A tatuagem em Portugal. Por Rocha Peixoto. In Revista de Sciencias Naturales e Sociaes, Vol. II, No. 708. Porto; 1892. 8°.

PERROT (*Père* NICOLAS).

Mémoire sur les Mœurs, Coutumes et Religion des Sauvages de l'Amérique Septentrionale. Par Nicolas Perrot; publié pour la première fois par le R. P. J. Tailhau de la Compagnie de Jésus. Leipsig and Paris; 1864. [Bibliotheca Americana, Collection d'ouvrages inédits ou rares sur l'Amérique.]

(*a*) p. 172.

PESCHEL (OSCAR).

The Races of Man and their Geographical Distribution. Translated from the German of Oscar Peschel. New York; 1876. 8°.

(*a*) p. 175.

PHILLIPS (HENRY, *jr.*).

(*a*) History of the Mexicans as told by their Paintings. In Proc. Amer. Philos. Soc , XXI, p. 616.

PIKE (*Maj.* Z. M.).

An Account of Expeditions to the Sources of the Mississippi and through the Western Parts of Louisiana to the Sources of the Arkansaw, Kans, La Platte and Pierre Jaun Rivers. By Maj. Z. M. Pike. Philadelphia; 1810. 8°.

(*a*) App. to Pt. I, p. 22.

PINART (ALPHONSE L.).

Note sur les Pétroglyphes et Antiquités des Grandes et Petites Antilles. Par A. L. Pinart. Paris; 1890. Folio. Fac-simile of MS.

(*a*) p. 3 et seq.

Aperçu sur l'Ile d'Aruba, ses Habitants, ses Antiquités, ses Pétroglyphes. Par A. L. Pinart. Paris; 1890. Folio. Fac-simile of MS.

(*b*) p. 1 et seq.

PIPART (*Abbé* JULES).

Éléments Phonétiques dans les Écritures figuratives des Anciens Mexicains. In Compte Rendu du Cong. Inter. des Américanistes, 2^me Session; Paris; 1878. Vol. II.

(*a*) p. 551. (*b*) p. 349. (*c*) p. 359.

PLENDERLEATH (*Rev.* W. C.).

The White Horses of the West of England, with notices of some other ancient Turf-monuments. By the Rev. W. C. Plenderleath, M. A., Rector of Cherhill, Wilts. London; (no year). 12°.

(*a*) pp. 5–35. (*b*) pp. 7–17. (*c*) pp. 33–34. (*d*) pp. 35–36.

POPOFF (M. LAZAR).

The origin of painting. In Popular Science Monthly, Vol. XL, No. 1, Nov., 1891. [Translated for the Popular Science Monthly from the Revue Scientifique.]

(*a*) p. 103.

POPULAR SCIENCE MONTHLY.

The Popular Science Monthly. Edited by W. J. Youmans, Vols. 1 [XLIII]. New York. 8°.

PORTER (EDWARD G.).

The Aborigines of Australia. In Proceedings of the American Antiquarian Society. New series, Vol. VI, pt. 3. Worcester; 1890.

(*a*) p. 320.

POTANIN (G. N.).

Sketches of North Western Mongolia. In Ethnologic Material, No. 4. St. Petersburg; 1883. 8°.

(*a*) Pl. I. (*b*) Pls. IV to XI.

POTHERIE (Bacqueville de la).

(a) Histoire de l'Amérique Septentrionale Divisée en Quatre Tomes. Tome Premier, contenant le Voyage du Fort de Nelson, dans la Baye d'Hudson, à l'Extrémité de l'Amérique. Par M. de Bacqueville de la Potherie, né à la Guadeloupe, dans l'Amérique Méridionale, Aide Major de la dite Isle. Paris; 1753. 4 vols. 16°.

(b) III, p. 43. (c) IV, p. 174. (d) I, p. 129. (e)ib., p. 128.

POWELL (Maj. J. W.).

(a) Outlines of the Philosophy of the North American Indians. By J. W. Powell. N. Y. 1877. 8°.

POWELL (Dr. J. W.).

Report on British Columbia. In Rep. of the Deputy Superintendent-General of Indian Affairs [Canada] for 1879. Ottawa. 8°.

POWERS (Stephen).

Tribes of California. By Stephen Powers. In Contributions to North American Ethnology, Vol. III. Washington; 1877.

(a) p. 244. (b) p. 321. (c) p. 20. (d) p. 166.

Northern Californian Indians. In Overland Monthly, San Francisco. Vol. VIII, 1872, and Vol. XII, 1874.

PRATZ (Le Page du).

See Le Page du Pratz.

PUTNAM (A. W.).

History of Middle Tennessee; or Life and Times of Gen. James Robertson. By A. W. Putnam. Nashville; 1859. 8°.

(a) p. 321.

PUTNAM (Prof. F. W.).

The Serpent Mound of Ohio. In The Century Illus. Monthly Magazine, April, 1890. New York. 8°.

(a) p. 871.

RAFN (Charles Christian).

Antiquitates Americanæ. Edidit Societas Regia Antiquariorum Septentrionalium. Studio et opera Charles Christian Rafn. Copenhagen; 1845. Folio.

(a) p. 359. (b) p. 360. (c) p. 397. (d) p. 401. (e) p. 357.

RAND·(Rev. Silas).

A First Reading Book in the Micmac Language; comprising the Micmac numerals and the names of the different kinds of beasts, birds, fishes, trees, etc., of the maritime Provinces of Canada. Also some of the Indian names of places and many familiar words and phrases, translated literally into English. By Rev. Silas Rand. Halifax; 1875. 12°.

(a) p. 91.

RAU (Dr. Charles).

Observations on Cup-shaped and other Lapidarian Sculptures in the Old World and in America. By Charles Rau. In Contributions to North American Ethnology. Vol. V. Washington; 1882; pp. 1–112. Figs. 1–161. 4°.

(a) p. 60. (b) p. 65. (c) p. 64. (d) p. 9.

REBER (Dr. Franz von).

History of Ancient Art. By Dr. Franz von Reber. Translated and augmented by Joseph Thacher Clarke. New York; 1882. 8°.

RECLUS (Élisée).

The Earth and its Inhabitants. By Élisée Reclus. Edited by A. H. Keane, B. A. New York; 1890. Large 8°.

(a) Oceanica, p. 476. (b) ib. p. 134. (c) ib. p. 304.

REISS (W.) AND **STUBEL** (A.).

Necropolis of Ancon in Peru. By W. Reiss and A. Stubel. London and Berlin. 1880–1887. Large folio.

 (a) Pls. 33 and 33a.

RENAN (ERNEST).

History of the People of Israel till the time of King David. By Ernest Renan. Boston; 1889. 8°.

 (a) p. 19.

RENOUF (P. LE PAGE).

An Elementary Grammar of the Ancient Egyptian Language, in the hieroglyphic type. By P. Le Page Renouf, one of Her Majesty's Inspectors of Schools. London and Paris; date of dedication, 1875. [No publication date.]

 (a) p. 2.

REVISTA TRIMENSAL do Instituto Historico e Geographico Braziliero.

Fundado no Rio de Janeiro. Debaixo da immediata protecção de S. M. I. O. Sr. D. Pedro II. Vols. 1 [–L]. Rio de Janeiro. 8°.

REVUE D'ETHNOGRAPHIE.

Lately incorporated with two other serials and published under the title of L'Anthropologie, q. v.

 (a) v, No. 2; 1886.

REVUE GÉOGRAPHIQUE INTERNATIONALE.

Journal mensuel illustré des sciences géographiques. Paris; 1884; 9e année.

Editorial notice of report made to the Société de Géographie de Tours, by General Colonieu.

 (a) No. 110, p. 197.

RIVERO (MARIANO EDWARD) AND VON **TSCHUDI** (JOHN JAMES).

Peruvian Antiquities. By Mariano Edward Rivero, * * * and John James von Tschudi. Translated into English, from the original Spanish, by Francis L. Hawkes, D. D. LL. D. New York and Cincinnati; 1855. 8°.

 (a) pp. 105–109.

RIVETT-CARNAC (J. H.).

Archæological Notes on Ancient Sculpturings on Rocks in Kumaon, India, similar to those found on monoliths and rocks in Europe. By J. H. Rivett-Carnac, Esq., Bengal Civil Service. * * * Reprinted from the Journal of the Asiatic Society of Bengal. Calcutta; 1883.

 (a) p. 1. (b) p. 15.

ROCK INSCRIPTIONS.

See *Archaic Rock Inscriptions.*

ROEDIGER (FRITZ).

Prehistoric Sign Stones, as boundary stones, milestones, finger posts. and maps. In Verhandl. der Berlin. Gesellschaft für Anthrop.; 1890.

 (a) p. 526.

ROGERS (*Rev.* CHARLES).

Social Life in Scotland from early to recent times. By the Rev. Charles Rogers. Edinburgh; 1884. 3 vols. 8°.

 (a) I, p. 35.

ROSNY (LÉON DE).

Archives Paléographiques, * * * Par Léon de Rosny. Paris; 1870. 8°.

 (a) Tom. I, 2me liv. Avril–juin, p. 93.

ROYAL GEOGRAPHICAL SOCIETY.

The Journal of the Royal Geographical Society of London. Vols. I [–L?] London. 8°.

 (a) XXXII, 1862, p. 125.

RUTHERFORD (David Greig).

(*a*) Notes on the People of Batanga, West Tropical Africa. In Jour. of Anthrop. Inst. G. B. & I., x, 1881, p. 466.

SAGARD (Gabriel).

Histoire du Canada et Voyages que les frères Mineurs recollet y ont faicts pour conversion des infidèles depuis l'an 1615. Par Gabriel Sagard Theodat, avec un dictionnaire de la langue Huronne. Nouvelle edition publiée par M. Edwin Tross. Paris; 1866. 4 vols. 8°.

(*a*) III, p. 724. (*b*) II, p. 347.

SAYCE (*Prof.* A. H.).

Address to the Anthropological Section of the British Association at Manchester. By Prof. A. H. Sayce. In Journal of the Anthropological Institute of Great Britain and Ireland.

(*a*) Nov., 1887, p. 169.

SCHOOLCRAFT (Henry R.).

Historical and Statistical Information respecting the History, Condition, and Prospects of the Indian Tribes of the United States. Collected and prepared under the direction of the Bureau of Indian Affairs, per act of Congress of March 3d, 1847. By Henry R. Schoolcraft. Illustrated by S. Eastman, Capt. U. S. Army. Published by authority of Congress. Philadelphia; 1851–1857. 6 vols. 4°.

(*a*) I, p. 351. (*b*) IV, 119. (*c*) III, 73 et seq. (*d*) I, 409, Pl. 58, Fig. 67. (*e*) IV, 253, Pl. 32. (*f*) V, 649. (*g*) III, p. 306. (*h*) I, 336, Pl. 47, Fig. c. (*i*) I, Pl. 58, op. p. 408. (*k*) ib. (*l*) I, Pl. 59, Figs. 79 and 103, text on pp. 409, 410. (*m*) I, p. 356. (*n*) III, p. 306. (*o*) I, Pl. 54, Fig. 27. (*p*) III, p. 85. (*q*) I, Pl. 18, Fig. 21. (*r*) I, Pl. 56, Fig. 67. (*s*) I, Pls. 58, 59, Figs. 8, 9, and 98. (*t*) I, Pl. 58. (*u*) ib. (*v*) I, Pl. 59, No. 91. (*w*) I, Pl. 64. (*x*) II, p. 58. (*y*) I, p. 410, Pl. 59, Fig. 102. (*z*) VI, p. 610.

SCHWATKA'S SEARCH.

(See *Gilder, Wm. H.*)

SCHWEINFURTH (Georg).

The Heart of Africa. By Georg Schweinfurth. New York; 1874. 2 vols. 8°.

(*a*) II, p. 23.

SEAVER (James E.).

A Narrative of the life of Mrs. Mary Jemison, who was taken by the Indians in the year 1755, when only about twelve years of age, and has continued to reside amongst them to the present time. Carefully taken from her own words. Nov. 29, 1823. By James E. Seaver. London; 1826. 24°.

(*a*) p. 70.

SHEA (*Dr.* John Gilmary).

First establishment of the Faith in New France. Now first translated by John Gilmary Shea. New York; 1881. 2 vols. 8°. (See also *Le Clercq* (*Père* Chrétien).

(*a*) I. p. 19.

SHRIFNER (Anton).

Ethnographic Importance of Property Marks. In Scientific Treatises of the Imperial Academy of Sciences. St. Petersburg; 1855. 8°.

(*a*) p. 601. (*b*) ib.

SHTUKIN (N. S.).

An Explanation of Certain Picture-writings on the Cliffs of the Yenesei River. In No. 4 of Quarterly Isvestia of the Imp. Geogr. Soc., St. Petersburg; 1882.

SIMPSON (*Lieut.* JAMES H.).

Journal of a Military Reconnaissance from Santa Fé, New Mexico, to the Navajo Country in 1849. By Lt. James H. Simpson, U. S. T. Engineers. Phila.; 1852. 8°.

(*a*) Pl. 72.

SIMPSON (*Sir* JAMES Y.).

On Ancient Sculpturings of Cups and Concentric Rings, * * * In Proceedings of the Society of Antiquaries of Scotland. Appendix to Volume VI. Edinburgh; 1867. pp. 1–147. Pls. I–XXXII.

SIMPSON (THOMAS).

Narrative of the Discoveries of the North Coast of America; effected by the officers of the Hudson's Bay Company during the years 1836–'39. By Thomas Simpson, Esq. London; 1843. 8°.

SMET (*Père* PETER DE).

Missions de l'Orégon et Voyages aux Montagnes Rocheuses, aux sources de la Colombie, de l'Athabasco et du Sascatschawin, en 1845–'46. Par le Père P. de Smet de la Société de Jésus. English translation, New York; 1847. 12°.

(*a*) p. 288. (*b*) p. 320.

SMITH (*Capt.* JOHN).

The True Travels, Adventures and Observations of Captain John Smith, in Europe, Asia, Africke and America; beginning about the yeere 1593 and continued to this present 1629. From the London edition of 1629. Richmond; 1819. 2 vols. 8°.

(*a*) I, p. 230.

SMITHSONIAN REPORTS.

Annual Report of the Board of Regents of the Smithsonian Institution. 1847 [–1892]. Washington. 8°.

SOCIÉTÉ D'ANTHROPOLOGIE DE BRUXELLES.

Bulletin de la Société d'Anthropologie de Bruxelles. Bruxelles. 8°.

(*a*) v, 1886–'87, p. 109. (*b*) ib., p. 108.

SOCIÉTÉ D'ANTHROPOLOGIE DE PARIS.

(See *Paris.*)

SOUCHÉ (B.).

Notes sur quelques découvertes d'archéologie préhistorique aux environs de Pamproux. Niort; 1879. 8°. Partly reported in Matériaux pour l'Histoire Prim., etc.

(*a*) 2ᵉ série, xi. 1880, p. 147.

SOUTH CAROLINA, DOCUMENTS CONNECTED WITH THE HISTORY OF.

Edited by P. C. J. Weston. London; 1856.

(*a*) p. 220.

SPENCER (HERBERT).

The Principles of Sociology. By Herbert Spencer. New York; 1884. 2 vols. 12°.

(*a*) II, p. 72 et seq.

SPROAT (GILBERT MALCOMB).

Scenes and Studies of Savage Life. By Gilbert Malcomb Sproat. London; 1868. 8°.

(*a*) p. 269.

STANLEY (HENRY M.).

The Congo and the Founding of its Free State. A story of work and exploration. By Henry M. Stanley. New York; 1885. 2 vols. 8°.

(*a*) I, p. 373.

STARCKE (*Dr.* C. N.).

The Primitive Family in its origin and development. By Dr. C. N. Starcke. New York; 1889. 8°. [International Scientific Series.]

(*a*) p. 42.

STARR (*Prof.* FREDERICK).

Dress and Adornment. In Popular Science Monthly, Vol. XL, Nos. 1 and 2; 1891.

(*a*) p. 499.

STEARNS (*Prof.* ROBERT E. C.).

Ethnoconchology; a Study of Primitive Money. In the Report of the U. S. National Museum; 1886–'87.

(*a*) p. 304.

STEPHENSON (*Dr.* M. F.).

Geology and Mineralogy of Georgia. By Dr. M. F. Stephenson. Atlanta; 1871. 16°.

(*a*) p. 199.

STEVENSON (JAMES).

Ceremonial of Hasjelti Dailjis and Mythical Sand Painting of the Navajo Indians. By James Stevenson. In the Eighth Annual Report of the Bureau of Ethnology, for 1886–87, pp. 229–285. Washington; 1891.

STRAHLENBERG (PHILIP JOHN VON).

(*a*) An Historico-Geographical Description of the north and eastern parts of Europe and Asia, but more particularly of Russia, Siberia, and Great Tartary. By Philip John von Strahlenberg. London; 1738. 2 vols. 4°.

SUMMERS (JAMES).

A Handbook of the Chinese Language. By James Summers. Oxford; 1863. 8°.

(*a*) Part I, p. 16.

TANNER (JOHN).

Narrative of the Captivity and Adventures of John Tanner * * * during Thirty Years' Residence among the Indians in the interior of North America. Prepared for the press by Edwin James, M. D. New York; 1830. 8°.

(*a*) pp. 341–344. (*b*) p. 193. (*c*) p. 176. (*d*) p. 174. (*e*) pp. 176 and 314.
(*f*) p. 367. (*g*) pp. 174 and 189.

TAYLOR (*Rev.* RICHARD).

Te Ika a Maui; or New Zealand and its Inhabitants. By Rev. Richard Taylor. M. A., F. G. S. London; 1870. 8°.

(*a*) p. 379. (*b*) Ib. (*c*) p. 320. (*d*) p. 209.

TEN KATE (*Dr.* H. F. C.).

Some Ethnographic Observations in the California Peninsula and in Sonora. In Revue d'Ethnographie, Vol. II, 1888.

(*a*) p. 321. (*b*) p. 324.

THOMAS (*Prof.* CYRUS).

Aids to the Study of the Maya Codices. In Sixth Annual Report of the Bureau of Ethnology. Washington; 1888. pp. 253–371. Figs. 359–388.

(*b*) p. 371. (*c*) p. 348.

Burial Mounds of the Northern Section of the United States. In Fifth Annual Report of the Bureau of Ethnology. Washington; 1888. pp. 3–119. Pll. I–VI, Figs. 1–49.

(*a*) p. 100.

THOMAS (JULIAN).

Cannibals and Convicts in the Western Pacific. By Julian Thomas. London; 1886. 8°.

(*a*) p. 37.

THOMSON (*Paymaster* WILLIAM J., *U. S. N.*).
Te Pito Te Henua; or Easter Island. In Report U. S. National Museum for 1888–'89; Washington; 1891. pp. 447–552. Pls. XII–LX, Figs. 1–20.
(*a*) p. 480. Pl. XXIII.

THURN (EVERARD F. IM).
See *im Thurn* (E. F.).

THRUSTON (GATES P.).
The Antiquities of Tennessee and the adjacent States, and the state of aboriginal society in the scale of civilization represented by them. By Gates P. Thruston. Cincinnati; 1890. 8°.
(*a*) pp. 90–96.

TOKYO (Anthropological Society of.)
The Bulletin of the Tōkyō Anthropological Society. Tōkyō Anthrop. Society office, Hongo, Tōkyō. Vols. I–[VII]. 8°.
(*a*) VII. No. 67. Oct. 1891, p. 30.

TREICHEL (A.).
Die Verbreitung des Schulzenstabes und verwandter Geräthe. In Verhandlungen der Berliner Gesellschaft für Anthropologie, Ethnologie und Urgeschichte. Sitzung vom 20. März 1886. Berlin; 1886. 8°. p. 251.

TRUMBULL (HENRY CLAY).
The Blood Covenant a Primitive Rite and its Bearings on Scripture. By H. Clay Trumbull. New York; 1885. 8°.
(*a*) pp. 236–7. (*b*) p. 342.

TSCHUDI (*Dr.* J. J. VON).
Travels in Peru. By Dr. J. J. von Tschudi. New York; 1847. 8°.
(*a*) Pt. II, pp. 344, 345. (*b*) p. 284.
See also *Rivero* (Mariano Edward) and *von Tschudi* (*Dr.* J. J.).

TURNER (GEORGE).
Samoa a hundred years ago and long before. By George Turner. London; 1884. 8°.
(*a*) p. 5]2. (*b*) p. 88. (*c*) p. 185.

TYLOR (*Prof.* EDWARD BURNETT).
Researches into the Early History of Mankind. By Edward Burnett Tylor. New York; 1878. 8°.
(*b*) p. 103.
(*a*) Notes on Powhatan's Mantle. In Internationales Archiv für Ethnographie, I, 1888, p. 215.

TYOUT ET DE MOGHAR (LES DESSINS DES ROCHES DE).
In Revue Géographique Internationale, 9e année, Paris; décembre 1884. No. 110, p. 197. Editorial.

UNITED STATES NATIONAL MUSEUM.
See *National Museum.*

VETROMILE (*Rev.* EUGENE).
A Dictionary of the Abnaki Language. English-Abnaki and Abnaki-English. By the Rev. Eugene Vetromile. MS. in the Library of the Bureau of Ethnology. 3 vols. Folio.

VICTORIA INSTITUTE.
Journal of the Transactions of the Victoria Institute, or Philosophical Society of Great Britain. London; published by the Institute. Vols. I [–XXVI ?]. 8°.

VINING (EDWARD P.).
An Inglorious Columbus, or Evidence that Hwui Shan and a Party of Buddhist Monks from Afghanistan discovered America in the Fifth Century A. D. By Edward P. Vining. New York; 1885. 8°.

WAKABAYASHIA (K.).

(a) Pictures on Dotaku or so-called Bronze Bell. By Mr. K. Wakabayashia. In Bulletin of the Tōkyō Anthropological Society, Vol. VII, No. 67, Oct., 1891, with illustrations continued in No. 69. Tōkyō. 8°.

WAKEFIELD (EDWARD JERNINGHAM).

Adventures in New Zealand from 1839 to 1844. By Edward Jerningham Wakefield. London; 1845. 2 vols. 8°.

(a) I, p. 64.

WAKEMAN (W. F.).

On the Earlier Forms of Inscribed Christian Crosses found in Ireland. In Journal of the Proceedings of the Royal Society of Antiquaries of Ireland. Vol. I, 5th ser. 1st quar. 1891. 8°.

(a) p. 350.

WALLACE (*Prof.* ALFRED R.).

A Narrative of Travels on the Amazon and Rio Negro. * * * By Alfred R. Wallace. London; 1853. 8°.

WARREN (WM. F.).

Paradise Found; the Cradle of the Human Race at the North Pole; a Study of the Prehistoric World. By Wm. F. Warren. Boston; 1885. 8°.

WARREN (W. W.).

Memoir of W. W. Warren; a History of the Ojibwa. In Coll. of the Minnesota Historical Society, Vol. V, St. Paul; 1885. 8°.

(a) pp. 89–90.

WESTON (P. C. J.). See *South Carolina.*

WEITZECKER (GIACOMO).

Bushman Pictograph. In Bollet. della Società Geografica Ital. Ser. II, Vol. XII. Fasc. Apr., 1887. Roma; 1887.

(a) pp. 297–301.

WHIPPLE (*Lieut.* A. W.).

Report upon the Indian Tribes. By Lieut. A. W. Whipple, Thomas Ewbank, Esq., and Prof. Wm. W. Turner. Washington; 1855. Forms Pt. III of Reports of Explorations and Surveys to ascertain the most practicable and economical route for a railroad from the Mississippi River to the Pacific Ocean. Washington; 1856. Senate Ex. Doc. No. 78. 33d Cong. 2d session.

(a) p. 42. (b) ib., pl. 36. (c) pp. 36–37, pls. 28, 29, 30. (d) p. 39, pl. 32. (e) pp. 9, 10. (f) p. 33.

WHITFIELD (J.).

In Journ. of Anthrop. Inst. of Gt. Br. and I.

(a) III, 1874, p. 114.

WHITTLESEY (*Col.* CHARLES).

Antiquities of Ohio. Report of the Committee of the State Archæological Society. In Final Report of the Ohio State Board of Centennial Managers to the General Assembly of the State of Ohio. Columbus; 1877. 8°.

Archæological Frauds. Western Reserve and Northern Ohio Historical Society, Cleveland, Ohio. Tracts 1 to 36, 1870–1877. Cleveland; 1877. 8°.

(a) No. 33, Nov., 1876, pp. 1–7; Ills. 1, 3, and 4.

WHYMPER (FREDERICK).

Travels and Adventures in the Territory of Alaska, formerly Russian American— now ceded to the United States—and in various other parts of the North Pacific. New York; 1869. 8°.

(a) p. 101.

WIED-NEUWIED (MAXIMILIAN ALEXANDER PHILLIP, *Prinz von*).
Travels in the Interior of North America. By Maximilian, Prince of Wied.
London; 1843. Imp. folio.
(*a*) p. 387. (*b*) p. 149, et seq. (*c*) pp. 339, 386. (*d*) p. 153. (*e*) p. 255.
(*f*) p. 340. (*g*) p. 341. (*h*) p. 352.

WIENER (CHARLES).
Pérou et Bolivie, récit de voyage, suivi d'études archéologiques et ethnogra-
phiques et de notes sur l'écriture et les langues des populations indiennes.
Par Charles Wiener. Paris; 1880. 8°.
(*a*) p. 759. (*b*) p. 763. (*c*) p. 167. (*d*) p. 705. (*e*) p. 770. (*f*) p. 763. (*g*) p.
77. (*h*) p. 706. (*i*) p. 669. Ill. on pp. 772 and 773.

WILKES (*Commodore* CHARLES, *U. S. N.*).
Narrative of the United States Exploring Expedition during the years 1838, 1839,
1840, 1841, 1842. By Charles Wilkes, U. S. N. Philadelphia; 1850. 5 vols. 4°.
(*a*) v, p. 128. (*b*) ib., p. 185.

WILKINSON (*Sir* J. GARDNER).
The Manners and Customs of the Ancient Egyptians. By Sir Gardner Wilkinson,
D. C. L., F. R. S., F. R. G. S. A new edition, revised and corrected by Samuel
Birch, LL. D., D. C. L. Boston; 1883. 3 vols. 8°.
(*a*) II, Ch. X.

WILLIAMS (*Dr.* S. WELLS).
The Middle Kingdom. A Survey of the Geography, Government, Literature,
Social Life, Arts and History of the Chinese Empire and its Inhabitants. By
S. Wells Williams, LL. D. New York; 1883. 2 vols. 8°.
(*a*) II, p. 248.

WILSON (*Sir* DANIEL).
Prehistoric Man. Researches into the Origin of Civilization in the Old and the
New World. By Daniel Wilson, LL. D. Cambridge and London; 1862. 2
vols. 8°.
(*a*) II, p. 185.
The Huron-Iroquois of Canada; a Typical Race of American Aborigines. In
Proceedings of the Royal Society of Canada.
(*a*) II., 1884, p. 82.

WINCHELL (*Prof.* N. H.).
The Geology of Minnesota. Vol. I of the final report. By N. H. Winchell. Min-
neapolis, Minn.; 1884. Imp. 8°.
(*a*) pp. 555–561, Pls. I, J, K, and L.

WISCONSIN (Annual Reports and Collections of the State Historical Society of).
Madison, Wis. Vols. I, 1854 [–XI]. 12°.

WORSNOP (Thomas).
The Pre-Historic Arts of the Aborigines of Australia. By Thos. Worsnop. Ade-
laide; 1887.
(*a*) pp. 7–9. (*b*) p. 22.

YARROW (*Dr.* H. C.).
See *Bureau of Ethnology.*

ZAMACOIS (*D.* NICETO DE).
Historia de México. Barcelona and Mexico; 1877–'80. 11 vols. 8°.
(*a*) I, p. 238.

ZEITSCHRIFT FÜR ETHNOLOGIE.
Organ der Berliner Gesellschaft für Anthropologie, Ethnologie und Urge-
schichte. Unter Mitwirkung des Vertreters desselben R. Virchow herausge-
geben von A. Bastian und R. Hartmann. Berlin. I[–XXV]. 1869–92.
(*a*) VIII, 1876, p. 195.

INDEX.

This comprehensive Index covers both volumes of the Dover edition, in which Volume I contains pages 1–460 and Volume II contains pages 461–822. The Index references to pages with roman numbers should be disregarded, since these pages (originally containing the 1889 Report of the Director of the Bureau of Ethnology) have been omitted in the present edition.

[The names of authors and works which appear in the List of Works and Authors cited (pp. 777–808) are not included in this index.]

A.

A CATALOG OF SELECTED DOVER
BOOKS IN ALL FIELDS OF INTEREST

DRAWINGS OF REMBRANDT, edited by Seymour Slive. Updated Lippmann, Hofstede de Groot edition, with definitive scholarly apparatus. All portraits, biblical sketches, landscapes, nudes. Oriental figures, classical studies, together with selection of work by followers. 550 illustrations. Total of 630pp. 9⅛ × 12¼.
21485-0, 21486-9 Pa., Two-vol. set $25.00

GHOST AND HORROR STORIES OF AMBROSE BIERCE, Ambrose Bierce. 24 tales vividly imagined, strangely prophetic, and decades ahead of their time in technical skill: "The Damned Thing," "An Inhabitant of Carcosa," "The Eyes of the Panther," "Moxon's Master," and 20 more. 199pp. 5⅜ × 8½. 20767-6 Pa. $3.95

ETHICAL WRITINGS OF MAIMONIDES, Maimonides. Most significant ethical works of great medieval sage, newly translated for utmost precision, readability. Laws Concerning Character Traits, Eight Chapters, more. 192pp. 5⅜ × 8½.
24522-5 Pa. $4.50

THE EXPLORATION OF THE COLORADO RIVER AND ITS CANYONS, J. W. Powell. Full text of Powell's 1,000-mile expedition down the fabled Colorado in 1869. Superb account of terrain, geology, vegetation, Indians, famine, mutiny, treacherous rapids, mighty canyons, during exploration of last unknown part of continental U.S. 400pp. 5⅜ × 8½. 20094-9 Pa. $6.95

HISTORY OF PHILOSOPHY, Julián Marías. Clearest one-volume history on the market. Every major philosopher and dozens of others, to Existentialism and later. 505pp. 5⅜ × 8½. 21739-6 Pa. $8.50

ALL ABOUT LIGHTNING, Martin A. Uman. Highly readable non-technical survey of nature and causes of lightning, thunderstorms, ball lightning, St. Elmo's Fire, much more. Illustrated. 192pp. 5⅜ × 8½. 25237-X Pa. $5.95

SAILING ALONE AROUND THE WORLD, Captain Joshua Slocum. First man to sail around the world, alone, in small boat. One of great feats of seamanship told in delightful manner. 67 illustrations. 294pp. 5⅜ × 8½. 20326-3 Pa. $4.95

LETTERS AND NOTES ON THE MANNERS, CUSTOMS AND CONDITIONS OF THE NORTH AMERICAN INDIANS, George Catlin. Classic account of life among Plains Indians: ceremonies, hunt, warfare, etc. 312 plates. 572pp. of text. 6⅛ × 9¼. 22118-0, 22119-9 Pa. Two-vol. set $15.90

ALASKA: The Harriman Expedition, 1899, John Burroughs, John Muir, et al. Informative, engrossing accounts of two-month, 9,000-mile expedition. Native peoples, wildlife, forests, geography, salmon industry, glaciers, more. Profusely illustrated. 240 black-and-white line drawings. 124 black-and-white photographs. 3 maps. Index. 576pp. 5⅜ × 8½. 25109-8 Pa. $11.95

SIR HARRY HOTSPUR OF HUMBLETHWAITE, Anthony Trollope. Incisive, unconventional psychological study of a conflict between a wealthy baronet, his idealistic daughter, and their scapegrace cousin. The 1870 novel in its first inexpensive edition in years. 250pp. 5⅜ × 8½. 24953-0 Pa. $5.95

LASERS AND HOLOGRAPHY, Winston E. Kock. Sound introduction to burgeoning field, expanded (1981) for second edition. Wave patterns, coherence, lasers, diffraction, zone plates, properties of holograms, recent advances. 84 illustrations. 160pp. 5⅜ × 8¼. (Except in United Kingdom) 24041-X Pa. $3.50

INTRODUCTION TO ARTIFICIAL INTELLIGENCE: SECOND, EN-LARGED EDITION, Philip C. Jackson, Jr. Comprehensive survey of artificial intelligence—the study of how machines (computers) can be made to act intelligently. Includes introductory and advanced material. Extensive notes updating the main text. 132 black-and-white illustrations. 512pp. 5⅜ × 8½. 24864-X Pa. $8.95

HISTORY OF INDIAN AND INDONESIAN ART, Ananda K. Coomaraswamy. Over 400 illustrations illuminate classic study of Indian art from earliest Harappa finds to early 20th century. Provides philosophical, religious and social insights. 304pp. 6⅜ × 9⅜. 25005-9 Pa. $8.95

THE GOLEM, Gustav Meyrink. Most famous supernatural novel in modern European literature, set in Ghetto of Old Prague around 1890. Compelling story of mystical experiences, strange transformations, profound terror. 13 black-and-white illustrations. 224pp. 5⅜ × 8½. (Available in U.S. only) 25025-3 Pa. $5.95

ARMADALE, Wilkie Collins. Third great mystery novel by the author of *The Woman in White* and *The Moonstone*. Original magazine version with 40 illustrations. 597pp. 5⅜ × 8½. 23429-0 Pa. $9.95

PICTORIAL ENCYCLOPEDIA OF HISTORIC ARCHITECTURAL PLANS, DETAILS AND ELEMENTS: With 1,880 Line Drawings of Arches, Domes, Doorways, Facades, Gables, Windows, etc., John Theodore Haneman. Sourcebook of inspiration for architects, designers, others. Bibliography. Captions. 141pp. 9 × 12. 24605-1 Pa. $6.95

BENCHLEY LOST AND FOUND, Robert Benchley. Finest humor from early 30's, about pet peeves, child psychologists, post office and others. Mostly unavailable elsewhere. 73 illustrations by Peter Arno and others. 183pp. 5⅜ × 8½. 22410-4 Pa. $3.95

ERTÉ GRAPHICS, Erté. Collection of striking color graphics: *Seasons, Alphabet, Numerals, Aces* and *Precious Stones*. 50 plates, including 4 on covers. 48pp. 9⅜ × 12¼. 23580-7 Pa. $6.95

THE JOURNAL OF HENRY D. THOREAU, edited by Bradford Torrey, F. H. Allen. Complete reprinting of 14 volumes, 1837–61, over two million words; the sourcebooks for *Walden*, etc. Definitive. All original sketches, plus 75 photographs. 1,804pp. 8½ × 12¼. 20312-3, 20313-1 Cloth., Two-vol. set $80.00

CASTLES: THEIR CONSTRUCTION AND HISTORY, Sidney Toy. Traces castle development from ancient roots. Nearly 200 photographs and drawings illustrate moats, keeps, baileys, many other features. Caernarvon, Dover Castles, Hadrian's Wall, Tower of London, dozens more. 256pp. 5⅜ × 8¼. 24898-4 Pa. $5.95

THE ART NOUVEAU STYLE BOOK OF ALPHONSE MUCHA: All 72 Plates from "Documents Decoratifs" in Original Color, Alphonse Mucha. Rare copyright-free design portfolio by high priest of Art Nouveau. Jewelry, wallpaper, stained glass, furniture, figure studies, plant and animal motifs, etc. Only complete one-volume edition. 80pp. 9⅜ × 12¼. 24044-4 Pa. $8.95

ANIMALS: 1,419 COPYRIGHT-FREE ILLUSTRATIONS OF MAMMALS, BIRDS, FISH, INSECTS, ETC., edited by Jim Harter. Clear wood engravings present, in extremely lifelike poses, over 1,000 species of animals. One of the most extensive pictorial sourcebooks of its kind. Captions. Index. 284pp. 9 × 12. 23766-4 Pa. $9.95

OBELISTS FLY HIGH, C. Daly King. Masterpiece of American detective fiction, long out of print, involves murder on a 1935 transcontinental flight—"a very thrilling story"—NY Times. Unabridged and unaltered republication of the edition published by William Collins Sons & Co. Ltd., London, 1935. 288pp. 5⅜ × 8½. (Available in U.S. only) 25036-9 Pa. $4.95

VICTORIAN AND EDWARDIAN FASHION: A Photographic Survey, Alison Gernsheim. First fashion history completely illustrated by contemporary photographs. Full text plus 235 photos, 1840–1914, in which many celebrities appear. 240pp. 6½ × 9¼. 24205-6 Pa. $6.00

THE ART OF THE FRENCH ILLUSTRATED BOOK, 1700–1914, Gordon N. Ray. Over 630 superb book illustrations by Fragonard, Delacroix, Daumier, Doré, Grandville, Manet, Mucha, Steinlen, Toulouse-Lautrec and many others. Preface. Introduction. 633 halftones. Indices of artists, authors & titles, binders and provenances. Appendices. Bibliography. 608pp. 8⅜ × 11¼. 25086-5 Pa. $24.95

THE WONDERFUL WIZARD OF OZ, L. Frank Baum. Facsimile in full color of America's finest children's classic. 143 illustrations by W. W. Denslow. 267pp. 5⅜ × 8½. 20691-2 Pa. $5.95

FRONTIERS OF MODERN PHYSICS: New Perspectives on Cosmology, Relativity, Black Holes and Extraterrestrial Intelligence, Tony Rothman, et al. For the intelligent layman. Subjects include: cosmological models of the universe; black holes; the neutrino; the search for extraterrestrial intelligence. Introduction. 46 black-and-white illustrations. 192pp. 5⅜ × 8½. 24587-X Pa. $6.95

THE FRIENDLY STARS, Martha Evans Martin & Donald Howard Menzel. Classic text marshalls the stars together in an engaging, non-technical survey, presenting them as sources of beauty in night sky. 23 illustrations. Foreword. 2 star charts. Index. 147pp. 5⅜ × 8½. 21099-5 Pa. $3.50

FADS AND FALLACIES IN THE NAME OF SCIENCE, Martin Gardner. Fair, witty appraisal of cranks, quacks, and quackeries of science and pseudoscience: hollow earth, Velikovsky, orgone energy, Dianetics, flying saucers, Bridey Murphy, food and medical fads, etc. Revised, expanded In the Name of Science. "A very able and even-tempered presentation."—The New Yorker. 363pp. 5⅜ × 8. 20394-8 Pa. $6.50

ANCIENT EGYPT: ITS CULTURE AND HISTORY, J. E Manchip White. From pre-dynastics through Ptolemies: society, history, political structure, religion, daily life, literature, cultural heritage. 48 plates. 217pp. 5⅜ × 8½. 22548-8 Pa. $4.95

AMERICAN CLIPPER SHIPS: 1833–1858, Octavius T. Howe & Frederick C. Matthews. Fully-illustrated, encyclopedic review of 352 clipper ships from the period of America's greatest maritime supremacy. Introduction. 109 halftones. 5 black-and-white line illustrations. Index. Total of 928pp. 5⅜ × 8½.
25115-2, 25116-0 Pa., Two-vol. set $17.90

TOWARDS A NEW ARCHITECTURE, Le Corbusier. Pioneering manifesto by great architect, near legendary founder of "International School." Technical and aesthetic theories, views on industry, economics, relation of form to function, "mass-production spirit," much more. Profusely illustrated. Unabridged translation of 13th French edition. Introduction by Frederick Etchells. 320pp. 6⅛ × 9¼. (Available in U.S. only)
25023-7 Pa. $8.95

THE BOOK OF KELLS, edited by Blanche Cirker. Inexpensive collection of 32 full-color, full-page plates from the greatest illuminated manuscript of the Middle Ages, painstakingly reproduced from rare facsimile edition. Publisher's Note. Captions. 32pp. 9⅜ × 12¼.
24345-1 Pa. $4.95

BEST SCIENCE FICTION STORIES OF H. G. WELLS, H. G. Wells. Full novel *The Invisible Man*, plus 17 short stories: "The Crystal Egg," "Aepyornis Island," "The Strange Orchid," etc. 303pp. 5⅜ × 8½. (Available in U.S. only)
21531-8 Pa. $4.95

AMERICAN SAILING SHIPS: Their Plans and History, Charles G. Davis. Photos, construction details of schooners, frigates, clippers, other sailcraft of 18th to early 20th centuries—plus entertaining discourse on design, rigging, nautical lore, much more. 137 black-and-white illustrations. 240pp. 6⅛ × 9¼.
24658-2 Pa. $5.95

ENTERTAINING MATHEMATICAL PUZZLES, Martin Gardner. Selection of author's favorite conundrums involving arithmetic, money, speed, etc., with lively commentary. Complete solutions. 112pp. 5⅜ × 8½.
25211-6 Pa. $2.95

THE WILL TO BELIEVE, HUMAN IMMORTALITY, William James. Two books bound together. Effect of irrational on logical, and arguments for human immortality. 402pp. 5⅜ × 8½.
20291-7 Pa. $7.50

THE HAUNTED MONASTERY and THE CHINESE MAZE MURDERS, Robert Van Gulik. 2 full novels by Van Gulik continue adventures of Judge Dee and his companions. An evil Taoist monastery, seemingly supernatural events; overgrown topiary maze that hides strange crimes. Set in 7th-century China. 27 illustrations. 328pp. 5⅜ × 8½.
23502-5 Pa. $5.95

CELEBRATED CASES OF JUDGE DEE (DEE GOONG AN), translated by Robert Van Gulik. Authentic 18th-century Chinese detective novel; Dee and associates solve three interlocked cases. Led to Van Gulik's own stories with same characters. Extensive introduction. 9 illustrations. 237pp. 5⅜ × 8½.
23337-5 Pa. $4.95

Prices subject to change without notice.
Available at your book dealer or write for free catalog to Dept. GI, Dover Publications, Inc., 31 East 2nd St., Mineola, N.Y. 11501. Dover publishes more than 175 books each year on science, elementary and advanced mathematics, biology, music, art, literary history, social sciences and other areas.